Computer Music in the 21st Century:
History and Practice

21世纪计算机音乐创作：
历史与实践

|中英双语版|

〔法〕马克·巴蒂耶（Marc Battier） 著

邹愈丹 杨晓曼 田港璨 译

U0330328

中山大学出版社
SUN YAT-SEN UNIVERSITY PRESS

·广州·

图书在版编目（CIP）数据

21 世纪计算机音乐创作：历史与实践 = Computer Music in the 21ˢᵗ Century：History and Practice：汉文、英文／（法）马克·巴蒂耶（Marc Battier）著；邹愈丹，杨晓曼，田港璨译 . —广州：中山大学出版社，2023.10

ISBN 978 - 7 - 306 - 07863 - 6

Ⅰ. ①2…　Ⅱ. ①马…②邹…③杨…④田…　Ⅲ. ①计算机应用—音乐制作—研究—汉、英　Ⅳ. ①J619.1 - 39

中国国家版本馆 CIP 数据核字（2023）第 139305 号

21 SHIJI JISUANJI YINYUE CHUANGZUO：LISHI YU SHIJIAN

出 版 人：王天琪
策划编辑：赵　冉
责任编辑：赵　冉
封面设计：曾　婷
责任校对：王贝佳
责任技编：靳晓虹
出版发行：中山大学出版社
电　　话：编辑部 020 - 84110283，84113349，84111997，84110779，84110776
　　　　　发行部 020 - 84111998，84111981，84111160
地　　址：广州市新港西路 135 号
邮　　编：510275　传　　真：020 - 84036565
网　　址：http://www.zsup.com.cn　E-mail：zdcbs@mail.sysu.edu.cn
印 刷 者：佛山市浩文彩色印刷有限公司
规　　格：787mm×1092mm　1/16　23.5 印张　410 千字
版次印次：2023 年 10 月第 1 版　2023 年 10 月第 1 次印刷
定　　价：88.00 元

如发现本书因印装质量影响阅读，请与出版社发行部联系调换

目 录

Computer Music in the 21st Century: History and Practice

Contents 目录

21 世纪计算机音乐创作：历史与实践

Computer Music in the 21st Century: History and Practice

1

Presentation

There are already some books published on history of electronic music, as well as advice on how to practice computer music in the 21st century. Those which discuss the historical development of electronic music have usually too much information which masks the main trends and facts of this evolution. Those which present how to use computer music tools have often been written many years ago and do not reflect the way computer music is practiced today.

Our textbook wants to introduce computer music to the Chinese public. For this, the place of Chinese composers will not be forgotten, as is generally the case with foreign books. The textbook is designed to bring readers information on the evolution of electronic and computer music since its appearance in the middle of the 20th century up to today. It includes the development and important works of Chinese electronic music. The historical account is informed by the long experience of the author in researching the evolution of electronic music and computer music, and his own experience as composer since the early 1970s.

A second part focuses on the technology: how synthesizers and computer create sounds, which are the main methods, what musical tools are offered by using computers, and, more precisely discuss the most important features of existing software and how to utilize them to create music by composing and mixing.

The techniques it is necessary to know when working in a studio—recording, mixing, mastering—are also introduced in the book.

In so doing, we are not going to a particular style, like pop, hip-hop, electronica, DJ'ing and classic electronic music. Rather, we hope that the textbook will be used by teachers, students and music lovers in a variety of styles.

The book ends with a number of useful appendices: tables for representation of pitch and frequency, including a rare table for micro-intervals up to eight-tone, a comprehensive index and a bibliography of Chinese and Western useful references.

2
Introduction

At a time when software gets updated at a very fast pace, when new operating systems are produced every year, when older pieces of codes or music scores and MIDI and audio sequences cannot run anymore because they become obsolete, it seems difficult to write a textbook which reflects the technology used to create music. There was a time when musicians could rely on their instrument. They still do. With electricity as a medium for music, this has changed. Engineers and instrument makers compete to come up with the latest technology.

In the seventy plus years since the invention of electronic music, the devices used have become numerous and more complex. They also provide better audio quality. They respond to various needs, as the number of styles of music depending on electronic and digital technology is staggering, from popular dance music to classical concert works.

This book is an introduction to the history of electronic music, including in China, and the techniques and technology used for creation.

Before entering into this book, we must distinguish between different types of computer music software. Each one induces a specific practice and an approach to composition with artificial sounds.

A first category, quite popular in this beginning of the 21^{st} century, is made of digital audio workstations programs, simply called DAWs.

Nowadays, they can be arranged into two categories.

First, there are all-purpose DAWs, meant to compose and produce. These are the most popular.

Composing or producing a piece of music consists of assembling segments of audio files and of MIDI sequences. These DAWs usually come with a large number of additional software, called plugins. Of those, some are digital instruments, like synthesizers, samplers and sample players; others are meant for processing audio, like compressors, filters and equalizers, reverberation, stereo imaging, and other kinds.

Those DAWs can accept different families of plugins, but rarely all. Some, like Cubase, will be happy to use VST plugins; others, like Logic, will mostly used AU (Apple Units).

In this category of DAWs are found popular programs such as Cubase, Logic, Ableton Live, FL Studio, Digital Performer, and several others.

Those DAWs are perfectly able to produce complete pieces: they are equipped with mixing, mastering and imaging tools, with automation of those operations.

The second category of DAW is more geared towards the recording and production phases of computer music. As of this writing, the main program for production is Avid's Pro Tools, which has a long history and has penetrated most recording studios the world over. Note that it only accepts plugins of its own kind, but most plugin manufacturers provide for this. Other excellent production DAW are Reaper and Mixbus 32-C. That one is made by Harrison, which also builds complete mixing boards. Even if all those DAWs are mostly known for their recording, mixing and mastering capabilities, they are perfectly suited for composition.

So, even though there are certain tendencies in all those programs, any of them is able to serve the main operations involved in making digital music: recording, composing, processing, mixing and mastering.

They are used to produce music which ends up recorded as a stereo or multi-channel file. They serve the need to produce a complete and finished piece of music, stored on a digital medium, which, in turn, can be distributed through Internet in various forms, such as MP3 files, for instance. That's why they are usually called studio software.

A second family of computer music software is found in the real-time programs designed for live interaction: those are used for performing music from laptop. In this situation, the music is produced directly, for instance on stage. The software can generate sounds, or can use plugins such as instruments or processing tools. The most popular of those programs are Max (also known as Max/MSP), from Cycling 74, which has been around since the 1990s, and SuperCollider. A recent trend related to this category are the line-coding environments, where musicians make music on the fly while writing lines of codes, which are interpreted and played without delay. A variant of Max is PD (Pure Data): this software was also written by Miller Puckette, the inventor of Max.

A third category of computer music software are the stand-alone programs: they

can be used independently, without the need for a DAW. However, most of those programs are also produced as plugins, which is convenient. For instance, the GRM Tools, produced by INA-GRM. Thus, they come as independent, stand-alone programs, as well as plugins. A company like Arturia has a collection of software instruments, like synthesizers, which are a digital reproduction of actual, and sometimes historical, hardware instruments. Those, too, are available as plugins.

A fourth category is composed of computer-generated programs. They are, actually, the oldest computer music software, as they are modern variations of a program invented in 1957 by Max Mathews. They are now used to create carefully crafted digital sound structures. The most popular these days is Csound, a program distributed freely. It benefits from an extensive documentation and large community of users worldwide.

A fifth category is made of other software, grouped under the name of computer-assisted composition (CAC). There, you can find IRCAM's OpenMusic, a very complete program for aiding composers. OM, as it is known, is today interfaced with other computer music software, like Csound. It also benefits from a large community of users around the world, which creates "libraries" specialized in certain types of operations.

Another such software is Sibelius Academy's PWGL. Like OpenMusic, it is graphical and is programmed in the Lisp language.

Choosing a particular software can be decided by the type of music you want to create. In any case, knowing about those categories will help you decide. This is what this book is about.

3

Early Historical Development

3. 1 Overview

The first half of the 20^{th} century saw the advent of sound technologies: radio, electric recording, the birth of the electronic lamp, microphone and loudspeaker, radio and sound recording magnetic tape. It was during this period that electric and then electronic violin making appeared at the end of the 19^{th} century.

The second half of the 20^{th} century: the electronic luthier of the beginning of the century gave way to the musician's growing interest in recording, which made it possible to design music directly on magnetic tape. Musical technology first takes the path of creation laboratories: electroacoustic music studios in which composers perform their works directly on the support of the magnetic tape.

This period also saw the advent of the use of digital techniques and the computer in musical composition: it was the appearance of computer music. The computer is gradually becoming the main platform for creative work. At the same time, modular analog synthesizers (non-digital) were designed which allowed electroacoustic music to take the stage to be played live in front of the public.

Nevertheless, the technological progress is not sufficient to explain the advent of new methods of creating and performing music. There is a whole movement towards what composer Edgard Varese called, in 1937, "the liberation of sound"[1] across the 20^{th} century up to today.

[1] Edgard Varese mentioned the liberation of sound in an interview for the journal *San Francisco Chronicle*, 28 November 1937, p. 13 (http://www. zakros. com/mica/soundart/s04/varese_ text. html, retrieved 2020 – 08 – 16).

Figure 3 – 1 Edgard Varese (1883—1965)

3. 2　Pioneering Technologies in Sound Recording and Transmission

　　The progressive domestication of electrical energy and the refinement of mechanical techniques set the stage for the invention of sound technologies. Some of them are, over a century later and in renewed forms, still in use. To these techniques respond the aspirations of artists to measure themselves against modernity. Movements appear; they often bring together poets, painters, musicians. Italian futurism offers a profound change in art, which must now integrate the new dimensions of society at the start of the 20th century: speed, noise, communication, mechanization, space.

　　The development of magnetic recording is exemplary. On it rests an impressive number of techniques and artistic achievements. The invention of magnetic recording is credited to the Danish Valdemar Poulsen, who developed a recording process. The principle consisted in running a steel wire past an electromagnet, the intensity of which was modulated by an electrical signal; the resulting variations in the magnetic field were retained by the wire, by remanence.

　　In 1888, Oberlin Smith published an article in the American magazine *Electrical World* entitled "Some Possible Forms of Phonograph", in which he described a mechanism for unwinding a support, consisting of a ribbon from a supply reel to the

8

receiver. An electromagnet generates a magnetic field which is fixed on the support, in the form of a magnetization which represents the variations of the sound wave. He imagined for this purpose that the support could consist of a silk or cotton thread, impregnated with iron.

Reproduction is allowed by reversing the process, since the electromagnet will be sensitive to the magnetization of the support and will be able to restore a signal to its image. The invention described by Smith is remarkable since the theory of electromagnetic waves had just been formulated the previous year by Heinrich Hertz. However, Smith does not appear to have made his invention, and there is no known patent he is said to have filed. It was therefore a Danish, Valdemar Poulsen, who imagined and produced a magnetic recording device, the Telegraphone. Poulsen experimented with various types of support: tape and metal disc, and wire. This version was one of the attractions of the Universal Exhibition in Paris in 1900. The wire ran at a speed of 2 meters per second, allowing up to 15 minutes of recording with 1.8 km support. The machine was sold by different companies, but the very poor sound quality did not allow it to survive.

The decisive improvement in recording on metal support is due to Kurt Stille, a German chemist for the purpose of making magnetic recorders. He designed the first recording device, the Dailygraph, designed like a dictaphone. In collaboration with Marconi, he produced a magnetic wire recorder which was a definite success. The Marconi-Stille machine remained in use on European radios long after the appearance of the tape recorder.

The invention of the support on tape with a magnetic coating goes back to Fritz Pfleumer. While working on paper ribbons for cigarette filters in a Dresden company, he came up with the idea of magnetic tape. This involved placing metallic particles to adhere to a paper tape. For this invention, he obtained a patent in January 1928.

In 1934, The German firm BASF produced 50 km of plastic magnetic tape. The first plastic tape recorder, dubbed the Magnetophon, was presented at the 12th Berlin Radio Show. He recorded on a plastic tape coated with magnetizing particles. The tape was traveling at a speed of 1 meter per second. Later, this speed was reduced to 77 cm/s then 76 cm/s. AEG built the Magnetophon with plastic film, a process developed in 1934 by BASF. But problems remained, and the firm decided not to market the machine immediately. The device was based on a mechanism based on three motors, a system which remained in use thereafter.

In 1937, the Magnetophon was marketed by AEG/Telefunken. The firm AEG (Berlin, Oberschoneweide) had first thought of calling its invention "Gea-Bandsprecher", which can roughly be translated by "speaking tape" or "voice on tape", then "Ferrophon". The name Magnetophon will become, after the second world war, a common name.

3. 3　Electrical Musical Instruments

We distinguish the qualifiers "electric" and "electronic", which designate two very different areas of the application of electricity to instruments.

An electrical instrument proceeds by transformation of the mechanical energy into current, such as the vibrations of a guitar string or the rotation of a metal disc in front of an electromagnet.

It applies to instruments like the electric guitar. The principle of sound production is based on capturing the movement of a solid body such as a dynamo (Dynamophone or Telharmium) or a plucked string (guitar). Other electric instruments were designed in the first half of the 20th century and some became popular (Hammond organ, electric pianos like the Neo-Bechstein).

By an electromechanical or electromagnetic, more rarely photoelectric or electrostatic (electric harpsichord) sensing, the vibration is converted into an electrical signal. With the exception of the ancestor that is the Dynamophone, a circuit amplifies this signal which is then led to a loudspeaker.

The system for capturing the movements of the vibrating body is called a transducer. In electromagnetic instruments like the electric guitar, the transducer is a microphone (pick up in English). Much depends on it the quality of the sound produced by the instrument.

If the capture system is electromagnetic or photoelectric, then we speak of an electroacoustic instrument.

Electric instruments were tested and built from the end of the 19th century. They continue being built and used today.

3. 4　Electronic Instruments

The principle of an electronic musical instrument is that of the production of a

signal by an oscillating circuit (oscillator).

This term "electronics" designates a general principle by which an electronic circuit directly produces a wave without resorting to a vibrating body.

It was the invention at the very beginning of the 20th century by Lee De Forest (United States) of the triode which enabled the development of electronic equipment such as the radio or the amplifier. It was a vacuum tube which was baptized by its creator "audion" since he had the hope of designing a musical instrument, which made it possible to produce and amplify sound signals.

Radio was a fertile ground for inventions which laid the conditions for the realization of electronic instruments (theremin, Ondes Martenot), but from the end of the 1920s, other synthetic principles were born (subtractive synthesis).

Thus, electronic technology became operational in 1906 with the invention of Lee de Forest and developed thanks to research on radio.

3.5 A Curious Precursor: The Electric Harpsichord

In France in 1761, Jean-Baptiste Delaborde published a small work, *The Electric Harpsichord*, with a new theory of mechanism and the phenomena of electricity, in which he described an ingenious device.

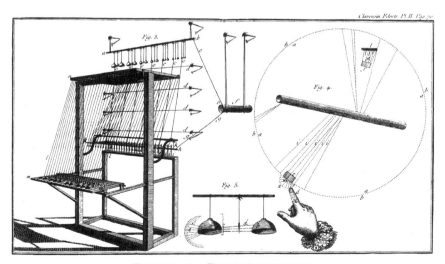

Figure 3 −2　Electric harpsichord

11

Delaborde's recently reprinted book explains how, through successive experiments on the mysteries of electricity and conduction, the instrument was made. It is therefore an electrostatic instrument.

Each note of the instrument is produced by two small tuned bells; between them, a small metal stick is attached. When the instrumentalist presses the key, an electrical charge is transmitted to one of the two bells which then attracts the metal stick. By an alternating play of positive and negative electric charges, the metal stick oscillates between the two bells and strikes them alternately: "The beater starts to move and strikes the two timbres with such speed that it only results in a wavy sound, which roughly imitates the effect of the organ trembling."

This wonderful quotation from his book was written at a time when electricity was not fully understood: "Electric matter is its soul like air is that of the organ."

Electricity, at a time when the battery did not exist, was supplied by turning a wheel to charge a metallic body with electricity. The author explained how the instrument is played and creates sounds in this fashion: "The electric material thus remains as captive and shivers unnecessarily around the timbres of the new harpsichord, until it is given freedom by lowering the keys. It then escapes with the greatest speed; but it stops working as soon as the keys are released."

This instrument, interesting as it may be, did not survive the 18th century. Only at the end of the 19th century were new electrical instruments invented. This was the result of intense scrutiny in applications of the electricity. In 1876, for instance, was invented the telephone. This device uses a simple form of transduction, which is the conversion of a type of energy into another, namely from the acoustic waves created by someone speaking into variations of electrical current.

The invention of the telephone was permitted by the discovery that wave movements created by sound could move a membrane. In turn, the movements of the membrane created an electrical current whose variations followed the molecular vibration of the air. In this respect, the principle of the 1876 microphone is not so different from what we use every day when we speak into our mobile phone, although the quality of our devices is far superior.

3. 6 Development of Electrical and Electronic Instruments

In the first half of the century, a large number of inventors designed real instruments from various electrical systems. These instruments allow interpretation. It is musicians or engineers, often in liaison with musicians, who design these instruments. This is the time of the electronic luthier who imagines sometimes entirely new instruments.

This research, carried out by radio electrical engineers and musicians, sometimes results in the creation of instruments with new expressions, always based on the electrical technology of their time. We will only discuss the most significant.

3. 7 Telharmonium

Conceived as early as 1892, the keyboard instrument conceived and built by an American inventor, Thaddeus Cahill, deserves to be mentioned. He named his device a Telharmonium. The name is a combination of "telephone" and "harmonium" which is a type of organ. The principle of the sound production consists in rotation wheels placed in front of an electrical circuit.

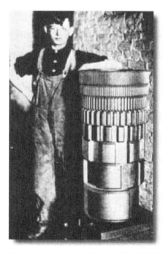

Figure 3 – 3 A dynamo of Cahill's Telharmonium

The wheels were designed so that when they rotated in front of the electrical circuit, a current was created and its variations were the electrical equivalent of a wave. Thus, a musical sound was generated.

Because electronic amplifiers did not yet exist, the wheels had to be very large, so that the musical signal would be of enough strength to be used in a telephone. Why a telephone? At the beginning of the 20th century, loudspeakers had not yet been invented, and the best way to listen to the electrical music was to use a telephone. Hence, it was possible for the listeners to subscribe and they would receive on their telephone lines some music played in the Telharmonium Hall in New York City.

The keyboard had a span of 7 octaves. The music consisted of transcriptions of popular airs, and no composers were involved in writing original music for the instrument.

The instrument, also known as Dynamophone, displayed a remarkable ingenuity in mastering electromechanical devices. He bears witness to an exemplary knowledge of the technology of his time, which he pushed to its limits by applying it to music, a field so demanding.

Because of multiple problems linked to the telephone distribution, and the enormous amount of circuitry and dynamos, the system ceased to exist. It remains, however, a significant step towards to production of sounds through electricity. ①

3. 8　Theremin

An instrument which, from its origin in 1920, offers a radically different mode of play is the thereminvox, designed in Russia by the young engineer Leon Theremin. It was the first electric instrument that stimulates the imagination of composers such as Edgard Varese, and many others.

① Reference for further study: Reynold Weidenaar, *Magic Music from the Telharmonium*, Metuchen (NJ), The Scarecrow Press, 1995; Reynold Weidenaar, *The Telharmonium: A History of the First Music Synthesizer*, 1893—1918, Ph. D thesis, New York, New York University, 1989, UMI n° 89160049 [available on ProQuest].

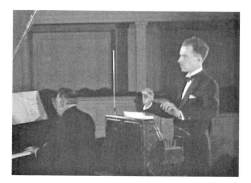

Figure 3 – 4　Leon Theremin playing his
instrument in New York, with
piano accompaniment

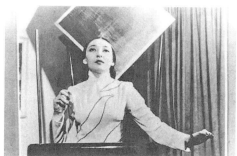

Figure 3 – 5　The virtuoso Clara Rockmore
performing on the theremin in
the 1930s

The instrument was designed using technology of the radio, in the sense that the sound production was derived from the process which reproduces the radio waves of the radio, the heterodyne effect. With this principle, the instrument is monodic. Radio technology was, around 1920, a new field and a lot of research went into refining the technology. In fact, radio-electricians of the time are what we call today electronic engineers.

A vertical antenna located to the right of the device allows the heights to be modified: it is sensitive to variations in the electromagnetic field and the simple movement of the hand or fingers changes the height. A curved antenna, placed horizontally, controls the nuances. With a lot of practice, a thereminist is able to play staccato by sudden movements.

The American firm RCA (Radio Corporation of America) proposed in 1929 the thereminvox as a new and unique instrument which could be played by everyone. It's all about, the advertisement claims, just moving your hands in the air to make music.

The theremin has been mostly used in cinema, for instance for science fiction movies or for thrillers, during the 1940s and 1950s.

Since 1920, this instrument has been built in numerous copies. The famous synthesizer manufacturer, Robert Moog, began his career by building it, and went back to producing it.

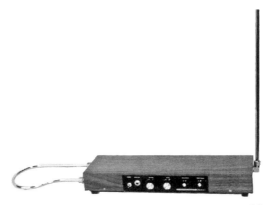

Figure 3 −6 A modern theremin built by the company Moog Music

It is possible to see thetheremin performed today. There are quite a few musicians who like to play it and it is still in production. Getting a new theremin is not difficult, although it has to be imported from the USA.

3. 9 Ondes Martenot

Other instruments are sometimes more surprising, like the Martenot wave, because they allow radically new modes of sound expression: choice of incredible timbres, continuous sliding between two notes, very free vibrato. The principle of producing a sound adapted from radio, the heterodyne effect, generates an almost pure frequency.

The instrument was invented by Maurice Martenot and presented for the first time in 1928 at the Paris Opera. Like the theremin, the instrument is designed using radio technology and is therefore monodic. Martenot developed processes to combine chromatic play and glissandi on the instrument's range, as well as loudspeakers with properties for coloring the sound and giving it diverse timbre.

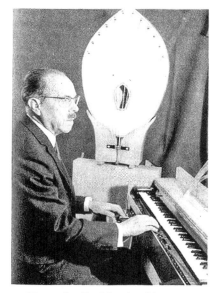

Figure 3 – 7　Maurice Martenot

The instrument is played using a mobile keyboard that allows you to perform vibrato. Throughout the keyboard runs a wire, on which is attached a ring. The performer passes the thumb there and this system allows portamenti and glissandi on the range of the seven octaves of the instrument.

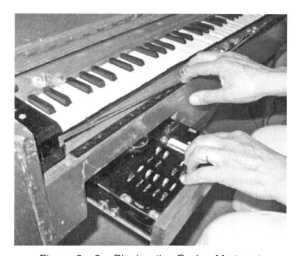

Figure 3 – 8　Playing the Ondes Martenot

To enrich the very simple timbre of the instrument, Martenot invented a principle of loudspeakers which color the sound in various ways. One of them, with an elegant and flame-shaped shape, is called "Palm", has twelve strings that resonate with sympathy. The Metal one was designed with a gong, directly connected to the speaker motor which receives the signals.

The instrumentalist chooses which one to use with a small control drawer located to the left of the keyboard. In addition, a kneepad allows the quality of the timbre to be changed continuously. Finally, two pedals are used to change the intensity and activate the mute effect.

The classical instrumental principle of source—resonance is established thanks to different types of resonators who made the artistic fortune of the instrument, since the wave generated the composition of more than 400 works by many composers.

The instrument is still used today: with so many compositions, often from important composers, it is necessary to teach young performers so that the repertoire can be played today and presented to the public. Some contemporary composers, even today, continue to write for it and there are many dedicated performers.

3. 10 Hammond Organ

In the 1930s, an inventor of electrical clocks had the idea of using its motors for a novel musical instrument. His name was Laurens Hammond. The principle of his device was similar to the Telharmonium, but of course the technology had evolved.

Instead of the large dynamos used by Cahill, Hammond placed a small metal wheel rotating in front of an electrical circuit. The colour of the sound, what is known as timbre, is controlled by the performer by pulling sliders: each one controls the amount of a harmonic of the sound, thus changing from a very thin and pure sound to a rich and colourful one. This is called a "drawbar" system.

The Hammond organ, which first came out in 1935, became a favorite of jazz musicians, who adopted the B3 model, an advanced instrument built in 1954. A famous Hammond organ jazz player is Jimmy Smith.

Today, there are numerous software versions of the Hammond organ for computers and even for smartphones.

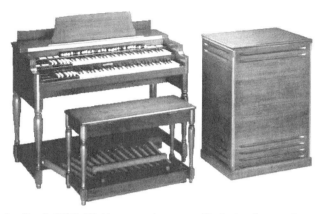

Figure 3 − 9 A 1954 B3 Hammond organ with its Leslie rotating speaker

4

The Development of Electronic Music in the World

Making music without orchestra instruments: this is how electronic was described at its beginning. The sounds used in that music were derived from two very different sources: recordings, first on discs, then on magnetic tape, were used in Paris as early as 1948. Electronic sounds, either from electronic generators or from electronic musical instruments, were used at the Cologone radio, in Germany, from 1951.

4. 1 The First Form of Electronic Music: Paris, 1948

We have to go back to 1948 to find the origin of music composed directly on a medium: first the phonographic record, then quickly the magnetic tape. Concrete music, as it was first called, is first constructed from the gestures allowed by the handling of sound reproduction machines which, at that time, were record players. Not without evoking the most recent techniques of techno music, the musician explores the degrees of freedom offered by the manipulation of machines and invents methods, such as the closed groove, where a sound sample is repeated, the sound in reverse. or gear change. He adds to this the removal of fragments of sound from selected places in a recording, like a filmmaker cutting out a fragment of a filmed scene.

When, in 1950, the first tape recorder was supplied to the Essai studio, the concrete music changed: henceforth, it became possible to cut the recorded sound object into short fragments, in order to keep only a few, which will be freely assembled.

But, true to his intuition, Pierre Schaeffer claimed the creative power of the ear: it is by listening attentively, scrutinizing the recordings that the musician identifies the musical characters that will make it possible to assemble the sound fragments. The tool on which listening relies is first of all the microphone. In 1951, he created the Radio Concrete Music Research Group (GRMC), and undertook research on the classification of sounds with the help of a young musician, Pierre Henry, and a

researcher, Abraham Moles, with whom he wrote in 1952 an *Esquisse du solfège concret*, the premise of his magnum opus, *The Treaty of Musical Objects* (1966). Concrete music is therefore not born from the machine, it is the listening and the gesture of the musician that engenders it.

Figure 4 – 1 Pierre Schaeffer at the GRM studio, 1970s

From a very abundant repertoire, we will retain *Cinq études de bruits* by Pierre Schaeffer (1948), which mark the birth of concrete music, *Symphonie pour un homme seul* by Schaeffer and Pierre Henry, the first version of *Déserts* by Edgard Varese. (1954); these works mark out the first era of concrete music. From the creation of the Musical Research Group (1958), other works illustrate the theory of the sound object developed by Schaeffer and Moles: *Étude aux allures* (Schaeffer, 1958) and especially *Étude aux objets* (Schaeffer, 1959). Other composers take liberties with Schaeffer's theoretical approach, and produce small masterpieces: *Concret PH* (1958, produced for the famous Philips Pavilion at the Brussels Universal Exhibition) and *Orient-Occident* (1960) by Iannis Xenakis.

4. 2 Cologne Radio Studio

The birth of the Cologne studio in 1951 on radio Nordwestdeutschen Rundfunk (NWDR) is informed by influences that are well studied today. It is strongly imbued with scientific work as we will see below, but it can be anchored in a curious text published in 1928 in the journal *Die Musik* by Robert Beyer, entitled "Problem der

Kommenden Musik" (Problems of future music). Two main ideas emerge, which will guide much research later on. The first is that it becomes necessary for new music to penetrate the essence of sound, and the second to interpret its different aspects in order to recompose it by integrating the space.

But it was above all the will of a composer, Herbert Eimert, to explore the means offered by electronic sound synthesis that motivated the founding of the studio. It is based on the work of a scientist, Werner Meyer-Eppler, who was researching the synthetic production of voice at the Institut für Kommunikationsforschung und Phonetik Institute for Communication Research and Phonetics in Bonn. It is also at Meyer-Eppler that Bruno Maderna, in 1951, composed the first version of *Musica su due dimensioni*, for flute and magnetic tape, an important work since, with that of André Hodeir, *Jazz and Jazz*, it inaugurates the mixed music, a genre that brings together the electronic and instrumental worlds.

The studio's founding act brings together, among others, Herbert Eimert, Robert Beyer, Fritz Enkel and Werner Meyer-Eppler. This is the first time that a laboratory has been created with the aim of putting new electronic means at the service of musical exploration. Varese's old dream finally finds an incarnation.

The first musical achievements were studies by Eimert and Beyer, carried out with the help of Enkel, which were presented in Darmstadt, a city in Germany famous for its summer courses on new music, in 1953. Contrary to popular belief, these studies do not use additive synthesis of sound by sinusoidal frequencies, but keyboard instruments producing sounds with a complex spectrum (made up of several harmonics), the monochord and the melochord because the founders see it as perfectly sufficient means and completely adapted to their project.

It was therefore with the two studies by Karlheinz Stockhausen, who arrived at the studio in 1953 after returning from a stay at the Paris studio, that electronic means became more intimate with musical composition. For these works, Stockhausen uses a method derived from the most recent advances in serial music, known as "generalized series", which can be summarily described as the application of the principle of series to other aspects of sound than heights: since the short work for piano composed by Olivier Messiaen in 1949, *Modes of Values and Intensity*, in which to the pitch mode is added a series of 24 duration values, 12 attack modes and 7 nuances of intensity, is born the idea of a music in which each parameter of the sound has its own and distinct identity.

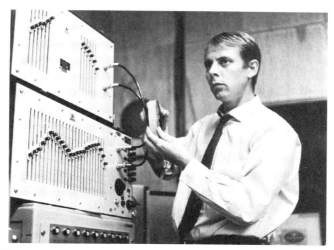

Figure 4 −2 Karlheinz Stockhause, ca 1960 © archive of the
Stockhausen Foundation for Music, Kuerten, Germany

Above all, these two short works are composed before they are made, affirming
that electronic music claims a true writing, which is based on the continuous passage
from the structure of the work to its material. The score of *Studie* II has thus become
the graphic symbol of electronic music. Following him, Franco Evangelisti composed
in 1957 *Incontri di fasce Sonore—studio elettronico* (1957) with electronic sounds,
making a graphic score beforehand.

Finally, Stockhausen innovates, starting from the idea of composing complex
sound spectra by adding pure frequencies (sinusoids). He had already experimented
with this approach during his visit to the Paris studio, against the will, moreover, of
Pierre Schaeffer but with the complicity of Abraham Moles. In Cologne, it was also
against the will of the founders of the studio that he imposed the additive synthesis of
sinusoidal signals.

With the second electronic study by Karlheinz Stockhausen (*Studie* II , 1953—
1954), the notation of the electronic score focuses on describing the physical
structure of synthetic sounds. The displayed parameters are measured in their
respective dimensions.

Pitches are shown in frequency, measured on the Hertz scale, and are displayed
not only for pitch, if one exists, but also for each spectral component.

The amplitudes are indicated in decibels, on a scale modeled on those of the

graduation of the mixer strips (between 0 dB and −60 dB or less).

Times are shown in absolute or relative time, but often in seconds. In the score of Stockhausen's work, the durations are indicated in centimeters of magnetic tape, the tape recorder playing it at 76 cm/s.

With such scores, a technician is able to perform a realization of the work written by a composer. Today, we are able to produce a new version faithful to the written text, even if its sound reality may seem different to us.

The purely electronic means, made up of sound synthesis instruments, were quickly combined with natural sounds, and in particular with the voice, in one of the most famous works of electronic music, *Gesang der Jünglinge* (1955—1956) from Stockhausen. Herbert Eimert composed *Epitaph für Aikichi Kuboyama* (1960—1962) from the simple recording of a poem, which is transformed by reverberation and modulation devices, masterfully using the device developed by an engineer, Anton Springer, the Zeit Regler, which allows a temporal stretching of the recorded sounds. It is also the model of an imaginary voice that led György Ligeti to compose *Artikulation* (1958), of which an artist, Rainer Wehinger, produced a superb graphic score.

With the 1960s, the studio radically diversified its orientations: some works indicate the new directions, explored first by Stockhausen: the integration of electronic music, until then composed of unique, unchanging works, carried out by the composer like a painter works his work, to living music, to the concert. Composed in 1960, *Kontakte* is a work for solo tape which can also be played in a "mixed" version, with piano and percussion. Having become one of the most performed mixed works, *Kontakte* is also known for its score, which is based on a set of graphic representations of complex sounds.

4.3　Milan RAI Studio of Musical Phonology

This studio was founded on the initiative of the composers Bruno Maderna and Luciano Berio in June 1955, under the name of Studio of Musical Phonology of the RAI in Milan. They composed several works there which marked the evolution of young electroacoustic music.

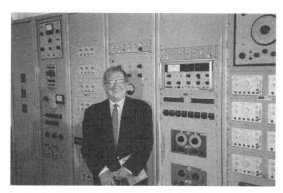

Figure 4 –3 Luciano Berio in front of the Milan studio equipment
(Photo Marc Battier)

They invited foreign composers, such as the Belgian Henri Pousseur (*Scambi*, 1957) or the American John Cage, who produced *Fontana Mix* there. Berio left the studio in 1961 after composing *Visage*. Luigi Nono will then direct it.

In the electroacoustic music studios of the 1950s and 1960s, we find technical processes that allow the sound material to be modified; spectral filtering, cutting of sound sequences into elementary fragments, transposition, recurrence, editing, mixing.

Berio composed *Tema. Omaggio a Joyce* (1958), a work based on readings from the beginning of Chapter 11, "The Sirens", a novel written by *Ulysses* (James Joyce, 1922). The text is read by the American singer Cathy Berberian, in the original English version.

In this work, he collected in the prosody fragments that will be treated as musical stylistic figures: appoggiatura, canon, etc. It transforms the vocal timbre into new sounds, by electronic processing: acceleration, transposition, reverberation, recurrence, fragmentation, clouds, frames, grain.

Listening to the work, we will try to perceive the many musical methods employed by Berio (trill, staccato, appogiature, glissando, condensation, canon, chord, segmentation, acceleration, reverberation, filtering).

In 1960, Berio produced a work intended for radio broadcasting, *Visage* (21'), based on the voice of Cathy Berberian pronouncing the word "parole" in various translations and, above all, dramatically composing many modes of expression, allowed by the vocal apparatus (sighs, cries, moans).

The work is based on a later passage from James Joyce's work, *Ulysses*. This is Chapter 13, "Nausicaa" (or "Fireworks"). By listening to the work, we will try to understand the six appearances of the word "parole" from these cues:

3'37 Whispered. A capella.

6'00 Whispered. Two successive appearances.

10'10 Whispered.

13'40 Shouted.

17'15 Spoken, merges with an electroacoustic layer.

4. 4　New York

Electronic music in the USA was established by John Cage with his collaboration in 1952 with Luis and Bebe Barron in New York. As Cage established the Tape Music Project with the Barrons, a whole different approach was being prepared around Columbia University. It was first undertaken by Vladimir Ussachevsky and Otto Luening. Ussachevsky and Luening, at Columbia University, were experimenting with recording instruments and processing them.

Luening had been attached to Barnard College since 1944; this university had been formed to accommodate female students, which Columbia, at that time, did not accept. Ussachevsky, on the other hand, was recruited by Columbia in 1947. Both were musicians trained in composition and with some experience in this field, but technology will cause them to branch out into other forms of music. It was through the tape recorder that Ussachevsky first began sound experiments. He was introduced to this device by Peter Mauzey, an engineer who worked at the university radio station, WKCR, then equipped with a newer tape recorder.

Shortly thereafter, the composer had access to a second Ampex-branded recorder, which had been acquired by the music department at Columbia University for the purpose of recording concerts of the Composers Forum series, presented in the university. It was on this machine that he made his first sound experiments. These were presented in May 1952 at the University's McMillin Theater. They consisted, according to what Cowell, witness to this event, reported in various transformations of recorded sounds. Cowell, in his review, quotes Ussachevsky's explanation, which states that he took three approaches; the first was to produce sounds in registers below and beyond the range of the piano, which Cowell said produced hitherto unheard of

timbres. He wrote "The fundamental pitch was inaudible, but its powerful harmonics produced a timbre never heard. " The second allowed him to modify the timbres and shapes of sounds, while the last allowed him to print rehearsals on recordings, using a device designed by Mauzey. Cowell, in front of these sound tests, congratulated Ussachevsky for choosing not to name them " compositions " but simply "experiments", while expressing the wish that Ussachevsky now undertakes real compositions with these technologies. He added that these sounds, even if they were not put together in the form of a work, could certainly provide material for composers.

Quickly, with Luening's *Low Speed* (1952), the two composers moved towards the electroacoustic manipulation of flute phrases played by the composer. We can hear very slowed down and superimposed recordings of the flute. Echo effects are present throughout the work: they are the result of treatments by the device built by Mauzey. The same principles were applied in *Fantasy in Space* and in *Inventions in Twelve Tones*, other works by Luening.

These three brief works were presented at the Museum of Modern Art in New York on October 28, 1952. In the same concert was performed *Sonic Contour*, a nearly eight-minute work by Ussachevsky, in which we hear transposed, mixed piano phrases. and processed by the Mauzey echo machine. For Luening, this concert was the first to feature electroacoustic music in the United States.

Ussachevsky and Luening continued their creations and succeeded in officially establishing an electronic music studio at Columbia University in 1955, making it the first institutional studio in the United States. Subsequently, it was the universities, in this country as in Canada, which created studios in their music departments or as university research entities.

In 1958, they acquired the gigantic RCA synthesizer, which they installed in New York with the collaboration of Milton Babbitt, a composer from Princeton University. They called their studio the Columbia-Princeton Electronic Music Center. There, Babbitt composed several pieces, as well as Charles Wuorinen and a few others.

This studio still exists but, under the guidance of Brad Garton, it is now called the Computer Music Center.

4.5　Tokyo

Japanese composers became interested in electronic music from the early 1950s. It is often considered that the earliest recorded tape composition dates from 1953 and was realized at the JOQR studio of Nippon Cultural Broadcasting by Mayuzumi Tôshiro (1929—1997), with Work *XYZ* for concrete music. This pioneer piece was inspired by the contact the young Mayuzumi had while in Paris between 1951 and 1952 with French concrete music. There, he studied at the Paris Conservatory (Conservatoire de Paris). He had a chance to hear concrete music during the festival in which Pierre Schaeffer demonstrated the whole repertoire of this music, and he left for Japan a few days later. The piece he realised upon his return reflected the influence of the Paris School, although it did not strictly adhere to Schaeffer's teaching of working with fragmented sound objects.

A few years later, the Japan Broadcasting Corporation in Tokyo, known as NHK, established an electronic music studio which was patterned after the Cologne studio. In any case, Japanese electronic music came under the influence of the Cologne studio, as can be heard in a piece jointly composed at the NHK studio by Mayuzumi and Moroi Makoto (1930—2013), *Variations on the Numerical Principle of Seven*, in 1956; entirely realised with electronic sounds, it evokes the two Stockhausen electronic studies. It is this large studio which saw the birth of "classic" electronic music production by Mayuzumi, Moroi, Ichiyanagi Toshi (1933—2022), Takemitsu Tôru (1930—1996) and later Stockhausen, who visited in 1966.

Despite the two examples by Mayuzumi and Moroi, the development of electronic music in Japan was marked by a quest for exploration and independence. It started in the very early 1950s with a group of artists and musicians who called themselves "Experimental Workshop" and included composers Takemitsu Tôru (1930—1996) and Yuasa Jôji (1929—　). The Experimental Workshop started producing tape music even before Mayuzumi, with pieces by Akiyama Kuniharu and Yuasa Joji, using early tape recorders from Sony. Later, these composers, joined by Takemitsu and Ichiyanagi, moved to the Sogetsu Art Centre in Tokyo. However, the 1968 compilation of electronic music by Hugh Davies listed 32 production centres in Japan, often a radio station with just a few pieces. This is, however, remarkable and is a testimony of the thirst for new forms of music after the Second World War in this

country. It also shows the dispersion of effort and a lack of unity in the styles and experiments at that time, which has somewhat remained up to today. Japan's electronic music research and production is scattered across the country. The Tokyo NHK studio, established in 1955, has failed somehow to respond to the increasing demands on the part of composers. There are still today many small computer music studios, either private or institutional. While China is attempting to propose a unified definition of the electronic music practices with the goal of facilitating education in the field (with, admittedly, some difficulty), it remains to be seen whether Japan attempts a similar pattern.

However, in the immediate period after the Second World War, throughout the 1950s, creative movements—such as music, visual art, poetry, literature—were striving to divert themselves from the values and terrible acts exacerbated by the nationalists before and during the war. For this they avidly studied the latest Western trends in their fields. When the 1960s arrived, and because Japan had somehow recovered from the terrible damage and poverty inflicted by the war, their attitude changed.

Today, electronic music is a forefront topic among young composers, and the various music schools have taken notice. There is now a wide selection of academic studios in universities and conservatories, such as the Tokyo National University of Fine Arts and Music, with teachings in the domain by composers Nishioka Tatsuhiko or Nodaira Ichiro, at the Nagoya City University with Mizuno Mikako, at Kunitachi College of Music with Imai Shintaro, at the Shobi university with composer Kojima Yuriko, at the Aichi Prefectural University of Fine Arts and Music, at IAMAS—but there are too many to cite them all.

Figure 4 – 4　Mikako Mizuno

As was noted for China, the question of terminology and translation of specialized vocabulary is acute in Japan. It would seem obvious that there is a need for precise terminology which enables proper communication and learning. This was discussed by Ishii Hiromi, a composer and scholar, in a presentation of the difficulties of selecting proper Japanese terms for such practices as electroacoustic music or electronic music. This creates problems not only for transmission but also with the question of giving electronic music the status of art music and attracting the attention of musicologists. Nevertheless, efforts are constantly made in Japan for presenting electronic music history and technology, the latest example being a book of 430 pages by composer and performer Goto Suguru, who now teaches at the Tokyo University of Arts.

Figure 4 – 5　Suguru Goto playing his instrument, SuperPolm

4.6　Other Electroacoustic Movements

One of the major works of the electroacoustic repertoire is *Poème électronique* by Edgard Varese. The work was produced in a temporary studio established by the firm Philips in the Netherlands (Eindhoven), in 1957—1958. It was composed to be shown in the famous (but also ephemeral) Pavillon Philips built by Le Corbusier and Iannis Xenakis during the Universal Exhibition in Brussels in 1958. During the performance, numerous photo projections accompanied the performance was broadcast by 400 loudspeakers. This work is the second (and last) electroacoustic music of Varese, who had already composed sections, called "interpolations", of *Déserts* for

orchestra and tape (1954, 1955).

We should point out the emergence, in 1965 and 1966, of a current of repetitive music marked by the composition of two purely electroacoustic works by Steve Reich, *It's Gonna Rain* (2 versions, 1965) and *Come Out* (1966). These works consist of a processing of a short vocal fragment by progressive shifting of two magnetic tapes (phase shift) or by editing (a version of *It's Gonna Rain*).

Popular music has been interested in electroacoustic means, especially from the industrial production of analog synthesizers (early 1970s). European (Eno, Kraftwerk) and American (Suzanne Ciani, ELP, Frank Zappa) musicians have used it.

4.7 Electronic Music in China

Probably the first introduction of electronic music composers in China was made by the visit of Zhou Wenzhong (also Chou Wen-Chung, 1923—2019). Zhou had left China for the United States in 1946 to study at Yale University, and then moved to Columbia University. In New York, he took lessons with Edgard Varese, a composer who had experience with electronic music. He began teaching at that university, and kept close contact with the electronic music studio established there. In 1978, while he had a brilliant career at Columbia University, he established the Center for US-China Arts Exchange. As we will see below, that Columbia University institution had an important role for the formation of young Chinese composers and for art exchanges in general[1]. For instance, he introduced to the Chinese audience, musicians, including electronic music ones, visual artists, and choreographers like Alwin Nikolais, who had composed electronic music for some of his ballets[2]. No doubt that, through his multiple visits to China, Zhou had been operational in introducing new music to China, starting at the end of the 1970s.

Jean-Michel Jarre, a French musician who made music with electronic

[1] The center closed in 2019, and its archives are now kept at the C. V. Starr East Asian Library of Columbia University.

[2] In 1964, Alwin Nikolais was the first client of Robert Moog to purchase his electronic synthesizer. This early synthesizer is now kept in a museum of the University of Michigan in the United States.

instruments such as synthesizers and a laser harp, had come to China in 1981. At that time, he presented his music with his group in front of very large audiences, who heard electronic music for the very first time. This happened in Beijing on October 21 and 22, and then in Shanghai on October 27 and 29. The first concert was even broadcast on the radio, this reaching an even larger audience.

Jarre had been a successful musician since the release of his album, *Oxygene* (1976), which sold a very large number of copies and made him famous and established him as an important pop artist in the field of electronic music. While his composition is conventional in the sense of harmonic progression and melodies, and pertain to the realm of popular music, the orchestration is entirely made of novel electronic sounds, which he performs with ease and virtuosity.

Those concerts had been heard by many people and they can be considered as the first introduction of electronic music in China. The following year, in November 1982, I visited the Beijing Central Conservatory and, upon my return to IRCAM, in Paris, sent to the school a number of magnetic tapes with works from IRCAM, and documents on computer music.

Even if the idea of making music with electronic means was introduced in China in the early 1980s, access to technical equipment, a must for this music, was an obstacle. Personal computers did exist in those days but were still expensive, slow and not yet capable of handling sounds. Synthesizers built by manufacturers in Japan, the UK and the United States, were rather expensive, and other equipment, such as mixing consoles, filters, tape recorders were also only available in professional studios. It is thus remarkable that, in front of this adversity, some young Chinese composers found way to create electronic music in those pioneering days.

Probably the earliest piece of electronic music was composed by Zhu Shirui for his piece *Goddess*. The composer gathered a number of synthesizers, of which there were few in China in those days, and presented this piece to the public in 1984. The piece was performed with seven synthesizers on September 24, 1984 at the Central Conservatory. The concert had been organised by Chen Yuanlin, Zhang Xiaofu, Tan Dun, Chen Yi, Zhou Long and Zhu Shirui [1].

[1] Wang Jing, a scholar from Hangzhou, gives details on this concert in her book *Half Sound, Half Philosophy. Aesthetics, Politics, and History of China's Sound Art*, New York, Bloomsbury Academic, 2021, pp. 101 – 102.

According to Zhang Xiaofu, none of them knew exactly what a concert of electronic music should be like, so they followed their imagination. Furthermore, it was very difficult to find appropriate equipment, and 1984 was still a bit early for MIDI equipment (which was finalized in 1983). However, that date marks the beginning of electronic music practice in China.

Figure 4 –6　Zhang Xiaofu

The Wuhan Conservatory was also pioneer in establishing an electronic music studio. This was in 1987, and, soon after, the studio founded by Liu Jian (1954—2012) and Wu Yuebei (1957) was opened to a bachelor program in electronic music. Thus was established the first academic program for teaching electronic music. However, at that time, information about that music was still scarce in China, so many young composers felt the need to travel abroad to learn all aspects of it.

In 1986, it was the turn of the Beijing Central Conservatory to start putting together a "Computer and Electronic Music Studio". This was achieved by Chen Yuanlin (1957) established a studio at the Central Conservatory, which he called "Computer and Electronic Music Studio". However, like other of his young colleague, he decided to further his studies abroad and went to the United States; There, he obtained his doctorate at the State University of New York at Stony Brook.

Moving abroad to receive precious teaching on new music and electronic techniques was also facilitated by Zhou Wenzhong and his Center for US-China Arts Exchange. Several composers who had joined the Central Conservatory and the Shanghai conservatories received help from Zhou to travel to the United States. This

was the case of, for instance, Tan Dun, Zhou Long, and Chen Yi. Thanks to the support of the Center, they could study and absorb Western techniques, while often preserving their Chinese cultural heritage.

In 1989, Zhang Xiaofu received a grant from the Chinese Ministry of Culture so that he can travel to France. This was, however, not intended to learn electronic music classes, but study at the Ecole normale de musique de Paris, a famous private school. He nevertheless spent a year there on the grant. When this ended, he decided to stay in France and to turn to studying electronic music. For this, he chose to register at the conservatory of Genevilliers, a town on the northwest outskirts of Paris. The teacher there was Jean Schwartz, who was not only a member of the famous Groupe de Recherches Musicales (GRM, Group of Musical Research), but also an ethnomusicologist. After a while, because Zhang had not more funding from the government, he returned to the Central Conservatory. In 1993, he established there the Center for Electronic Music of China (CEMC). It gave birth, the following year, to the Beijing electroacoustic music festival. This first festival received the visit of several foreign composers. As this edition of the festival was soon followed by others, then held every other year, the idea of gathering Western composers who would present their works and interact with Chinese students and teachers became a tradition. In 2004, the festival took the name of MUSICACOUSTICA-BEJING and became held each year[1]. Over the years, Zhang Xiaofu developed theories of electronic music as practiced by Chinese composers[2]. He insisted on the creation of mixed music, in which traditional Chinese instruments would be performed along with electronic music parts. In fact, in 1994, he composed a piece for bass bamboo flute and electronic music, which was presented at the first festival. He gave it a French

[1] On the history of the festival up to 2011, see Wang Hefei, "Exploration and Innovation, the Chinese Model of the MUSICACOUSTICA-BEIJING Festival", in Marc Battier and Kenneth Fields, eds., *Electroacoustic Music in East Asia*, London, Routledge, 2020, pp. 146 – 159.

[2] See Zhang's theoretical discussion of these cultural aspects in: Zhang Xiaofu, "The Power of Arterial Language in Constructing a Musical Vocabulary of One's Own. Inheriting the Inspiration and Gene of Innovation in Electroacoustic Music from Chinese Culture", in Marc Battier and Kenneth Fields, eds., *Electroacoustic Music in East Asia*, London, Routledge, 2020, pp. 125 – 145.

title, *Le chant intérieur* (*The Internal Song*)①. Two years later, he realized the first version of a piece inspired by his travels to Sichuan and Tibet, called *Nuo Ri Lang*. It is composed by layers of sounds and voices recorded during his travels by the composer, and transformed in the Beijing studio. This tape part is played along with live percussions. This piece has constantly been extended and reworked, sometimes with three percussions, and with video, image projections, lights and dancers②.

In 2006, Zhang worked with the Electroacoustic Music Studies Network and his colleague Kenneth Fields in Beijing to organize the third EMS conference, a large gathering of scholars taking electronic music as a topic for analysis and discussion.

Figure 4 – 7　EMS conference at the MUSICACOUSTICA-BEJING festival in 2006

①　See a presentation of this piece in Li Qiuxiao, "Characteristics of Early Electronic Music Composition in China's Mainland", in Marc Battier and Kenneth Fields, eds., *Electroacoustic Music in East Asia*, London, Routledge, 2020, pp. 135 – 145.

②　For an analysis of *Nuo Ri Lang*, see Marc Battier "Nuo Ri Lang by Zhang Xiaofu", in *Between the Tracks. Musicians on Selected Electronic Music*, Cambridge (MA), The MIT Press, 2020, pp. 174 – 193. See also (in Chinese) Zhao, Xiaoyu. "Zhangxiaofu duomeiti jiaoxiangyue 'Nuo Ri Lang' chuangzuo duihua" (A Dialogue on the Creativity Process of Zhang Xiaofu's Multimedia Symphony Nuo Ri Lang, 张小夫多媒体交响乐 "诺日朗" 创作对话) in *Yinyue · Keji* (Music & Technology, 音乐·科技), Beijing, Central Conservatory, 2016, pp. 49 – 55.

Two years later, he hosted the first EMSAN Day symposium (Electroacoustic Music Studies Asia Network) during the festival. Since then, the EMSAN Day symposium, devoted to studying the development of electronic music in Asia, was often held at the Central Conservatory. [①]

The MUSICACOUSTICA-BEJING festival has, over the years, become an important part of the development of electronic music in China, adding to the concert series of lectures, symposiums, and composition competitions.

Today, electronic and computer music are gathered under the department of Music Artificial Intelligence Information Technology, under the direction of Li Xiaobing.

In 1984, the Shanghai Conservatory of Music introduced the MIDI system in its electronic music curriculum. Another important step occurred with the composer Xu Shuya (1961) with his piece *Taiyi* Ⅱ, which he realized while studying at the Groupe de Recherches Musicales (GRM, Group of Musical Research) in Paris in 1991. It is a piece for flute and electronic parts (what is called the "tape"), hence a mixed piece. Later, Xu came back to Shanghai and became a leader of the conservatory.

Another important composer from Shanghai in the field of electronic music was An Chengbi (1967). He received his musical training at the Paris Conservatory. While at the Shanghai Conservatory, he trained many students in the art of live mixed music, mostly using the Max/MSP software along with the real-time processing of instruments and the playback of prepared sounds, triggered during the performance. Both Xu Shuya and An Chengbi were trained in France, at the Paris Conservatory. However, Xu studied at GRM, as noted above, while An was more inclined to use real-time interactive software such as MAX/MSP, widely in use at IRCAM. This difference of training explains the diversity of stylistic influences.

① For more information visit http://www. ums3323. paris-sorbonne. fr/EMSAN.

FORUM IRCAM Hors Les Murs Shanghai
IRCAM国际论坛 | 上海

31 Octobre - 2 Novembre 2019　Conservatoire de musique de Shanghai
31st October - 2nd November 2019　Shanghai Conservatory of Music
2019年10月31日—11月2日　　　　上海音乐学院

Figure 4 –8　Shanghai Conservatory, Forum IRCAM, 2019

The Shanghai Conservatory has hosted a number of meetings and conferences, making it an important hub for the development of electronic music in China.

The photo shows organizers and some participants of the EMS conference, held in 2010 at the Shanghai Conservatory. Recently, the Shanghai Conservatory hosted the meeting of the IRCAM Forum, an event which takes place every year in a different city around the world and in which are presented advances and applications of the software tools developed by IRCAM.

Figure 4 –9　The organizers of the EMS 2010 conference at the Shanghai Conservatory

Xu Yi（1963—　）is also a famous composer from the Shanghai Conservatory. She received international recognition for several of her pieces, while living in France

and in China. She and Xu Shuya were part of the "New Wave" movement[①]. Other places where electronic music can be learned and practiced are, amongst others, the Zhejiang Conservatory of Music, where Li Qiuxiao, a former student of Zhang Xiaofu, is teaching, the Xi'an Conservatory, with Zhou Yuan, who herself studied in Shanghai with An Chengbi, and the Sichuan Conservatory in Chengdu, where Hu Xiao introduced electronic music to numerous students, and today Lu Minjie, herself a major practitioner of interactive music and installations. Another historical center, still quite active, is the Wuhan Conservatory, where electronic was started early on by Liu Jian (1954—2012) and Wu Yuebei, cited above, and where Li Pengyun is teaching.

Figure 4 –10 Lu Minjie

The variety of stylistic influences is unavoidable. Whether the young composers travel abroad to study or chose to remain in China and receive their education from a local teacher, the question of canons and schools always comes into play. For instance, teachers who themselves have studied in Europe will have received different set of techniques. Even if they went to France, as was mentioned above, their approach to electronic and computer music will be quite different. For instance, if they studied at GRM or at a conservatory where teachers were raised in the GRM aesthetics, which is mostly based on creating pieces on fixed media. On the other hand, if they went to the IRCAM computer music courses, they would prefer to create

① See Jinmin Zhou, *New Wave Music in China*, Ph. D thesis, Baltimore, University of Maryland, 1993.

pieces for instruments and real-time electronic processing, usually using MAX/MSP. This software, in fact, had been conceived when Miller Puckette was at IRCAM in the late eighties, before being further developed and commercialized by Cycling 74 in the United States. Similar differences can be observed for composers who studies in Germany or in the United Kingdom, both countries very active in electronic and computer music. Other composers may have been to the United States or Canada, and there, the stylistic practices tend to differ from those of Europe.

In addition, and this is a vert noticeable trend, electronic music in China is increasingly attached to the local culture. Chinese musical elements easily find their way into contemporary compositions, for instance when some forms of Chinese opera for various parts of the country are integrated into the electronic texture. Also, an increasing number of mixed pieces using Chinese instruments played with electronic parts form a very powerful movement. This is considered a way to detach the act of composing electronic music from simply copying the styles introduced by the West by establishing strong links to elements of Chinese culture.

This trend can also be observed in other regions of China, such as in Hong Kong, Taiwan and Macau. Electronic music started to blossom, particularly in Hong Kong and Taiwan, during the 1970s and the 1980s. Electronic music can be learned with Clarence Mak at the Hong Kong Academy of Performing Arts, and at the School of Creative Media of the City University of Hong Kong with PerMagnus Lindborg and Ryo Ikeshiro. Taiwan has quite a few teachers involved into electronic music as composers and researchers, such as Huang Chih-Fang, who, in addition to conducting and composing, is involved in artificial intelligence research, and Tseng Yu-Chung, who teaches electronic music and is one of the most active composers in the field. Macau, on the other hand, is quite active in electronic dance music, a field which escapes to the scope of this book. Another domain of interest if the non-academic electronic music, often called "experimental". It is quite a vibrant scene in China. There has been exhibition and festivals devoted to this trend. Some of them were fostered by Yao Dajuin and took place in Beijing and Shanghai. The reader interested to learn more about this can refer to the book by Wang Jing[1], cited above,

① Wang Jing, *op. cit.*, pp. 106 – 121.

and to a short text by one of the actors of this movement, Yan Jun[1].

4.8 Repetitive Electronic Music, New Age Music, Ambient Music

4.8.1 Ambient Music

In ambient music, it is most important to establish a "mood", an "atmosphere", with slowly evolving textures. There may be a drum track, but not often. The structure is very loose. The quality of sound is most important. The sounds are often with reverberation. Pieces tend to be long. They are well suited to play the role of a sound environment.

4.8.2 Brian Eno

Brian Eno started by playing the VCS3 synthesizer in the British rock group, Roxy Music, in the early 1970s (1971—1973). In the group, Eno played the VCS3 synthesizer, introduced in London in 1969. He was one of the first musicians to play a synth in a rock group.

After being a rock musician, Eno created the style of ambient music. The first piece on this album was made with only a Synthi AKS synthesizer, a guitar, two tape recorders and an equalizer (seen on the photo).

The second piece of the disc are variations on Pachelbel's Canon in D major, played by an orchestra.

4.8.3 *Music for Airports*

With this album, *Music for Airports* (1978), it was the first time the word "ambient" was used to describe a style of music. The form of ambient music is derived from its intention (its goal, its purpose): it is an environment music. It is static, it does not develop or have contrasting sections. It can be compared to a sound installation (background music for an exhibition or an art gallery).

There are four pieces on this record, simply called *1/1*, *2/1*, *1/2* and *2/2*.

① Yan Jun, "RE-INVENT: Experimental Music in China", in Christoph Cox and Daniel Warner, *Audio Culture. Readings in Modern Music*, New York, Bloomsbury, revised edition, 2017, pp. 345 – 352.

The first piece is based on a theme played on a piano and an electric piano. The track is composed by playing several tape loops of various lengths and mixing them. This way, the individual elements are always the same but they are presented in various settings and this bring variety within a context of familiarity. The second piece (*2/1*) uses four voices: three women and the voice of Eno. There are transposed and looped. The third piece (*1/2*) seems like a continuation of the previous, but with piano. The last piece (*2/2*) is entirely made with an ARP 2600 synthesizer.

Figure 4 - 11　The cover of *Music for Airports*

4.8.4　*Thursday Afternoon*

Thursday Afternoon is a video made by Eno, with a whole composition of ambient music. He called it a video painting. It was composed in 1986 specifically for the CD, a new technology at the time. Eno used a video camera he had acquired. The images were processed.

It is in the style of ambient music, slow and quiet. The audio material is mostly piano and synthesizers.

4.8.5　Harold Budd

Harold Budd (1936—2020) was an American pianist and composer known for his minimal music in the ambient style. He played the piano, often with long reverberation. He collaborated by Brian Eno for a couple of records.

See for example his album, *Ambient* 2: *The Plateaux of Mirrors* (1980). See also: *The White Arcades* (1988), produced by Eno. The record is composed of nine pieces, some of which were recorded with other musicians.

4.8.6　Simon Stockhausen

Simon Stockhausen is the son of Karlheinz Stockhausen. He plays saxophone and synthesizers. As a sound designer, he creates patches for software synthesizers such as Arturia's Pigments.

Figure 4 – 12　Patch for Pigments made by Simon Stockhausen

4.8.7　Repetitive Electronic Music

Repetitive electronic music is composed in a minimal style. It often repeats its musical material, and uses synthesizers. It emerged in Germany and in the USA in the late 1960s and in the 1970s. It was developed in the styles of techno and ambient, sometimes new age.

Some musicians: Tangerine Dream (Germany), Kraftwerk (Germany), Klaus Schultze (Germany), Suzanne Ciani (USA).

4.8.8　Suzanne Ciani

Suzanne Ciani, an American composer and performer, used analog synthesizers.

She became known for her passion for the Buchla synthesizers she discovered in the late 1960s at Mills College (California).

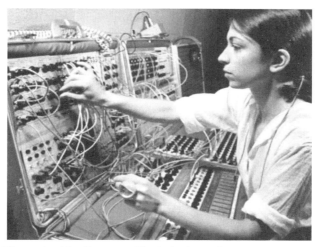

Figure 4 – 13　Suzanne Ciani playing a Buchla synthesizer

4. 8. 9　Kraftwerk

Kraftwerk is a German group. They are known for their robotic electronic music, which they composed starting in the 1970s.

Example: *Trans-Europe Express*.

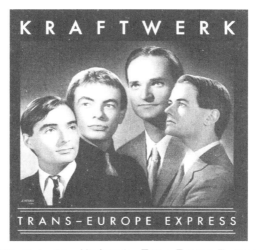

Figure 4 – 14　Kraftwerk, *Trans-Europe Express*

4.8.10　Tangerine Dream

The group was formed in Germany in 1967 with various musicians around Edgar Froese, the founder.

Tangerine Dream became famous in the 1970s with their spatial and dreamy electronic music. Their music is often called "Electronica".

Example: *Phaedra* (1974).

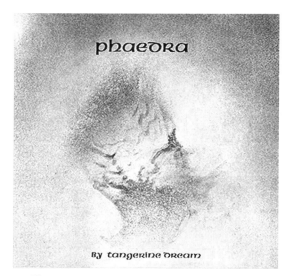

Figure 4 – 15　Tangerine Dream, *Phaedra*

5

The Forms of Electronic Music in the World

At Bell Laboratories (United States) , Max Mathews wrote, in 1957 , a first digital sound synthesis program. He was working on a brand-new computer of the day, the IBM 704 , which was equipped with 4096 words of memory. Known today as MUSIC Ⅰ , the program he wrote was the first in a large family. It was capable of producing a sound wave by a series of numbers representing the evolution of its levels, with a sampling rate (we speak of digitalization) of about 10000 samples for one second of sound.

Figure 5 – 1 Max Mathews working at home in California (Photo Marc Battier)

The MUSIC Ⅲ program (1960) introduced the concept of a modular instrument. The model imagined by Max Mathews was more inspired by laboratory equipment or an electronic music studio than by acoustic violin making. The program offered a range of independent modules (Unit Generators, now called opcodes) , each loaded with an elementary function: programmable waveform oscillator, signal adder, multiplier, generator of envelopes and random signals, etc.

The musician builds an " instrument " by connecting a selection of modules together, which creates a " patch ". Signals produced by oscillators or generators are routed to other modules for modification or mixing. Several instruments can be brought

together in an "orchestra", each instrument having its own identity. Unlike in the physical world, there is no limit to the number of modules that can be used simultaneously, except perhaps the memory of the computer. The result of the implementation of the instrument is the progressive calculation of sound in the form of a sequence of numbers which, placed end to end, represent a complex sound wave. These numbers are called "samples". Today, the most common number of samples representing one second of sound is 44100 per channel (although a 48000 sampling rate is also common).

Due to the relative slowness of the machines and the mass of calculations to be carried out, the time taken to generate the sound wave was in the past much greater than the duration of the sounds; the operation of these programs is said to be "in deferred time". Originally, digitally computed sound waves were stored on a digital tape that rolled out as a block of sample calculations was completed. This mode of sound production is called "direct synthesis". This creates a "sound file". Once completed, the musician calls in a second program, which plays the sound file in real time and sends the samples to a digital-to-analog converter, which is connected to an amplifier and speakers. Today, all those operations are integrated.

To activate the orchestra, the musician must write a "score", in which all the parameters requested by the instrument's modules are specified. This score is presented as a list of numbers or symbolic codes, each "note" or each event being the subject of a particular list. These lists are ordered in time. We will see below how this done with the Csound program.

Specifying each parameter is a daunting task, especially since musicians are not trained to give measured values to the sonic dimensions they manipulate. To combat this obstacle, support languages for writing scores have been designed; the best known is Leland Smith's SCORE program (1972). SCORE is not an automatic composition program: it allows you to specify parameters using terms derived from musical practice (pitches, nuances, durations), automatically calculate changes in tempo or nuances, or even complete sections with notes corresponding to a trajectory given by the composer.

The instrument/score model was firmly established with the arrival of MUSIC Ⅳ (1962). From this program were born many variations, some of which still exist today. Among these avatars, let us quote MUSIC4BF (1966—1967), of which there is nowadays a version for Macintosh (MUSIC4C, 1989), and especially MUSIC360

by Barry Vercoe (1968). This descendant of MUSIC IV has the characteristic of presenting itself as a real programming language, which probably explains why it has become today with Cmusic the most widely used acoustic compiler. It was first adapted to Digital's PDP-11 minicomputer in 1973, then, entirely rewritten in C in 1985, it took the name Csound, and was quickly adapted to all kinds of computing platforms, including personal computers like Macintosh and PC.

In 1969, MUSIC V appeared, a program designed to facilitate musical programming of instruments and scores; MUSIC V is less used today, often as an adaptation of it by Richard Moore, Cmusic (1980).

The computer was also very successful in a highly speculative field, musicological analysis. In the eyes of the interested public in the early sixties, computer science, still quite mysterious and inaccessible, hinted at strange musical works; in composition, in musicology and finally, limited to Bell laboratories, in sound production. Meanwhile, Mathews's program was, in the 1960s and 1970s, adaptations to other sites, such as New York, Princeton, and Stanford universities.

The progress of personal computer was fast and impressive. When the first Macintosh computer came out in 1984, it was equipped with an internal memory, or RAM, of 128 kilo-bytes. Quickly, a second version was released with 512 kilo-bytes. In 1986, one could purchase a Macintosh with 1 Mega-bytes of RAM memory. The data and the programs were then stored on small 3 inches floppy-discs, also called "diskettes", containing either less than 1 mega-bytes for the singled-sided diskettes (720 kilo-bytes), or 1.44 mega-bytes for the double-sided. This meant that often a program and its data were stored on several consecutive discs, and the user had to load them one by one. It took patience and time to start working!

Today, an average laptop has a RAM of at least 8 giga byte, that is 8 billion bytes.

5.1 Analysis of Music for Instruments and Electronic: Mixed Music

In this section, I present a number of very short excerpts from scores of music for instruments and electronics. It is interesting to observe the variety of approaches when it comes to finding a way to have performers dialog with electronics. Some composers use fixed media, where all the electroacoustic music has been realized and recorded, and during the performance, is played back. This is often called "music for

instrument and tape", where the term "tape" is a reminder of the old magnetic tape used until the advent of digital media. There are examples by Marc Battier, Wang Hefei, Mizuno Mikako, João Pedro Oliveira. Each score from those composers shows a different way to solve the problem of having an instrumentalist play with an invisible source of electronic sounds. An Chengbi adds, in the example shown in 5. 1. 13, a complex diffusion system.

In other cases, the recorded media is played with live processing by electronic devices, such as in the piece by Yang Xiaoman. At times, an elaborated digital processor captures and transforms the instrument, such as with Daniel Teruggi, or use contact microphones on percussion to trigger electronic material such as with Christopher Dobrian.

In recent years, at least since the 1980s, it has become possible to use the computer as a partner, and introduce interaction in the rapport between performer and electronics. There are examples by Mari Kimura and Philippe Manoury.

5. 2 Philippe Manoury, *Jupiter*

Philippe Manoury, a French composer, had studied electronic and computer music during the 1970s. That led him to integrate the composition of a piece with come concepts of organizing pitches sets, rhythm and harmony derived from what he had learned during those studies. For instance, he applied the theory of the Markov chains to pitch and rhythm organization. In addition, he strongly believes that, in electronic music, the performer ought to influence what the machines were doing during the performance, when he received a commission for a new piece from IRCAM in Paris, for flute solo and electronics, he wanted the instrument to dialog in an interactive manner with the electronics. At that time, it was the 4X digital processor which was to be used. This is how he composed *Jupiter* (1987), for flute and digital processor.

In *Jupiter*, the flute interacts with the digital processor. First, its sound is transformed by processing software:

　　– Harmonizer to transpose the sound up or down.

　　– Frequency shifter.

　　– Infinite reverberation. The resonance is maintained until a command to stop it arrives.

All this processing actions are triggered by a program called Max. Max is a real-time software. Its interface on the computer is graphical.

The harmonizer receives the transposition interval, which is noted in the score. In this illustration, the flute plays a *do#*, which is transposed by 2 harmonizers. The bottom staff is the flute, the top staves are the processing.

Figure 5 −2 Transposition through the use of the Harmonizer

The frequency shifter the pitch of the modulating oscillator. In this illustration, the flute plays a *do#*, and the frequency shifter is set at 10 Hz, which creates a tremolo.

Figure 5 −3 Modulation of the flute *do#* by the frequency shifter

The processing units (Harmonizer, Frequency shifter, reverberation) can be linked. The output of one is sent to another. In this illustration, the output of the Frequency shifter is sent to the Harmonizer. Next, the output of the Harmonizer is sent to the reverberation.

In addition, there are real interactive processes. At times, the computer is

Figure 5 – 4　Patching various transformation modules

recording the performance of the flute. The short recording is analysed and transformed into MIDI data, which then serves to play pre-recorded sounds of flute or other sounds. This way, each performance of *Jupiter* is unique.

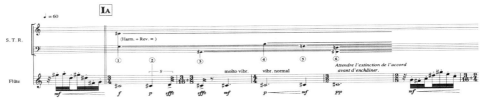

Figure 5 – 5　Beginning of *Jupiter*

5. 3　Marc Battier, *Mist on a Hill*

The piece was composed as a commission from the Zhang Xiaofu for the MUSICACOUSTICA-BEIJING festival in 2009. It is composed for pipa and four electronic sections. Although not using interaction between the instrument and electronics, the piece places the pipa in the center of attention. It drives the piece, while the electronic parts seem to flat around, like clouds in the sky. There is, however, a solo section of the electronic part, but all the sounds come from the processing of the pipa. During the composition, Battier had many interactions with the performer, whom he had met in Beijing some years earlier. He would send her some parts of the score, and she would reply by sending recordings and discussing the score. For an analysis of this piece, see the thesis of Chin, Hong Da[①].

①　Chin, Hong Da, *The Music of Marc Battier, Kee Yong Chong and Gene Coleman: Compositions for Traditional Asian Instruments and Electronics in the Twenty – First Century*, Ph. D thesis, Bowling Green, Bowling Green State University, 2017.

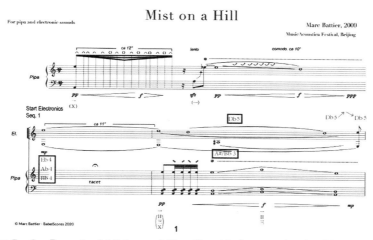

Figure 5 – 6 Page 1 of *Mist on a Hill*, with added annotation by Chin Hong Da

The pipa recordings were processed with various software and mixed to create contrasting materials. The software used in the composer home studio consisted of programs capable of altering the time, by stretching, and of deeply changing the timbre and texture, so that the pipa would sound at times like vocal sounds.

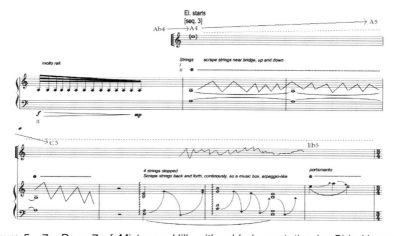

Figure 5 – 7 Page 7 of *Mist on a Hill*, with added annotation by Chin Hong Da

In *Rustle and Shimmer*, composed in 2019 for Chinese flutes, percussion and electronics and first performed in Beijing, all the sounds emerging from the loudspeakers come from percussion recordings. They are heavily processed so that they become an artificial texture. This way, they contrast with the live percussion, played

in the premiere by Thierry Miroglio and the Chinese flutes, xindi and xun flutes played by Li Yue.

The processing of the percussion was mostly made with GRM Tools, some time-stretching software, band-pass and low-pass filters, and mixed with Pro Tools with the multi-band McDSP ML4000 limiter-compressor.

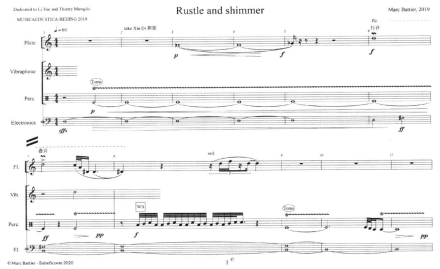

Figure 5 – 8　Page 1 of *Rustle and Shimmer*

5. 4　João Pedro Oliveira, *In Tempore*

For *In Tempore* by João Pedro Oliveira, the approach is different. The electroacoustic part, marked tape, is noted there precisely like the piano. The sixteen-page score, written in 2000, transcribes as rigorously as possible the materials attached to the tape. These are very lively and often brief, and the composer has made a notable effort to make them appear transcribed on the staff.

As the piano writing is also nimble, the instrumentalist can follow the unfolding of the events of the electroacoustic part, even if the timbres and textures denote artificial sounds. The writing incorporates accelerating or slowing down passages, and the tape's rigorous notation becomes an invaluable aid in the synchronization between piano and electroacoustics.

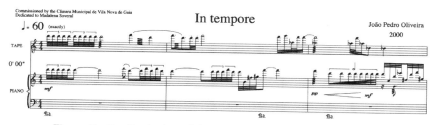

Figure 5 – 9　Beginning of *In Tempore* by João Pedro Oliveira

5. 5　Wang Hefei, *Fairyland*

In her piece, *Fairyland*, written for guzheng and electronics in 2010, Wang Hefei asks the performer to adapt strictly to the recorded medium. The notation is precisely measured with frequent changes of meters, as well as quite a few tempo changes. To help the performer, the electronic part, which is fixed, is represented in a graphical manner. It is thus possible to see the amplitude peaks. In the illustration below, for instance, measure 80 starts at the same time as a strong accent on the fixed medium, and opens a passage in 5/8. The same type of event happens at measure 87, and often elsewhere in the piece.

It is important for this type of approach that the guzheng player spends time rehearsing to adjust the performance to the recorded medium.

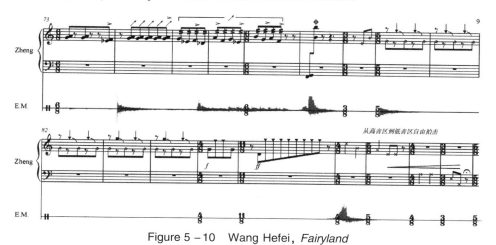

Figure 5 – 10　Wang Hefei, *Fairyland*

5.6　Mikako Mizuno, *Kaymakli*

The piece *Kaymakli* was composed in 2013 by Japanese composer Mikako Mizuno. It is written for oboe and a four-channel electronic music parts. The sounds were recorded partly in caves in Turkey, but most of them were produced in her studio in Japan with generative programs. The title comes from the old underground Turkish city of Kaymakli which has deep tunnels. This is where the composer captured some sounds. The electronic parts are played in four channels, and an oboe dialogs with them.

Figure 5 – 11　Mikako Mizuno, *Kaymakli*, beginning

Figure 5 – 12　Mikako Mizuno, *Kaymakli*, fragment

5.7　Yang Xiaoman, *Fantasia of the Little Match Girl*

The piece by Yang Xiaoman, *Fantasia of the Little Match Girl* is written for flute, cello and electronics, The electroacoustic part is composed of processed sounds. The fragment from the beginning shows an effect called "shuffling". It is realized through the use of a software from the GRM Tools collection. Other effects intervene later in the piece, such as "reverse" and "delay". The score also shows in

54

a precise manner elements of the electroacoustic layers, such as bells, jingle, and spoken text, where a girl can be heard reciting a short fragment from the well-known story.

All the sounds contribute to transporting the listener to a situation evocating the story which gave its title to the piece.

Figure 5 – 13 Yang Xiaoman, *Fantasia of the Little Match Girl*, excerpt 1, beginning

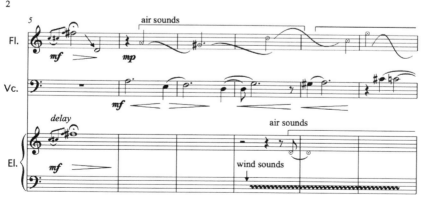

Figure 5 – 14 Yang Xiaoman, *Fantasia of the Little Match Girl*, excerpt 2

5.8 Hu Xiao，*Vague Shadow—Mild Moonlight*

Hu Xiao wrote *Vague Shadow—Mild Moonlight* for piano and electronics in 2019—2020. He specified that the electroacoustic part is made or pre-composed elements and deformation processing of the piano. The performer has to use a couple of small electric device，called e-bow，to sustain the resonance of some strings，as indicated in the score as "e-bow sound – 1 mod." (in the first system，measure 1) and "e-bow sound – 2". The transformed material played on the loudspeaker are not graphically notated，but they appear as verbal annotations，as can be seen on in measures 2 and 6 of the illustration. Hence，these events are synchronized with the piano performance. This is an example of a notation which relies on the tight relation between the instrument and the electronic parts.

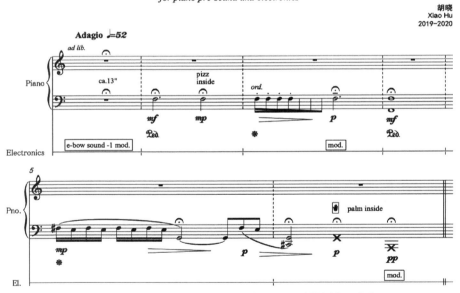

Figure 5 – 15 HuXiao，*Vague Shadow—Mild Moonlight*

5. 9　Chris Dobrian, *0'0'*

In his score for percussion and computer, American composer Christopher Dobrian chose to indicate the intervention of the electronic parts in a sparse manner. This is because the percussions are equipped with four contact microphones, which are placed directly on some parts of the instruments. At the same time, a couple of condenser microphones capture the overall sounds. The audio signals coming from the contact microphones are mostly used by the software, which interprets them as triggers. This way, the computer score is guided by the flow of triggers coming from the instruments.

The software used in this piece is Max for Live: it is a combination of the Max/MSP software x and the Ableton Live software. Dobrian has been an expert on Max for along time, to the point where, early on, he wrote most of the documentation for it. With this system, the performer does not have to receive any visual cues regarding the workings of the program, as it is fully automated. At times, the performers improvise, and so does the computer. The two streams, instruments and electronics, use the same harmonic progression, which was inspired by the jazz idiom, so they remain in the same harmonic fields.

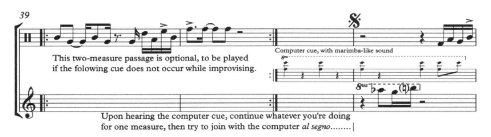

Figure 5 – 16　Chris Dobrian, *0'0'*, measure 36 and following

5. 10　Mari Kimura, *Canon Élastique*

Mari Kimura is a Japanese composer and performer living in the United States. As a violin virtuoso, she developed a body of works for her instrument and a package of electronic processing devices and software. In particular, she developed a motion sensor to capture the position and movement of the hand holding the bow. It was built

with the Arduino hardware kit, following various other designs. Some were made at IRCAM in Paris during a research residency of the composer.

Figure 5 – 17　Mari Kimura playing her violin with the MUGIC motion sensor

Below is an example of a piece for violin and interactive system, *Canon élastique* (*Elastic Canons*). It was composed in 2010 while Kimura was spending her summer as composer in residence at IRCAM in Paris. This institute has a team of developers for real time musical interactions, and she used some of the tools they had developed. In this piece, for example, she relies on a software system with which what she just played on the violin is kept in a buffer memory. She can then change what was recorded and play the revised version as a second voice, hence the idea of musical canon: this may affect the pitches and thus, the chord progression. In this piece, she uses the motion sensor device she created, MUGIC, which is attached to her right hand.

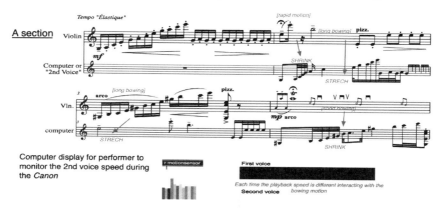

Figure 5 – 18　Mari Kimura, example of the interactive canon system in
Canon élastique (2010)

5.11 Lu Minjie, *Populus Sketch* Ⅱ

The piece by Lu Minjie, *Populus Sketch* Ⅱ, is written for flute and real-time processing by Kyma, a software driving a Pacarana digital hardware device. This processor is popular for real-time synthesis and processing, particularly in interactive situations. Some of the main practitioners of the Kyma device are Jeffrey Stolet, who frequently performs in China, Wang Chi, a Chinese composer, and Lu Minjie, amongst others.

In her piece, Lu Minjie established a very tight and agile dialog between a flute and the electronic parts. The notation used in the score has some graphic and verbal indications of the types and behaviour of the electracoustic material.

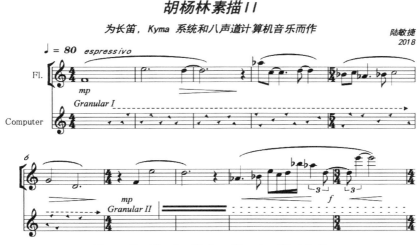

Figure 5 – 19 Lu Minjie, *Populus Sketch* Ⅱ

5.12 Anthony de Ritis, *Shui. Life*

The American composer Anthony de Ritis has frequent contacts with the Chinese musical world. That led him to compose pieces using Chinese instruments.

In his piece *Shui. Life*, composed in 2012, the erhu dialogs with 4 channels of electronic material, The excerpt below shows the kinds of processing used in

producing the electronic layers. The treatments of sounds of water were realized using the Max program. The inspiration of the piece comes from the issue of sustainable resources, such as water, and it was presented in 2015 in an event linked to UNESCO and its efforts in this domain.

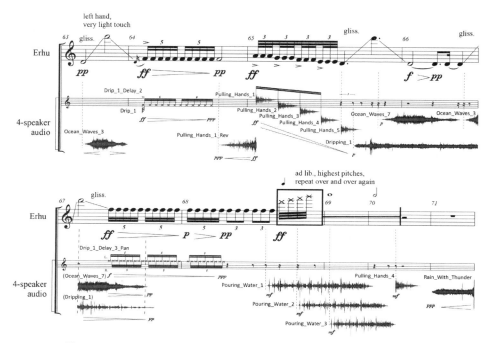

Figure 5-20　Anthony de Ritis, *Shui. Life*, for erhu and electronics

5.13　An Chengbi, *Sound Assembly*

An Chengbi, already mentioned in the chapter on electronic music in China, resides in Europe after having been a teacher at the Shanghai Conservatory. He received several commissions for mixed pieces. In 2006, he composed *Gediao*, a piece for piano and electronic music in 5.1 diffusion. It was the result of a commission from the GRM, the Musical research group in Paris. It was premiered in France, and then performed again during the Electroacoustic Music Studies conference (EMS), held in Paris in 2008.

Another piece for piano and electronics music, also diffused on 5.1 channels, came out of a commission from the Studio of Electroacoustic Music of the Akademie

der Künste in Germany, to be premiered during the festival Kontakte in June 2019. It was given a name in French, *L'Assemblage sonore (Sound Assembly)*.

Performing *Sound Assembly* requires some technical equipment. Three microphones must be placed inside the piano, to capture different registers of the instrument. The five loudpseakers must be placed according to the specification indicated in the score: three in front of the audience, and two left and right. A mixing console receives all the signals: the microphones and the electronic parts, and sends the audio to the five loudspeakers and to the subbass loudspeaker, in a typical 5.1 setup.

Here is a representation of the installation.

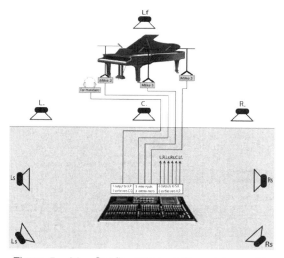

Figure 5 –21 Configuration of *Sound Assembly*

The next illustrations show an excerpt of page 9 the score of *Sound Assembly*. It shows the complexity and precision of notation for the pianist.

In the first system of this passage, the performer moves from playing in the body of the piano ("corps de piano") to the keyboard. The second system of the example shows a precise notation of pedal. The drawings of hands indicate that the performer must sweep both hands across the strings.

Meanwhile, the electronic part is notated in three manners: at the bottom is a representation of the amplitude variations. It is just like an oscilloscope would show a sound. There is no indication of pitch or timbre, only the overall amplitude envelope.

Just above is a spectral analysis which gives an idea of the density of the sound in different registers. It also helps understand the articulation between the various electroacoustic elements. Finally, right above are time measurement in minutes and seconds. Those three modes or representation help the performer get cues from the invisible electronic parts.

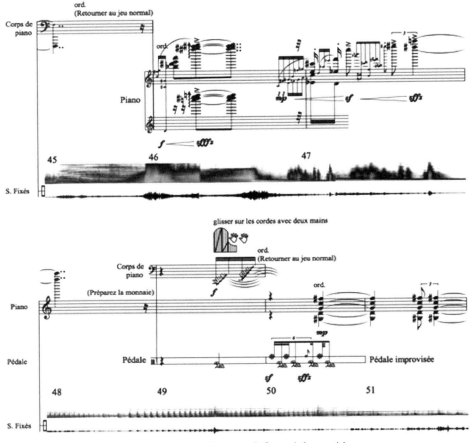

Figure 5 – 22　Except of *Sound Assembly*

5. 14　Li Qiuxiao, *Wu Song Fights the Tiger*

The piece from Li Qiuxiao is written for clarinet and fixed medium, the electronic part appears in common musical notation (CMN), although some passages use indeterminate graphical signs. This is merely to indicate the overall movement and

62

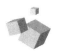

activity of the recorded part. This is how the composer comments her use of electroacoustic elements: "I apply various music elements of Beijing opera in the whole music. The music theme of clarinet uses swing rhythm to portray Wu Song's half-drunk state. The electronic section extensively uses percussion sound, which centers around drum sound to describe the drama scene of the fight with the tiger."

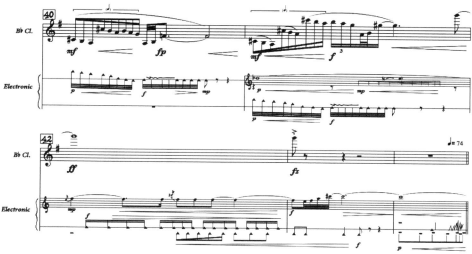

Figure 5-23 Li Qiuxiao, *Wu Song Fights the Tiger*

5.15 Daniel Teruggi

Daniel Teruggi composed most of his pieces at GRM (Groupe de recherches, musicales Group of Musical Research), an entity founded in Paris by Pierre Schaeffer in 1958. He was the director of GRM from 1997 until 2017. His repertoire consists of acousmatic pieces, where all the electroacoustic parts are played from a medium, such as magnetic tape in the past, and nowadays from digital media.

In *Xatys*, saxophones dialog with the electronics, which are played in real time: they capture the sound of the saxophones, played by Daniel Kentzy, and process them on stage, during the performance. When the piece was first performed, in 1988, it consisted of a real time digital processor developed at GRM, the SYTER system. Now that the device no longer exists, it is replaced by the GRM Tools set of software.

Teruggi also composed a number of pieces for instruments and fixed media, in a variety of formats: orchestra and tape (*Circling Waters*, 2011), voice and tape

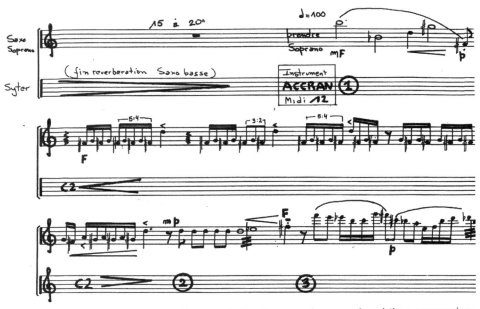

Figure 5 – 24　Daniel Teruggi, *Xatys* (1988), for saxophone and real time processing

(*Umana museria*, 2011), and several solo instruments and tape, such as percussion
(*Struggling*, 2000), bandoneon (*Summer Band*, 1996), saxophones (*Xatys*,
1988). For those mixed pieces, the composer chose to represent the contents of the
electroacoustic parts in two manners: a loose graphic drawing showing the dynamic
envelopes of the sounds, and a measure of the time at which peak amplitude
occurred, as can be seen in this excerpt of *Struggling*, for percussion and tape.

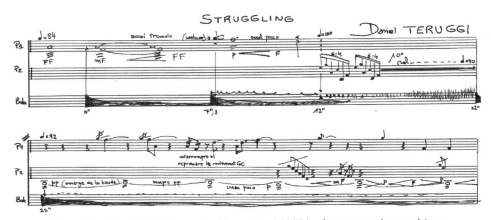

Figure 5 – 25　Daniel Teruggi, *Struggling* (2000), for percussion and tape

5. 16 Li Pengyun, *Under the Cover*

The piece *Under the Cover* by Li Pengyun was written for a percussionist and Max/MSP. The performer sits at a table. The indication P in the score indicate an action, which is made by the performer by pressing on a pedal.

The score has a number of indications to be followed by the performer. These are very precise to ensure a proper performance. The illustration shows a section of the piece called Cadenza 3, which is to be interpreted with freedom.

This piece is a case where the performer is in command of the timing of the piece, thanks to the interactive quality of the software, Max/MSP (now called Max).

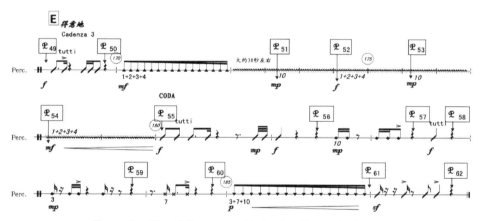

Figure 5 – 26 Li Pengyun, *Under the Cover*, last page

5. 17 Zhang Xiaofu, *Le Chant Intérieur*

One of the first major Chinese electroacoustic piece, and an important work in its own right, Zhang Xiaofu's *Le chant intérieur* was written in 1987—1988 for Chinese bass bamboo flute and electronics. In writing for the flute, the composer explored different modes of playing. Innovative aspects are created when the performer changes the vibrating membrane, a characteristic feature of Chinese flutes. This creates a palette of various colors coming from the instrument, which are relayed by the electronic layers.

As is customary for the composer, the piece was later revised, and audiovisual components were added. The electroacoustic layers were revised in 1981.

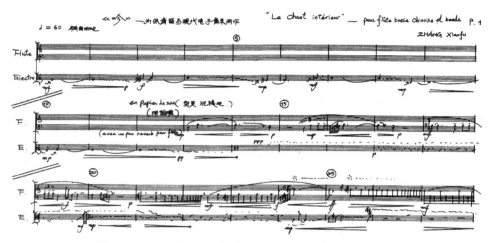

Figure 5 – 27 Zhang Xiaofu, *Le chant intérieur*, page 1

6

Basic Knowledge and Techniques

Synthesizers were designed to create sounds from basic electronic components. Contrary to a conventional musical instrument, there are no moving parts. All the sounds are made by electronic circuits. Today, these are actually software simulations inside a computer or a digital instrument.

Synthesizers were first invented during the 1950s. In those days, the electronic circuits used were called "analog", and today we still distinguish between analog and digital synthesizers.

Analog synthesizers are built around electronic circuits made of transistors, integrated circuits, resistors and other components which enable the creation of waveforms or their transformation, so that they can become musical sounds. Analog synthesizers are based on electronic operations, and all the sounds are represented as continuous signal, with voltages which vary according to the waveforms. It is the fact that the signals are continuous that they are called "analog". What is analog is a phenomenon which is continuous. When you look at the movements of the clouds in the sky, you see them moving: that is an analog phenomenon.

In a computer, or in any digital system, there is no continuous signal. This is because everything is represented by a series of numbers. Each number is the value of something at any given moment. Hence, a sound inside a computer can only be represented by a long suite of numbers. The opposite of an analog, continuous movement is called "discrete" or simply digital.

Digital synthesizers are based on computer operations, and all the sounds are represented as discontinuous or "discrete" signals, which are, in fact, a series of numbers.

6. 1 Synthesizers and Sound Synthesis

6. 1. 1 The Analog Synthesizer

The first attempt to produce complex sounds imitating the instruments of the

orchestra resulted in the construction of a gigantic synthesizer at the American firm RCA (1952—1955), by two talented engineers, Harry Olson and Herbert Belar. The instrument was made with electronic lamps, the use of the miniature transistor was not yet common, which explains the enormous size of the instrument. The music is encoded by means of a keyboard which creates a perforated tape: the elementary information of duration, pitch and timbre are codified. The sound synthesis is produced in real time (without delay).

The publication in 1955 of a demo record sparked a protest movement from musicians' unions who saw their profession threatened by a machine. Nevertheless, RCA undertook the construction of a second model (Mark Ⅱ) which was completed in 1958, but it was impossible to market it (protests, price). The device was then installed, in 1959, in a studio set up expressly by Vladimir Ussachevsky, Otto Luening (from the Columbia studio) and Milton Babbitt (from Princeton University, near New York), the Columbia-Princeton Electronic Music Center, thanks to a grant from the Rockefeller Foundation (1958, $175000). It was Babbitt who used the instrument for several important works whose rhythmic complexity led the composer to produce synthetic, perfectly accurate versions.

A great musical upheaval occurred a few years later, with the appearance, in 1964, of modular, so-called "analog" synthesizers since they did not contain digital electronics. Independently conceived by Paolo Ketoff (Italy), Robert Moog and Donald Buchla (United States), the synthesizers provide the answer to the technological aspirations of many musicians, especially after the popular success of the disc *Switched on Bach* by W. Carlos which really made known these instruments to a large audience.

6. 1. 2　How Analog Synthesizers Work

An acoustic instrument has essentially two parts: the "excitation" part, which creates a wave, and a "resonance" or "amplification" part, which makes the sound audible by the human ear.

Think of the excitation part as the mouthpiece of a clarinet, the plucking of a string on a guitar or the hitting of a drum. In an acoustic instrument, it is the resonant part which gives the colour of the sound, such as the body of a violin or a guitar, the wooden tube of a clarinet, and so on. In a synthesizer, the excitation and the resonance have to be constructed, as there is no mechanical part: the excitation is

done by an oscillator, which creates a waveform, as we will see below. Just remember that a musical sound has a complex waveform, because it is composed of many harmonics. To use a synthesizer, it is necessary to understand the basic types of sounds created by the oscillators: these are the basic waveforms, and there are four main types of them.

The resonance is a bit more complex and is usually done by different operations.

One important function for this is the filter. Any synthesizer will offer a low-pass filter. It is the effect of this filter which you hear frequently in electronic music.

6. 1. 3 Some Historical Landmarks

The first synthesizer built by Robert Moog came out in 1965. A few models were sold in the following years. They were built by hand in a small shop, one after the other. Then, by the end of the 1960s, orders started to arrive from different sources: schools were now interested in having an electronic music studio, musicians from the experimental and contemporary music scene became aware of the instrument, as well as jazz and pop music artists. Below is an advertisement for the Moog system 55.

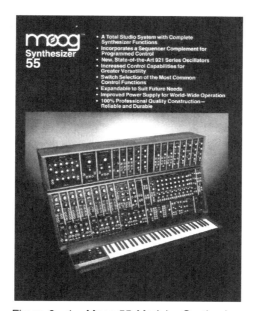

Figure 6 – 1 Moog 55 Modular Synthesizer

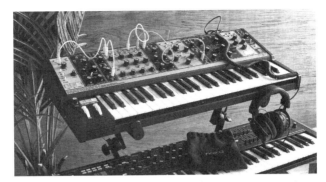

Figure 6 – 2 Semi-modular Moog Matriarch synthesizer

Here is a photo of the popular Syntrx synthesizer, built by the firm Erica in Latvia. It is modeled after the old Synthi A from the EMS (London) company in 1971, but has some improvements, such as a sample and hold and a digital matrix.

Figure 6 – 3 The Syntrx analog synthesizer by Erica

Figure 6 – 4 Yamaha DX7 digital synthesizer

6.1.4 Synthesizers in China

In Beijing, Meng Qi is today developing hardware for interactive electronic music. These are modules for EuroRack, and a couple of small independent modules based on low-pass filters.

He caters to the EDM (Electronic Dance Music) and experimental scene, which took off in China at the end of the 1990s. [1]

Figure 6 −5　Some devices built by Meng Qi

6.1.5 Signals in a Synthesizer

In a synth, there are several types of signals. Audio signals: they come from the oscillators, the noise generator and the output of processing modules (such as filters, reverberation, envelopes...). Control signals: in an analog synth, there are control voltages. A control voltage cannot be heard: it is slowly varying and in most cases, it does not oscillate. They are used to control (that is, change) values, such as the frequency of an oscillator. In a software synth, most control signals are MIDI messages. A pulse is used to trigger an event, such as to start (trigger) an envelope.

6.2　Notions of Acoustics

Before we go any further, let's review some basic acoustic notions.

[1]　For more information, visit https://www.mengqimusic.com.

6.2.1 Frequency

A frequency is a measure of pitch. More precisely, it is a measure of the number of cycles per second. Each pitch has a number of cycles, which repeat themselves, like in the picture below. The unit used to measure frequencies is the Hertz (Hz).

Lower Pitch Higher Pitch

Figure 6 −6 Two different frequencies

The more cycles per second, the higher the pitch. The pitch la is a pitch whose frequency is 440 Hz. There are 440 cycles in one second.

It is said the humans can hear sounds from 20 Hz (very very low) up to 20000 Hz. Actually, we recognize a pitch only from about 30 Hz up to about 8000 Hertz.

Let's look at the range of a piano. The piano goes from 25.5 Hz (lowest note) up to 4186 Hz. However, this is theoretical. In reality, the pitch of the piano starts being clear above the lowest note, and in the highest octave, there's more noise than pitch. The space above 4000 Hz is mostly reserved for the harmonics of a sound.

6.2.2 Spectrum

All the harmonics of a sound are called a spectrum. This is the spectrum of a low *do*. When we play this note, for instance on the piano, all those harmonics are contained in what we hear. Only, we hear a *do*, because our brain fuses all those harmonics into a single sound.

Figure 6 −7 Harmonic series of a spectrum

6.2.3 Bandwidth

Another notion that is useful is that of the audio bandwidth. This is the

bandwidth of a good microphone. The level is flat between 200 Hz up to 4000 Hz, then there's a slight bump around 10000 Hz (10 kHz), which is good for music and voice.

Each microphone has its own bandwidth.

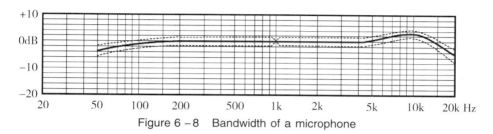

Figure 6 –8 Bandwidth of a microphone

6. 2. 4 Level

The level of sound as perceived by the human ear, or as measured, is expressed in decibels (dB). Unfortunately, a decibel (dB) is not an easy unit. There are several categories of dB.

To make it simple, let's say a dB is a measure of the intensity of a sound. In this situation, the human ear can perceive sounds between around a few dB (let's say, around 30 dB), which is almost complete silence, up to very loud sounds, around 140 dB. Below 30 dB (or so, this is an approximation) we cannot hear anything. This is because our own body creates noise: noise of the heart, noise of the nervous system. If we enter an anechoic chamber (a room which absorbs all reverberation), then after a while, we can hear our own body. Measure of levels of human hearing: loudness scale. The word loudness is used for the sound levels as perceived by humans. It is perceptual. Intensity is a measure of a sound produced. It can be measured exactly. Loudness is a measure of sound perceived. It is difficult to measure perception. It can only be a ratio (louder than, softer than...). A difference of 10 dB means sound A is twice as loud (or twice as soft) as sound B. A 10 dB difference represents a tenfold increase in intensity (level of sound produced). It is because decibels are measured on a logarithmic scale.

Signals are often represented by diagrams that show the variation of a parameter in a dimension. Four types of representations are commonly used, according to the following three categories: amplitude/time, amplitude/frequency, frequency/time.

6.2.5 Amplitude/Time

This mode of representation is twofold, depending on the chosen time scale. In the diagram below, time is measured in seconds, so that the sound here is represented in full, from start to finish, in the form of its amplitude envelope.

By this representation, you can evaluate the overall contour of the evolution of the amplitude of the sound over time; it is generally possible to reduce the profile intoa number of segments, linear or curved; this is how one proceeds to transcribe the amplitude envelope of a natural sound in a sound synthesis program. Some analysis programs give a certain number of points, spaced in time at a fixed interval, which, placed end to end, define the contour. From these results, it is then necessary to perform a data reduction to convert this analysis into a limited number of segments, which illustrate the envelope in a significant way.

The evolution of the amplitude of a sound can be represented by an envelope. Here is the envelope of a bell sound.

Figure 6 –9 The amplitude envelope of a bell sound

The amplitude/time diagram also describes the signal in the time domain; the signal is represented there as a function of time. This description mode shows the waveform of the signal being examined. The time scale is reduced to the order of a millisecond. This mode is sometimes called oscilloscopic, since it shows the waveform

over time, much like an oscilloscope.

The shape of a wave can be seen by zooming into the time scale.

1 periode (1 cycle)

Figure 6 – 10 A sinewave

It is in the amplitude/time mode that we can observe the notion of phase and of period. In a simple way, the phase is defined as the relative position of the wave on the time axis. There are several units for measuring phase; in the figure below, the phase is expressed in degrees.

Figure 6 – 11 Phases of a period

6. 2. 6 Amplitude/Frequency

When we want to know the spectral content of a sound, we have recourse to a process allowing to show the components of the sound as functions of the frequency, in what we call the frequency domain. The axes are then amplitude and frequency. The simplified diagram below shows the spectral content of a harmonic sound, in the form of a series of components of order f (harmonic 1) , 2f, 3f, 4f, etc. By referring to the axis of the amplitude, one can appreciate the relative amplitude of each component.

Figure 6 – 12　Harmonic series of a spectrum

Programs performing signal analysis by the fast Fourier transform method accurately show the frequency position and amplitude of each component.

6.2.7　Frequency/Time

A last mode of representation shows the evolution in frequency, duration, and, in a less precise way, the variations in amplitude of the components of a sound. It is mainly used to measure the position and especially the duration of the components. It is called a sonogram, in reference to the analog instrument of analysis.

Figure 6 – 13　Spectral analysis of a bell

6.2.8　Combined Representation

These diagrams can be combined, giving three-dimensional representations. The three axes are: amplitude, frequency (in kHz) and time (in seconds). Here is how Pierre Schaeffer represented sounds in three dimensions.

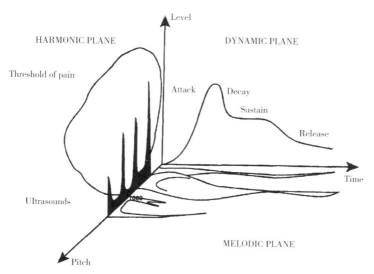

Figure 6 – 14　Three-dimension representation of a sound

The three representations are gathered in three planes. Pierre Schaeffer called them:

– Hamonic plane, amplitude/frequency;

– Dynamic plane, amplitude/time;

– Melodic plane, frequency/time.

Here is the spectral analysis of the sound of a bell, represented in three dimensions.

Figure 6 – 15　Spectral analysis of the sound of a bell

6.2.9 Fourier Synthesis

Fourier showed how the spectrum decomposes mathematically into a series of simple vibrations: each one is a sinusoidal signal. Their frequencies are integer multiples of the most serious vibration: these vibrations, the harmonics, have frequencies f, 2f, 3f, 4f, 5f, etc. Note that as a consequence, the duration of their periods decreases: T, 1/2T, 1/3T, 1/4T. A point of terminology, to remove a confusion too often observed: the component f is also called fundamental or harmonic 1.

Thanks to the tools discovered by Fourier, we know how to analyze and synthesize complex spectra; let us take a square signal, of which only the first 3 harmonics are present (that is to say harmonics 1, 3 and 5, since the square signal only contains harmonics of odd rank). We will successively see the harmonics 1, 3 and 5, then their summation, and finally the shape of the wave resulting from this synthesis.

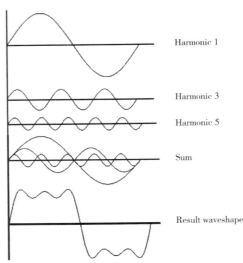

Figure 6 – 16　How a waveshape is built by addition of harmonics

6.3　Basic Waveforms

In sound synthesis, it is useful to understand the basic waveforms. These are

found in analog and virtual synthesizers, and used in software synthesis such as Csound, which is discussed further in the book.

Sinewave: only one harmonic. It is often called "pure sound".

Triangle wave: only odd harmonics, their amplitude decaying very fast.

Rectangle wave: only odd harmonics, sound richer than triangle.

Sawtooth wave: all harmonics. Sounds like a buzz.

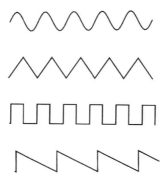

Figure 6 – 17 The four basic waveshapes: sine, triangle, square, sawtooth

6.3.1 Sinewave

A sinewave has only one harmonic. This is why it is sometimes called a "pure sound". When a complex musical sound is analyzed, the analysis shows that it is mostly composed of a series of harmonics, each one being a sinewave.

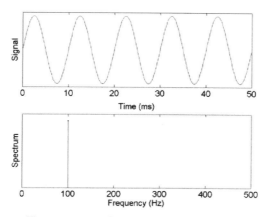

Figure 6 – 18 Spectrum of a sinewave

6.3.2 Triangle

The spectrum of a triangle wave contains only odd numbered harmonics. The amplitude of each harmonic is the square of its rank: it is 1/odd harmonic number. Thus, if the amplitude of harmonic 1 is 1, the amplitude of harmonic 3 is $(1/3)^2$ or 1/9; the amplitude of harmonic 5 is $(1/5)^2$, or 1/25, and so on. This gives the triangle wave a rather smooth sound, but very far from the sinewave.

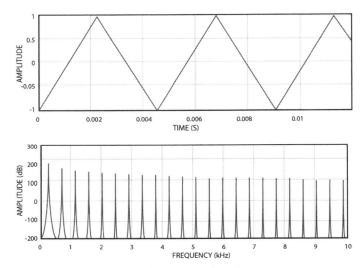

Figure 6 - 19 Spectrum of a triangle wave

6.3.3 Rectangle

The spectrum of a rectangle wave contains only odd numbered harmonics. The amplitude of each harmonic is the inverse of its rank. It is 1/odd harmonic number. Thus, if the amplitude of harmonic 1 is 1, the amplitude of harmonic 3 is 1/3; the amplitude of harmonic 5 is 1/5, and so on.

The square wave is thus considered a "rich" spectrum, with a piercing sound in all registers.

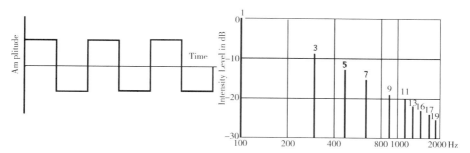

Figure 6 – 20　Spectrum of a square wave

6. 3. 4　Sawtooth

The spectrum of a sawtooth wave contains all harmonics. The amplitude of each harmonic is the inverse of its rank. It is 1/harmonic number. Thus, if the amplitude of harmonic 1 is 1, the amplitude of harmonic 2 is 1/2; the amplitude of harmonic 3 is 1/3, and so on. It is considered a very rich spectrum and is sometimes called a buzz.

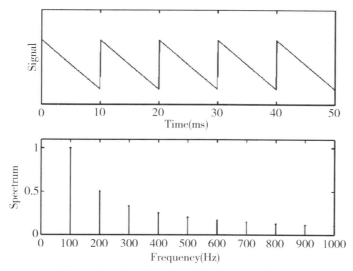

Figure 6 – 21　Spectrum of a sawtooth wave

6. 3. 5　Noise

The different types of noise are characterized by their varied spectral distribution. This distribution is represented by an amplitude/frequency diagram.

White noise is perceived as a fairly concentrated breath in the treble. It has an equal energy distribution per band: we will have the same amount of energy for each frequency band of the same width, whatever the register. Thus, there is as much energy between 100 Hz and 200 Hz (octave interval), as between 1000 Hz and 1100 Hz (interval of about a semitone). Perceptually, one has the impression of a brilliance carried towards the top of the spectrum. It is the sound of analog magnetic tape. It is represented as a flat spectrum.

Another type of noise has a very different energy distribution characteristic: pink noise. It has an equal distribution of energy per octave: there will be an energy comparable between the 100/200 Hz octave and the 1000/2000 Hz octave. Its energy decay slope is 3 dB per octave. The ear perceives the pink noise as a deep breath, not very bright. It is sometimes also called noise in 1/f. Conversely, white noise increases its energy by 3 dB per octave, which explains its brilliant character.

Noise is a source widely used in sound synthesis. A first quality of noise is that it is non-pitched. It has either no pitch at all, or a "fuzzy", unclear pitch. In this sense, a noise is opposed to a musical sound, which has a clear pitch. This opposition is today meaningless in music, but is still true from an acoustic or scientific position.

Examples of raw noise (not musically processed) are: white noise, pink noise, brown noise.

6. 3. 6　Example in Analog Synthesizers

Arturia Synthi V synthesizer, which models the analog Synthi A by EMS (London), has three oscillators: 1: sine, triangle; 2: square, triangle; 3: square, triangle.

Figure 6 –22 Arturia Synthi V (L) and Erica Syntrx (R) —3 oscillators

There also have two additional signals: Noise (white = High, pink = Low); Filter (when Response is at 10).

6. 4 Digital Synthesis

In the computer, sound synthesis often starts with a single period of a wave. It is stored as a series of numbers, each one being called a sample, in a wavetable. The wavetable is used to keep, in sampled form, a period of a sound, or of a basic signal (such as a sine). It is made up of the series of samples which describe the chosen period; the samples are arranged in what in computer science is called a table, one after the other. A table can be thought of as a series of words in computer memory. Each sample is placed in a memory word. The sequence of memory words necessary to store all the samples is called wavetable. The synthesis languages of sound call it a function. This name will often be used in this text to designate a wavetable.

During the sampling process, the wavetable is loaded into the main memory. As the size of it is generally counted, it must be carefully preserved. Thus, until recently, synthesis programs employed small wavetables, and defined a period on the fewest possible points. When MUSIC Ⅳ (1962) appeared, the wavetables were defined on 512 points, due to the very small size of the central memory of the computer used at the time (a few thousand words only). We will see below the drawbacks linked to the use of a small table, and the compensation mechanisms that

this entails. Computers today are experiencing a significant increase in the size of their main memory, and we commonly find tables of at least 4K words (4096 words).

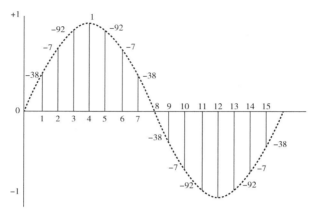

Figure 6 -23　One cycle and its samples

Here is an illustration of MUSIC V, which shows one cycle and its representation as a series of numbers in a wavetable.

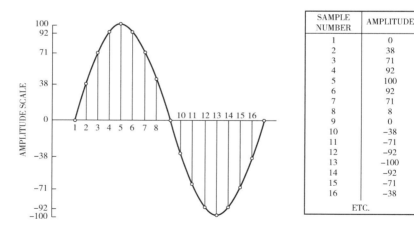

SAMPLE NUMBER	AMPLITUDE
1	0
2	38
3	71
4	92
5	100
6	92
7	71
8	8
9	0
10	-38
11	-71
12	-92
13	-100
14	-92
15	-71
16	-38
ETC.	

Figure 6 -24　A wavetable and the sampling of a period

6. 5　Filters

The filter section of a synthesizer can have several types: as mentioned earlier,

the low-pass filter is quite common. Let's see how it works.

To describe the action of a filter, let's first look at a visual representation of a sound. This image is of a "frequency domain" representation: it shows a sound at one moment, as if we could stop a sound and look its composition. This image shows a sound at 100 Hz, which is a low sound (between *sol2* and *sol #2*), and its harmonics. Here is the effect of a low-pass filter on that spectrum. Note that the higher harmonics have been eliminated.

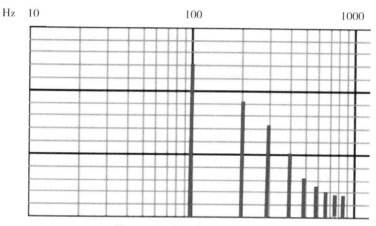

Figure 6 – 25 A spectrum

6. 5. 1 Low-pass Filter

This is the effect of the low-pass filter on the frequency spectrum. Note that the higher overtones are eliminated.

The low-pass filter has a variety of settings. The most important thing is its cut frequency. Above this frequency, the frequency spectrum is gradually weakened and eliminated. The cutoff frequency can be moved, as often heard in electronic music.

An important setting is resonance. There is a separate control for this setting. When pushed up, the resonance places the filter in or near the oscillation mode. This is a highly recognizable effect.

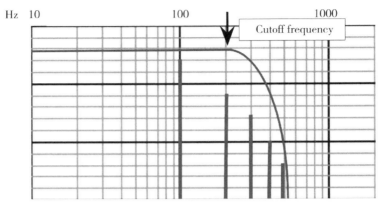

Figure 6 - 26　Low-pass filtering of the spectrum

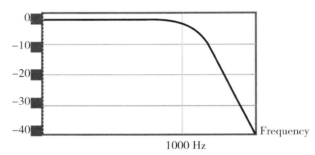

Figure 6 - 27　Low-pass filter

6. 5. 2　High-pass Filter

Contrary to the low-pass filter, it cuts off the low components of a spectrum.

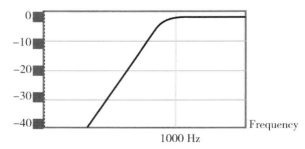

Figure 6 - 28　High-pass filter

6. 5. 3　Band-pass Filter

It has two cutoff frequencies and cuts off the low and high components of a spectrum.

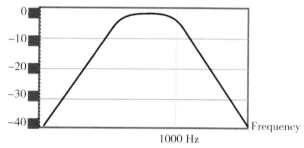

Figure 6 – 29　Band-pass filter

6. 5. 4　Notch Filter

The notch filter is rarer. It creates a "hole" in the spectrum and keeps the low and high components.

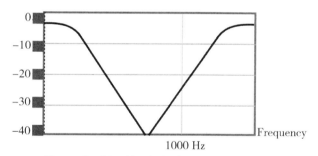

Figure 6 – 30　Notch (rejection) pass filter

6. 5. 5　Equalizer

This is a bank of several filters. You can move the places at which you can attenuate or boost parts of a spectrum.

Figure 6 – 31　Logic Vintage Graphic EQ

Figure 6 – 32　EQ-Steinberg Frequency

6. 6　Envelopes and VCA

6. 6. 1　Basic Envelope Shapes

Some basic synthesizers only have 3 segments: Attack, Sustain, Release. This is called an ASR envelope.

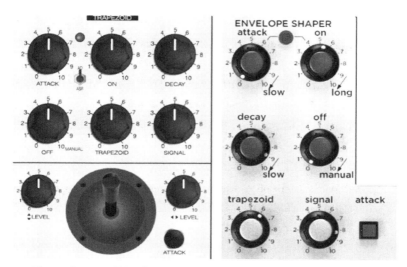

Figure 6 – 33　EricaSyntrx analog synthesizer envelope (L) and
Arturia Synthi V envelope (R) which modelled after the EMS VCS3

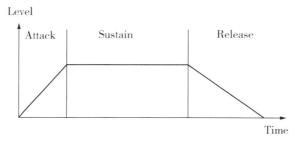

Figure 6 – 34　ASR envelope

Also common in synthesis devices are the four-segment envelopes. After the attack, the envelope drops: this is called a Decay segment, which is followed by a sustain segment. This type of envelope is called ADSR, for Attack, Decay, Sustain, Release.

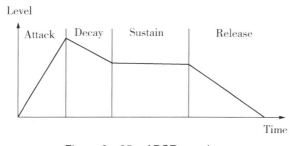

Figure 6 – 35　ADSR envelope

The duration of each segment can be set precisely, so that the ADSR can successively be a percussive sound or the opposite, with a slow attack and release, like a bowed instrument.

Note that when triggered by MIDI, the ADSR (or ASR) envelope has a particularity: the release portion is played only when the note ends. This is similar to a resonance or a decay when a musician stops playing a key on a piano with the resonance pedal all the way down. Thanks to the release segment, the sound is not abruptly cut off.

Sophisticated synthesizers offer a choice of linear segments, as the ones we just saw, or exponential ones. These shapes should be more natural to the ear.

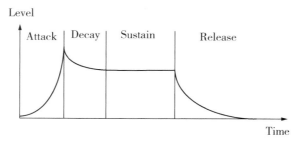

Figure 6 – 36 ADSR envelope (exponential)

6. 6. 2 VCA: Voltage-Controlled Amplifier

The name VCA comes from the time of analog synthesizers. Today, digital synthesis do not have control voltages, which are replaced by digital commands. However, the term VCA has remained, for amplifiers controlled by automation in DAWs.

6. 6. 3 Synthesizer Patches

All synthesizers, hardware or software, use a combination of individual modules. There are two types of "modules":

– a circuit which can produce a sound, called "oscillator" or "generator";

– a circuit which process or transform a sound.

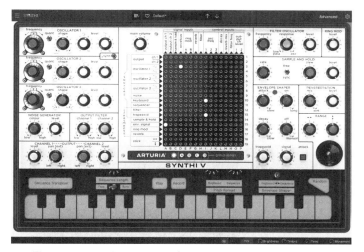

Figure 6 − 37　The Arturia Synthi V software synthesizer

In a synthesizer, sounds are called "signals". They become sounds once they reach a loudspeaker or earphones. Synthesizers have a variety of modules. Typically, the user makes connections to send the output of a module to the input of another, until the signal is sent to the output.

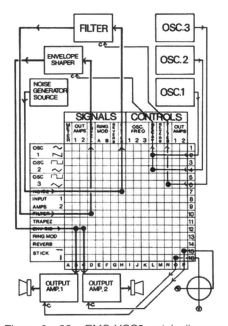

Figure 6 − 38　EMS VCS3 patch diagram

In the Arturia Synthi V (analog or software), the connections are made though a matrix. The left list shows the sources (the outputs of modules). The top line shows the columns, which are the destinations. In the Synthi V, the sources are "patched" —sent to a column.

In the matrix of the Synthi V, the left colums receive audio signals, while the right columns receive control signals.

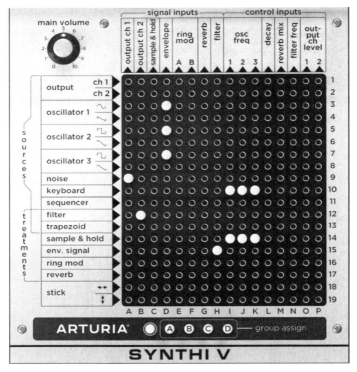

Figure 6 –39 Matrix of the virtual Synthi A by Arturia

6. 6. 4 Sample and Hold

When a signal a generated, it can be represented as a shape, or curve.

In the digital world, this curve is "sampled", that is a sequence of consecutive numbers.

Each number is called a sample.

A Sample and hold, receive a signal, looks at the curve and, at certain moments, freezes the value of the curve at that moment.

A usual method is to send to the Sample and hold module a noise signal, which is a random curve.

The output of the Sample and hold, that is the sampled noise signal, is generally applied to oscillators, or sometimes the cutoff frequency of a filter.

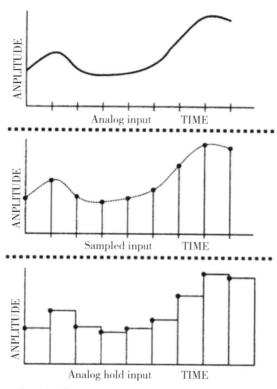

Figure 6 – 40 Representation of a Sample and Hold effect

7

Computer Music Practice in the 21st Century

7.1 The DAW, or Digital Audio Workstation

DAW stands for Digital Audio Workstation. This is a general name for audio and MIDI sequencers, such as Cubase, Logic, Pro Tools, Reaper, Harrison Mixbus, Ableton Live and others.

Modern DAWs are able to process very different types of signals. They can read external sound files, which, once imported, may appear on the timeline of the software. Once imported, the sound files become a part of a sequence, or a session, as some DWAs call a sequence. Some sound files are simply stored in a special place, while others are placed on the timeline of the sequencer.

Some DAWs are particularly adept at mixing. They offer tools designed to help you achieving proper mixing, mastering and imaging. With them, you will be able to create professional mixes. They focus on music production just like a commercial studio does. Some allow for multitrack mixes, such as 5.1 or 7.1, or even 22.2 tracks. Some of them, like Pro Tools, only accept plugins of a certain format, like AAX in this case, others will gladly work with AU or VST plugins. All will be a good platform for creating stereo mixes of high quality. Among those fine-tuned for mixing, let's mention at least three: Avid Pro Tools, Harrison Mixbus and Mixbus32C, and Reaper.

Other DAWs are more polyvalent. They are inclined to help you use software sounds. For that, they often come equipped with sample players, sample libraries and software synthesizers. They also accept plugins from other manufacturers, and they of course have all the necessary tools for mixing. In a way, they are trying to fulfill all tasks of composing and mixing.

It is important to mention that the costs of those DAWs vary considerably. Some of them are even entirely free, such as Pro Tools First, which offers a limitation of 16 tracks but comes with a number of useful plugins. When we speak of DAWs (Digital

Audio Workstation), we consider software like Cubase, Logic, Pro Tools, Digital Performer, Reaper, Mixbus, or others. Those are all DAWs. So what exactly is a DAW and why are those software all in the same category? This is because they began their life with one purpose: to be able to mix sounds and produce music.

A DAW is composed of a sequencer. With that word, it is understood that several sounds can be gathered to create a sequence, which, in turn, is a technical word to mean a piece of music. Essentially, a DAW is a sequencer where the musician can arrange bits of sounds, just like an orchestrator arranges instruments on a score. Just like an orchestrator, the musician using a DAW is able to create an arrangement from a variety of sound sources.

This may be where the analogy stops. When the orchestrator's work is finished and the arrangement is completed, the orchestra enters the stage, and the conductor climbs unto the podium. The orchestrator worked on paper, the score, but the real sounds are produced by the orchestra under the baton of the conductor.

With a DAW, the musician is the orchestrator and the conductor. All those tasks are integrated. So, let's break down the musical operations offered by a DAW. At the center of the DAW is the sequencer. This is the main window of a DAW. It displays the sequence with all the tracks.

Knowing how to effectively use a DAW is not a trivial question. A DAW is a complex software. It has benefited from the experience of sound engineers, sound mixers, music producers and studio techniques. At the same time, it exploits digital technology to its advantage.

A DAW has several types of channels, because there are several types of signals:

– Audio signals (sounds), such as synthesizers, external soundfiles or samples, for instance. There are several types of audio signals.

– Auxiliary signals, such as outputs from effects (reverberation equalizer, compressors...).

– MIDI signals: for example, Sibelius or Finale can play their scores through MIDI through sending messages to sample libraries. The music in Sibelius or Finale is indeed represented as MIDI data, but these programs can use actual sounds, such as samples. In this instance, the MIDI notes of the score are sent to a player, which is a plugin software which, in turn, uses actual sounds to play the notes sent by MIDI.

The MIDI notes can also be sent to an external device, such as a synthesizer or a

sampler, but this is rarely used these days. MIDI notes can be received from an external MIDI control keyboard, such as from a keyboard.

To handle the various types of signals, a DAW offers different kinds of channels:

– Audio channel: soundfiles loaded from your disk, played or mixed with other audio signals.

– Instrument: often, DAWs have instruments (like HALion Sonic SE in Cubase).

– MIDI: MIDI signals convey commands. They do not convey audio.

– Master: this collects the audio channels and mix them in stereo.

– Aux, Insert, Group, Bus: these are special types of channels which we will see. Beware that the names of those channels may vary, but their functions are always present.

7.2 Tracks and Channels

At this point, we should talk about the distinction between tracks and channels. In a DAW, you can set up your mixer to have a number of channels. Most modern DAWs have a large number of available channels, depending on the version you use. Some free DAWs, like Pro Tools First, has, at the time on this writing, 16 channels. However, commercial DAWs offer routinely hundreds of available channels.

What about a track? The word track comes from the time when tape recorders were used. There were stereo tape recorders (2 tracks), 4 track, 8 tracks, 32 tracks up to 64 tracks. It is now commonplace to use indifferently the words channel and track. There is, however, a difference, but it's true that, when using a DAW, the two words are synonymous.

When using a hardware mixer, however, there is a distinction. A hardware mixer may have 16 channels: that would be a fixed number. Each channel can receive a track, that is a stream of mono or stereo audio. In that case, the channel is the recipient and the track the contents. The photo below shows a modern analog mixing board, the Audient 4816, which has 16 channels.

Figure 7 – 1 The analog Audient mixing console installed in the
computer music lab of Shenzhen University

This said, it is often easier to use these two words without making a difference. In this text, I will try to use "channel" as much as possible, but you will also see "track" with the same meaning, because there's no harm in using them interchangeably.

7. 2. 1 Mixing: Notion of Bus

Each channel can send its signal to a bus. So, a bus is not a channel. A bus is used to collect audio from several channels. This way, you can group, for example, all the drum channels. Then the bus which contains all the drum channels is sent to one stereo Aux channel. An auxiliary channel receives its audio from a bus.

That way, you can control all the drums, which may have 4, 5 or 6 channels to one stereo channel and adjust its level with one fader or add some effects, like a compressor, equalizer or reverberation.

Hence, a bus collects the signals from channels. Each channel is able to send its signal to one or several busses. Also, it can control the level of the signals sent to a bus. You can think of a mixing bus as a city bus which collects people along its route. Usually, the bus sends its signals to an Aux channel. An Aux channel, then, receives its audio from a bus.

An audio channel (or "main" channel) is able to send its signal to a bus. That is the Send operation. The bus can collect the signals from several channels and carry them as a group to an Aux channel. The Aux channel can send the signal received

from the bus to some plugin effects, like reverberation, and then receive the processed sounds from the effects. This is also a send/receive operation. As we saw, the notion of Send, Receive, Aux, Group and Bus are all linked. There is simply a distinction in the functions.

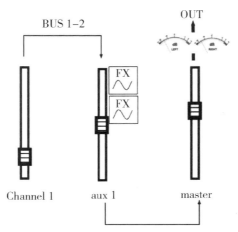

Figure 7 −2 Bus, Aux with effects

To create an Aux channel, go the mixer and click on Sends. This opens a menu window. Click on Bus, this opens a scrolling list with all the available busses. Signals on a bus can be received by an Aux channel.

In this Pro Tools example, the 4 audio channels are all sent to a stereo bus (bus 1 −2). In turn, bus 1 −2 is received by an Aux channel (called Aux 2 here). It is then possible to add effect plugins on the Aux channel, and they will affect all the signals received from channels 1 to 4. For example, it is on this Aux channel that reverberation can be applied to the mix of the 4 audio channels. This way, we use only one instance of the reverb, rather than four times the same plugin, each one for channels 1 to 4. The pressure on the computer's CPU is not as much as if we used 4 reverberation plugins.

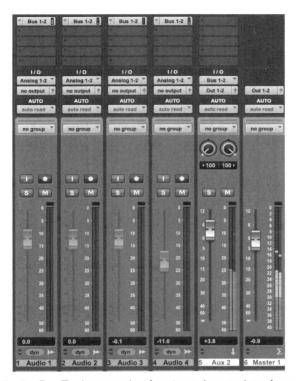

Figure 7 – 3 Pro Tools example of a stereo bus and an Aux channel

You can say that you send channels 1 to 4 to the bus, and the Aux channel receives the bus. The notion of sends and receives are common in a mixer and in a DAW. To put it more precisely: an audio channel (or "main" channel) is able to send its signal to a bus. That is the Send operation. The bus can collect the signals from several channels and carry them as a group to an Aux channel. The Aux channel can send the signal received from the bus to some plugin effects, like reverberation, and then receive the processed sounds from the effects. This is also a send/receive operation.

As we saw, the notion of Send, Receive, Aux, Group and Bus are all linked. There is simply a distinction in the functions.

Note that the audio channels 1 to 4 have no output: their signals are sent to the stereo bus instead. Then, the Aux channel receives the stereo bus.

Finally, the Master channel (stereo) receives the Aux channel without any particular setting: it is all routed internally.

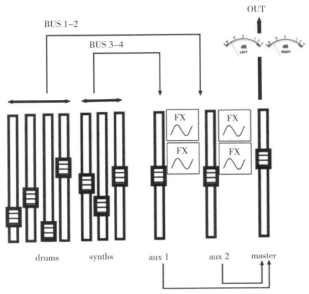

Figure 7 – 4 Busses, Aux with plugin effects ("FX")

To use a "solo" button on any of the 4 audio channels, you'll have to put the Aux channel also in solo.

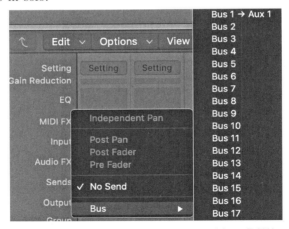

Figure 7 – 5 Selection of a bus send in a DAW

7.2.2　The Sequencer Window

Here's a main Edit window in Pro Tools.

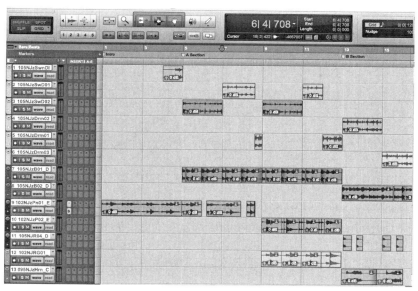

Figure 7–6 A Pro Tools sequencer window or Main window.

7.3 Levels and VU-Meters

In a DAW, the levels are displayed on meters placed alongside the faders of the mixers. There are also small faders in the edit window near the left side of each track. Getting to understand what these meters indicate is very important to control the way the music sounds.

Before examining the mastering steps, let's see the question of measuring the levels of a recording. This is important when recording as well as when mixing and mastering. Digital systems such as DAWs measure the sound levels with peak meters (or PPM, Peak Programme Meters). Peak meters show the instantaneous variations of levels. In a DAW like Pro Tools or Cubase, the scale is graduated up to 0. The units of that scale are called deciBels Full Scale (or dBFS). In a DAW, the levels are often measured in dBFS. The level 0 dBFS means that the audio is clipping: it has no headroom, no way to go beyond that level. This must be avoided at all cost. Never reach 0 dBFS!

Another measure of levels is more adapted to human perception. This is called

101

"Volume Unit", or VU. It is an average of the level variations. It usually is shown on old-fashioned VU-Meters.

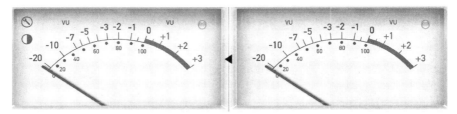

Figure 7 –7　A VU-meter plugin

This scale is very different from that of analog devices, which uses dBVU. The VU-meter is graduated in dBVU units, which is different from the dBFS.

In general, and in most DAWs, 0dBVU = − 18 dBFS. So, a level of 0 dBVU corresponds to − 18 dBFS on a DAW. A 0 dBFS is the threshold of clipping, which is very bad in the digital world. Setting the average level of your tracks at − 18 dbFS will leave plenty of headroom for eventual peaks. It is fine to allow short peaks above − 18 dbFS.

When mixing and mastering on a DAW, aim your average level around − 18 dbFS on the meter. This level will be displayed on the meter placed to the right of the faders. This matches the way we humans perceive sounds and music. That's why VU-meters are preferred by sound engineers and whoever is mixing.

At the mixing stage, it is good practice to create a master fader, which will be used to control the final levels before the mixdown. However, individual channels receiving the other tracks must be set so that they will not reach 0 dBFS. Use the master fader to set the average level displayed on the meter.

The figure below shows three different VU-meters applied to a test signal in Pro Tools. The test generator emits a sinewave at a frequency of 1000 Hz. The meter of the master channel is set − 18dBFS (deciBel full scale), and the Master fader is set at 0. The VU-meters show a level of 0 dBVU. This confirms that the levels controls of Pro Tools are set at 0 dBVU = − 18 dBFS.

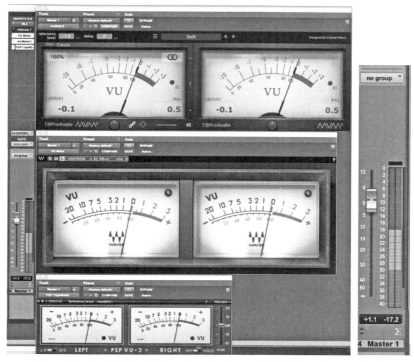

Figure 7 –8 Various VU-meter plugins at 0 dBVU and –18 dBFS

In addition to the level meters which come with you DAW, you can use external plugins. You can download a free VU-Meter as a plugin for your DAW. ①

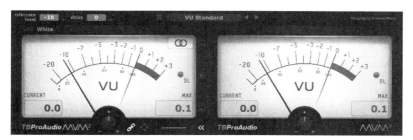

Figure 7 –9 MVMeter2, a free plugin

① MVMeter2 is a free plugin, available from TBProAudio: https://www. tbproaudio. de/ products.

7. 3. 1　Timeline

A DAW can also play MIDI sequences. As we saw, a MIDI sequence is not composed of sounds, but of commands: that is comparable to a musical score, which has notes, silences, signs for the meter or the tempo, and other forms of notation. In fact, many DAWs are able to display MIDI sequences as a score. This is the case with Cubase or with Logic. MIDI can be entered directly into a DAW through a MIDI keyboard or a MIDI instrument. In that case, the MIDI sequence is recorded into a MIDI track of the sequence.

7. 3. 2　MIDI Track

Another way to enter a MIDI sequence is to import a MIDI file, that is a MIDI sequence produced, for example, by another software.

Once a MIDI sequence is in the DAW, it can be displayed with a score editor, and showed in common practice notation.

7. 3. 3　MIDI Score Notation

It can also be displayed as a list of MIDI events: in the parlance of MIDI, note on, note off, program change, continuous controls, etc.

To play the MIDI sequence, a source of sounds is needed. There are several such sources of sounds. One is a software instrument, usually a synthesizer, which is part of the DAW, or offered as a plugin which may or may not be free. Some of those software synthesizers are in fact VST plugins (favored by Cubase and Mixbus), other are AU (Apple Units).

7. 4　Plugins

All modern DAWs, like Cubase, Logic, Pro Tools or MixBus come equipped with a number of plugins. A plugin is simply a piece of software which is independent from the DAW. The DAW is able to use the plugins for a number of operations. These plugins may be intended to create sounds such as synthesizers and sample players. Plugins also exist to process some aspects of the sounds. The three main categories are:

 – Reverberation adds a resonance to a sound;

 – Equalizer has filters for changing the timbre of a sound;

– Compressor changes the dynamic range of a sound, so that the sound does not exceed the volume limit.

All popular DAWs come equipped with plugins. Cubase, Logic, Pro Tools, MixBus all come with a set of plugins. When you purchase or get one of those DAWs, you automatically receive a set of plugins. Being the most popular among musicians who work in home studios, Logic and Cubase have the most extended number of plugins. There are plugins for reverberation, equalizer and compressors: these are the processing plugins. The other category of plugins are the source plugins, otherwise known as synthesizers and sample players: those provide musical sounds.

Logic and Cubase have plugins of instruments like synthesizers and sample players, as well as processing plugins used in mixing, such as reverberation, equalizers and compressors. Pro Tools and MixBus have mostly plugins for mixing (reverberation, equalizers and compressors). In addition to the plugins which come with your DAW, it is possible to purchase plugins from commercial companies. Look on the web for free plugins: you will find them easily.

There are multiple formats for plugins: some formats can be used with your DAW, while others cannot. For example, Pro Tools only works with plugins in a specific format, which is not compatible with other DAWs. Below is a list of various plugin formats and their corresponding DAWs (at the time of writing). We focus on four DAWs: Apple Logic, Avid Pro Tools, Harrison Mixbus and Steinberg Cubase. Other DAWs are also very popular, such as Ableton Live, Digital Performer, Cakewalk, FL Studio, Reaper, Sonar, etc.

A plugin is a piece of software which works with a larger program. For instance, DAWs use plugins for a variety of sound processing: reverberation, equalization, compression, and so on. There are several categories of plugins, and it is important to know which one is compatible with your DAW.

A VST plugin is an external piece of software which is attached to the DAW through a protocol called VST, introduced in 1996 by Steinberg in Cubase ver. 3. 02. VST stands for Virtual Studio Technology. It is the most known interface type for effects and instruments. As of today, VST has evolved into its 3rd version and is commonly referred to as VST3. VST is the most widely implemented format in the industry and is supported by DAWs such as Ableton, Cubase, Sonar and more.

There have been several generations of VST plugins, which are identified by a number: VST1, VST2, VST3. Not all DAWs accept VST plugins. Obviously, Cubase

does. Another popular protocol is AU, which stands for Apple Unit, and, as you may guess, is reserved for Apple computers. The AU plugins use the Apple's proprietary audio technology, part of the Core Audio provided by Mac X OS. It is part of the operating system so it provides low latency and system-level support for the interface. Apple Logic only utilizes Audio Unit format plugins, but other DAWs such as Mixbus or Ableton Live can also use these.

AAX is a unified plugin format which comes in 2 variations: AAX DSP, AAX Native. AAX was introduced as Avid created a 64-bit version of Pro Tools, and this meant that a plugin format with 64-bit processing was required. With AAX, you can share sessions between DSP-accelerated Pro Tools systems and native-based Pro Tools systems and continue using the same plugins. Starting with version 11, Avid Pro Tools (including Pro Tools First) only accepts AAX plugins; as of Pro Tools 11, the AAX plugins are 64 bits. Note that Pro Tools 10 accepted 32 bit AAX plugins.

The RTAS plugin format was implemented in the Pro Tools series by Digi design up to Pro Tools 10. Many plugin manufacturers developed RTAS versions of their plugins for the sake of compatibility with the Pro Tools series of DAWs. RTAS plugins can only be used within Pro Tools (up to version 10 only), because it has been discontinued afterwards.

TDM (Time-division Multiplexing) are Pro Tools plugins which are installed on outboard hardware such as dedicated DSP Processors. TDM Plugins are usually installed in studios equipped with dedicated Avid company hardware, so that the computer does not have to handle the tasks.

Here is a list of the various plugin formats, and the DAWs they work with (at the time of this writing).

Table 7 – 1 List of plugin formats and DAWs

Format	Name	Compatible DAW
AAX	Avid Audio eXtension	Avid Pro Tools (including Pro Tools First) only accepts AAX plugins; AAX plugins of Pro Tools 11 are 64 bit; Pro Tools 10 accepts 32 bit AAX plugins
AU	Apple Unit	Compatible with Logic and Mixbus
RTAS	Real Time Audio Suite	Former Pro Tools format, no longer available since Pro Tools 11

续表

Format	Name	Compatible DAW
VST	Virtual Studio Technology	Developed by Steinberg, compatible with Cubase, Nuendo, Mixbus
VSTi	Virtual Studio Technology Instruments	VST plugin for software instruments (VST instrument plugin)
VSTfx	Virtual Studio Technology Effects	VST plugin for software effects (VST plugins-effects, signal processing)

To insert a plugin in Logic, open the mixer. Select an audio track. The plugins are displayed when you click on a slot in the panel labelled Audio FX. The labels appear to the left of the mixer. When you select a plugin, the site will download an application on your computer. Run it, choose the plugins you want and they will download the installer. Run the installer, and the plugins will be available for your DAW.

There is quite a number of plugins available on the web at no cost. Those free plugins are often surprisingly good, even if they sometimes are not as sophisticated as the commercial ones. Here is a site which provides both free and paying plugins. There are some very interesting free plugins which will be useful both for mixing and mastering as well as for sound design and musical creation. They are provided by Melda Production. ①

Once on the site, here are some plugins for mixing and mastering:

MCharmVerb: a very decent reverberation.

MCompressor: a simple but effective level compressor.

MonvolutionEZ: a convolution reverberation.

MEqualizer: 6 band equalizer.

MLoudnessAnalyzer: based on EBU R128, for controlling the levels in broadcasting situations.

MOscillator: a test generator useful to check levels.

MSpectralPan: very interesting effect of panning spectral regions. The interface resembles that of anequalizer but the output is stereo. Applied on different tracks, it can help separating instruments.

① To access them, go this address: https://www. meldaproduction. com/effects/free.

MStereoExpander: useful to control the stereo field.

MStereoScope: displays the stereo field.

For sound design and electronic music creation, explore those effects.

MComb: a resonating multi-comb filter.

MFlanger: flanging effect.

MFreqShifter: an effective frequency shifter with its own modulating frequency oscillator.

MPhaser: phasing effect.

MRingModulator: a powerful ring modulator. This is a rare effect.

7. 4. 1 Changing the Level: Normalization

If the overall level of the recorded files seems low, apply the Normalize plugin in Protool, or any other DAW which has this function.

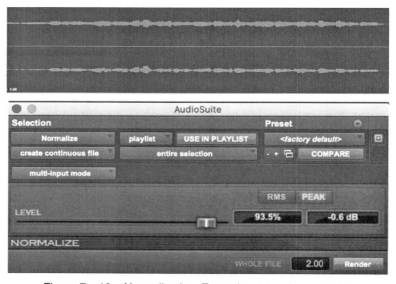

Figure 7 – 10 Normalization. Example: 90% (– 0. 6 dB)

7. 4. 2 Inserting a Virtual Instrument

To insert a source (instrument) plugin in Logic, open the mixer. Select a MIDI track. The plugins are displayed when you click on a slot in the panel labelled Input. The labels appear to the left of the mixer. Below is a possible list of source plugins. There are also instrument and sample player plugins.

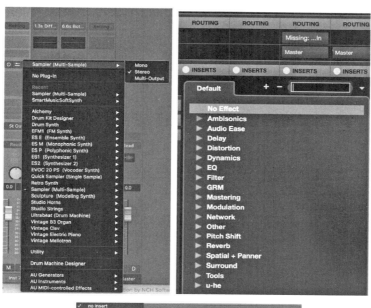

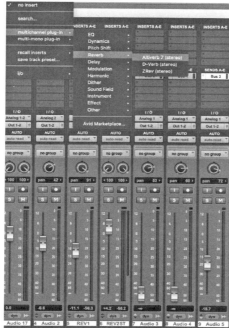

Figure 7 – 11 Scrolling menu of available plugins (Logic, Cubase, Pro Tools)

7.4.3 Cubase

Operating System	Macintosh，Windows
Address	https://www.steinberg.net/cubase
Availability	commercial

7.4.4 Logic

Operating System	Macintosh
Address	Apple App Store
Availability	commercial

7.4.5 Pro Tools

Operating System	Macintosh，Windows
Address	https://www.avid.com/pro-tools
Availability	free and commercial

7.4.6 Harrison MixBus and Mixbus32C

Operating System	Macintosh，Windows
Address	https://harrisonconsoles.com/product/mixbus
Availability	commercial

7.4.7 Reaper

Operating System	Macintosh，Windows，Linux
Address	https://www.reaper.fm
Availability	free and commercial

7. 4. 8　Ableton Live

Operating System	Macintosh, Windows
Address	https://www. ableton. com/en
Availability	commercial

7. 4. 9　MOTU Digital Performer

Operating System	Macintosh, Windows
Address	https://motu. com/en-us/products/software/dp
Availability	commercial

7. 5　MIDI

7. 5. 1　Birth of MIDI

The MIDI standard was designed in 1983 to allow the control of several synthesizers from a single keyboard; messages are transmitted in digital format, according to a well-defined protocol. The principle of MIDI is derived from the instrumental gesture control mode. This term was chosen when MIDI was first created because there was a need to transmit digital information, such as keyboard performance, to analog synthesizers. The MIDI system was designed to do just that: transport and convert performance information such as notes being played, selection of a sound family or electronic instrument, nuances such as forte, piano or crescendo.

What had not been defined, on the other hand, was the success that this standard would quickly gain. It is used today to interconnect various machines of an electronic music studio, and even the light games of stage scene.

It was Dave Smith, then manager of the California company Sequential Circuits, which manufactured very famous analog synthesizers, like the Prophet, who had the idea of a system allowing the exchange of musical information between synthesizers

and keyboards. During 1982, he created the specification for an exchange of data between instruments, the signal representing musical information being digital. He first presented his project at the NAMM show. The NAMM show (International Music Merchants Association) is an international fair of musical instruments which is held every year in January in Los Angeles. There is also an edition in the summer, but not as important.

Despite the reluctance of several manufacturers, its system interested Japanese companies and, in January 1983, a Sequential Circuits keyboard controlled via this system a synthesizer from a Japanese brand: the MIDI standard was born and a first norm was published for the exchange of information between digital musical devices.

The acronym stands for: musical instruments digital interface, which translates to "Digital interface for musical instruments". An interface is a device which ensures the communication between two systems. The word inter means "between", and face is here to signify the aspect, or face, of the system. Hence, the purpose of an interface is to enable the transmission of data between two parts of a computer or a digital system.

It should be noted that the principle of MIDI has not evolved since 1983, even if microcomputing has known great upheavals since its origin. Indeed, the appearance of MIDI was boosted by the introduction of the first PCs and Macintosh computers. Personal computers have changed a lot since then, but the heart of how MIDI works has not changed. Only new functionalities have been added to make its operation more flexible and powerful, and better adapted to the evolution of modern digital tools.

7.5.2 The Structure of MIDI Messages

Handling MIDI messages is now easy and quite transparent. The system is integrated in virtual instruments, digital keyboards, music notation software and DAWs. However, understanding how MIDI works helps managing its limits and its possibilities.

MIDI is able to convey different types of messages between digital devices. A keyboard can be linked to a computer via a USB connection, for instance. Whatever is played on the keyboard is received by a DAW or a notation software as pitches and nuances, so the performance can be recorded and appear as a score.

Musical information in MIDI come in specific forms. For instance, nuances, which correspond to the level of a musical sounds, are not given the conventional

way. MIDI does not understand *mezzo-forte* or *fortissimo*. Instead, levels are given on a scale of 128 values. By the same token, pitches are not indicated as *do*, *re*, *mi* or C, D, E, not even in frequencies in Hertz. There are expressed on a scale which is also composed of 128 values. You may have also noticed that the selection of the different instruments and samples in a MIDI environment, what is called a Program Change, has 128 values.

The number 128 was chosen because it corresponds to a mode of storage of digital data. More precisely, a computer memory word whose length is 7 bits is able to store numbers from 0 to 127, hence 128 integer numbers. Let's see a bit more closely how that works.

First, it is useful to look at the way data is stored in a computer or any digital system. All information, such as text or sounds, is represented by numbers. We have seen that above in the chapter 6. Those number are gathered in units called "words". Those words are composed of a series of bits. Having several bits in word enables the representation of numbers. All information in the digital world are numbers. A computer does not understand anything else. Digital sounds are long strings of numbers.

To understand how that works, let's consider how we represent numbers.

0	0	1
1	1	
2	10	2
3	11	
4	100	3
5	101	
6	110	
7	111	
8	1000	4
9	1001	
10	1010	
11	1011	
12	1100	
13	1101	
14	1110	
15	1111	
16	10000	5
...
127	01111111	7
128	10000000	8
...
255	11111111	8

Figure 7 – 12 Table of binary digits

MIDI transfers messages between digital devices, as was mentioned above. MIDI data, or MIDI information, is broken up in a chain of "words". These have 10 bits. Two bits are only used to ensure the quality of the transmission. This leaves 8 bits, which is called a "byte". The leftmost bit, called MSB, for Most Significant Bit, is used to inform MIDI of the type of message being sent. This leaves 7 bits for the data.

7.5.3 MIDI Message

A MIDI message is usually made of several consecutive bytes, each byte being a group of 8 bits.

7.5.4 Note ON Group of 3 Bytes

When a note is sent by MIDI, for instance from a MIDI keyboard, there are three consecutive bytes; together, they constitute a MIDI Note ON message.

The three bytes are:

Byte 1: contains the channel number. This information is coded in 4 bits. The first bit (the most significant bit) is set 1 the value "1", indicating this is the first byte of a message. The 3 next bits show that this message is Note ON.

Byte 2: this contains the pitch. It is coded on 7 bits, which permits 128 different values. The first bit is set at 0, indicating it is a continuing byte.

Byte 3: this conveys the "velocity", i.e., the amplitude of the note. It is coded on 7 bits, hence 128 values of velocity are possible.

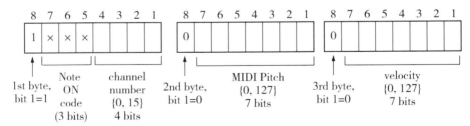

Figure 7 – 13 MIDI Note ON message

To stop the note from playing, a Note OFF is generated when, for instance, the key of a MIDI keyboard is released, or a DAW send that message.

It takes about 1 millisecond to transport a Note ON MIDI message. Those messages are consecutive, or serial, which means that a chord consisting of 10 notes

will take about 10 milliseconds. While this may seem short, other factors will delay the transportation of the message: the time for the emitting device to prepare the message, and the same for the receiving device. In addition, when the note being sent is released or stopped, another 3 byte message must be sent, a Note OFF message, which carries the same types of information (channel, pitch and velocity which, in this case, is set a 0).

Conventional representation of a sequencer: the computer sends MIDI messages to a synthesizer or a sampler.

Today, most operations are embedded in the computer, but MIDI is still used.

Each information (pitch, nuance, instrument...) is coded.

There are 128 pitches (semitones), numbered from 1 to 128.

There are 128 nuances, numbered from 1 to 128.

There are 128 instrument numbers, from 1 to 128; However, a larger number of instruments can be transmitted (banks of instruments, such as: orchestra bank, percussion bank, ethnic bank, and so on).

Due to the principle of data coding, it was not possible to represent more than 128 instruments. It might have seemed generous in the early years, but very quickly the notion of instrument also applied to samples and these were not limited to orchestral instruments, but also to non-European instruments as well as sound effects. Likewise, the MIDI protocol provided that the number of voices belonging to different instruments was limited to 16. Even if each voice could be polyphonic, the notion of polytimbrality was thus contained in this number. It was necessary to invent programming tricks to circumvent these constraints, due to the principle of digital representation of the initial definition of MIDI.

Despite these problems, the advent of MIDI, coupled with the rapid development of the micro-computer during the eighties, made it possible to create personal studios, also called, in English, home studios, to emerge. On this new practice of computer electroacoustic music, the software industry also experienced dizzying growth, which took over from the first developments which had appeared in music research centers, such as the CCRMA at Stanford, MIT, the GRM or IRCAM.

These are the sequencers that emerged in 1985. Originally, they allowed to represent a musical score. Very quickly, in the early nineties, it extended to sound files. Thus, they combined MIDI data and sounds prepared in advance. Musicians were very quickly interested in using sequencers in music. The General MIDI standard

was released.

A list of instruments names has been selected at the end of the 1980s. The list fits the 128 different "programs" which contain names of sounds. Named "General MIDI", it is a fixed classification. For instance, Instrument number 1 is always a grand piano, while number 2 is "Bright acoustic piano" and so on. Note that each manufacturer is able to choose the samples for each instrument. Hence, General MIDI implementation may differ in the way the instruments sound, but these are generally slight differences.

While General MIDI is rather universal and is encounter in many software, it is usually preferable to select libraries of samples, which offer better quality in sound reproduction.

Among the 128 instruments, there is most of the Western orchestra, some Japanese traditional instruments (albeit no Chinese ones, General MIDI having been invented in Japan), and some sound effects.

A second classification is composed of 47 percussion instruments. This is reserved for MIDI channel 10, which is devoted to drums and percussions.

The appendix of the book gives the list of General MIDI instruments.

8

Mixing, Mastering, Imaging

8.1 The Types of Signals

In a mixing console as well as in a DAW, there are several types of signals. You can think of:

- Audio signals (sounds), such as samples, for instance.
- MIDI signals, for example, Sibelius plays its scores through MIDI.
- Instrument, meaning software plugins creating or playing sounds.

For example, the music in Sibelius is indeed represented as MIDI data, but Sibelius can use actual sounds, such as samples. In this instance, the MIDI notes of the score are sent to a player, which, in turn, uses actual sounds (Samples) to play the notes sent by MIDI.

The MIDI notes can also be sent to an external device, such as a synthesizer or a sampler, but this is rarely used these days. MIDI notes can be received from an external MIDI control keyboard.

In general, you'll find in a DAW these types of channels.

- Audio channel: soundfiles loaded from your disk, played or mixed with other audio signals.
- Instrument: often, DAWs have instruments (like HALion Sonic SE in Cubase).
- MIDI: MIDI signals convey commands. They do not convey audio.
- Master: this collects the audio channels and mix them in stereo.
- Aux, Insert, Group, Bus: these are special types of channels which we will see. Beware that the names of those channels may vary, but their functions are always present.

8.2 The Mixer

To do a mix, you need to access the mixing console, or "mixer" of the DAW.

In Cubase, to show the mixer, click on Studio → MixConsole. The Cubase mixer is displayed.

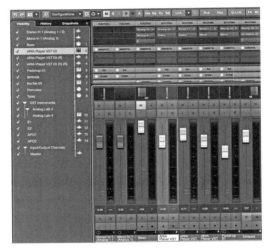

Figure 8 –1　A Cubase mixer window

In Logic, there are two ways of opening the mixer. The first is to select Window → Open mixer. The mixer is displayed in a separate panel which is freely movable anywhere.

The second method is to choose View → Show mixer. The mixer is placed below the main window (the sequencer window). Either way, the Logic mixer window is displayed.

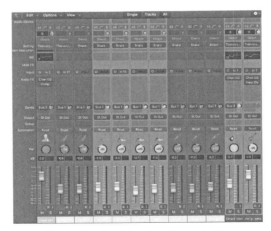

Figure 8 –2　A Logic mixer window

In Pro Tools, the mixer is easily accessible through the command Window → Mix.

8. 2. 1 Other Windows of a DAW

We have seen the main window (the sequence), and the mixer. A modern DAW offers other types of windows, so that you can compose and edit your music with a variety of tools. You will find:

Score: representation of MIDI tracks in common musical notation. Audio tracks cannot be represented as scores.

Piano Roll: see the score not as notes but as graphical symbols. Note that audio tracks can be represented as piano rolls, albeit the representation can be confusing.

Event list: displays all the MIDI notes and commands as a list, which you can edit and modify.

8. 2. 2 Piano Roll

The Piano Roll displays the MIDI events: notes, continuous controls, and various MIDI settings. You can edit and modify the list, which is a very precise way of adjusting the MIDI notes and commands.

The MIDI notes are displayed as musical names of notes, followed by the octave: C3, C#3, D3.

The time is expressed in measures and beats. The beginning and the end of the notes appear in two columns. Note that because MIDI was conceived as a live, real-time system, the exact duration of the notes (in seconds) does not appear.

In Logic, simply select Window → Open Piano Roll.

The Cubase piano roll window is quite similar in its layout and features.

Pro Tools uses a different terminology and calls this a MIDI editor. To open it, select Window → MIDI Editor. The Pro Tools piano roll is displayed.

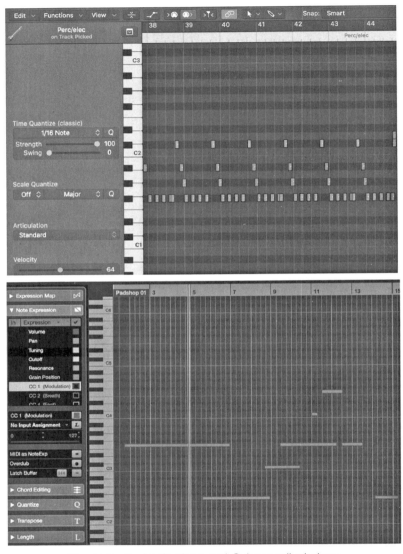

Figure 8 – 3　Logic piano and Cubase roll windows

8.2.3　Event List

The Event List displays the MIDI events: notes, continuous controls, and various MIDI settings. You can edit and modify the list, which is a very precise way of adjusting the MIDI notes and commands.

Figure 8 – 4　A Logic event list

The MIDI notes are displayed as musical names of notes, followed by the octave: C3, C#3, D3.

The time is expressed in measures and beats. The beginning and the end of the notes appear in two columns. Note that because MIDI was conceived as a live, real-time system, the exact duration of the notes (in seconds) does not appear. The duration of an event such as a note is computer as the difference between its activation (Note On) and its end (Note Off). This may be expressed not in seconds but as subdivisions of a beat. The beat itself depends on the tempo of the score or the passage, and the time signature. This is why editing an event list may sometimes be delicate.

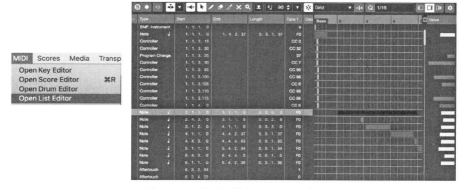

Figure 8 – 5　A Cubase event list

The Cubase Event List is displayed. It shows the type of event: note, instrument (program Change), controller, aftertouch... It also shows the beginning and end of the note as well as the length, in measure and beats. It also shows the notes as a piano roll notation, and finally the level appears to the right. You can edit most of these data.

8.2.4　Imaging

Imaging is creating a sort of sound "image". Think of how a painter arranges objects on a canvas.

See how some features are on the forefront, while others seem far away. The perspective is composed of fore ground, middleground and background. Yet, it's all painted on a flat surface, a two-dimensional space. Combining the elements in a realistic perspective create the impression of depth. The landscape seems to be in three dimensions.

In music, this is imaging which help achieve this effect.

Imaging consists of placing the sounds in a mix anywhere from left, center and right. To achieve this, the PAN control is used, and it can be automated.

The other dimension of imaging is the depth. This is where a track can be placed on the forefront or further back. The tools used to create depth are reverberation and low-pass filter. A sound in the background, that is, giving the impression it is further from the listener, as somewhat more reverberation. Also, its spectrum has fewer high partials. For that, a low-pass filter is used. Finally, its level may be weaker, but that is not necessarily so.

9

Csound and Models of Synthesis

9. 1 Structure of Synthesis Programs

The synthesis programs are split into two very distinct parts. One part is responsible for calculating the samples, according to a choice of oscillator and processing modules. The assembly of modules is also known, depending on the program, under the name of instrument, orchestra or patch.

A second part is used to store and transmit to the instrument the values defining the sound events: this is the score. Because of the type of computer processing carried out by the program, and which consists in generating a series of elementary instructions in exchange for the data which are provided by the musician, this class of program is called acoustic compilers.

An instrument consists of an assembly of functions, known under the name of "modules", in reference to the analog synthesizers born in the sixties, which offered to the musician a choice of elementary devices of synthesis and processing, such as oscillators, generators, noise, different types of fixed or variable cutoff frequency filters, ring modulators, frequency shifters, envelope generators, variable gain amplifiers, etc. In analog synthesis, these modules are assembled by audio links or by control voltage connections, in order to produce a complex instrument. When it is a digital system which is responsible for producing the signal, the approach is most often of the same type: an instrument is assembled from functions of synthesis or processing of samples. Note that this is the Max Mathews program; MUSIC Ⅲ, designed in 1960, which introduced this principle, with functions then called Unit generators. There are programs for defining the configuration of modules; some are structured like real languages, allowing to incorporate calculation algorithms on the samples which cross the instruments, such as several versions of the MUSIC Ⅳ program.

The simplest instrument only consists of two modules: an oscillator, which reads

a sinusoidal wavetable, and an output module, here connected to a symbolic speaker, but which in reality is responsible for conveying the produced samples to the sound file or the converter.

The modules are divided into several categories. The main categories are: sound synthesis, and sound processing (effects). There is other, like the generation of random numbers.

Note that a module has several names, used at different times. For instance, in the early days, they were called Unit generators. The term "opcode" is used in Csound and designates the name of a specific module. In other programs, such as Max/MSP, a module is called an "object".

Do not let the diverse vocabulary fool you. In each case, we are talking about what the computer science calls a "function": a bit of software which receives data and, in exchange, produces a result, which is also a data. For instance, an oscillator receives a frequency (the pitch), an amplitude (the level—in most cases), and a waveshape. It may also receive a phase. The output is a signal which, in turn, is sent, or "patched" to another module.

The program Csound is a survivor of the long series of MUSIC programs, which first started in 1957. A researcher at the Bell Telephone Laboratories near New York, Max Mathews, invented a method to have a computer calculate a waveform which then could be converted to sound. It is this method which is widely used even today.

After the first appearance of his program, which was more a scientific experiment than a music software, he saw the interest of musicians to be able to compute musical sounds. Although in those days computers were rare and generally not available for musicians, Mathews added new features and soon his programs became able to create interesting and novel types of sounds. This happened in 1960 with the program MUSIC Ⅲ.

Csound was written in 1985. Barry Vercoe, the author of the software, had previously adapted a version of Max Mathews's MUSIC Ⅳ program for an IBM 360 computer at Princeton University in 1968. In 1973, as he was assistant professor at the Masschusetts Institute of Technology (MIT), he wrote a version of his program, much developed, for a DIGITAL PDP-11 computer. He called it Music 11. It is in this version that he introduced the notion of control rate, denoted by the letter "k" placed in front of the names of variables. It is this version which he rewrote in the C language during a residence at IRCAM in Paris in 1985. He named that program Csound, and

it has been widely used ever since.

9. 2 Overview of Csound

Csound is a software for creating complex and interesting sounds. It does not replace your usual DAW, such as Cubase or Logic or others, but it can generate sounds which other programs are unable to do with the same precision or qualities. In that, Csound is a tool which comes an addition to those available for the modern composer in a computer music studio. You will use Csound for creating sounds which will be imported into a DAW (Pro Tools, Logic or Cubase) before being mixed to create a complete composition.

One way to use Csound is to compose a piece for electronic sounds and instruments: the electronic sounds will be played while the instrument is performed. This is called "Mixed music". Another way is to compose a piece entirely for electronic sounds, played on loudspeakers. This is called "Acousmatic music".

9. 2. 1 Installing Csound

To install Csound, this link will provide the necessary software. Note that Csound is installed in the background and does not appear in your application folder. This web site csound. com is a gateway to current Csound software and documentation.

```
https://csound.com/download.html
```

To use Csound, you must install a "frontend" program, which offers the user interface to access the program. Install CsoundQT: this is a frontend interface to run Csound.

```
https://github.com/CsoundQt/CsoundQt/releases
http://csoundqt.github.io/pages/install.html
```

The link gives access to multiple resources, such as the reference manual.

```
https://csound.com/download.html
```

9. 2. 2 Csound Useful Links

List of opcodes:

```
https://csound.com/docs/manual/index.html
```

List of GEN functions GEN：

```
http://www.csounds.com/manual/html/ScoreGenRef.html
```

9. 2. 3　CSD Files

In the modern frontend of Csound，instruments，functions，and scores are combined in one file.

The file extension is "．csd".

CSD files are similar to XML files（files containing content and markup）．At the time of writing，as mentioned above，the most common frontend program is CsoundQT.

Here is the structure of a CSD file.

```
<CsoundSynthesizer>
<CsOptions>
-odac
</CsOptions>
<CsInstruments>
sr=44100
ksmps=64
nchnls=2
0dbfs=1
        *** INSTRUMENT GOES HERE
</CsInstruments>
<CsScore>
        *** SCORE GOES HERE
</CsScore>
</CsoundSynthesizer>
```

9. 2. 4　The Csound Syntax

A Csound session is composed of several parts. We will see the different sections of a Csound file.

9. 2. 5　Header

This is where general settings are specified：sampling rate，control rate，channels...This information is essential，but usually it is enough to copy it from

previous scores. Simply decide if your output is mono or stereo.

9. 2. 6　Instrument

An instrument is composed of several opcodes (or "modules"). The output of the opcode handling audio signals starts with the letter "a" (as in "audio"). The output of the opcode handling controls, similar to control voltages in an analog synth, starts with the letter "k". The output (an audio file) is sent to the opcode "out".

9. 2. 7　Opcode

This term designates a module (synthesis or processing). It used to be called a Unit generator. Today, Csound offers several hundreds of opcodes, but fear not: only a handful are commonly used.

9. 2. 8　Function Definitions: GEN Definitions

This is where waveshapes and envelopes are defined. The definition of an envelope is made by breakpoint functions, that of waveshapes is done by relative amplitude of the harmonics (between 0 and 1). In most cases, a function is a table (a zone of the computer memory containing a list of values). A function stores a waveshape, such as a sinewave or a triangle wave or an envelope. Each type of function has a specific number. ①

The GEN function contains the definition of the frequency spectrum or envelope shape, amongst other things. Some opcodes, such as oscillators and envelope opcodes, will read the GEN function and use them. There are many different types of GEN functions. Each type has a specific number. In this example, GEN 10 is used. With GEN 10, you can define the spectrum of a harmonic component, starting from harmonic 1. Each harmonic receives an amplitude value between 0 and 1 {0, 1}.

The function in the example looks like this:

Function 1: this is the name of this particular function, so it is f1. The name is freely chosen. It starts at time 0. This is usually the case, but f1 can be redefined later with a different start time.

4096 is the length of the table (memory area in the computer) containing the

① For the definition of opcode, see: https://csound. com/docs/manual/index. html.

frequency spectrum. The length of the table is usually a power of two. 4096 is a useful value.

10 is the function type, allowing the spectrum defined by continuous harmonics. It can have any number of harmonics, always starting from harmonic 1.

```
f 1 0 4096 10 0 0 0 0 .1 .2 .3 .4 .5 .7 .65 .6 .55...
```

9.2.9 Tag

Tags define certain areas of a Csound file, such as: header, instrument, score. Each area is embedded in a begin tag and an end tag. A begin tag is written as: <tag>. An end tag is written as: </tag>. For instance, all Csound files start with the tag <CsoundSynthesizer>, and the last tag of the file is </CsoundSynthesizer>.

Options are embedded by <CsOptions> and </CsOptions>.

Instruments are embedded by <CsInstruments> and </CsInstruments>. Then there can be several instruments within these tags.

```
instr 1...endin
```

Scores are embedded by <CsScore> and </CsScore>

9.2.10 Instruction

The name "instruction" is used in Csound for the lines which have some sort of operation: an oscillator, a filter, an envelope, each is defined by an instruction. Two examples of Csound instructions:

```
ifreq = p6
asig oscil 1, 440, 0
```

9.2.11 Variable

Csound's instrument makes a distinction between audio signals (preceded by the letter "a"), signals which vary at the sampling rate, prefixed by the "a", control signals (with the letter "k"), and variable whose content do not vary during a whole note, for instance for the duration of the note; These start with the letter "i".

The audio signals are evaluated according to the sampling rate (here, 44100 times for one second of sound), while the control signals are only evaluated according to the selected control rate (kr), that is here 500 times per second. This principle of

double calculation rate partly explains the gain in speed of calculation of Csound compared to other synthesis programs.

A variable receives a value (a number, a name). In Csound, a variable can be like a cable in a synthesizer: it receives data, like an audio signal. Variables in Csound are used to receive data, and then give the data to an opcode. It serves a link between different steps of the Csound operation. A variable is like a box: it receives the output of an opcode.

Note that the contents of the variable can be fixed for the whole duration of a note, or canvary: this is the case when the variable receives the output of an oscillator

Csound variables always start with one these letters: { a, i, k...}. To understand this, look at the header of a Csound file.

```
< CsInstruments >
sr = 44100          ; sampling rate
kr = 4410           ; control rate
ksmps = 10          ; should be sr /kr
```

The letter a is reserved for variables whose contents change at the audio rate. For instance, the output of an oscillator is sent to a variable whose name starts with an a, such as asig. This means the variable will receive data changing at the audio rate, such as 44100 times per second. This is the sampling rate and its value is specified in the header: sr = 44100.

The letter k is used for variable whose contents vary more slowly: they change at the k-rate, which is the control rate. This value is indicated in the header. In the example above, kr = 4410. This value is ten times slower than the sampling rate.

The letteri indicates that the variable is set for the whole duration of a note. The letter i is also used in the Csound score, at the very beginning of a note and is always followed by the instrument number.

9. 2. 12 Real Time Output

```
< CsoundSynthesizer >
< CsOptions >
– odac
< /CsOptions >
< CsInstruments >
```

Odac means: output to DAC (in real time): the result sound is sent to the chosen output of your computer.

If "-odac" is omitted, Csound will create an audio file called test. aif.

9. 2. 13　Render and Output Sounds

Use the fout opcode to produce a soundfile.

```
Fout "outputfilename.wav" 8  asig
```

9. 2. 14　Structure of the Score

The traditional partition of a synthetic language is presented in the form of a list of groups of values. Each group contains the values requested by the different modules of the instrument.

A score is a list of events. An "event" is a more general term for a musical note. Each event has a number of values which are read and executed by the instrument. It is a list of values, divided into P-fields. P-field 1 is the instrument number. P-field 2 is the attack time ("action or activation time"). P-field 3 is the duration of the note in seconds.

The score is arranged in consecutive lines. Each line represents an event.

A note is divided in consecutive "fields": these are values which are read by the instrument. For that, the values are placed in a specific field. When the first programs were conceived in the 1960s, the values were encoded on punched cards.

The instrument looks at each line to find arguments in the consecutive fields:

P1 (field 1) is the instrument number.

P2 is the "action time", that is the beginning time of the event. It is given in seconds.

P3 is the duration of event, that is the duration of the note. It is given in seconds.

P4 to Pn are freely chosen but must correspond to what the opcodes are expecting.

One event line usually contains all the P-fields expected by the various opcodes of the instruments. The name P-field (or Parameter field) came from the old method of providing data to the computer through punched cards. The data was encoded on columns of the punched card, hence the name "field". Here is an old punched card.

Figure 9 – 1 Old punched card with P-fields

Ex :

```
< CsScore >       ; tag indicating the start of the score
   i10 0 60       ; event played on instrument 10 starts at 0 " and
lasts 60 "
   s              ; end of section ( if any )
   e              ; end of score
< /CsScore >      ; tag closing the score
```

Here is the example of an actual Csound note :

$$;1\ \ 2\ \ 3\ \ 4\ \ 5\ \ \ \ 6\ \ 7\ \ 8\ 9$$
$$i\ 10\ 0\ 60\ 49\ 2100\ .03\ .5\ \ 1\ \ 1$$

Figure 9 – 2 Example of a Csound note (event list)

9. 2. 15 Settings of CsoundQT

If you are using CsoundQT as a frontend interface when running Csound, you can change the settings to better suits your needs. On the CsoundQT top menu, click on Configuration tag. It should the seventh tag from the left.

Figure 9 – 3 Top menu of CsoundQT

131

9. 2. 16　Let's Build a Simple Instrument

Let's build a simple instrument with: 1 oscillator and 1 amplitude envelope.

The oscillator will be a poscil opcode, a precision oscillator. The envelope will be a linen opcode.

The linen opcode provides the envelope: this is the variation of amplitude. When the sound starts, the amplitude is at zero: the sound emerges from silence. As the envelope grows, if the sound is to be heard, the level will become louder: this is the result of the envelope, which progressively reaches its maximum. The maximum level is that called "amplitude". So, the amplitude is the level to be reached. In musical terms, one can think of a nuance like *mezzo-piano* or *fortissimo*.

In the illustration below, there is, to the left, a linen opcode which provides the envelope. To the right, the oscillator generates a wave, and its amplitude is 1: it needs to be scaled to a proper level, and this is the function of the linen.

In this diagram, the output of the envelope from the linen opcode and the audio signal from the oscillator are multiplied.

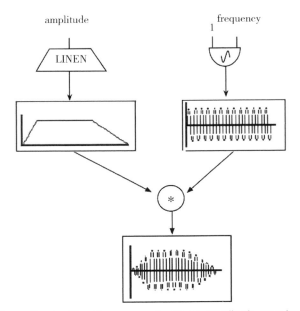

Figure 9 –4　Creating a sound with an amplitude envelope

With Csound, there is no need to have this multiplication of the envelope by the

audio signal: on the drawing of the patch below, the linen is directly connected to the left inlet of the oscillator.

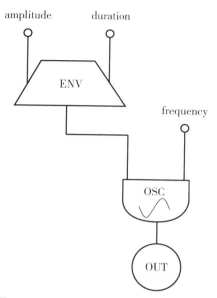

Figure 9 −5 Simple Csound instrument

9. 2. 17 Representation of an Instrument Patch

To help design an instrument and control all the operations involved in producing musical sounds, it is most useful to be able to draw a representation of the instrument you are creating. In this book, I use schematics of instrument patches. Those drawings are a great way to visualize the modules gathered in the patch: the various oscillators, the envelopes, the operators such as addition or multiplication of signals, etc.

In order to learn how to draw an instrument patch, look at the following illustrations. They show a sequence of operations to draw a patch. The example is based on the patch shown above, a simple instrument with one oscillator and one envelope.

1) Draw an oscillator, as a half circle. On top, to the right, is the frequency inlet, and to the left, an inlet which receives a value which will multiply the amplitude of the wave computer by the oscillator. This is why the left input is called the amplitude inlet.

2）Place the envelope, which, here, is a linen opcode. The linen opcode receives four arguments: the maximum amplitude reached by the envelope, then three arguments measured in seconds: the attack time, or rise segment, which starts at zero and reaches the amplitude level; The duration, which, usually, comes from the 3ʳᵈ argument of the score, called P3, and the release, or decay, or final segment, where the envelope goes back to zero. However, in the drawing, we'll omit the duration, because it is most often that of the note, which is given by P3.

3）We can start creating the links between the modules by drawing lines.

4）Here, we draw the frequency inlet of the oscillator.

5）Let's not forget the output.

6）Here, we add the names of the variables which are feeding the inlets.

7）Finally, we add the P-fields, which are the location in the score which contain the values given to the variables.

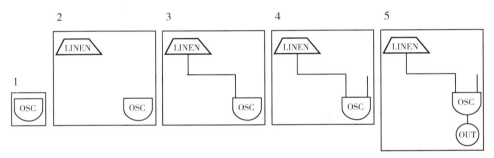

Figure 9 −6 First steps of drawing an instrument patch

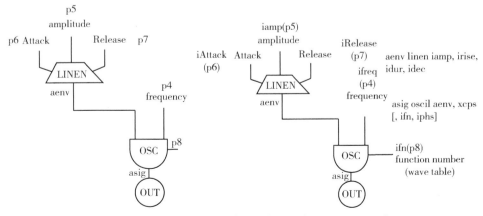

Figure 9 −7 Last steps of drawing an instrument patch

Here is the complete code of this instrument.

```
<CsoundSynthesizer>
<CsOptions>
-odac                    ; realtime output
</CsOptions>
<CsInstruments>
sr = 44100         ; sampling rate
ksmps = 64         ; control rate
nchnls = 1         ; mono (1 channel)
0dbfs = 1          ; amplitude between 0 and 1
instr 1
idur      = p3
ifreq     = p4
iamp      = p5
iAttack   = p6
iRelease  = p7
ifn       = p8
aenv      linen        iamp, iAttack, idur, iRelease
asig      poscil       aenv, ifreq, ifn
out       asig
endin

</CsInstruments>
<CsScore>
; 1: a sine wave
; 2: spectrum with harmonics
; 3: playback of an external soundfile

f 1 0 4096 10 1
f 2 0 4096 10 .5 .5 .5 .4 .3 .2 .1
f 3 0 131072 1 "isthatyou.aiff" 0 0 0
; caution: the audio file must be in the same folder
; the size of the table must be a power of 2
;p1      p2      p3      p4      p5      p6      p7      p8
i 1      0       2       110     1       .1      1       1      ; uses function 1
i 1      1.6     2       98      .5      .001    1       2      ; uses function 2
i 1      3.1     1       .7      1       .001    .01     3      ; uses function 3
</CsScore>
</CsoundSynthesizer>
```

9. 3 Additive Synthesis

The method called Additive synthesis uses a number of oscillators. Each one is producing a single partial or harmonic (also called a " component ") in a complex spectrum.

The diagram below shows a bank of oscillators. Each one receives a frequency (labelled f_n) and an amplitude (labelled a_n). While this instrument may not give interesting musical results, it shows the basic setup of additive synthesis.

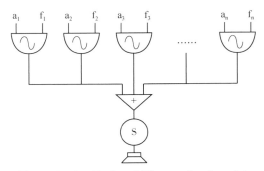

Figure 9 −8　Basic additive synthesis patch

This rudimentary instrument lacks a device for varying amplitudes over time. This is what the patch below does. Each oscillator receives its own amplitude envelope. In this way, there is independence of the components with regards to their amplitude profile and their duration, and even, by adjusting the shape of the amplitude envelope, of their instant of attack and of their duration of the release. It would be necessary to add to this instrument other controls, such as vibrato, for example.

If additive synthesis is a very general method, which gives a perfect independence of the components, it is clear that a large number of control modules are needed to give life to the sound produced. This poses problems of the time it takes to specify all the necessary values.

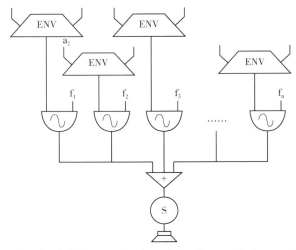

Figure 9 −9　Additive synthesis patch with amplitude envelopes

9. 3. 1 A Musical Example Using Csound

In this example, we will use an instrument created by French composer and researcher Jean-Claude Risset, and used by German composer Karlheinz Stockhausen in his 1984 piece, *Kathinka's Gesang*. It is an instrument of additive synthesis. The sound is based on one frequency (one pitch). A number of additional oscillators are set to a very close frequency. The interval between the frequencies is set in a variable called delta (or idelta in Csound), where delta is the interval measured in Hertz. Then all the oscillators are added together.

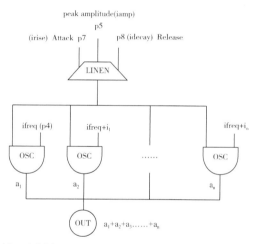

Figure 9 – 10 Additive synthesis instrument—Creating pitch beatings

In Csound, the spectrum used in this instrument is defined as an amplitude value. The amplitude of each harmonic is given by a number between 0 and 1. It starts at harmonic 1 (the fundamental). Here is the example:

```
</CsInstruments>
<CsScore>
f1 0 4096 10 1 0 0 0 .1 .2 .3 .4 .5 .7 .65 .6 .55 .5 .45 .4 .35 .2 .1.5 .1 .07 .05
```

The chart below shows a graphic representation of this spectrum.

All the harmonics of a sound are called a spectrum. Below is the spectrum of a low *do*. When we play this note, for instance on the piano, all those harmonics are contained in what we hear. Only, we hear a *do*, because our brain fuses all those harmonics into a single sound.

137

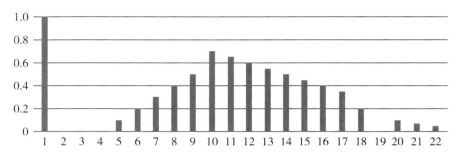

Figure 9 – 11　List of harmonics（from h1 to h22）and their values

Here is the Csound instrument of additive synthesis.

```
instr 10
iduration = p3        ; duration of the note
ifreq     = p4        ; frequency in Hertz
iamp      = p5        ; max = 32767
idelta    = p6        ; frequency interval
iAttack   = p7        ; duration of the attack portion in seconds
iRelease  = p8        ; duration of the release portion in seconds
iwf       = p9        ; function number (wavetable)

i1 = idelta
i2 = 2*idelta
i3 = 3*idelta
i4 = 4*idelta
i5 = 5*idelta
i6 = 6*idelta
i7 = 7*idelta
i8 = 8*idelta
aenv      linen iamp, iAttack, iduration, iRelease
a1        oscili aenv, ifreq, iwf
a2        oscili aenv, ifreq+i1, iwf
a3        oscili aenv, ifreq-i1, iwf
a4        oscili aenv, ifreq+i1, iwf
a5        oscili aenv, ifreq-i2, iwf
a6        oscili aenv, ifreq+i3, iwf
a7        oscili aenv, ifreq-i3, iwf
a8        oscili aenv, ifreq+i4, iwf
a9        oscili aenv, ifreq-i4, iwf
a10       oscili aenv, ifreq+i5, iwf
a11       oscili aenv, ifreq-i5, iwf
a12       oscili aenv, ifreq+i6, iwf
a13       oscili aenv, ifreq-i6, iwf
a14       oscili aenv, ifreq+i7, iwf
a15       oscili aenv, ifreq-i7, iwf
a16       oscili aenv, ifreq+i8, iwf
a17       oscili aenv, ifreq-i8, iwf
out       a1+a2+a3+a4+a5+a6+a7+a8+a9+a10+a11+a12+a13+a14+a15+a16+a17
endin
</CsInstruments>
<CsScore>

f 1 0 4096 10 1 0 0 0 .1 .2 .3 .4 .5 .7 .65 .6 .55 .5 .45 .4 .35 .2 .1 .5 .1 .07 .05
;1    2 3      4       5        6        7        8 9
i 10 0 60      55      800      .03      .5       1 1
e
```

The synthesis of this Csound score will give a sound with cyclic beatings. Its frequency analysis looks like this.

Figure 9 – 12 Spectrogram of the additive synthesis instrument with
a frequency of 49 Hz

Let us consider the Additive synthesis instrument presented above: in that instrument, a number of oscillators are played together. The frequency of each one is slightly above or below the main frequency. The interval between the frequencies is a multiple of a very small value measured in Hertz. In our example, it is called delta. The delta was 0.03 Hz, a very small value. The choice of the value was made in this way. At the beginning of the note, all the oscillators start together: the phases of the waves are aligned. Because their frequencies are very slightly different, they begin shifting: there is a phase shift and this is heard as beats. After a while, all the periods become aligned again.

The time between those two moments can be measured. In the example, the phase shift lasts 33 seconds. To find the value of the delta is easy. It is 1/33, which is 0.03. The delta is thus 0.03 Hz.

In this Additive synthesis example, the delta was a fixed value; The instrument created an interesting sound with internal and cyclic variations. With a delta of 0.03, all the oscillators will come back "in phase" after 33 seconds. The beatings we hear are thus cyclic, and choosing the duration of the whole phase-shift cycle is easy.

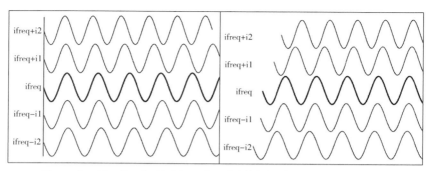

Figure 9 – 13 Begin (left) and end (right) of a full beating cycle

9. 3. 2 Exercise

The purpose of this problem is to create a variable delta. It will start at 0, reach the maximum value, which is delta, and then decrease to 0 during the duration of the note.

For this, delta must be controlled by an envelope, such as the linen opcode. In this case, the amplitude given to the opcode will be the value of delta. In this way, the linen will produce an envelope that reaches the peak delta at the end of the attack time, and then drops for the duration of the release time.

Copy the Additive synthesis Csound file and modify the copy to include a variable delta.

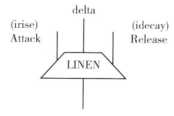

Figure 9 – 14 Envelope for a variable delta

Here is an FFT image of this effect. It shows a slow beating which increases, and, when it reaches the value of delta, it decreases. The solution is given below. Experiment with different values. Sometimes, it may be useful to have a fairly large value of the delta.

Figure 9 – 15 Representation of a delta increasing and decreasing (analysis with Wavepad)

Figure 9 – 16 Representation of a delta increasing and decreasing (analysis with Audacity)

Here is a possible solution to the problem. In any case, the variable containing delta cannot remain an i-variable, that is a variable whose name starts with an i, denoting a fixed value during the duration of the note. This is because it will not receive the output of a linen envelope. In this solution, the variable containing delta is now an a-variable, whose content change constantly.

The linen generates an envelope which starts at zero, rises to its maximum, which is the value of the delta, and then decreases back to zero. Hence, the delta will increase from zero, reach its top value, and then go back to zero.

Once this is established, oscillators 2 to n will add the frequency (P4) to the variable delta, as shown in this patch. When the note starts, there is no beating, and then the beating increases, then decreases towards the end of the note.

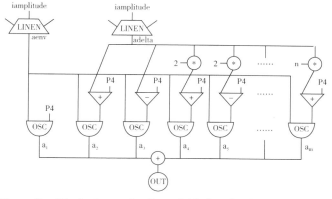

Figure 9 – 17 Instrument with variable beating interval (delta)

```
instr 10
idur       =        p3
; p4 = freq
iamp       =        p5            ; max = 32767
ideltaf    =        p6            ; interval
irise      =        p7            ; attack duration of the amplitude envelope
idecay     =        p8            ; release duration of the amplitude envelope
iwf        =        p9            ; function number
iriseDLT   =        p10           ; attack duration of the delta envelope
idecayDLT  =        p11           ; release duration of the delta envelope

aenv    linen iamp, irise, idur, idecay
adeltalinen   ideltaf, iriseDLT, idur, idecayDLT

a1         oscili aenv, p4, iwf
a2         oscili aenv, p4+adelta, iwf
a3         oscili aenv, p4-adelta, iwf
a4         oscili aenv, p4+(adelta*2), iwf
a5         oscili aenv, p4-(adelta*2), iwf
a6         oscili aenv, p4+(adelta*3), iwf
a7         oscili aenv, p4-(adelta*3), iwf
a8         oscili aenv, p4+(adelta*4), iwf
a9         oscili aenv, p4-(adelta*4), iwf
a10        oscili aenv, p4+(adelta*5), iwf
a11        oscili aenv, p4-(adelta*5), iwf
a12        oscili aenv, p4+(adelta*6), iwf
a13        oscili aenv, p4-(adelta*6), iwf
a14        oscili aenv, p4+(adelta*7), iwf
a15        oscili aenv, p4-(adelta*7), iwf
a16        oscili aenv, p4+(adelta*8), iwf
a17        oscili aenv, p4-(adelta*8), iwf
out   a1+a2+a3+a4+a5+a6+a7+a8+a9+a10+a11+a12+a13+a14+a15+a16+a17
endin
f 1    0  4096  10  1  1  0  0  0  0  0  0  0  0  0  0  0  0  0  0  .55  .5  .45  .4  .35  .2  .1  .5
01   .01 .01 .01 .01 .01 .01 .01 .01 .01 .01 .01 .01

;p1   p2     p3     p4     p5     p6     p7     p8     p9     p10    p11
i10   0      75     27.5   1500   .1     .001   1      1      35     35
e
```

9.4 Modeling the Sound: Subtractive Synthesis

Subtractive synthesis had its heyday in the epoch of analog synthesis: it is a simple way to produce a variety of sounds from a few complex sources. The process consists in using a sound whose spectrum is sufficiently rich and to process it by filtering: the filters will attenuate certain regions of the spectrum, or boost to bring out others. A signal often used by subtractive synthesis is the impulse, which as a very rich spectrum. This is what Karkheinz Stockhausen used in his famous 1956 electroacoustic work *Gesang der Jünglinge* (*Song of the Youth*) where he filtered groups of pulses.

Subtractive synthesis has been used in electronic musical instruments since the 1920s. For instance, the trautonium, which was invented in Germany, used oscillators which produced rich waves, and filters placed after them were set to change the timbre. In modern synthesizers, it is common to have a combination of oscillators, filters and envelopes placed one after the other, creating a "voice".

In the illustration below, the output of an oscillator is sent to a filter. The type of

filter used here is band-pass: there are two cutoff frequencies. The one on top suppresses the frequency contents above the cutoff frequency, and the one below cancels the frequencies which are lower.

The oscillator can be replaced by a module reading an external soundfile.

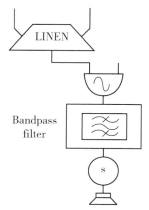

Figure 9 – 18 A simple substractive synthesis instrument with a band-pass filter

9. 5 Frequency Modulation Synthesis

9. 5. 1 Overview of the FM Synthesis

Frequency modulation (FM) synthesis, only uses two sinewave oscillators, but it produces a rich spectrum (that is, a spectrum containing many components). This is why it is called a nonlinear synthesis method. The modulator is a sinewave oscillator. The carrier is also a sinewave oscillator.

Let us take the example of the vibrato of a musical sound (such as a voice or a clarinet). Let's call the source of the vibrato the modulator. In this case, the frequency of the modulator oscillator will be the speed of the vibrating tone. Generally, in musical vibrato, such as sound, the speed is quite slow: its frequency is lower than 10 Hz.

The amplitude of the modulator oscillator will be the depth of the vibration: a small amplitude will produce a slight depth. The greater the amplitude, the greater the deviation from the center pitch (or center frequency) of the sound. This sound is produced by a modulated oscillator and, in a synthesis instrument, is called a carrier oscillator. In a synthesizer, this is done by a LFO (low frequency oscillator).

The depth of the modulation is also called the deviation: it creates a deviation from the original pitch. The depth of the modulation is measured in Hertz, or pitch: for example, we can talk about a semitone deviation, which is quite large. This deviation can also be smaller, such asquarter-tones, or larger. It can also be measured in cents. A semitone is 100 cents, so a quarter tone is 50 cents.

The synthesis of complex sounds by way of frequency modulation is derived from what we just described. In FM synthesis, the frequency of the modulator is in the audio range, so we cannot perceive a vibrato. Instead, we hear a rich sound. This was discovered by the American composer John Chowning.

The quality of the sound which results from frequency modulation depends on the frequency of the modulator, but also greatly from its amplitude: this is what makes the method very interesting for the creation of musical sounds.

To help understand what happens in FM synthesis, Chowning, in his 1973, presents mathematical functions, called the Bessel functions. They describe how partials, called sidebands, are created and evolve depending on the amplitude of the modulator. FM synthesis can thus be understood by the mathematical model of the Bessel functions.

Before we go any further, let's see some important vocabulary.

c = carrier frequency (Hz)

m = modulator frequency (Hz)

d = deviation (in Hz)

i = modulation index, computed as d/m. This is the ratio of the deviation to the modulator frequency.

Another parameter used in FM instruments is the ratio of the carrier to the modulator: c : m.

Through the Bessel function, we can intuitively express what happens when the modulation index changes. The functions represent the variation of the amplitude of each frequency band with it. In this illustration, the modulator is a sinewave oscillator. The carrier is also a sinewave oscillator.

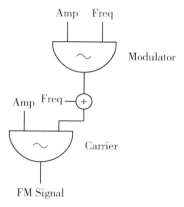

Figure 9 – 19　Basic model of frequency modulation

It is recommended that you look up "Bessel function" on Internet. You'll see the effects of the value of the index on the amplitude and time placement of the sidebands. The image below shows how sidebands evolve as index increases from 0 to 20.

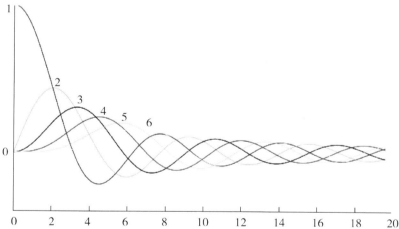

Figure 9 – 20　Evolution of the 6 first sidebands with an increasing index

9. 5. 2　FM Instruments

Here is a simple FM instrument. Note that it has an amplitude envelope.

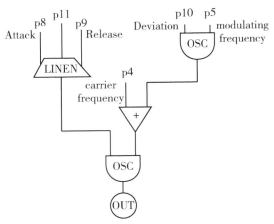

Figure 9 −21 Simple FM instrument in Csound

In this instrument, the modulating frequency is specified as p4 and the carrier frequency as p6. One way to specify the value of p4 is to consider the ration c ∶ m. For instance, ratios of 2.1 or 1.4 give interesting results. Then, you can multiply the carrier frequency by the ratio. You can also divide the carrier frequency by the ratio.

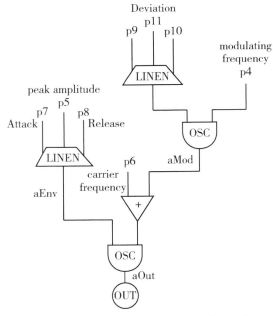

Figure 9 −22 FM instrument in Csound

In this instrument, the modulating frequency is not specified. Instead, the modulating oscillator receives at its frequency input the value carrier + ratio. The value of the ratio determines whether the spectrum will be inharmonic. For instance, a ratio of 2.1or 1.4 creates inharmonic ratios. Then, the carrier frequency is added. Here is the Csound code for this instrument. You can copy it and change the values in the score.

```
sr = 44100
ksmps = 44
nchnls = 1
0dbfs = 1 ; max amp = 1.
instr 1
aEnvMod       linen p11, p9, p3, p10
aMod          poscil aEnvMod, p4
aEnv          linen p5, p7, p3, p8
aOut          poscil aEnv, aMod
out           aOut
endin
</CsInstruments>
<CsScore>
;1     2      3      4      5      6      7      8      9      10     11
i1     0      10     55     .80    77     2      2      5      5      1500
i1     8      8      110    .80    154    2      2      2      6      2000
```

In the next figure, the deviation varies between two limits: deviation (min), the minimum value, which can be 0 or any other value, and deviation (max), the value reached by the linen envelope.

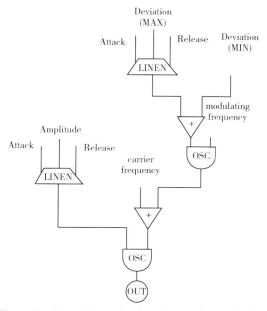

Figure 9 –23 FM synthesis with varying deviation

9.5.3 Listening to *Phone* by John Chowning

Phone was composed and realised in 1981 at CCRMA (Stanford University). It is composed of mostly short sounds (percussive), which are produced by FM synthesis. There are also long, stretched sounds which evolve. The evolution of the long sounds is made through interpolation: gradual passage from one state to another. This is timbral interpolation.

When a vibrato is applied to a long sound, a vocal sound emerges. Note the quality of the vibrato is crucial: it must have some randomness around a central value, and may change over time (such as the beginning, where it increases, at the end, where it decreases). By the same token, the pitch may not be completely stable and must include some variations, which occur in a natural voice. Also, the richness of the spectrum depends on its amplitude.

9.6 Granular Synthesis

The principle of granular synthesis is to use a tiny fraction of sound. This is called a grain. Under your control, the software will group a number of grains and produce a "cloud" of sounds. The number of grains played is controlled by the density parameter. The grains receive an amplitude envelope which may look like this:

Figure 9 –24 Image of a sound grain

There is usually a choice of different envelopes. Some may give a sharp attack, while others are smooth. While being played, a grain can be transposed, so the is a control over the range of transposition values.

To use granular synthesis, you have a choice of different software. While all have

a specific interface, they have similar controls. In Csound, granular synthesis is achieved through the use of the grain opcode, which is seen below. Curtis Roads, an American composer, at the University of California, Santa Barbara, is promoting EmissionControl2. Roads has been a pioneer in granular synthesis. A software distributed by Arturia is devoted to granular synthesis: Pigments. It can run as a stand-alone program or be used as plugin, with various formats: VST, VST3, AU and AAX.

In Csound, the opcode for granular synthesis is grain. However, there are other opcodes in the grain family. The opcode grain2 has less controls, and thus is easier to use. The opcode grain3 offers most controls for the synthesis of grain, but if a bit more delicate to handle. Finally, granule is also dedicated to granular synthesis, with different controls.

Let's start with the most popular, the grain opcode.

Here is the syntax of grain as given by the Csound manual.

```
ares grain xamp, xpitch, xdens, kampoff, kpitchoff, kgdur, igfn,
iwfn, imgdur [, igrnd]
```

With over nine arguments, it is an impressive opcode. Each one corresponds to a control over the type of synthesis offered by the granular model.

9.7 Plucked String Synthesis: Karplus-Strong Algorithm

The synthesis process according to the algorithm of Kevin Karplus and Alex Strong lends itself above all to the simulation of plucked string type sounds, as well as certain categories of percussive sounds. It was developed in the 1980s at Stanford, and was popularized by two works by David Jaffe, *May All Your Children Be Acrobats* (1981), and *Silicon Valley Breakdown* (1982).

A wavetable is filled with a sequence of random samples, or any type of waveform. An algorithm for reading and processing the samples read from the table converts the initial sound into an excitation-resonance sound. From the start of sound production, a series of operations progressively transforms both the spectrum and the amplitude of the initial sound. Like real plucked strings, the algorithm produces a faster decay of the treble components than of the bass.

One of the advantages of the method is that it allows both the synthesis of sounds

from the class of plucked strings or certain types of percussion, as well as the processing of sounds. Indeed, a sound can be introduced into the wavetable of the device, and come out transformed.

The pluck opcode produces a sound which decays and simulates a plucked string. It is based on the Karplus-Strong algorithm. It belongs to the category of physical modeling.

In this instrument, an expseg opcode generates an envelope whose duration is P3, the duration of the note. Then, a filter helps adjust the color of the sound.

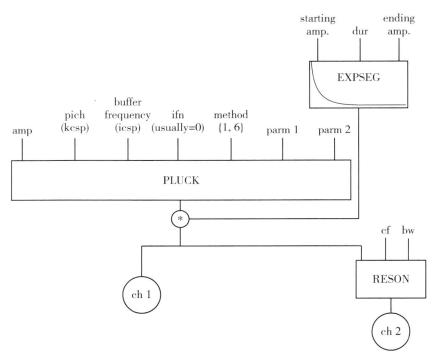

Figure 9 −25 A plucked string instrument in Csound

```
1    ; KS-2.csd
2    ; KARPLUS STRONG WITH ENVELOPE AND RESON<CsoundSynthesizer>
3    <CsOptions>
4    -odac
5    </CsOptions>
6    <CsInstruments>
7
8    sr = 44100
9    ksmps = 32
10   nchnls = 2
11   0dbfs  = 1
12
13   instr 1
14   ;p4    method of decay {1, 6}
15   ;p5    pitch of the plucked string (kcps)
16   ;p6    usually same as kcps, but can be set at other values (icps)
17   ;p7    value needed by some methods
18   ;p8    value needed by some methods
19   ;p9    reson: bandwidth
20   ;p10   reson: center frequency of the filter
21
22   kcps = 220
23   icps = p5
24   ifn  = 0
25   imeth = p4
26
27   kenv   expseg 1., p3, .01    ; exponential amplitude envelope
28
29   ;asig pluck kamp, kcps, icps, ifn, imeth [, iparm1] [, iparm2]
30   asig pluck .9,     p5,   p6,   ifn, imeth, p7, p8
31
32   a2 reson asig, p10, p9, 2    ;filter for channel 2
33   outs asig * kenv, a2 * kenv
34   endin
35   </CsInstruments>
36
37   <CsScore>
38   p1    p2    p3    p4  p5    p6    p7    p8    p9      p10
39   i1    0     4     2   110   92    2     2     2200    2
40   i1    4     4     2   92    92    2     4     100     2
41   i1    8     4     2   92    92    2     2     200     200
42   i1    12    4     2   92    92    2     10    1200    1200
43   i1    16    4     5   92    92    .5    .5    100     2
44   i1    20    4     5   92    92    .5    .5    300     100
45   i1    24    15    1   92    92    2     10    .       .
46   e
47   </CsScore>
48   </CsoundSynthesizer>
```

Figure 9 – 26 Csound code for the plucked string instrument

151

10

Music Software for the Studio and the Stage

10. 1　Editing Software

10. 1. 1　Audacity

Audacity is useful for a number of tasks.

To add markers in Audacity:

You can add MARKERS at certain points of the soundfile. A MARKER is a verbal indication, called a "label". You can type any label, such as "Verse 1", "chorus", "break" or any other.

To input a marker, put your cursor (the mouse pointer) where you want to add a marker.

Menu: Edit/ Labels / Add Label at Selection.

Figure 10 - 1　Audacity—markers menu

A marker appears below the waveform image. Type your label.

Figure 10 –2　Audacity—Markers labels

10. 1. 2　Saving and Exporting with Audacity

When you have finished, to save your work,

Menu: File / Save Project.

This will create a file with the extension ". aup". Caution: an ". aup" file is not a soundfile. It contains the soundfile, but adds specific data for Audacity. To save (or export a soundfile in Audacity, use the command File / Export.

Operating System	Macintosh, Windows, Linux
Address	https://www. audacityteam. org/download
Availability	free

10. 1. 3　Max

In 1987, Miller Puckette invented the Max program, to be used for several new pieces, including *Jupiter*, a piece for flute and digital processing composed by Philippe Manoury in 1987.

The year 1997 was the foundation of the company Cycling 74 by David Zicarelli which began in 1998 the distribution of Max/MSP (audio processing) by Cycling 74.

Figure 10 – 3　A simple MIDI patch

Already from the beginning, Max appeared to be a popular tool for live performance, because of two qualities: it worked in real time, and it could respond to controls from external devices.

Those two characteristics were preserved even when the software was extended by MSP, with which audio signals could be handled. This occurred during the 1990s. At that time, Max became widely used the world over for live performance, often with complex modes of interaction.

Today, what was known as Max/MSP is simply called Max, and incorporates MIDI and audio signals processing.

Figure 10 – 4　Groove Machine, an application built with Max

Operating System	Macintosh, Windows
Address	https://cycling74. com
Availability	commercial (with demo period)

10. 2 Pure Data

Just as Max, Pure Data is a real-time graphical programming environment. In fact, Pure Data has been created by Miller Puckette, the inventor of Max. It is thus no surprise to find in those two programs many objects with similar names. A major difference is that Max is supported by a commercial company which aimed at polishing the graphical interface and augmenting the number of objects, while Pure Data is essentially maintained by Miller Puckette, who is a professor of music at the University of California, San Diego.

Pure Data (also called PD) is used for real time, interactive music and also for video processing. As it is available for free an available on three platforms, Macintosh, Windows and Linux, an international community of users has been formed. Its members share patches and developments. A good place to start is to go to the web site which is kept up to date and publishes the latest information about what the community has been doing.

Note that music examples in several books are programmed in Pure Data, such as the book by Miller Puckette, *The Theory and Technique of Electronic Music*, which can be purchase or downloaded for free[1], or the book published in 2005 by a community of Pure Data users, *Bang: Pure Data* .

[1] Download link: http: //msp. ucsd. edu/techniques. htm.

Figure 10 −5 An illustration of a Pure Data patch from *Bang*:
A Pure Data Book, p.118

Operating System	Macintosh，Windows，Linux
Address	https://puredata.info
Availability	free

10. 3　SuperCollider

SuperCollider is well maintained for various platforms. It is also well documented here：doc. sccode. org/Overviews/Documents. html. The community around SuperCollider is active and share their work.

Here is an example of various applications of a comb filter.

```
// These examples compare the variants, so that you can hear the difference in interpolation
// allocate buffer
b = Buffer.alloc(s,44100,1);
// Comb used as a resonator. The resonant fundamental is equal to
// reciprocal of the delay time.
{ BufCombN.ar(b.bufnum, WhiteNoise.ar(0.01), XLine.kr(0.0001, 0.01, 20), 0.2) }.play;
{ BufCombL.ar(b.bufnum, WhiteNoise.ar(0.01), XLine.kr(0.0001, 0.01, 20), 0.2) }.play;
{ BufCombC.ar(b.bufnum, WhiteNoise.ar(0.01), XLine.kr(0.0001, 0.01, 20), 0.2) }.play;
// with negative feedback:
{ BufCombN.ar(b.bufnum, WhiteNoise.ar(0.01), XLine.kr(0.0001, 0.01, 20), -0.2) }.play;
{ BufCombL.ar(b.bufnum, WhiteNoise.ar(0.01), XLine.kr(0.0001, 0.01, 20), -0.2) }.play;
{ BufCombC.ar(b.bufnum, WhiteNoise.ar(0.01), XLine.kr(0.0001, 0.01, 20), -0.2) }.play;
// used as an echo.
{ BufCombC.ar(b.bufnum, Decay.ar(Dust.ar(1,0.5), 0.2, WhiteNoise.ar), 0.2, 3) }.play;
```

Operating System	Macintosh, Windows, Linux
Address	https://supercollider.github.io/download
Availability	free

10. 4 Processing and Analysis Software

10. 4. 1 GRM Tools

GRM Tools is a set of processing software. It comes as plugins in various formats, which can be used in all popular DAWs and editing software. It also comes as standalone programs, which are used independently.

GRM Tools is the result of a long history of innovative sound processing research. It started when Pierre Schaeffer invented "Musique concrete" in Paris in 1948, and then set up the GRM (Groupe de Musical Research, or, in French, "Groupe de recherches musicales") in 1958. In the later 1970s, the GRM started to use computers and naturally implemented their sound processing ideas into the digital world. For that, they developed a special hardware, SYTER (or Real Time System, système temps réel). The SYTER machine could run many algorithms for the purpose of sound processing mostly recorded sounds. This was in line with the history of GRM, where most of the electronic music was made from transforming recorded sounds.

In the 1990s, the GRM developed GRM Tools, so that the processing software could be used without the need to purchase the SYTER digital processor machine.

GRM Tools comes as a set of plugins and standalone programs. The plugins are designed for most of the DAWs, VST, RTAS, AAX, Stand Alone, and Audio Unit on Mac.

Operating System	Macintosh, Windows
Address	https://inagrm.com/en/store
Availability	commercial

10.4.2　IRCAM TS2

IRCAM in Paris produces a number of software for music applications. For a long time, AudioSculpt was the program dedicated to sound analysis. As of this writing, it is no longer available for Macintosh OS 10.15 (Catalina) and has been replaced by a newer program, TS2.

Operating System	Macintosh, Windows, Linux
Address	https://www.ircamlab.com/products/software
Availability	commercial

10.4.3　Praat

Praat is a software tailored for research on the voice, including that of animals. It has many settings and algorithms for analyzing sounds. It also has excellent document, albeit quite technical. Because it is free and its possibilities for sound analyzing are excellent, it has been quite popular in research laboratories.

Operating System	Macintosh (up to 10.14), Windows, Linux
Address	https://www.fon.hum.uva.nl/praat
Availability	free

10.4.4　Spear

This analysis software is really unique in the way it displays the analysis of a sound. Once the analysis is completed, the spectrum of the sound is shown as a number of lines. The shades of grey indicate the amplitude. The user can grab any line and move it around the spectrum. It is also possible to select a region of the spectrum and move that section to another place (such as transposition).

Another interesting feature is that the program will synthesize any set of lines which have been selected. In a way, this is a sort of additive synthesis.

Operating System	Macintosh, Windows
Address	https://www. klingbeil. com/spear/downloads
Availability	free

10. 4. 5　GRM-Player

GRM-Player is a standalone program which was introduced recently by GRM. It is distributed freely and runs on Macintosh and Windows machines.

Despite a deceptively simple appearance, it is a powerful software aimed at transforming a soundfile in many ways.

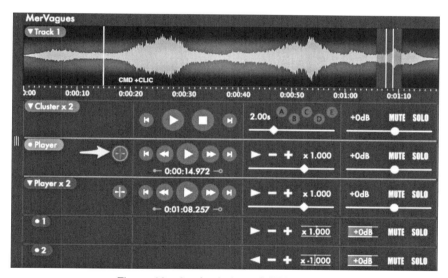

Figure 10 −6　A window of GRM-Player

Operating System	Macintosh, Windows
Address	https://inagrm. com/fr/showcase/news/372/grm − player
Availability	free

11

Composition and Artificial Intelligence Software

11. 1　Graphical and Interactive Software

In this category are placed the computer-assisted composition software. A program like IRCAM's OpenMusic is based on the programming language Lisp, which has been since its invention in 1958 an environment dedicated to artificial intelligence research.

To present OpenMusic, let's listen to what researchers from IRCAM said about it: "OpenMusic (OM) is a visual programming environment dedicated to music composition, designed and developed at IRCAM. It allows for the creation of and experimentation with compositional models through programming by means of a graphical interface that represents musical structures and processes. "[①]

11. 2　Analysis of Computer-Assisted Composition

11. 2. 1　Kaija Saariaho's *Love from Afar* and the Use of OpenMusic

Kaija Saariaho was a Finish composer born in 1952. After her studies at the Sibelius Academy in Helsinki and then in Freiburg with the British composer Brian Ferneyhough, at the beginning of the 1980s, she established residence in Paris and worked closely with IRCAM, the music research center founded in Paris by Pierre Boulez.

There, she composed several pieces for which she received the assistance of Jean-Baptiste Barriere and a team of researchers. This oriented her compositional work

① Carlos Agon and Moreno Andreatta, "Modeling and Implementing Tiling Rhythmic Canons in the OpenMusic Visual Programming Language", in *Perspectives of New Music* vol. 49, n. 2, 2011, pp. 66 – 91.

towards the use of computer-assisted composition programs, such as OpenMusic which will be introduced later in this book. For the audio processing, she worked extensively with a software called "Models of Resonance". In this approach, sounds are analysed and their spectral envelope is extracted.

This piece is the composer's first opera. It resulted from commissions of the Salzburg Festival (Austria), the Chatelet Theatre (France) and the Santa Fe Opera (USA).

Each character has its own set of chords. The music is notated in micro-intervals.

Figure 11 –1 Chords for the Jaufré character

Figure 11 –2 Chords for the pilgrim character

Figure 11 –3 Chords for Clemence character

Below are two examples of OpenMusic programming for the piece by Saariaho,

Love from Afar. The first one shows the spectral analysis of a Bosendorfer piano sound and a chord.

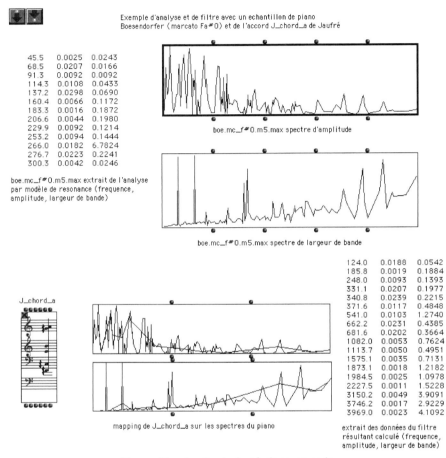

Figure 11 −4 Analysis of piano sounds

The next illustration shows a complex patch written with the OpenMusic language. Here, a set of chords is processed through a "model of resonance", which is essentially the envelope of a spectrum, what is called a spectral envelope. Hence, the colour of the chords is entirely transformed by the spectral structure of the model. This way, there is an interaction between the pitches and the sonority of the chord and the timbre of the piano sounds.

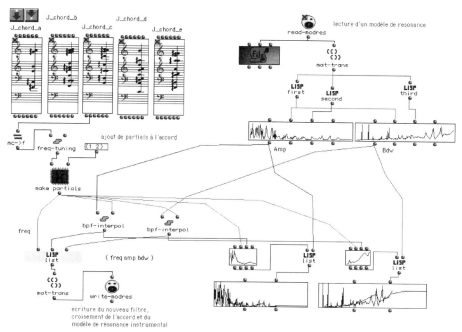

Figure 11 −5 Example of an OpenMusic patch used in Saariaho's piece

11. 2. 2 AudioMulch

This Australian software has created a community of users. It is designed for real time interactive performances.

The software web site has a dedicated page for the presentation of AudioMulch. The interface is built as two panels. One permits a visual programming, and is quite similar to Max, Pure Data or Kyma. In the other panel, the user can assemble effect modules such as a mixer, delay and other algorithms.

A useful feature of AudioMulch is its ability to load VST and Audio Unit plugins to be used in real time.

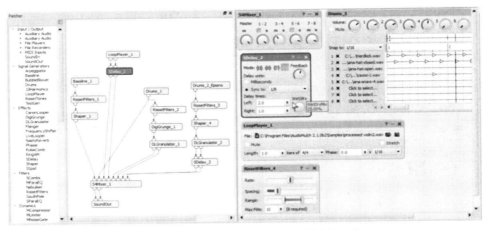

Figure 11 −6 Illustration from theAudioMulch web page,
showing the various interactive panels.

Operating System	Macintosh, Windows
Address	https://www.audiomulch.com
Availability	commercial (2 months demo)

11.2.3 ChucK

This program was first developed by a Chinese musician while he was studying at Princeton University, Wang Ge. He is now on the faculty at Stanford University. However, ChucK is still maintained.

ChucK is a real-time software aimed sound synthesis during live performances. The program is constantly scanning the input from the performer and reacts to it. In that, it is well suited for the practice of "live coding".

All the programming is by entering lines of codes. Those instructions are interpreted, as opposed to compiled, so that the program reacts in real time to all operations by the user. This is why it is well suited for the musical style of "live coding".

```
// a simple comb filter
// Ge Wang (gewang@cs.princeton.edu)
// feedforward
Impulse imp => Gain out => dac;
// feedback
out => Delay delay => out;
// our radius
.99999 => float R;
// our delay order
500 => float L;
// set delay
L::samp => delay.delay;
// set dissipation factor
Math.pow( R, L ) => delay.gain;
// fire impulse
1 => imp.next;
// advance time
(Math.log(.0001) / Math.log(R))::samp => now;
```

Operating System	Macintosh, Windows, Linux
Address	https://chuck. cs. princeton. edu
Availability	free

12

Studio Practice in the 21ˢᵗ Century

12. 1　Recording

12. 1. 1　Recording Vocals

Take these precautions (i. e., while the recording is made).

– Place the microphone slightly higher than the mouth, and a little to the side. This way, the plosives won't reach the microphone.

– Also possible, turn the microphone just a little bit so that it does not face the mouth.

– Use an omnidirectional microphone, if possible. It is less sensitive to the plosives.

– Use a pop shield, placed in front of the microphone, 5 or 6 cm away.

– You can also ask the singer to slightly turn the head when singing vowels starting with "P" or "B".

– Watch the meter on the microphone input channel: if any clipping occurs, it will show on the meter and there is nothing you can do at the mastering stage. This is why it is crucial to rehearse with the singer to test the levels. Watch that during a song, the overall level may increase near the end.

– Watch the meter (peak meter and VU-Meter) on the recording DAW.

12. 1. 2　Sibilance

Sibilances are high energy in the upper register, often occurring with the consonant "S" and sometimes in "T" as well. It can happen frequently in women's voices but also in men's. The emission of sibilance varies with languages: some languages (like English) are more prone to them (if you are a native speaker), but it also varies with voices.

Use a DeEsser plugin at the mastering stage (i. e., AFTER the recording is

made).

A DeEsser plugin is designed to attenuate or erase sibilances. It is a must for mastering vocal recordings, when the singer is prone to sibilances.

Just like for the plosives, place the microphone slightly higher than the mouth, and a little to the side. This way, the sibilance will be attenuated.

12. 1. 3　Clipping

Clipping occurs when the audio level is too high. That can happen anywhere in the chain of audio, between the microphone to the recording DAW.

There is little chance to overload the microphone. A condenser microphone will accept a very high level without any difficulty. It is plugged into the mixing board (or an audio interface). More precisely, it is plugged into a microphone preamp, located in the mixing console or the audio interface (the "Mic Input"). It is crucial to watch the level arriving at the mic input and make sure there's no clipping there.

12. 1. 4　Proximity Effect

Condenser microphones which are directional (like the Neumann TLM103) may produce what is called "Proximity effect".

This effect occurs when the microphone is placed close to the mouth. What happened is that the low part of the voice gets somewhat amplified. It may create a "boomy" sound, that is too much emphasis of the low register. This effect is used to give an impression of closeness, intimacy or emotions like inducing fear (in movies). It is not necessarily something useful in normal singing, although it may be interesting when recording female voices, for example. Be aware of the proximity effect, but do not hesitate to use it when appropriate.

12. 2　Microphones

First, let's see the families of microphones. You are likely to encounter some of these: Dynamic microphone; Condenser microphone—electret; Condenser microphone (professional) —phantom power.

12. 2. 1　Dynamic Microphone

The Dynamic microphone was invented around 1925. It's the oldest. Before,

there were "carbon microphones", used in telephone since 1876.

Dynamic microphone are commonly used on stage, for singers who hold the microphone in their hands, and also on instrument: in front of guitar amplifiers or on drums.

Figure 12 – 1　Typical recording of a guitar amplifier by dynamic microphones placed in front of the amp

The Shure SM87A is liked by vocalists because it has protection against breath and wind noise (from the mouth of the singer). It also protects against noise coming from the microphone stand.

Figure 12 – 2　Shure SM87A

12. 2. 2　Electret Microphone

A Condenser microphone—electret usually requires some light power, like a single battery of 1. 5 V. Some electrets are powered by the device, like smartphones or digital recorders.

The quality of an electret microphone varies from good to plain bad. They often lack the ability to capture high frequencies. Electret microphones are commonly found on affordable digital recorders. They were invented in 1962.

12. 2. 3 Condenser Microphone

A Condenser microphone (professional) —phantom power offers the best recording quality. This is why it is used in recording studios. It requires more mower than an electret. Typically, a professional condenser microphone requires 48 V, sometimes 12 V. The most common is 48 V.

The word phantom (= ghost) means that the power (48 V or 12 V) is sent on the same cable as the audio signal: the power is "invisible". The power is provided by the audio mixer, the interface or a digital recorder.

12. 3 Microphone Characteristics

In this section, we will see how microphone respond to the sounds they capture. This falls into the category of microphone characteristics. There are several ways in which a microphone captures sounds, and it is an important information to know when handling recordings.

12. 3. 1 Cardioid (or Directional) Microphone

A microphone which captures mostly sound in front is called cardioid or directional. The image of a bulb in the picture is called a polar pattern. It shows the area most sensitive for the microphone.

If you hold the microphone, you will mostly capture the sounds coming in front.

The word cardioid comes from the shape of the polar pattern, which looks like a heart. Cardioid microphones are useful to eliminate sound from sides or back. However, their bandwidth is rarely flat.

Most microphones are cardioid. This is the most common type of microphone.

In this image provided by Shure, the sphere is the area of sounds captured by the directional microphone.

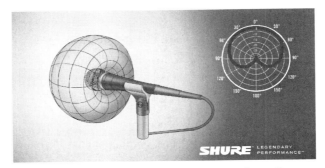

Figure 12 −3　A cardioid microphone polar pattern

12. 3. 2　Omnidirectional Microphone

A microphone which captures mostly sound all around (front, sides, back) is called an omnidirectional (or omni, for short).

Figure 12 −4　Omnidirectional microphone pattern

12. 3. 3　Figure of Eight Microphone

A microphone which captures sound from the front and from the back is called a figure of 8. Certain microphones have this polar pattern, but there are less used than cardioids and omnis. A certain type of studio microphones, called ribbon microphones, have this polar pattern. These ribbon microphones are usually expensive and fragile, and cannot be used outside of the recording studio. They have very good quality.

12. 3. 4　Shotgun (or Hypercardioid) Microphone

A microphone which captures sound from the front along a narrow polar pattern

is a shotgun. It is highly directional. Shotgun and hypercardioid are very similar but not quite the same. Shotguns are used, for example, to record birds, as well as in cinema to avoid the various noises around actors (camera, etc.). A shotgun is an hypercardioid placed in a long tube.

Such a microphone is used to focus on a sound source, but its bandwidth is limited.

12. 3. 5 Polar Patterns of Microphones

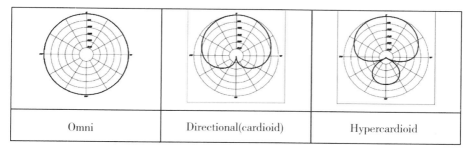

| Omni | Directional(cardioid) | Hypercardioid |

Figure 12 –5 Polar patterns of microphones

12. 4 Stereo Recording

12. 4. 1 XY Pair

Two directional microphones are placed at 90° (one above the other). There are many commercial XY stereo microphones. It provides a good stereo image, but not wide. The sound image is narrower than with some other techniques.

Figure 12 –6 Røde NT4 stereo microphone

12. 4. 2 ORTF Pair

Two directional microphones are placed 17 cm apart, at an angle of 110°. It

provides an excellent stereo image, wide. Often used by sound engineers for concert halls, suspended above and in front of the orchestra.

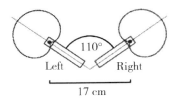

Figure 12 −7 ORTF technique

12. 4. 3 AB, or Spaced Pair

Two directional microphones are placed at a distance of 40 to 80 cm. The three-dimensional impression is good, but not very natural. It is best to use XY or ORTF pair.

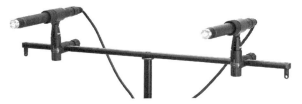

Figure 12 −8 AB technique

21 世纪计算机音乐创作：
历史与实践

1

前言

当今，市场上关于电子音乐史的著述颇丰，亦有书籍着重讨论计算机音乐在 21 世纪的实践。展现电子音乐发展史的出版物往往信息冗杂，掩盖了这一领域演化的主要趋势和现实。而那些关于如何使用计算机音乐工具的内容大多编写于多年以前，并不能反映现如今计算机音乐的实践方式。

为了让读者了解计算机音乐，我们出版了这本教材。与同一领域外国教材不同的是，在本教材中，我们会回顾那些曾被略去不谈的中国作曲家的努力和成就。本教材旨在向读者介绍 20 世纪中叶至今电子和计算机音乐的发展进程，其中包括中国电子音乐的发展史和中国作曲家的重要作品。本书的历史记载源于作者在电子音乐和计算机音乐演变方面长期积累的研究经验，以及作者自 20 世纪 70 年代初开始作为作曲家的经历。

本书的第 6 至 11 章侧重讲解音乐科技：如何使用合成器和计算机创造声音，其主要方法有哪些，如今的计算机提供了哪些音乐工具，现有计算机软件具备的重要功能，以及如何使用它们来进行创作和后期混音处理。

本书还会介绍在录音室工作时必须了解的技巧——录音、混音、母带制作。

在进行介绍时，本书不会着重讨论某一特定的音乐风格，例如流行音乐、嘻哈音乐、电子音乐、DJ 或经典电子音乐。作者更希望本教材能够为音乐风格各不相同的教师、学生和音乐爱好者所用。

本书结尾部分有多个实用的附录，包含微分音表、音高/频率对照表、详细的综合索引和中西实用参考书目。

2
介绍

当今时代，软件更新迭代速度飞快，新的操作系统逐年推出，旧的代码、乐谱、MIDI 文件、音频序列常因为软件版本过时而无法运行。因此，撰写一本如实展现音乐科技的教科书虽然任务艰巨，但刻不容缓。曾经，音乐家基本只围绕乐器进行创作，当然纯为器乐曲而作的作品现在也依然存在，但当电学开始作为音乐的引擎和媒介之后，情况发生了变化，工程师和新乐器制造商开始竞相发掘最新的技术。

自电子音乐出现至今的 70 多年里，音乐家们所使用的设备愈加繁多且更加先进。这些设备不断提供更高的音频质量，响应多元创作需求。同时，依赖于电子和数字技术的音乐风格激增，作品类型横跨流行音乐与古典音乐。

本书介绍了中国及世界电子音乐历史，以及音乐创作所使用的技术和工艺。

在正式开始介绍电子音乐史之前，必须先区分各种不同类型的计算机音乐软件，以及各种软件所包含的特定实践和用人工创造声音作曲的方法。

第一类软件被简称为 DAW（Digital Audio Workstation，即"数字音频工作站"）。它在 21 世纪初非常流行，是由数字音频工作站程序所组成的。如今，DAW 可以分为两种。

第一种是最受欢迎、应用范围最广的 DAW，用于作曲和制作。

这种 DAW 可创作或制作一段由组合音频文件片段和 MIDI 序列组成的音乐。这种 DAW 通常附带大量插件，其中有一些是数字乐器，比如合成器、采样器和采样播放器；另一些是音频效果器，主要用于处理音频，如压缩器、滤波器和均衡器、混响、立体声音频可视化等。

这些不同类型的 DAW 支持不同格式的插件，但很少可以支持所有格式的插件。比如 Cubase 更倾向于使用 VST 插件（VST 指 Virtual Studio Technology，该类插件为虚拟乐器或音频插件），Logic 等其他 DAW 主要使用 AU（Apple Unit，苹果电脑系统组件）。

在这一种 DAW 中，有许多目前广为流行的软件，如 Cubase、Logic、Ableton Live、FL Studio、Digital Performer 等。这些 DAW 能够制作完整的作品，它们配备混音、母带制作和音频可视化工具，并实现了相应操作的自动化。

第二种 DAW 更适合于计算机音乐的录制和制作阶段。比如，在撰写本书时，市场上最多人使用的软件是 Avid 公司的 Pro Tools。Pro Tools 有着悠久的历史，广泛应用于世界各地的专业录音制作工作室。需要注意的是，Pro Tools 只支持特定的插件格式，不过大多数插件制造商都提供这类插件。其他出色的 DAW 产品有 Reaper 和 Mixbus 32 – C，制造商为哈里森（Harrison），哈里森也生产调音台。尽管第二种 DAW 以其录音、混音和母带处理能力而闻名，但它们同样也非常适用于创作。

虽然这些软件的某些功能较为出色，但它们都具有制作数字音乐的主要功能：录音、作曲、音频处理、混音和母带处理。

创作者可使用 DAW 来制作音乐，可在最终录制后导出为立体声或多声道文件。这类 DAW 基本可满足制作完整音乐作品的需求。随后，创作者可以将这些音乐片段存储在数字媒体上，继续通过互联网以各种形式（如 MP3 文件）传播。这也是 DAW 被称为"工作站软件"的原因。

第二类计算机音乐软件是为现场交互式音乐设计的实时播放和实时生成音乐的程序。它们用于在笔记本电脑上播放音乐。在这种情况下，音乐是直接产生的，例如在舞台上。该软件可以直接生成声音，也可以使用数字乐器或音频处理工具等插件。这些软件中最受欢迎的是 20 世纪 90 年代问世的 Cycling 74 公司的 Max（也被称为 Max/MSP）和 SuperCollider。最近与此相关的趋势是使用编码创作音乐，在这种创作模式中，音乐家一边创作音乐，一边编写代码行，这些代码可以立即运行和播放。Max 的变体是 Pure Data，该软件也是由 Max 的开发者米勒·帕克特（Miller Puckette）设计的。

第三类计算机音乐软件是独立程序。它们可以单独使用，不需要 DAW。这些程序大多数是作为插件生成的，使用方便，例如由 INA-GRM 公司生产的 GRM Tools。它们就像插件一样，可以在 DAW 软件中使用，但它们也可以作为程序独立使用。另外还有像 Arturia 这样的公司也生产软件乐器（如合成器），那些软件乐器是对传统硬件乐器的数字复刻，同样可以作为插件使用。

第四类是由计算机生成的程序。它们是最早出现的计算机音乐软件，是 1957 年马克斯·马修斯（Max Mathews）所开发的程序的现代变体，现在也常被用于制作数字声音结构。最近这类软件中最受欢迎的是一款免费软件 Csound，该软件拥有大量文档资料和庞大的用户社区。

第五类是计算机辅助作曲软件（CAC，computer-assisted composition）。这类软件有 IRCAM（Institute for Research and Coordination of Acoustics and Music，声学、音乐研究与协调中心）的 OpenMusic，它是一款完备的作曲家辅助软件，可与其他计算机音乐软件（如 Csound）交互，同时还受益于世界各地的

大型用户社区，这些用户创建了专门用于某些类型操作的"库"。另一个此类软件是西贝柳斯音乐学院（Sibelius Academy）的 PWGL。与 OpenMusic 相似，它是一款使用 Lisp 语言编程的图形化软件。

　　本书的内容能帮助读者了解这些不同的计算机音乐软件类别，帮助他们在日后创作音乐作品时，根据作品类型选择所需的软件。

3
早期历史发展

3.1 概述

20世纪上半叶,电波、电子录音设备、电子管、麦克风、扬声器、收音机和磁带等声音技术成果纷纷问世。在稍早前的19世纪末,电动和电子小提琴制作技术诞生。

20世纪下半叶,音乐家们对录音技术产生日益浓厚的兴趣,这种在磁带上制作音乐的新技术的出现,意味着20世纪初电子制琴师时代的落幕。这类音乐技术最开始应用于创作型实验室:在电子声学音乐工作室中,作曲家可以在磁带技术的支持下直接创作和演奏他们的作品。

这一时期同样见证了数字技术和计算机在音乐创作中的运用:计算机音乐就此诞生。计算机逐渐成为创造性工作的主要平台。同时,模块化模拟合成器(非数字)的发明让电子声学音乐得以登上舞台,为观众现场表演。

然而,技术进步不足以涵盖层出不穷的音乐创作和表演新方法。1937年被作曲家埃德加·瓦列兹(Edgard Varèse,1883—1965,图3-1)称为"声音的解放"① 的运动贯穿了整个20世纪,直至今日仍未停歇。

图3-1　埃德加·瓦列兹

① 埃德加·瓦列兹在接受《旧金山纪事报》(*San Francisco Chronicle*)采访时提到了"声音的解放",采访刊于该报1937年11月28日,文章参见 http://www.zakros.com/mica/soundart/s04/varese_text.html,[2020 - 08 - 16]。

3.2 开创性的录音和传输技术

电力的逐渐普及，机械技术的日臻完善为声音技术的发明奠定了基础。其中一些技术在一个多世纪后仍以新的形式被人们投入使用。这些技术引发了艺术家对现代性美学的反思和革新。美学革新运动也应运而生：诗人、画家、音乐家纷纷投身其中。其中，意大利未来派为当代艺术带来了深刻的变化，根据 20 世纪初社会的新视野可将其观点整合为：速度、噪音、交流、机械化、空间。

磁性录音技术的发展就是一个典型的例子，其发展带来了大量叹为观止的新技术和艺术成就。磁性录音的发明归功于丹麦人瓦尔德玛·普尔森（Valdemar Poulsen），他研究出一种记录声音的方法：利用剩磁原理，让钢丝穿过电磁铁，电磁铁的强度由电信号调制，由此产生的磁场变化就能被钢丝记录下来。

1888 年，奥伯林·史密斯（Oberlin Smith）在美国杂志《电气世界》（*Electrical World*）中发表了题为《留声机的几种可能存在形式》（*Some Possible Forms of Phonograph*）的文章，他在文中描述了一种卷轴型装置，该装置由供应声音的卷轴与有着带状接收器的支架组成。通过电磁铁产生一个固定在支架上的磁场，以其磁化形式来表示声波的变化。为此，他设想其支架可以由浸有铁的丝绸或棉线组成。

电磁铁对载体的磁化敏感且能够将信号还原成图像，因此可以通过反转这个过程来实现复制。奥伯林·史密斯所描述的发明非常了不起，因为仅仅在前一年，海因里希·赫兹（Heinrich Hertz）才提出电磁波理论。然而，史密斯似乎并没有完成他的发明，而且据说他也未曾申请任何已知的专利。此后，来自丹麦的普尔森设计并制造了磁性录音设备，即"留声电话"。普尔森试验了各种材料类型的载体，包括胶带、金属圆盘以及金属丝。这款留声电话成为 1900 年巴黎万国博览会的亮点之一。电线以每秒 2 米的速度运行，使用 1800 米的载体就可以录音 15 分钟。多家公司都曾出售该设备，但因其音质极差而无法在市场上生存。

德国化学家库尔特·斯蒂尔（Kurt Stille）在金属载体录音方面取得了重大进步。他设计了第一台录音设备磁录放机（Dailygraph），其设计类似于录音电话机。他与马可尼合作制造的磁线录音机获得了巨大成功。在磁带录音机出现许久之后，在欧洲仍有人使用马可尼－斯蒂尔录音机。

带磁性涂层的磁带载体的发明要追溯到波弗劳姆（Fritz Pfleumer）。他在德国德累斯顿的一家公司研究香烟过滤嘴用的纸带时，产生了发明"磁带"

的想法：在纸带上放置并黏附金属颗粒。终于在 1928 年 1 月，他获得了关于这项发明的专利。

1934 年，德国巴斯夫公司（BASF）生产了 5 万米的塑料磁带。第一台塑料磁带录音机在第十二届柏林广播展上亮相，名为 Magnetophon。它用涂有磁化粒子的塑料磁带进行录音。磁带运转的速度为每秒 1 米，后降低至每秒 77 厘米，再到每秒 76 厘米。德国通用电气公司（AEG）用塑料薄膜制造了磁力电话，这是巴斯夫于 1934 年开发的一种工艺。但由于当时该工艺仍存在问题，所以巴斯夫没有立即将机器推向市场。通用电气的设备采用了基于三个电机的机械装置，这套系统此后一直沿用至今。

1937 年，通用电气公司和德律风根公司（Telefunken）开始销售磁带录音机。通用电气最初考虑将其发明命名为 Gea-Bandsprecher（大意为"会说话的磁带"或"磁带上的声音"），后来又改名为 Ferrophon。第二次世界大战后，Magnetophon 成为"磁带录音机"的通用名称。

3.3 电驱动乐器

"电驱动"（electric）和"电子"（electronic）是两个需要区分的限定词，它们代表了电力应用于乐器的两个截然不同的领域。

电驱动乐器的工作原理是将机械能转化为电流，例如吉他弦的振动或金属圆盘在电磁铁前的旋转。

这一原理适用于电吉他等乐器。其发声原理基于捕捉发电机（如电传簧风琴或电传乐器）、弹拨弦（吉他）等实体的运动。20 世纪上半叶还出现了其他的电驱动乐器，其中一些电驱动乐器（如哈蒙德管风琴、新贝希斯坦电钢琴等）开始广泛流行起来。

通过机电或电磁，以及较为少见的光电效应或静电学（如电羽管键琴）传感，振动被转换为电信号。电路会放大该信号，然后将其引导至扬声器，而动力琴（Dynamophone）这类乐器属于例外情况。

捕捉振动体运动的系统名为"换能器"（又名"拾音器"）。在电吉他这一类电驱动乐器中，换能器起到麦克风的作用，乐器发出的声音质量很大程度上取决于它。

若乐器的捕捉系统是通过电磁或光电效应来实现的，那我们会将这类乐器称为"电驱动乐器"。

自 19 世纪末人们开始进行测试和生产电驱动乐器起，时至今日它依旧活跃在市场中，人们仍在不断生产和使用它。

3.4 电子乐器

电子乐器的原理是通过振荡电路（振荡器）产生信号。

"电子"一词指的是电子电路不借助振动而直接产生波的一般原理。

20 世纪初，美国人李·德·福瑞斯特（Lee De Forest）发明了三极真空管，从而推动了收音机和放大器等电子设备的发展。这种真空管被创造者命名为 audion（该词有"声音"之意），因为他希望设计出一种能够产生和放大声音信号的乐器。

无线电是发明创造的沃土，它为电子乐器（如特雷门琴、马特诺音波琴）的发明奠定了基础。直至 20 世纪 20 年代末，其他的声音合成原理（如减法合成）开始诞生。

可以说，电子技术在 1906 年随着李·德·福瑞斯特的发明开始投入使用，并在人们对无线电的研究中逐渐发展壮大。

3.5 新奇的先驱：电羽管键琴

1761 年法国，让 – 巴蒂斯特·德拉博德（Jean-Baptiste Delaborde）出版了一本篇幅短小的著作《电羽管键琴》（*The Electric Harpsichord*），该书至今仍在不断再版，他在其中提出了新的机械理论和电现象理论，并描述了一种巧妙的乐器装置（如图 3 – 2）。

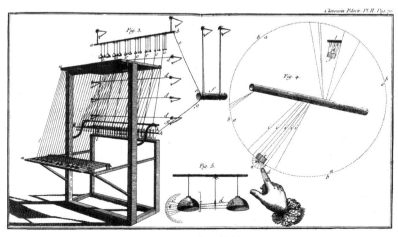

图 3 – 2　电羽管键琴

该装置即是因书得名的电羽管键琴，它是一种静电学乐器，德拉博德在该书中解释了如何通过对电和传导的连续实验制造它。

乐器的每个音符都由两个小铃铛发出，在它们之间附有一根小金属棒。当乐器演奏者按下琴键时，电荷会传输到两个铃铛中的一个来吸引金属棒。通过正负电荷的交替作用，金属棒在两个铃铛之间摆动并交替撞击它们。"金属棒开始移动并以极快的速度敲击两个铃铛，这样就会产生波浪形的声音，大致与风琴颤动的效果相似……电是它的灵魂，就像空气是风琴的灵魂一样。"这段引用自德拉博德书中的精彩文字，是在公众对电学还没有完全了解的时候写成的。

在没有电池的时代，人们通过转动轮子给金属体充电来供电。德拉博德解释了电羽管键琴如何演奏及如何产生声音："因此，电子材料就像俘虏一样，在新羽管键琴的音色周围保持紧绷并不必要地颤抖，直到通过按下琴键进入自然发声状态，它才能获得自由，然后以最快的速度逃脱。而一旦松开琴键，它就会停止工作。"

这种乐器虽然很有趣，但并未在 18 世纪中留存下来。19 世纪末，人们对电进行了孜孜不倦的研究，发明了新的电子乐器。1876 年，电话诞生了。电话使用的是一种简单的转换形式，即将一种能量转换为另一种能量，将人说话时产生的声波转化为电流的波动变化。

电话的发明得益于人们发现声音产生的波运动可以使膜振动。反之，膜的振动可以产生电流，电流跟随空气中的分子振动而变化。就这方面而言，1876 年麦克风的发明原理与我们日常手机通话时使用的麦克风并没有太大的区别，只不过现代手机通信设备在音质方面有了质的飞跃。

3.6　电驱动乐器和电子乐器的发展

20 世纪上半叶，大批发明家参照各种电子系统的逻辑，设计出了真正的乐器。这些乐器自有一套独立的设计逻辑。设计这些乐器的大多为音乐家或工程师。工程师通常会在设计时与音乐家交流，往往配合音乐家的需求完成设计。也是在这个时代，电子制琴师们开始设想全新的乐器。

这项研究由无线电电子工程师和音乐家进行，有时他们会创造出具有新表现形式的乐器。这些乐器的制作一般以制作者所处时代的电子技术为基础。在本书中，我们只讨论最具代表性的乐器。

3.7　电传簧风琴

非常值得一提的是，早在 1892 年，美国发明家泰戴斯·卡希尔（Thaddeus Cahill）就构思和制造了一种键盘乐器。他将自己的发明命名为"电传簧风琴"（Telharmonium，如图 3-3），此名称是由"电话"和"簧风琴"（一种风琴乐器）两个单词组合而成的。它通过在电路前置转轮而发声。

图 3-3　卡希尔的电传簧风琴发电机

之所以采用这样的设计，是因为轮子在电路前旋转可以产生电流，电流的变化相当于电波。由此，声音便产生了。

由于当时还没有电子放大器，所以所用的轮子必须非常大，这样才能产生足够强的音乐信号，能够在电话中使用。为什么要在电话中使用呢？因为在 20 世纪初，扬声器尚未发明，听电子音乐最好的方式就是通过电话。听众可以订阅并通过电话线收听纽约市电传簧风琴音乐厅播放的音乐。

该键盘乐器的音区跨度足足达到了 7 个八度。用于演奏的音乐基本由当时的流行乐曲的改编而成，没有作曲家为该乐器创作过原创音乐作品。

这种乐器也被称为"动力琴"（Dynamophone），体现了发明者对机电设备的纯熟使用及非凡创造力。卡希尔对当时技术的了解堪称典范，并通过将机电技术应用于音乐这一要求极高的领域，将其推向了极致。

由于电话连接线路分配、大量的电路集成和直流发电机共同运作时产生的故障和大量问题，该系统不复存在。然而，它的制作和探索依旧是通过电力产

生声音方面迈出的重要一步。①

3.8 特雷门琴

由年轻工程师雷奥·特雷门（Leon Theremin）在俄罗斯设计的特雷门琴（Thereminvox）诞生于1920年，该乐器为音乐家展示和提供了完全不同于传统的演奏方式。它是首个激发了埃德加·瓦列兹等众多作曲家创作想象力的电子乐器（如图3-4、3-5所示）。

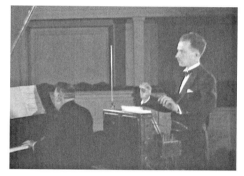

图3-4　雷奥·特雷门于纽约
在钢琴伴奏下演奏他
发明的乐器

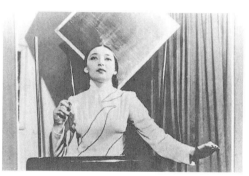

图3-5　20世纪30年代演奏家
克拉拉·洛克莫尔（Clara
Rockmore）演奏特雷门琴

该乐器使用无线电技术设计，从某种意义上说，声音的产生源自再现无线电波的过程，即外差效应。根据这一原理，该乐器是单声道的。1920年前后，无线电技术还是一个新领域，许多研究致力于完善这一技术。事实上，当时的无线电工程师就是我们今天所说的电子工程师。

特雷门琴（如图3-6）右侧的垂直天线可修改高度：它对电磁场的变化极为敏感，手或手指的简单移动即可改变音高。水平放置的弯曲天线控制音乐的细微变化。通过大量练习，特雷门琴演奏者能够凭借突然的动作演奏断奏。

RCA（Rdio Corporation of America，美国无线电）公司于1929年将特雷门

① 进一步研究可参阅：Reynold Weidenaar，*Magic Music from the Telharmonium*，Metuchen（NJ），The Scarecrow Press，1995；Reynold Weidenaar，*The Telharmonium*：*A History of the First Music Synthesizer*，1893—1918，Ph. D thesis，New York，New York University，1989，UMI n° 89160049（可从 ProQuest 上获取）。

琴作为一种新型独特、人人皆可使用的乐器向大众普及，并广告声称，特雷门琴的巧妙之处在于：在空中舞动双手就可以创造音乐。

20 世纪四五十年代，特雷门琴主要用于电影配乐，如科幻片或惊悚片。

自 1920 年以来，该乐器经历多次改造。著名的合成器制造商罗伯特·穆格（Robert Moog）便是以制造特雷门琴开始他的职业生涯，他曾转而生产合成器，后又重操旧业。

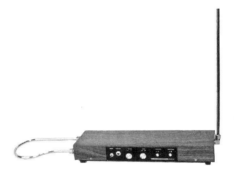

图 3-6　穆格音乐公司打造的现代特雷门琴

如今仍有不少音乐家钟情于特雷门琴，因此我们仍可以欣赏到特雷门琴的表演。想要获得一个新的特雷门琴并不困难，可以从美国购买。

3.9　马特诺音波琴

除上文介绍的乐器之外，还有一些令人称奇的乐器，比如马特诺音波琴，它创造了全新的声音表达模式：马特诺音波琴具有独特的音色，可以在两个音符之间连续滑动，演奏出极为飘逸的颤音。其声音产生原理为无线电理论的外差效应，外差效应是一种运用无线电产生声音的原理，发出的频率可几近纯频率。

该乐器由莫里斯·马特诺（Maurice Martenot，图 3-7）发明，并于 1928 年首次在巴黎歌剧院亮相。与特雷门琴一样，该乐器是使用无线电技术设计的单声道乐器。马特诺开创了在乐器范围内结合半音阶演奏和滑音的方法，且发明了赋予乐器丰富音色特性的扬声器。

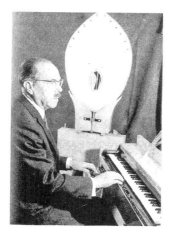

图 3 −7 莫里斯·马特诺

马特诺音波琴的演奏使用可以产生颤音的键盘（如图 3 −8）。键盘上有一根电线，电线上面有一个环，表演者将拇指放入环中从而产生颤音。该乐器可在 7 个八度音阶范围内演奏滑音和颤音。

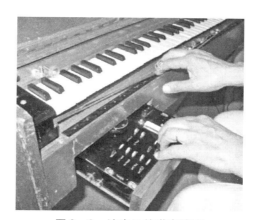

图 3 −8 演奏马特诺音波琴

为了使乐器音色更加丰富，马特诺提出一种扬声器原理，他认为可以通过各种方式为声音增色。其中一种扬声器形状优雅，呈火焰状，名为 palm（意为"棕榈树"，因其形状酷似棕榈树的叶子而得名，如图 3 −7），它有 12 根弦，可产生共鸣。另一种金属质地的扬声器带有一面锣，直接连接到接收信号的扬声器电机。

乐器演奏者可以通过位于键盘左侧的小控制抽屉来选择要使用的扬声器。

此外，马特诺音波琴还可以让音质不断变化。它的两个踏板可以用于改变声音强度以及激活静音效果。此外，马特诺音波琴还运用了经典乐器声学原理——共振，通过马特诺音波琴不同类型的共振器引起共振，为该乐器带来更多层次的艺术创造力。基于声波生成理论，多位作曲家创作了 400 多部新作品。

马特诺音波琴至今仍在使用，大量具有影响力的作曲家使用它作曲。因而，有必要将这一乐器教授给年轻的演奏家，使得那些曲目能够向公众演奏。即使在今天，一些作曲家仍在用它作曲，许多表演者也在继续演奏这一乐器。

3.10 哈蒙德管风琴

20 世纪 30 年代，电子钟的发明者劳伦斯·哈蒙德（Laurens Hammond）想使用电动机创造一种新型乐器。他设计的乐器原理与电传簧风琴类似，但在技术上更为精进。

哈蒙德没有像卡希尔一样使用大型发电机，而是在电路前放置了一个旋转的小金属轮。声音的色彩，也就是所谓的"音色"，是由演奏者拉动滑块来控制的：每个滑块都控制着声音的一个谐波频率的高低，从而可以让声音从非常单薄的单音变化为丰富多彩的声音。这套系统被称为"拉杆"（drawbar）。

1935 年首次亮相的哈蒙德管风琴（如图 3 – 9）成为爵士乐手的最爱，其中佼佼者为 1954 年制造的先进哈蒙德 B3 风琴。吉米·史密斯（Jimmy Smith）是著名的哈蒙德管风琴爵士乐演奏家。

图 3 – 9 1954 年的哈蒙德 B3 风琴，配有莱斯利旋转扬声器

如今，计算机甚至智能手机上都有许多哈蒙德管风琴的软件版本。

4
世界电子音乐的发展

不使用管弦乐器也能创作音乐——这是电子音乐诞生之初人们所产生的想法。电子音乐所使用的声音来自两个截然不同的媒介：录音和电子声音。早在1948年，录音就已经在巴黎得到应用：先是光盘录音，然后是磁带录音。从1951年起，德国科隆广播电台开始使用电子发生器与电子乐器中的声音。

4.1 电子音乐的第一种形式：1948年的巴黎

回溯至1948年，我们可以找到直接在媒介上创作音乐的源头：首先是留声机唱片，然后是磁带。具体音乐（Concrete Music），正如其名，最初指的就是由在声音再现工具上进行变化处理而产生的音乐，当年的声音再现工具为留声机唱片。当时的音乐家们从科技舞曲（techno）中汲取灵感，也从机器操作中探索创作的自由度，总结出各种创作方法，如律动闭环、重复声音采样、声音反向或改变齿轮速度等。除此之外，作曲家还增加了从录音中选择特定位置截取声音片段的操作，就像电影制作人剪下场景片段一样。

1950年，皮埃尔·舍费尔（Pierre Schaeffer）的 Essai 工作室启用第一台录音机时，具体音乐发生了变化：录制的声音对象可被分割成小片段，以便只保留一些可以自由组合的部分。

出于直觉，舍费尔认为人耳是具备创造力的：音乐家通过认真聆听，仔细分析录音来识别音乐特征，探索组合出声音片段的可能性。聆听所依赖的首要工具是麦克风。1951年，费舍尔成立了无线电具体音乐组（GRMC），并在年轻音乐家皮埃尔·亨利（Pierre Henry）和研究员亚伯拉罕·莫尔斯（Abraham Moles）的帮助下进行了声音分类研究（图4-1）。1952年他与莫尔斯共同创作了《具体音乐理论概要》（*Esquisse du solfège concret*），这是费舍尔代表作《音乐对象的规律》（*Treaty of Musical Objects*，1966）的前身。因此，具体音乐并非起源于机器，而是脱胎于音乐家的聆听过程和提取的音乐成分。

图 4-1　20 世纪 70 年代在 GRM 工作室中的皮埃尔·舍费尔

在浩如烟海的曲目中，我们需要格外铭记皮埃尔·舍费尔的《五首噪音练习曲》（*Cinq études de bruits*，1948），这首作品标志着具体音乐的诞生。此外，皮埃尔·舍费尔和皮埃尔·亨利合作的作品《为一个人的交响曲》（*Symphonie pour un homme seul*，1950）、埃德加·瓦列兹第一版本的《沙漠》（*Déserts*，1954）标志着具体音乐的第一个时代。从 1958 年 GRM（Groupe de recherches musicales，意为"音乐研究小组"）的成立开始，各种作品阐释了舍费尔和亚伯拉罕·莫尔斯设想的声音对象研究理论；比如《诱惑练习曲》（*Étude aux allures*，舍费尔，1958），以及《声音的动态练习曲》（*Étude aux objets*，舍费尔，1959）。其他作曲家创意性地采用舍费尔的理论方法，并创作出各类小体裁杰作，例如伊阿尼斯·泽那基斯（Iannis Xenakis）的《具体 PH》（*Concret PH*，1958，为布鲁塞尔世博会的飞利浦馆制作）和《东方–西方》（*Orient-Occident*，1960）。

4.2　科隆广播工作室

1951 年，科隆广播工作室诞生于西德意志广播电台（NWDR），因其影响深远，至今仍被广泛研究。正如下文所述，大量科研活动在科隆广播工作室进行，其中很重要的一项成果为 1928 年罗伯特·拜尔（Robert Beyer）在《音乐》（*Die Musik*）杂志上发表的一篇题为《关于未来音乐的问题》（*Problem der Kommenden Musik*）的充满探究精神的文章。这篇文章提出了两个主要思想，为日后的许多研究指引了方向：一是新音乐需专注于突破声音的本质；二

是新音乐需专注于诠释声音的不同方面，在更大的空间单位里重新整合各种声音成分。

但最为重要的是，作曲家赫伯特·艾默尔特（Herbert Eimert）决意探索电子声音合成的方法，这才是工作室成立的动机。艾默尔特的这一想法受到在波恩通讯与语音研究所研究声音合成的科学家瓦纳·梅耶－埃普勒（Werner Meyer-Eppler）的研究工作的启发。布鲁诺·马代尔纳（Bruno Maderna）于1951年，为长笛和磁带创作了第一版《二维上的音乐》（*Musica su due dimensioni*）。这部重要的作品与安德烈·霍德尔（André Hodeir）的作品《爵士乐和爵士乐》（*Jazz and Jazz*）一起开创了混合类电子音乐的先河，创造了一种将电子世界和器乐世界结合在一起的流派。

该工作室汇集了赫伯特·艾默尔特、罗伯特·拜尔、弗里兹·恩克尔（Fritz Enkel）和瓦纳·梅耶－埃普勒等人。这是首个以"探索新电子手段为音乐服务"为目标的实验室。埃德加·瓦列兹的梦想终于实现了。

在恩克尔的帮助下，艾默尔特和拜尔取得了工作室的第一批研究成果。这些研究于1953年在德国的达姆施塔特市（一座以新音乐暑期课程而闻名的德国城市）展示和发表。与大众观念不同的是，这些研究并没有使用正弦曲线频率对声音进行加法合成，而是使用键盘乐器产生复杂的频谱（由多个谐波组成），以及电子单弦琴和旋律琴。工作室创始人认为这些乐器是完全充分的研究手段，而且适合这个项目。

卡尔海因茨·斯托克豪森（Karlheinz Stockhausen，图4－2）于1953年从巴黎工作室返回科隆工作室，他的两项研究让电子技术与音乐创作有了更为紧密的联系。对于这些作品，斯托克豪森使用了一种被称为"广义序列"的、源自序列主义的最新创作方法。这一方法可以概括为：将序列主义原理应用于声音的其他方面而不仅限于音高。这种方法源自奥利维耶·梅西安（Olivier Messiaen）于1949年为钢琴创作的一部短篇作品《数值和强度模式》（*Modes of Values and Intensity*）。作品中的数值和强弱力度都有自己的模式，梅西安将音高建模于一个包含24个持续时间值的系列中，并将12个起音模式数值和7种不同强度的参数各自建立为单独的体系，这激发了广义序列主义的创作灵感和理念——声音的每一个参数都有自己独特的值。

最重要的是，斯托克豪森先后制作了两部小型作品《研究Ⅱ》与《音响乐队会议》，由此确立了电子音乐属于真实的记谱类作曲的身份，因为这两部作品都包含了从作品结构规划到声音材料实现的连续过程。《研究Ⅱ》（*Studie Ⅱ*，1953—1954）的乐谱由此成为电子音乐图形化记谱的标志性作品。在他之后，佛朗哥·伊万格里斯蒂（Franco Evangelisti）于1957年在提前制作好图形

化乐谱的情况下，创作了电子音乐作品《音响乐队会议》（*Incontri di fasce Sonore*）。

最后，斯托克豪森深入探索通过添加纯频率（正弦曲线）来组成复杂声波频谱的想法。他在访问巴黎工作室期间，就已尝试过这个声音实验方法，虽然未得到皮埃尔·舍费尔（Pierre Schaeffer）的认可，不过他的构想得到了亚伯拉罕·莫尔斯的支持。在科隆工作室，斯托克豪森也和工作室创始人在构思方面产生了分歧，不过他依然坚持用正弦信号的加法合成进行创作。

在斯托克豪森的电子实验作曲作品《研究 II》中，电子乐谱的记谱标记侧重于描述合成声音的物理结构，他在谱中记下的参数都各有其不同的衡量单位和维度。

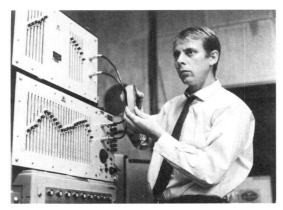

图 4-2　卡尔海因茨·斯托克豪森，约 1960 年
（图片来源：斯托克豪森音乐基金会，德国库尔滕）

音高显示为频率，以赫兹为单位。如果基音存在，则不仅显示基音，还显示每个频谱分音。

振幅以 dB（分贝）为单位显示，显示刻度样仿混音条的刻度（0 dB 至 -60 dB 或更少）。

时间显示为绝对时间或相对时间，通常以秒为单位。在斯托克豪森作品的乐谱中，持续时间以磁带的厘米数表示，录音机以 76 厘米/秒的速度播放。

有了这样的乐谱，技术人员就能够演奏出作曲家创作的作品。如今我们也可以制作出忠实于书面文本的新版本，即使它实现的声音听起来可能有所不同。

人们已迅速将由合成器产生的纯电子声音与原声乐器结合起来，尤其是人声与电子声音的结合应用得更为成熟。在这方面，最著名的电子音乐作品代表

作之一为斯托克豪森创作的《青年之歌》（*Gesang der Jünglinge*，1955—1956）。另一首是赫伯特·艾默尔特创作的《久保山爱吉墓志铭》（*Epitaph für Aikichi Kuboyama*，1960—1962）。该曲从一首诗的简单录音采样开始，通过混响和调制设备将这份声音材料进行变形处理。作曲家巧妙地使用工程师安东·斯普林格（Anton Springer）开发的"时间调节器"（Zeit Regler）对录制的声音进行了时间拉伸。此外，杰尔吉·利盖蒂（Györgi Ligeti）在人声模型的启发下也创作了《发声法》（*Artikulation*，1958）。艺术家雷纳·韦亨格（Rainer Wehinger）为这部作品创作了出色的图形乐谱。

到了 20 世纪 60 年代，斯托克豪森工作室的方向变得高度多元化，其中一些作品代表了斯托克豪森探索的新方向。经过他的整合，电子音乐不再是像绘画一样的固定作品，而是成为具备现场即兴可能性的音乐会作品。创作于 1960 年的《孔塔克特》（*Kontakte*）最初是一首独奏磁带预制作品，但后来也有为钢琴、打击乐与电子音响而创作的混合类电子音乐的版本。《孔塔克特》除了是表演最多的混合类作品之一，也因其基于一组复杂声音图形谱写的乐谱而著名。

4.3 米兰 RAI 广播电台音乐语音工作室

米兰语音工作室由作曲家布鲁诺·马代尔纳和卢西亚诺·贝里奥（Luciano Berio，图 4 - 3）于 1955 年 6 月共同建立，最初名为"米兰 RAI 广播电台音乐语音工作室"。两人在此工作室中创作的多部作品，标志着新一代电子声学音乐的演变。

图 4 - 3　卢西亚诺·贝里奥在米兰工作室设备前（马克·巴蒂耶拍摄）

工作室创始人邀请多位外国知名作曲家前来工作室进行作品创作，例如比利时的作曲家亨利·普瑟尔（Henri Pousseur），代表作品有《交流》（*Scambi*，1957），以及美国的作曲家约翰·凯奇（John Cage）。凯奇在此工作室中创作了《方塔纳混合》（*Fontana Mix*）。1961 年，贝里奥在此创作了作品《面容》（*Visage*）后，离开了工作室，由鲁伊基·诺诺（Luigi Nono）继续担任指导工作。

在 20 世纪五六十年代的电子声学音乐工作室中，处理声音材料的技术流程为：频谱滤波、剪辑声音序列将其切割成基本片段、移调、重复、编辑、混合。

贝里奥创作的重要作品《主题——乔伊斯赞》（*Tema. Omaggio a Joyce*，1958），该作品的基本文本素材来自美国歌手凯茜·贝贝里安（Cathy Berberian）朗读的英文原版《尤利西斯》（詹姆斯·乔伊斯［James Joyce］所著的小说）第十一章的开头部分。

在这部作品中，他收集了一些典型音乐风格人物的前奏片段，例如延音、卡农、颤音、断奏等。通过加速、移调、混响、回声、分裂、粒子等电子处理，将人声的音色转化为新的声音。

聆听这部作品，我们能感知到贝里奥使用的多种声音生成手法：颤音、断奏、延音、滑奏、减缩、卡农、和弦、分段、加速、混响、过滤。

1960 年，贝里奥创作的一首用于无线电广播的 21 分钟作品《面容》（*Visage* 21′）。贝里奥基于凯茜·贝贝里安用多种语言念出的 parole（意大利语，意为"词"）一词进行创作，戏剧性地糅合了由人声演绎的多种情绪（叹息、哭泣、呻吟）。

《面容》取材于《尤利西斯》的第十三章《瑙西卡》。聆听该作品时，我们能感知到 parole 一词的 6 种表现形式：

（1）3′37 低语，无伴奏合唱；

（2）6′00 低语，连续两次；

（3）10′10 耳语；

（4）13′40 大喊；

（5）17′15 言语，与电子音响融合。

4.4 纽约

1952 年，约翰·凯奇与路易斯·巴伦（Luis Barron）和比伯·巴伦（Bebe Barron）在纽约的合作标志着美国电子音乐风格的形成。在凯奇与巴伦夫妇共同建立"磁带音乐项目"（Tape Music Project）的同时，一种全新的电

子音乐创作思维正在哥伦比亚大学逐步形成。早期先驱包括弗拉德·乌萨切夫斯基（Vladimir Ussachevsky）和奥托·吕宁（Otto Luening），他们正在哥伦比亚大学进行着录制乐器、处理声音的实验。

　　吕宁自 1944 年以来一直在巴纳德学院工作，这是一座女子文理学院，而当时的哥伦比亚大学并不招收女学生。1947 年，乌萨切夫斯基被哥伦比亚大学聘用。他们都是受过专业作曲训练的音乐家，且在该领域具有一定的经验，不过新兴的技术让他们得以将音乐创作范畴扩展到其他形式。乌萨切夫斯基首先利用录音机开始进行声音实验。在大学广播电台 WKCR 工作的工程师彼得·莫西（Peter Mauzey）向他介绍了录音机这种录音设备。后来 WKCR 又配备了一台更新型的录音机。

　　此后不久，乌萨切夫斯基又获得了一台 Ampex 录音机，这台录音机是哥伦比亚大学音乐系为录制该校举办的"作曲家论坛"系列音乐会而购买的。他正是使用这台机器进行了首次声音实验。1952 年 5 月，他在哥伦比亚大学的麦克米林剧院中展现了自己的实验。考威尔（Cowell）见证了这一事件并记录称该实验包括了对录制声音进行各种转换。考威尔在评论中引用了乌萨切夫斯基的解释，并记录了他所使用的多种电子声音实验方法。第一种是使用钢琴的音域之外产生的声音，考威尔说这产生了迄今为止闻所未闻的音色。他写道："基音是听不见的，但其强大的谐波产生了闻所未闻的音色。"第二种是对声音的音色和形状进行转换和处理。考威尔观看了这些声音测试后，对乌萨切夫斯基选择不将它们称为"作曲"而只是称为"实验"感到赞同，同时表示希望乌萨切夫斯基当时就使用这些技术进行真正的作曲。考威尔补充说，这些声音，即使不是以作品的形式组合在一起，也肯定可以为作曲家提供素材。

　　很快，在吕宁的作品《低速》（Low Speed，1952）中，两位作曲家进而对自己所演奏的长笛乐句进行了电声处理，我们因而得以听到非常缓慢和交叠的长笛录音。乐句经莫西制造的设备处理后，回声效果贯穿了整个作品。同样的原理也应用在吕宁的《空间幻想》（Fantasy in Space）和《十二音内的创作》（Inventions in Twelve Tones）等作品中。

　　1952 年 10 月 28 日，这三部简短的作品在纽约现代艺术博物馆演出。在同一场音乐会上，还演奏了乌萨切夫斯基近八分钟的作品《声波轮廓》（Sonic Contour）。在该作品中，我们可以听到经过莫西的回声机处理后的变形、混合的钢琴乐句。吕宁认为，那是美国史上第一场演奏电子声学音乐的音乐会。

　　乌萨切夫斯基和吕宁继续他们的创作，并于 1955 年在哥伦比亚大学正式成立电子音乐工作室，这是美国第一家隶属于学术机构的电子音乐工作室。随后，美国和加拿大的其他大学也陆续在音乐系或大学研究部门中成立工作室。

1958 年，他们与普林斯顿大学的作曲家米尔顿·巴比特（Milton Babbitt）合作，在纽约安装了巨型的 RCA 电子音乐合成器。他们将其工作室命名为"哥伦比亚—普林斯顿电子音乐中心"（Columbia-Princeton Electronic Music Center）。在那里，米尔顿·巴比特创作了多部作品，查尔斯·沃里宁（Charles Wuorinen）和其他作曲家也参与其中。

这个工作室仍然存在，不过现在由布拉德·加顿（Brad Garton）领衔，工作室如今已被更名为"计算机音乐中心"（Computer Music Center）。

4.5　东京

从 20 世纪 50 年代初开始，日本作曲家就对电子音乐产生了极大的兴趣。日本最早录制的磁带音乐可追溯到 1953 年，是黛敏郎（Mayuzumi Tôshiro，1929—1997）在日本文化广播公司（Nippon Cultural Broadcasting）的 JOQR 工作室录制的具体音乐流派作品《XYZ》。这首先锋作品的灵感来源是年轻的黛敏郎于 1951 年至 1952 年在巴黎接触的法国具体音乐。黛敏郎在巴黎音乐学院（Paris Conservatory，全称为"巴黎国立高等音乐舞蹈学院"，法语缩写为"CNSMDP"）学习时，有幸在音乐会上听到了皮埃尔·舍费尔展示具体音乐的全部曲目。黛敏郎在这场音乐会中首次听到了具体音乐。尽管并没有严格遵循舍费尔处理碎片化声音对象的原则，但黛敏郎回国后所作的曲目体现了巴黎学派对他的影响。

几年后，位于东京的日本广播协会（NHK）仿照科隆工作室建立了一间电子音乐工作室，由此，日本电子音乐受到了科隆工作室的影响。这种影响从在 1956 年由黛敏郎和诸井诚（Moroi Makoto，1930—2013）在 NHK 工作室共同创作的作品《7 的数字原理变奏曲》（*Variations on the Numerical Principle of Seven*）便可见一斑。该作品是完全通过电子声音实现的，让人联想到斯托克豪森的两项电子研究。正是这间大型工作室见证了由黛敏郎、诸井诚、一柳慧（Ichiyanagi Toshi，1933—2022）、武满彻（Takemitsu Tôru，1930—1996）和后来于 1966 年访日的斯托克豪森共同制作的"经典"电子音乐的诞生。

尽管有黛敏郎和诸井诚两个参考西欧工作室的例子，但日本电子音乐的发展仍以探索精神和独立性为标志。这一路径始于 20 世纪 50 年代初期，发起者是一群自称为"实验工作室"（Experimental Workshop）成员的艺术家和音乐家，其中包括作曲家武满彻和汤浅让二（Yuasa Jôji，1929—　）。实验工作室甚至在黛敏郎加入之前就已开始制作磁带音乐，其中秋山邦春（Akiyama Kuniharu）和汤浅谦二使用索尼公司的早期磁带录音机创作作品。后来，这些

作曲家与武满彻和一柳慧一起搬到了东京的草月艺术中心（Sogetsu Art Centre）。1968 年，休·戴维斯（Hugh Davies）的电子音乐合集囊括了日本 32 个制作中心的作品。虽然收录的作品中，每个广播电台都只有几首，即便如此，这在当时亦是非凡的成就，也变相证明了日本在第二次世界大战后对创造新音乐形式的渴望。当然，这一现象也体现了当时在风格和实验方面较为分散且缺乏统一性。该情况一直延续到今天，日本的电子音乐研究和制作依然分散于全国各地。于 1955 年在东京创建的 NHK 工作室无法满足作曲家日益增长的需求，时至今日，仍有许多私人或隶属于机构的小型计算机音乐工作室，继续为创作需求源源不绝地提供动能。当中国正在探索统一的电子音乐实践定义，以促进该领域的教育（不可否认的是，困难是存在的）之时，日本是否也开始了尝试相似的发展模式还有待观察。

然而，"二战"结束后的第一阶段（整个 20 世纪 50 年代），日本的音乐、视觉艺术、诗歌、文学等创造性活动都在努力摆脱战前和战时被极端民族主义扭曲的价值观和暴行。为此，日本积极地研究和借鉴各领域中最新的西方潮流趋势。20 世纪 60 年代时，由于日本总算从战争造成的破坏和贫困中恢复过来，他们的艺术导向和态度也发生了变化。

如今，电子音乐已成为年轻作曲家关注的热门话题，也引起了各个音乐学院的注意。现在，想学习电子音乐的话，在日本综合大学和音乐学院有很多学术工作室可供选择，例如作曲家西冈达彦（Nishioka Tatsuhiko）或野平一郎（Nodaira Ichiro）所在的东京艺术大学、水野美香子（Mizuno Mikako，图 4-4）所在的名古屋市立大学、今井慎太郎（Imai Shintaro）所在的国立音乐学院、作曲家小岛有利子（Kojima Yuriko）所在的尚美学园大学，还有爱知县立艺术大学等，高等媒体艺术与科学研究所等院校数量众多，不胜枚举。

图 4-4　水野美香子

和中国一样，日本亟待解决专业词汇和术语翻译方面的问题。显然，电子音乐行业和学术界需要精确的术语来实现高效的交流和学习。作曲家兼学者石井博美（Ishii Hiromi）在一份简报中，提到过自己在介绍电子声学音乐或电子音乐等实践时，在选择合适的日语用语上遇到了困难，她也就此讨论了术语翻译的问题。专业词汇和术语翻译的不完善不仅阻碍电子音乐的传播，而且在赋予电子音乐艺术音乐的地位和吸引音乐学家关注的方面也造成困难。尽管存在种种困难，日本的音乐家依然致力于研习电子音乐的历史和技术，最近的例子是目前在东京艺术大学任教的作曲家兼演奏家后藤诚（Goto Suguru，图 4 – 5）出版了一本 430 页的研究文集。

图 4 – 5 后藤诚正在演奏乐器 SuperPolm

4.6 其他电子声学运动

埃德加·瓦列兹的《电子音诗》（*Poème électronique*）是电子声学音乐的代表作品之一。这部作品是 1957 至 1958 年间，瓦列兹在荷兰埃因霍温市的临时工作室中为飞利浦公司谱写的。这首作品是为了在 1958 年布鲁塞尔世博会期间在勒·柯布西耶（Le Corbusier）和泽那基斯建造的著名的飞利浦馆演出而创作的。演出时，展馆一边放映照片投影，一边演奏音乐，乐声从 400 个扬声器中播放出来。《电子音诗》是瓦列兹的第二部（也是最后一部）电子声学音乐。他之前在为器乐与电子音创作的作品《沙漠》（*Déserts*，1954—1955）中，也创作了被称为"插部"（interpolation）的部分。

史蒂夫·赖希（Steve Reich）的两部纯电声作品《出来》（*Come Out*，1966）和拥有两个版本的《天要下雨了》（*It's Gonna Rain*，1965）标志着重复音乐潮流的崭露头角。这些作品通过两个磁带的渐进移动（相位移动）或编辑简短的人声片段来进行处理和创作（人声片段来自《天要下雨了》的其中

一个版本）。

　　流行音乐一直对电子声学技术手段很感兴趣，尤其是模拟合成器开始量产之后（20世纪70年代初期）。欧洲音乐家如伊诺（Eno）、克拉夫特维克乐队（Kraftwerck）和美国音乐家苏珊·希雅妮（Suzanne Ciani）、弗兰克·扎帕（Frank Zappa）等音乐家都使用过模拟合成器。

4.7　中国电子音乐

　　电子音乐最早是由作曲家周文中（1923—2019）介绍和引入中国的。周文中于1946年前往美国深造，就读于耶鲁大学，后转入哥伦比亚大学。在纽约，他师从电子音乐作曲经验丰富的作曲家埃德加·瓦列兹。后来周文中任教于哥伦比亚大学，并与该高校成立的电子音乐工作室保持着密切联系。1978年，当他在哥伦比亚大学的事业顺利发展之时，成立了美中艺术交流中心（the Center for US – China Arts Exchange）[①]。美中艺术交流中心在培养中国青年作曲家和进行艺术交流方面发挥了奠基作用。例如，他把为他的芭蕾舞剧创作电子音乐的阿尔文·尼古拉斯（Alwin Nikolais）[②] 和其他音乐家（包括电子音乐家）、视觉艺术家和编舞家介绍给中国观众。毫无疑问的是，从20世纪70年代末开始，在新音乐走进中国的过程中，周文中的多次引荐起到了关键作用。

　　法国音乐家让－米歇尔·雅尔（Jean-Michel Jarre）于1981年访问中国，他是一位使用合成器、激光竖琴等电子乐器进行创作的音乐家。1981年10月21日和22日，他和他的团队在北京举办了大型表演。在这两场演出中，许多中国观众第一次听到电子音乐。他又于10月27日和29日在上海举办演奏会，其中27日的演奏会进行了广播，让更多的听众接触到电子音乐。

　　雅尔发行的专辑《氧气》（*Oxygene*，1976）让他在音乐上获得了成功，这张专辑的畅销不仅使他家喻户晓，更确立了他电子音乐大师的地位。他的作品在和声进行和旋律上遵循传统，属于流行音乐领域，但配器完全由新颖的电子声音组成，与其灵动而精湛的演绎相得益彰。

　　雅尔音乐会的广泛传播，被视为电子音乐首次传入中国的标志性事件。次年，即1982年11月，笔者访问了北京中央音乐学院，在回到巴黎IRCAM后，笔者向中央音乐学院寄送了包含IRCAM作品的磁带和计算机音乐的相关文件资料。

　　①　该中心于2019年关闭，但其档案一直保存在哥伦比亚大学东亚图书馆。
　　②　阿尔文·尼古拉斯是首批购买罗伯特·穆格合成器的客户之一。这批合成器目前保存在美国密歇根大学。

即使用电子媒介制作音乐的理念在 20 世纪 80 年代初期就已经引入中国，但是获取制作这类音乐所必需的技术设备却是个障碍。虽然当年已经有个人电脑，但当时的电脑昂贵、缓慢且无法处理声音。日本、英国和美国的制造商所制造的合成器更是价格不菲，其他设备，如调音台、滤波器、录音机等还只有在专业工作室中才能见到。值得一提的是，在这样的逆境面前，一些年轻的中国作曲家开拓创新，找到了创作电子音乐的方法。

中国最早的电子音乐作品为朱世瑞的《女神》。作曲家为创作该曲汇集了当时国内少有的多种合成器。该曲于 1984 年 9 月 24 日，在中央音乐学院举办的电子音乐会上面向社会公演，使用了七台合成器演奏。这场音乐会由陈元林、张小夫、谭盾、陈怡、周龙、朱世瑞共同筹办。①

据张小夫（图 4–6）所述，他们当时甚至不知道一场电子音乐的音乐会应该是什么样子的，只能凭着自己的想象去做。此外，为演出找到合适的设备也相当不容易，在 1984 年很难弄到一台 MIDI 设备（MIDI 设备在 1983 年刚刚完成）。尽管困难重重，但是那一天标志着中国电子音乐实践的开始。

图 4–6　张小夫

武汉音乐学院率先建立了电子音乐工作室。工作室于 1987 年创立，不久之后，刘健（1954—2012）和吴粤北（1957—　　）作为工作室的创建者，在武汉音乐学院开设了电子音乐学士学位课程，这是中国第一个教授电子音乐的学术课程。虽然如此，当时中国这方面的资料还很稀缺，很多年轻的作曲家都

① 王婧，一位来自杭州的学者。在她的著作《声也哲也：中国的声音艺术史》（Wang Jing, *Half Sound, Half Philosophy*：*Aesthetics, Politics, and History of China's Sound Art*, New York, Bloomsbury Academic, 2021, pp. 101–102）中详细讲述了这场演出。

觉得有必要到国外全面地学习电子音乐。

1986 年，陈元林（1957—　）着手在中央音乐学院组建计算机和电子音乐工作室。然而，和其他年轻同事一样，他决定赴美深造，并在纽约州立大学石溪分校攻读博士学位。

周文中和他的美中艺术交流中心也积极助力作曲家出国接受新音乐知识和学习电子技术：一些任职于中央音乐学院和上海音乐学院的作曲家，比如谭盾、周龙、陈怡，均在周文中的帮助下前往美国。在该中心的支持下，他们得以在学习和吸收西方技术的同时传承中国文化传统。

1989 年，张小夫获中国文化部的资助，前往法国。虽然这笔奖学金原本并非支持他专门学习电子音乐课程，而是资助他前往著名的私立学校巴黎高等音乐师范学院深造。他依靠这笔奖学金在该学院度过了一个学年。一年结束后，他决定留在法国并转向电子音乐的学习。为此，他选择就读位于巴黎西北郊小镇热讷维耶的音乐学院。在那里他跟随让・施瓦茨（Jean Schwartz）学习，让・施瓦茨不仅是著名的 GRM 的成员，还是一名民族音乐学家。一段时间后，因为张小夫没有得到后续的资助，便返回了中央音乐学院。1993 年，他在中央音乐学院成立了中国现代电子音乐中心（Center for Electronic Music of China，CEMC）。次年，他发起了首届北京国际电子音乐节。第一届的音乐节就迎接了多位外国作曲家前来观摩。随着这届音乐节的举办，各地也纷纷效仿，音乐节每两年举办一届。由此，汇聚西方作曲家、展示他们的作品并与中国师生进行交流的设想演变成为一种传统。2004 年，音乐节更名为MUSICACOUSTICA-BEJING（中文仍称其为"北京国际电子音乐节"），每年举办一次。① 多年来，张小夫不断发展基于中国作曲家实践的电子音乐理论，他坚持混合类电子音乐的创作。在这种音乐中，中国传统乐器与电子音乐同时演奏②。他在 1994 年为低音竹笛和电子音乐创作了一部作品，并在第一届北京国

①　关于音乐节至 2011 年的历史，见王鹤霏《探索和创新：北京国际电子音乐节的中国运行模式》（Wang Hefei，"Exploration and Innovation, the Chinese Model of the MUSICACOUSTICA-BEIJING Festival"，in Marc Battier and Kenneth Fields，eds.，*Electroacoustic Music in East Asia*，London，Routledge，2020，pp. 146 – 159）。

②　见张小夫从文化层面对电子音乐进行的理论探讨《从母语主干构建主体音乐语汇的力量：电子音乐创作从中国文化继承得到的启发和创新基因》（Zhang Xiaofu，"The Power of Arterial Language in Constructing a Musical Vocabulary of One's Own. Inheriting the Inspiration and Gene of Innovation in Electroacoustic Music from Chinese Culture"，in Marc Battier and Kenneth Fields，eds.，*Electroacoustic Music in East Asia*，London，Routledge，2020，pp. 125 – 145）。

际电子音乐节上演出。他给这部作品起了一个法语名字: *Le chant intérieur*
(《吟》)①。两年后，受四川和西藏之旅启发，张小夫创作了第一个版本的
《诺日朗》。这部作品的素材为他在旅途中搜集的声音和人声，回北京后，他
在工作室对这些声音材料进行了处理。作品磁带部分的演奏结合了现场打击
乐。他此后多次扩展和重新制作这首曲子，有的版本包含三种打击乐，还配有
视频、图像投影、灯光和舞蹈演出。②

2006 年，张小夫与 EMS（Electroacoustic Music Studies Network，国际电子
音乐研究协会）及同事肯尼斯·菲尔茨（Kenneth Fields）在北京共同组织举
办了第三届 EMS 年会，这是一场以电子音乐为分析和讨论主题的大型学术讨
论会谈。（如图 4 – 7）

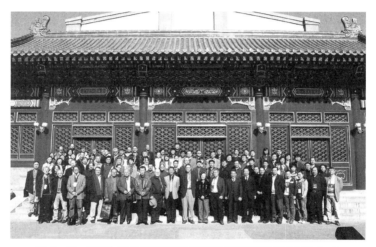

图 4 – 7　2006 年北京国际电子音乐节暨第三届 EMS 年会

两年后，他在北京国际电子音乐节期间举办了第一届 "亚洲电子音乐日"
（EMSAN Day）主题论坛。从那时起，专门研究亚洲电子音乐发展的 "亚洲电

①　见李秋筱《中国大陆早期电子音乐的特点》（Li Qiuxiao, "Characteristics of Early
Electronic Music Composition in China's Mainland", in Marc Battier and Kenneth Fields, eds.,
Electroacoustic Music in East Asia, London, Routledge, 2020, pp. 135 – 145）。

②　关于《诺日朗》的分析，见马克·巴蒂耶《张小夫所作〈诺日朗〉》（Marc
Battier, "Nuo Ri Lang by Zhang Xiaofu", in *Between the Tracks. Musicians on Selected Electronic
Music*, Cambridge MA, The MIT Press, 2020, pp. 174 – 193）。亦见赵晓雨《张小夫多媒体交
响乐〈诺日朗〉创作对话》载《音乐·科技》，中央音乐学院 2016 年版，第 49 – 55 页。

子音乐日"主题论坛多次在中央音乐学院举办。①

经过多年的发展，北京国际电子音乐节已成为中国电子音乐发展的重要组成部分，后来逐渐增设音乐会系列讲座、研讨会和作曲比赛等活动。

如今，由李小兵教授担任系主任的中央音乐学院音乐人工智能与音乐信息科技系，云集了一批电子音乐和计算机音乐创作者和研究者。

1984 年，上海音乐学院在所开设的电子音乐课程中引入了 MIDI 系统。另一个重要里程碑是作曲家许舒亚（1961— ）的作品《太一 II》。该曲目创作于 1991 年他在巴黎 GRM 学习期间，是一首为长笛和电子音乐（预制）而作的曲目，是一首混合类电子音乐作品。后来，许舒亚返回上海，担任上海音乐学院教授。

另一位电子音乐作曲家安承弼（1967— ）也来自上海音乐学院。他毕业于巴黎音乐学院。在上海音乐学院任教时，他培养了许多现场实时混合类电子音乐艺术方面的学生。安承弼的主要创作手法是使用 Max/MSP 软件、在演奏过程中实时处理触发的乐器和播放预制声音材料。许舒亚和安承弼都曾在巴黎音乐学院接受过教育。但如上所述，许舒亚曾在 GRM 学习，而安承弼更倾向于使用实时交互软件，例如在 IRCAM（图 4 - 8）中广泛使用的 Max/MSP。他们所受教育流派的差异解释了二人音乐风格的多样性。

FORUM IRCAM Hors Les Murs Shanghai
IRCAM国际论坛│上海

31 Octobre - 2 Novembre 2019 Conservatoire de musique de Shanghai
31st October - 2nd November 2019 Shanghai Conservatory of Music
2019年10月31日—11月2日 上海音乐学院

图 4 - 8 2019 上海音乐学院主办的 IRCAM 国际论坛

上海音乐学院曾多次举办各种会议，成为中国电子音乐发展的重要枢纽。

图 4 - 9 为 2010 年在上海音乐学院举行的 EMS 年会的组织者和部分与会者。2019 年，上海音乐学院主办了当年的 IRCAM 国际论坛，该论坛每年在全球的不同城市举行，介绍 IRCAM 开发的软件工具的进展和应用情况。

① 如需了解更多详情，可访问 http://www.ums3323.paris-sorbonne.fr/EMSAN。

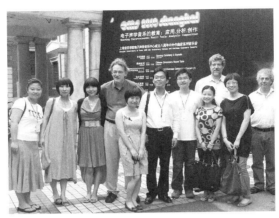

图 4 –9 　2010 年在上海音乐学院举办的 EMS 年会组委会成员

　　徐仪 (1963—) 也是上海音乐学院的著名作曲家。在法国和中国生活期间，她的多部作品获得了国际认可。她和许舒亚同是"新浪潮"运动①的一员。其他开设电子音乐课程的学府包括浙江音乐学院（张小夫的学生李秋筱执教）、西安音乐学院（曾在上海跟随安承弼学习的周媛执教），以及四川音乐学院。四川音乐学院的胡晓教授向众多学生介绍电子音乐，如今陆敏捷（图 4 – 10）也在四川音乐学院教授电子音乐课程，她本人也是互动音乐和装置艺术的主要实践者。还有武汉音乐学院，武汉音乐学院在电子音乐也有着多年历史，如今依然活跃在该领域内。该学院的电子音乐课程早期由前文提及的刘健和吴粤北开设，现今由李鹏云主讲。

图 4 –10 　陆敏捷

　　①　参见 Zhou Jinmin, *New Wave Music in China*，博士学位论文，马里兰大学，1993 年。

多种风格的交叉影响是不可避免的。年轻作曲家无论是选择出国留学还是留在国内接受当地教师的教育，学校和教学方法的不同总是会产生不同的影响。例如，曾赴欧深造的教师之间都会接触到不一样的流派技术。即使他们同去法国，他们对电子音乐和计算机音乐的态度也会因所在学校和教学方法等原因而有所不同。如果他们在 GRM 或受到 GRM 影响的学院学习，就会受到以"在固定媒介上创作作品"为主要研究活动的美学熏陶。但如果他们参加 IRCAM 计算机音乐课程，就会更喜欢使用 Max/MSP 为乐器和实时电子处理工具创作作品。Max/MSP 软件是 20 世纪 80 年代后期米勒·帕克特在 IRCAM 时设计的，之后由美国的 Cycling 74 公司进一步开发和商业化。在德国或英国接受教育的作曲家也会有类似的差异，这两个国家在电子音乐和计算机音乐方面都非常活跃。至于在美国或加拿大学习的作曲家，其风格实践往往又与欧洲不同。

此外，在中国，电子音乐本土化的趋势日益明显。当代作品中以新形式呈现的中国音乐元素比比皆是。例如，中国的创作人将全国各地各种形式的曲艺和传统剧目整合到电子曲式构造中。同时，还出现了越来越多的混合类电子音乐作品，这些作品融合了中国乐器和电子音乐，形成了颇具影响力的风格流派。通过与中国文化元素建立紧密联系，中国电子音乐作曲家将电子音乐的创作从对西方的因袭中脱离出来。

在中国的香港、台湾和澳门，也可以观察到这种趋势。电子音乐在 20 世纪七八十年代开始蓬勃发展，在香港和台湾的发展尤其迅速。在香港，香港演艺学院的麦伟铸（Clarence Mak）以及香港城市大学创意媒体学院的林德伯格（Magnus Lindborg）和池城良（Ryo Ikeshiro）都有开始电子音乐的课程。台湾也有不少教师以作曲家和研究人员的身份从事电子音乐工作：如有黄志芳，除指挥和作曲之外还从事人工智能研究；还有曾毓忠，教授电子音乐的同时，也是该领域最活跃的作曲家之一。澳门在电子舞曲领域非常活跃，可惜这个领域不在本书的讨论范围之内。中国电子音乐作曲家感兴趣的另一个领域是非学术类电子音乐，通常被称为"实验性"电子音乐。实验性电子音乐在中国已经形成了一个相当活跃的社群，有专门针对这一趋势而举办的展览和音乐节。其中一些活动由作曲家姚大军发起，在北京和上海举办。有兴趣了解更多信息的读者可以参阅前文所引用的王婧的著作①，以及活动的组织者之一闫军的

① 王婧，同前，第 106–121 页。

短评①。

4.8 重复性电子音乐、新世纪音乐、氛围音乐

4.8.1 氛围音乐

氛围音乐着重于在逐步演化和渐变的声音纹理之上营造的"情绪"和"气氛"。可能会加入鼓音轨，但不常使用。氛围音乐的结构非常松散，音色富含混响，作品时段偏长，形成延绵不绝的听觉体验。

4.8.2 布莱恩·伊诺

布莱恩·伊诺（Brian Eno）的事业始于 20 世纪 70 年代初期（1971—1973），当时他在英国摇滚乐队罗西音乐（Roxy Music）担任键盘手，演奏 VCS3 合成器。VCS3 合成器于 1969 年引入英国，他也是最早在摇滚乐队里演奏合成器的音乐人。

开启摇滚生涯后，伊诺创造了氛围音乐这一风格。

4.8.3 《机场音乐》

布莱恩·伊诺在《机场音乐》（Music for Airports，1978，如图 4 - 11）这张专辑中，首次使用"氛围"一词来描述这种音乐风格。氛围音乐的形式即目的：它是一种环境音乐，是静态的，没有展开或对比的部分。它可以比作声音装置（展览或艺术画廊的背景音乐）。

这张专辑收录四首曲目，被简单地称为《1/1》《2/1》《1/2》《2/2》。

第一首曲子基于钢琴和电钢琴上演奏的主题创作，由多种长度的磁带循环并混合而成。这样，各个元素始终是不变的，但它们在不同的模式中呈现，故此为熟悉的语境加入了多样性。第二首（《2/1》）使用了四个声音：三个女声和伊诺本人的声音。这首曲子使用了移调和循环的方法。第三首（《1/2》）是前一首的延续和衍生，但用的是钢琴。最后一首（《2/2》）完全由 ARP 2600 合成器制作而成。

① 闫军，《再发明：实验音乐在中国》（Yan Jun，"RE - INVENT: Experimental Music in China", in Christoph Cox and Daniel Warner, *Audio Culture. Readings in Modern Music*, New York, Bloomsbury, revised edition, 2017, pp. 345 - 352）。

图 4 – 11　专辑《机场音乐》封面

4.8.4　《星期四下午》

《星期四下午》（*Thursday Afternoon*）是伊诺制作的一段视频，配有一整部氛围音乐作曲。他称之为"视画"（video painting）。《星期四下午》创作于 1986 年，是伊诺专门为 CD 这项当时的新技术而创作的。伊诺购买了一台摄像机用于拍摄，再处理拍摄的图像。

这部氛围音乐的作曲风格舒缓而静谧，音频材料主要是钢琴和合成器。

4.8.5　哈罗德·巴德

哈罗德·巴德（Harold Budd，1936—2020）是一位美国钢琴家和作曲家，以极简的氛围风格音乐而著名。他演奏的钢琴声具有长混响效果。巴德与伊诺合作制作了几张唱片。

他发行了专辑《氛围音乐 2：镜之高原》（*Ambient 2：The Plateaux of Mirrors*，1980），以及与伊诺合作制作的《白色拱廊》（*The White Arcades*，1988）等。《白色拱廊》包含九首曲目，部分曲目是他与其他音乐家一起录制的。

4.8.6　西蒙·斯托克豪森

西蒙·斯托克豪森（Simon Stockhausen，1967—　　）乃卡尔海因茨·斯托克豪森之子。他善于演奏萨克斯管和合成器。他也是一名声音设计师，为诸如

Arturia 公司开发的 Pigments 等软件制作程序补丁（如图 4 - 12）。

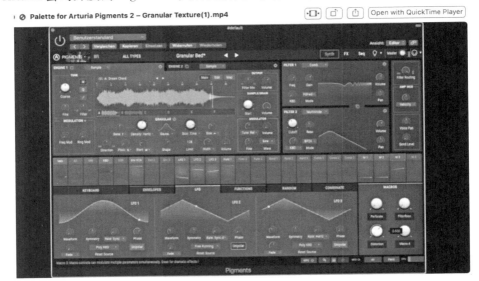

图 4 - 12　西蒙·斯托克豪森制作的 Pigments 补丁

4.8.7　重复性电子音乐

重复性电子音乐使用合成器，以极简主义为原则创作。该风格于 20 世纪 60 年代后期起源于德国，并于 70 年代在美国兴起。这类风格而后被科技舞曲风格、氛围音乐风格和新浪潮风格吸纳和使用。

代表音乐家有德国的橘梦乐团（Tangerine Dream）、克拉夫特维克乐队、克劳斯·舒尔茨（Klaus Schultze）以及美国的苏珊·希雅妮。

4.8.8　苏珊·希雅妮

苏珊·希雅妮（图 4 - 13），是一名美国作曲家、表演家，使用模拟合成器进行创作。她于 20 世纪 60 年代末在加利福尼亚米尔斯学院（Mills College）接触到"波科勒"（Buchla）合成器后，对其产生了强烈的兴趣。后因用波科勒合成器进行创作和演奏而闻名。

图 4-13 苏珊·希雅妮演奏布克拉合成器

4.8.9 克拉夫特维克乐队

克拉夫特维克乐队是一支德国乐队。他们因为从 20 世纪 70 年代开始创作机器人电子音乐而为人所知。

乐队的代表专辑有《环欧快车》（*Trans-Europe Express*，如图 4-14）等。

图 4-14 专辑《环欧快车》封面

4.8.10 橘梦乐团

橘梦乐团于 1967 年在德国成立，成员是以创立者埃德加·弗罗斯（Edgar Froese）为核心的几位音乐家。

20 世纪 70 年代，橘梦乐团凭借其充满空间感和梦幻感的电子音乐打开知名度。他们的音乐风格通常被称为"电音"（electronica）。

橘梦乐团的代表专辑有《费德拉》（*Phaedra*，1974，如图 4 – 15）等。

图 4 –15　专辑《费德拉》封面

5
世界电子音乐的形式

1957 年，当美国贝尔实验室（Bell Laboratories）的马克斯·马修斯（图 5 -1）正在研发一台内存为 4096 个字节的新型计算机 IBM 704 时，他编写出了第一个数字声音合成程序。该程序就是目前为大家所知的 MUSIC Ⅰ，即 MUSIC 系列程序的首个成品。它能够通过一系列代表声级变化的数字产生声波，1 秒钟的声音采样率（声音的数字化）约为 1 万个样本。

图 5 – 1　马克斯·马修斯在加利福尼亚州的家中工作（马克·巴蒂耶拍摄）

MUSIC Ⅲ（1960）引入了模块化乐器的概念。为马克斯·马修斯设计的模型带来启发的主要是实验室设备或电子音乐类工作室，而不是原声小提琴乐器制作。该程序提供一系列独立模块（单元发生器，现在称为 "操作码"），每个模块都加载了一个基本功能，如可编程波形振荡器、信号加法器、乘法器、包络和随机信号的发生器等。

音乐家将一系列模块连接起来，创建工程文件，从而构建出 "乐器"。振荡器或发生器产生的信号被传送到其他模块进行修改或混合。多个乐器可以组合成一个 "管弦乐队"，每个乐器都独具音色特点。不同于现实中的实体乐器，只要计算机内存没有限制，可以同时使用的模块数量是没有限制的。该乐

211

器的实施结果是以数字序列的形式逐步组成和计算声音的，数字序列首尾相连，产生复合声波。这些数字称为"样本"。如今，最常见采样数是 1 秒钟内每个通道 44100 个样本（每秒每通道 48000 个样本也很常见）。

由于过去机器运行缓慢以及需要进行大量计算，产生声波所需的时间远比声音的持续时间要长，因此程序运行具有"延时性"。最初，数字计算的声波存储在数字磁带上，当采样计算块完成时，磁带就会滚动播放，这种发声方式称为"直接合成"，这一过程会创建一个声音文件。在声音文件创建完成后，音乐家调用第二个程序，该程序实时播放声音文件并将样本发送到数模转换器，该转换器连接到放大器和扬声器。如今这些操作都已经整合到了一起。

如要调用"管弦乐队"，音乐家必须编写乐谱，并指定乐器模块的所有必要参数。该乐谱以数字或符号代码列表的形式呈现，每个"音符"或"事件"代表特定列表的主题，这些列表按时间排序。本书将在后续章节介绍如何使用 Csound 程序实现这些操作。

逐个模块指定参数是一项繁杂艰巨的任务，尤其因为音乐家往往缺乏相关培训，不擅长为他们操纵的声音维度提供测量值。为了克服这个障碍，人们致力于开发编写乐谱的程序语言；其中最著名的是利兰·史密斯（Leland Smith）的 SCORE 程序（1972）。SCORE 不是自动作曲程序，它允许使用音乐术语（音高、细微动态、时长）来指定参数，自动计算速度或细微动态的差异，甚至使用与作曲家给出的音乐轨道对应的音符创作出完整的旋律。

随着 MUSIC Ⅳ（1962）的问世，乐器/乐谱模式得以牢固确立。这个程序衍生出许多语言程序，其中一些沿用至今。在这些语言程序中，有 MUSIC4BF（1966—1967），它现今已有适用于 Macintosh（苹果电脑系统，简称 Mac）的版本（MUSIC4C，1989）；还有巴里·菲尔柯（Barry Vercoe，1968）的 MUSIC360，它具备实时编程语言的特质，因此如今与 Cmusic 一同成为使用最广泛的声学编译器。1973 年，Cmusic 首次应用于 Digital 公司的 PDP-11 微型计算机，1985 年，开发者使用 C 语言重新编写了该语言，将其取名为 Csound。Csound 迅速广泛应用于各种计算机平台，包括苹果系统和微软系统等个人电脑系统。

1969 年，MUSIC V 诞生，这是一个为方便乐器和乐谱音乐编程而设计的程序。MUSIC V 现今已较少使用，较常使用的版本是理查德·摩尔（Richard Moore）改编的 Cmusic（1980）。

计算机在推测成分非常高的音乐学分析领域也取得了巨大的成功。20 世纪 60 年代初，在充满好奇的公众眼里，计算机科学仍然相当神秘难懂，计算机音乐也显得新奇古怪。当时从作曲到音乐学，最后到声音制作（特指贝尔

实验室的声音制作），统统都给人留下这样的印象。与此同时，马修斯的程序在 20 世纪六七十年代在其他院校得到应用和研究，例如纽约大学、普林斯顿大学和斯坦福大学。

个人电脑发展一日千里，令人赞叹。1984 年第一台苹果电脑问世时，它配备的是 128 kB 的内存。不久后，苹果又推出了第二代版本，内存为 512 kB。1986 年，人们可以购买内存为 1 MB 的苹果电脑，当时数据和程序都储存在 3. 5 英寸的软盘上，分为单面高密软盘（720 kB）和双面高密软盘（1.44 MB）。这意味着一个程序及其数据往往要连续存储在几张磁盘上，用户必须一张一张地加载它们。可见当时要用计算机工作，确实需要不少耐心和时间！

而如今，一台普通笔记本电脑的内存至少为 8 GB，即 80 亿字节。

5.1 乐器和电子音乐分析：混合类电子音乐

本节中将摘录一些非常简短的乐谱片段，这些乐谱来自为乐器和电子音乐创作的作品节选。从中我们可以发现，演奏者能够使用各种不同的方法与电子设备对话。有些作曲家使用固定媒介，即提前实现和录制所有的电子音乐，并在表演期间回放。这种方法我们通常称为"为乐器和磁带而作"，其中"磁带"一词让人想起数字媒体时代之前使用的旧磁带。下文示例包括马克·巴蒂耶（Marc Battier）、王鹤霏、木村麻里（Mari Kimura）、若昂·佩德罗·奥利维亚（João Pedro Oliveira）等作曲家的代表作品。这些作曲家的每一份乐谱都展示了器乐演奏者与无形的电子音乐一起演奏的不同方式。例如，在本章第 5.1.13 节的例子中，作曲家安承弼增加了一个复杂的扩散系统。

除了上述的回放电子音乐外，录制媒介更多是通过电子设备实时处理来播放的，比如杨晓曼的作品。有时，精密的数字处理器会对乐器声音进行收音和变形，比如丹尼尔·泰鲁吉（Daniel Teruggi）的作品，或者在打击乐器上使用接触式麦克风来实时触发电子音乐素材，比如克里斯托弗·多里安（Christopher Dobrian）的作品。

近年来，甚至可说从 20 世纪 80 年代开始，作曲家就已经将计算机视作创作伙伴，并在表演者与电子音乐装置之间引入交互。木村麻里和菲利普·马努里（Philippe Manoury）的作品就是这样的例子。

5.2 菲利普·马努里，《木星》

菲利普·马努里，法国作曲家，曾于 20 世纪 70 年代学习电子和计算机音

乐。那一段学习经历，促使他将乐曲的创作与他在学习期间了解到的音程组、节奏与和声的组织概念相结合。例如，他将马尔可夫链理论（Markov chains）应用于音高和节奏组织。此外，他坚信就电子音乐而言，表演者应该在表演过程中有影响电子设备并与之互动的行为。因此，当巴黎 IRCAM 委托他创作用于长笛独奏和电子音乐的新作品时，他希望乐器可以用交互的方式与电子音乐进行对话。以下是他为长笛和4X 数字处理器创作的《木星》（*Jupiter*，1987）。

在《木星》中，长笛与数字处理器之间形成交互。首先，作曲家通过声音处理软件将声音进行变形处理：

（1）使用谐调器（即"谐波调制器"，又称"和声器"）将声音向上或向下移调；

（2）使用移频器；

（3）使用无限混响效果器，产生持续共鸣效果，直到电子设备收到停止共鸣的指令。

所有这些指令皆由名为 Max 的程序触发。Max 是一款实时处理交互性声音的图形化编辑软件。

然后，移调音程由谐调器接收，并在乐谱中注明。如图 5 - 2 所示，长笛演奏 do#，由两个谐调器进行转调。底部五线谱是长笛，顶部五线谱是处理后的电子声音。

图 5 - 2　通过使用协调器进行移调

接着，移频器调制振荡器的频率（比音高的变动更细微）。如图 5 - 3 所示，长笛演奏 do#，移频器设置为 10 Hz，从而产生颤音。

图 5-3 移频器进行长笛 do#调制

最后，可以将这些处理器（谐调器、移频器、混响效果器）连接起来，输出的结果从一个处理器输出并被传送到另一个处理器。如图 5-4 所示，移频器的输出被发送到谐调器，然后，谐调器的输出被发送到混响效果器。

图 5-4 各种处理模块的衔接

此外，还有一些真正的交互过程。有时，计算机会记录下长笛的演奏，简短的录音经过分析和识别后被转换成 MIDI 数据，随后用于播放预先录制的长笛或其他声音。如此一来，作品《木星》的每一次演出都是独一无二的（如图 5-5）。

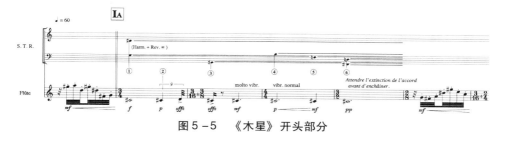

图 5-5 《木星》开头部分

5.3 马克·巴蒂耶,《山中薄暮》

《山中薄暮》(*Mist on a Hill*,部分曲谱见图 5 - 6、5 - 7),是马克·巴蒂耶受张小夫委托为 2009 年北京国际电子音乐节所创作的曲子,由琵琶和电子音乐(分为 4 个部分)组成。该作品没有采用乐器和电子设备之间的交互,而是将琵琶置于中心地位——以琵琶驱动这部作品,电子音乐如空中云彩般平铺在四周。不过,电子音乐也有一个独奏部分,但所有电子音乐的声音素材皆来自对琵琶声音采样的变形处理。在作曲过程中,巴蒂耶与几年前在北京结识的表演者高韵翔进行了多次交流。作曲家和表演者通过前者给后者发送乐谱片段,后者回以演奏录音的方式进行交流并讨论乐谱。对于这部作品的分析,可参见秦宏达的论文①。

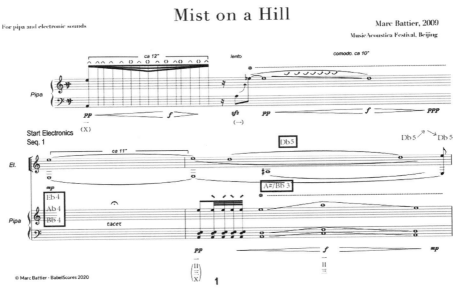

图 5-6 《山中薄暮》第 1 面,秦宏达补充注释

① 秦宏达:《Marc Battier、Kee Yong Chong 和 Gene Coleman 的音乐:21 世纪传统亚洲乐器和电子产品的作曲》(Chin Hong-Da, *The Music of Marc Battier, Kee Yong Chong and Gene Coleman: Compositions for Traditional Asian Instruments and Electronics in the Twenty - First Century*),博士学位论文,博林格林州立大学,2017 年。

　　琵琶录音经过各种软件的处理和混合，形成对比材料。作曲家在工作室使用的软件能够改变声音的时域值，通过拉伸深度改变琵琶的音色和质地，使琵琶时而发出像人声的声音。

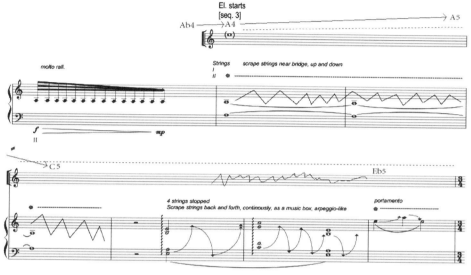

图 5 - 7　　《山中薄暮》第 7 面，秦宏达补充注释

　　《沙沙作响，闪闪发光》（*Rustle and Shimmer*，2019，部分曲谱见图 5 - 8），是为竹笛、打击乐和电子音乐创作的作品，它在北京首演。在此乐曲中，从扬声器中发出的所有声音都来自对打击乐的录音采样，并经过大量声音处理和加工，使声音在人工处理后极具电子音乐质感。通过这种方式创作的乐曲，与蒂埃里·米罗格里奥（Thierry Miroglio）在北京国际电子音乐节开幕表演中现场演奏的声学打击乐，以及李越演奏的竹笛、新笛和埙的作品形成了鲜明对比。

　　打击乐的处理主要使用 GRM Tools、时间拉伸软件、带通和低通滤波器，并使用 Pro Tools 和多频段 McDSP ML4000 限幅压缩器进行混音。

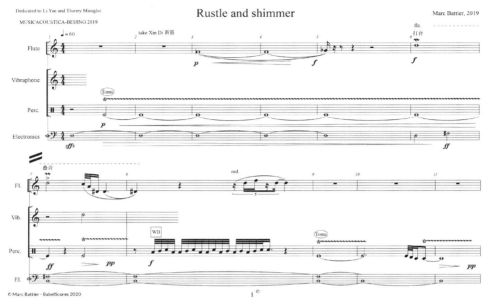

图 5-8　《沙沙作响，闪闪发光》第 1 面

5.4　若昂·佩德罗·奥利维亚,《及时》

　　若昂·佩德罗·奥利维亚的《及时》(*In tempore*) 中使用了别具一格的方法。电子音乐部分,作曲家采用的是磁带声部,像钢琴曲谱一样精确地记谱(如图 5-9)。这份 16 页的乐谱创作于 2000 年,它尽可能严格地记录了磁带上的声音材料。作曲家不遗余力将这些声音材料记录到五线谱上,以充分展现其生动和短小精悍。

　　《及时》的钢琴创作也很灵活,即使音色和质地部分都是生成声音,乐器演奏者可以随着电子音乐事件的展开而演奏。作品的创作中包含了加速或减速的段落,对磁带预制音乐的严格记谱成为钢琴和电子音乐部分同步的重要辅助工具。

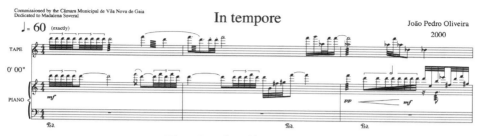

图 5－9 《及时》开头部分

5.5 王鹤霏，《琼楼引》

王鹤霏在为古筝和电子音乐创作的作品《琼楼引》（*Fairyland*）中要求演奏者严格保持与录制后播放的电子音乐的同步。这部作品的记谱精确地记录了节拍的频繁变化以及许多速度变化。为了帮助演奏者，固定的电子音乐部分以可以展现振幅峰值的图形表示，如图 5－10 所示。第 80 小节中电子音乐部分的振幅图形与固定媒介的强重音同时开始，并同时展开 5/8 拍的段落。在第 87 小节及作品其他小节中，也可以看到同样的事件。

对于这种方法来说，古筝演奏者需要花大量的时间练习，才能根据预制电子音乐部分来调整演奏。

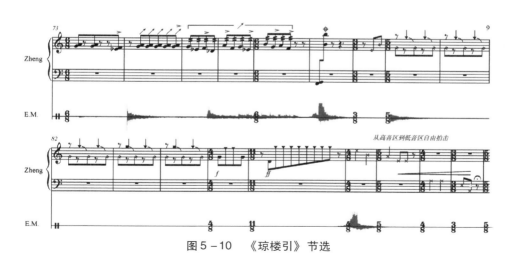

图 5－10 《琼楼引》节选

5.6　水野美香子，《卡伊马克勒》

2013 年，日本作曲家水野美香子（Mikako Mizuno）为双簧管和四声道电子音乐创作了作品《卡伊马克勒》（*Kaymakli*，部分曲谱见图 5 – 11、5 – 12）。音乐中的一部分声音是在土耳其的洞穴遗址中录制的，另外大部分都是她在日本的工作室用程序制作生成的。这首乐曲的名字源于古老的土耳其地下城卡伊马克勒（Kaymakli），城中隧道错综复杂，那里正是作曲家捕捉采样声音的地方。电子音乐部分由四个声道演奏，双簧管与四声道形成对话。

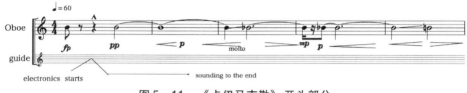

图 5 – 11　《卡伊马克勒》开头部分

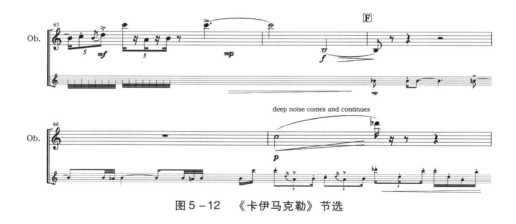

图 5 – 12　《卡伊马克勒》节选

5.7　杨晓曼，《卖火柴的小女孩幻想曲》

杨晓曼的作品《卖火柴的小女孩幻想曲》（*Fantasia of the Little Match Girl*，部分曲谱见图 5 – 13）是为长笛、大提琴与电子音乐而作的作品。电子音乐部分由各种经过处理的声音材料组成。作品的开头片段使用了插件 GRM Tools 中的 shuffling 效果器，其他的声音处理在作品后部出现，比如反转和延迟。乐谱中还详细精确地显示出电子音乐的层次和元素，如钟声、铃铛和旁白朗诵文

本，包括小女孩朗诵著名童话故事《卖火柴的小女孩》的一个小片段。各种声音共同将听者带入情景，重现那个与作品同名的童话故事。

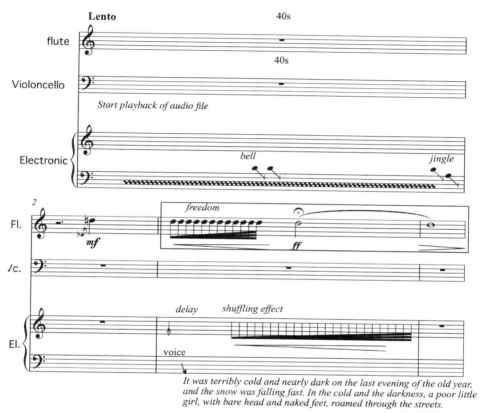

图 5－13 《卖火柴的小女孩幻想曲》节选 1 开头部分

如图 5－14 所示，曲谱的第 2 面，大提琴进入，与电子音乐以及作曲家在乐谱中所描述的长笛"气声"形成对话。

2

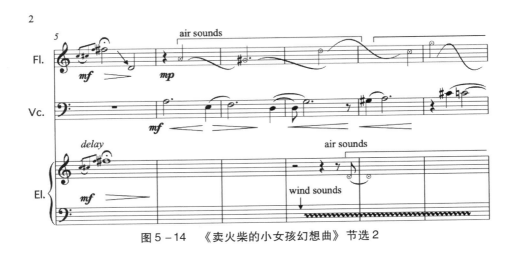

图 5 – 14　《卖火柴的小女孩幻想曲》节选 2

5.8　胡晓，《疏影淡月》

2019 年至 2020 年，胡晓为钢琴与电子音乐创作了《疏影淡月》（*Vague Shadow—Mild Moonlight*）。他指出该作品的电子音乐部分是由钢琴采样以及预制声音材料变形处理而成的。演奏者必须使用小型电子设备"电子弓"（e-bow）来维持一些弦的共鸣，如"e-bow sound – 1 mod."（见图 5 – 15，第 1 小节）和"e-bow sound – 2 mod."等标记处。经由扬声器播放的经过电子手段处理的材料，没有采用图形化标注的方式标注在乐谱中，而是文字注释的形式出现（见图 5 – 15，第 2 和第 6 小节）。因此，这些事件是与钢琴演奏同步进行的。这是一个依靠乐器和电子声部之间的紧密联系来记谱的例子。

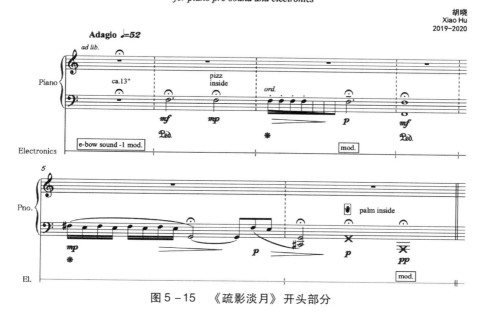

图 5 – 15　《疏影淡月》开头部分

5.9　克里斯托弗·多里安，《0˅0》

　　美国作曲家克里斯托弗·多里安在这首为打击乐和计算机而作的音乐乐谱中，选择以零散的方式标识电子音乐部分的介入。这是因为打击乐器配备了四个接触式麦克风，它们直接放置在乐器的不同位置上（另外还有两个电容式麦克风捕捉整体声音）。接触式麦克风拾取的音频信号主要被软件用作触发器，计算机乐谱由乐器的触发器引导。

　　《0˅0》（部分曲谱见图 5 – 16）使用的软件是 Max for Live：它由 Max/MSP 软件和 Ableton Live 软件组合而成的。多里安一直是 Max 方面的专家，他在早期撰写了大量关于 Max 的文章。有了这个系统，表演者不需要在程序运行中接收任何视觉提示，因为它是完全自动化的。有时，表演者会即兴表演，电脑也会即兴演奏。这个作品中的乐器和电子音乐都受到爵士风格的启发，使用相同的和弦进行，因此它们始终处于相同的和声领域。

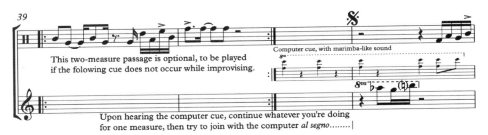

图 5 − 16 《0ˆ0》第 39 小节及后续

5.10 木村麻里,《弹性卡农》

木村麻里（图 5 − 17）是旅居美国的日本作曲家和演奏家。作为一名小提琴演奏家，她为小提琴与一套电子处理器和软件创作了一系列作品。尤为特别的是，木村麻里还研发了一款用来捕捉握弓时手部位置和动作的运动传感器。该动作传感器采用了 Arduino 硬件套件，同时还遵循各种其他设计，其中一些设计是木村麻里驻留巴黎时，在 IRCAM 从事研究期间制作的。

图 5 − 17 木村麻里演奏带 MUGIC 动作传感器的小提琴

《弹性卡农》（*Canon élastique*，如图 5 − 18）是一首为小提琴和交互系统创作的作品。该作品创作于 2010 年，当时木村麻里以常驻作曲家的身份在巴黎 IRCAM 度过了一个夏天。IRCAM 研究所拥有一个实时音乐交互开发团队，木村麻里在创作过程中会使用他们开发的一些工具。比如，木村麻里在作品

《弹性卡农》中主要使用了一个软件系统。这个系统将她演奏的内容保存在一个缓冲存储器中，然后，她可以修改录制的内容，并将修改后的版本作为第二声部演奏，由此形成音乐卡农的概念：因为这样可能会影响音高，从而影响和声进行。另外，在这首作品中，她自行开发了可以佩戴在右手上的动作传感器MUGIC。

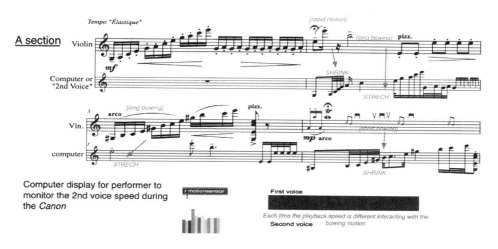

图 5-18　《弹性卡农》中交互式卡农系统示例

5.11　陆敏捷，《胡杨林素描 Ⅱ》

陆敏捷的作品《胡杨林素描 Ⅱ》（*Populus Sktech* Ⅱ，部分曲谱见图 5-19）是为长笛和 Kyma 的实时处理程序而作的作品。Kyma 是一个驱动 Pacarana 数字硬件设备的软件，广泛应用于实时合成和处理，特别是在交互情况下。Kyma 的主要使用者包括经常在中国演出的杰弗里·斯托雷特（Jeffrey Stolet）、中国作曲家王驰和陆敏捷等。

在陆敏捷的作品中，长笛和电子声部之间建立起非常紧密而灵活的对话。乐谱中使用的一些图形和文字符号是电子音乐声音材料的指引。

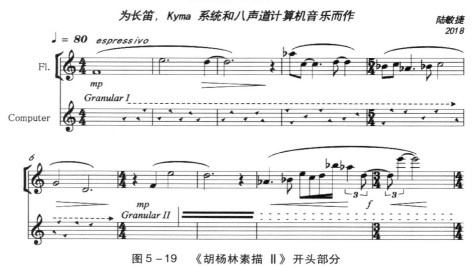

图 5 - 19　《胡杨林素描 Ⅱ》开头部分

5.12　安东尼·德·里蒂斯,《水。生命》

在安东尼·德·里蒂斯（Anthony de Ritis）2012 年创作的作品《水。生命》（*Shui. Life*）中，二胡与四声道电子音乐材料形成对话。如图 5 - 20 片段所示，该作品展现了在制作电子音乐部分中使用的各种处理方法。里蒂斯利用 Max 程序实现了水声的处理。这首音乐的灵感来源于水资源等可持续资源的问题，并于 2015 年在与联合国教科文组织及水资源保护相关的活动中演出。

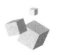

图 5 – 20　　《水。生命》节选

5.13　安承弼,《声音组装》

安承弼曾在上海音乐学院任教,现居欧洲,他常常收到大量混合类电子音乐作品的创作邀约。2006 年,他受 GRM 的邀约,创作了为钢琴独奏和电子音乐而作的 5.1 多声道环绕作品《格调》。该作品在法国首演,此后在 2008 年巴黎举行 EMS 年会上再次演出。

《声音组装》(*Sound Assembly*)也是使用 5.1 多声道环绕系统,为钢琴独奏和电子音乐而作的作品。这首受德国柏林艺术学院电声音乐工作室委约创作的作品,在 2019 年 6 月的孔塔克特音乐节(Kontakte)期间首次演出。

演奏《声音组装》需要一些技术设备。钢琴内必须放置三个麦克风以捕捉乐器的不同音域。还要按照乐谱的说明放置五个扩音器:三个放在观众面前,两个放在左右两侧。

在典型的 5.1 多声道配置中,调音台接收麦克风和电子音乐部分的所有信号,并将音频发送给五个扩音器和低音频扩音器。

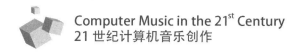

图 5 – 21 是这个装置的图示：

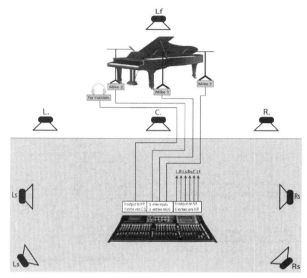

图 5 –21　　《声音组装》的配置

　　如图 5 – 22 所示，《声音组装》的第 9 面乐谱展示了钢琴家记谱法的复杂和精确。

　　在这一段的第一个系统中，表演者的演奏从在钢琴本体（corps de piano）上转到键盘上。图 5 – 22 的第二个系统显示了踏板的精准记谱，手的图案表明演奏者必须用双手划过琴弦。

　　同时，电子音乐部分用三种方式记谱。底部表示振幅变化，就像示波器显示声音一样。这部分曲谱不指示音高或音色，只有整体振幅包络。上方是频谱分析，它展现了不同音域中的声音密度，也助于演奏者理解各种电子声部之间的连接。正上方是以分和秒为单位的时间度量。这三种记谱模式可以更好地帮助表演者理解看不见的电子音乐部分。

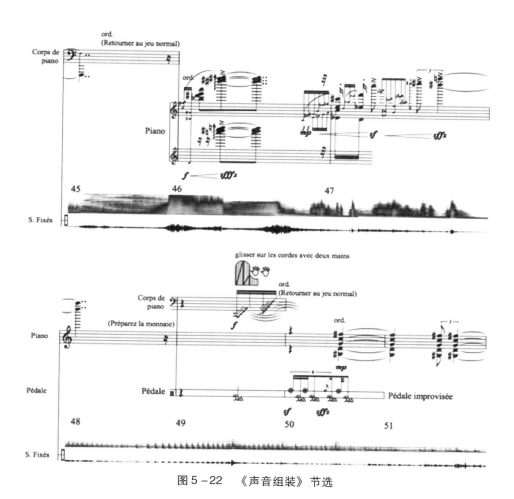

图 5 – 22 　《声音组装》节选

5.14　李秋筱，《武松打虎》

《武松打虎》（*Wu Song Fights the Tiger*，部分曲谱见图 5 – 23）是李秋筱为单簧管和固定媒介而创作的作品。电子音乐部分以通用音乐记谱法（CMN）记录。虽然有些段落使用了模糊的图形符号，但这仅仅是为了表明记录部分的整体移动和活动。李秋筱对这部作品的电声元素运用评论道："我在整首音乐中运用了各种京剧的音乐元素。单簧管的音乐主题使用摇摆的节奏来描绘武松半醉半醒的状态。电子音乐部分则大量使用打击乐声音，以鼓声为主来描述与老虎博斗的场面。"

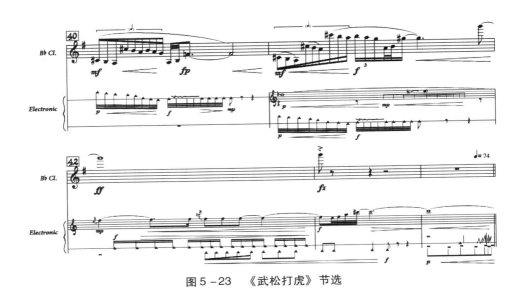

图5-23 《武松打虎》节选

5.15 丹尼尔·泰鲁吉

丹尼尔·泰鲁吉在皮埃尔·舍费尔于1958年在巴黎成立的GRM中创作了大部分作品。1997年至2017年，泰鲁吉担任GRM总监。他创作的曲目基本都是幻听类电子音乐，这类音乐的所有电子声音部分都是由媒介播放的，过去用磁带，现在则是通过数字媒体播放。

在泰鲁吉的作品《萨蒂斯》（*Xatys*）（部分曲谱见图5-24）中，萨克斯管与实时电子音乐进行对话：电子设备捕捉丹尼尔·肯齐（Daniel Kentzy）演奏的萨克斯的声音，并在舞台表演期间对声音进行处理。这首作品于1988年首演时，使用的是由GRM开发的实时数字处理器（SYTER系统）。现在该设备已不复存在，取而代之的是GRM Tools软件套装。

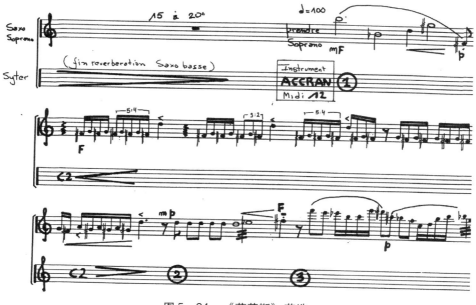

图 5-24　《萨蒂斯》节选

　　泰鲁吉还为乐器和固定播放媒介创作了许多不同形式的作品，如有为管弦乐队和磁带所作的《循环水域》（*Circling Waters*，2011）、为人声和磁带所作的《*Umana museria*》（2011），以及为独奏乐器和磁带所作的作品，如为打击乐器所作的《奋斗》（*Struggling*，2000）、为班多钮琴所作的《夏日乐队》（*Summer Band*，1996）、为萨克斯管所作的（《萨蒂斯》，1988）等等。在这些混合类电子音乐中，泰鲁吉选择用两种方式来表现电子音乐的部分：一种是松散图形，显示声音动态包络；另一种是时间度量，显示峰值振幅出现的时间。二者都可在图 5-25 的曲谱节选中看到。

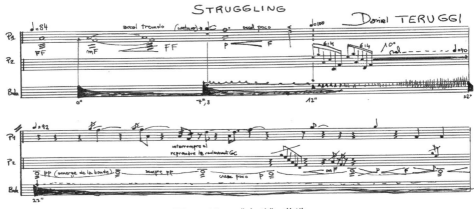

图 5-25　《奋斗》节选

5.16　李鹏云,《暗渡陈仓》

　　李鹏云的《暗渡陈仓》(*Under the Cover*)是为打击乐手和 Max/MSP 而作的作品。演奏者坐在一张桌子旁,如图 5-26 所示,乐谱中的"P"指示演奏者踩下踏板(pedal)。

　　该乐谱包含许多需要演奏者遵循的指示,这些指示都非常精确,以确保演奏得恰到好处。图 5-26 展示的是华彩段 3 中的一段,需要得意地演绎。由于软件 Max/MSP 的交互性,在这种情况下,演奏者可以控制乐曲的时间。

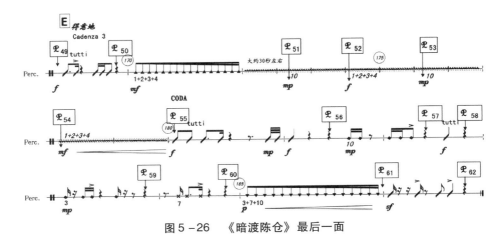

图 5-26　《暗渡陈仓》最后一面

5.17　张小夫，《吟》

　　张小夫的《吟》（部分曲谱见图5－27）是中国最早的电子音乐作品之一，也是张小夫的重要作品之一，它创作于1987年至1988年，是为中国传统乐器低音竹笛和电子音乐而作的作品。在为竹笛创作的过程中，张小夫探索了不同的演奏模式。与其他为竹笛而创作的作品相比，《吟》的创新在于演奏者要在演奏中更换竹笛的振动膜。振动膜是影响竹笛音色的关键，通过更换振动膜可创造出更多彩的乐器音色，并由电子音乐的层次将这些丰富的音色传递出来。

　　出于创作习惯，张小夫后来对这首曲子进行了修改，并添加了与音频相关的视觉元素。其电子音乐部分在1981年进行了修订。

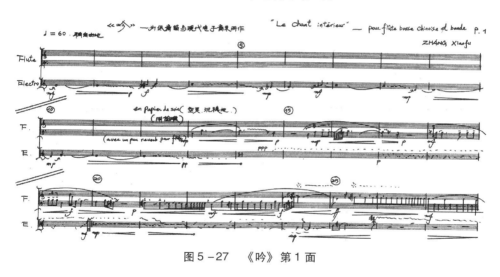

图5－27　《吟》第1面

6

基础知识与技巧

合成器的设计原理是采用基本的电子元件创造声音，与传统乐器不同的是，合成器没有活动（机械）部件，所有的声音都是由电子电路产生的。如今，合成器已成为计算机或数字乐器内部的模拟软件。

合成器发明于 20 世纪 50 年代，当时使用的电子电路被称为"模拟"电路，如今的合成器分为模拟合成器（如图 6 - 1—6 - 3）和数字合成器（如图 6 - 4）两类。

模拟合成器是由晶体管、集成电路、电阻器和其他元件组成的电子电路搭建的，这些元件可以创建或转换波形，从而使其成为音乐声音。模拟合成器以电子操作为基础，所有的声音都表示为连续信号，其电压随波形变化而变化。事实上，正是由于所有的声音信号都是连续的，所以它们才被称为"模拟"信号。模拟是一种连续现象。当你观察天上的云时，你会发现它们在不断变幻，模拟现象也是如此。

任何计算机或任何数字系统中都不存在连续信号，因为一切都是由数字表示的。每个数字都是某物在任何给定时刻的值。因此，计算机内部创造的声音只能用一长串数字来表示。与模拟信号相反，这种持续变化被称为"离散"或"数字化"。

数字合成器依靠计算机操作，所有的声音都表现为不连续或离散信号，但实际上只是一系列数字。

6.1 合成器和声音合成

6.1.1 模拟合成器

在美国 RCA 公司（1952—1955），两位才华横溢的工程师哈里·奥尔森（Harry Olson）和赫伯特·贝拉尔（Herbert Belar）首次尝试通过模仿管弦乐队的乐器来制造复杂的声音，并为此建造了一个巨型合成器。该合成器是用电子管制造的，由于当时微型晶体管尚未普及，合成器的体积十分庞大。音乐的编码是通过键盘产生的穿孔纸带进行的：纸带记录着声音的持续时长、音高和音

色。所以，这台仪器的声音合成是实时产生的（没有延迟）。

1955 年，样本唱片机的发行引发了音乐家工会的抗议，音乐家们认为自己的职业受到了机器的威胁。尽管如此，RCA 公司还是在 1958 年生产了 Mark Ⅱ声音合成器，但因抗议、定价等原因无法将其推向市场。1959 年，在洛克菲勒基金会（于 1958 年投入 17.5 万美元）的资助下，Mark Ⅱ声音合成器装进了由来自哥伦比亚实验室的弗拉德·乌萨切夫斯基、奥托·吕宁和来自普林斯顿大学的米尔顿·巴比特成立的工作室中，即哥伦比亚—普林斯顿电子音乐中心。巴比特在几部节奏复杂的重要作品中都使用了这个设备，即使这些作品节奏非常复杂，但这位作曲家依旧创作出了准确无误的合成类音色版本。

1964 年，模块化也就是所谓的"模拟"合成器出现了。这类不包含数字元件的合成器在音乐界掀起了一场变革。由意大利的保罗·凯托夫（Paolo Ketoff）和美国的罗伯特·穆格、唐纳德·布克拉（Donald Buchla）独立构思设计的合成器，成为许多音乐家运用科技进行创作时使用的设备。特别是唱片《电音巴赫》（*Switched on Bach*）大获成功之后，大量听众通过这张专辑了解到这类合成器乐器。

6.1.2 模拟合成器的工作原理

声学乐器本质上由两部分组成：产生波形的"激发"部分和使人耳能听到声音的"共振"或"放大"部分。

不妨把"激发"部分想象成单簧管的吹口、吉他的弦或鼓皮。在声学乐器中，"共振"部分是赋予声音不同色彩的重要部分，如小提琴或吉他的共鸣箱、单簧管的木质管身等等。在合成器中，因为没有机械部分，所以必须构造出合成器特有的"激发"部分和"共振"部分。合成器的"激发"部分是由振荡器完成的，它的主要作用在于创造波形。要记住，音乐的声音是复杂的波形，由许多谐波组成。要使用合成器，就必须了解振荡器所创造声音的四种基本波形。

"共振"部分略为复杂，通常由不同的操作完成。其中一个重要功能就是滤波器。任何合成器都会提供低通滤波器，这也是电子音乐中常说的滤波效果。

6.1.3 发展里程碑

1965 年，罗伯特·穆格制造了第一台合成器。在接下来的几年中他陆续售卖一些型号的 Moog 合成器。这些设备原本是在一家小店里一台接一台地手工制作出来的。到了 20 世纪 60 年代末，穆格的工作室开始接到不同客户的订

单：有的是打算建立电子音乐工作室的院校，有的是开始注意到这种乐器的实验音乐家和当代音乐家，还有爵士乐和流行音乐艺术家。图6-1、6-2分别为两款 Moog 合成器。

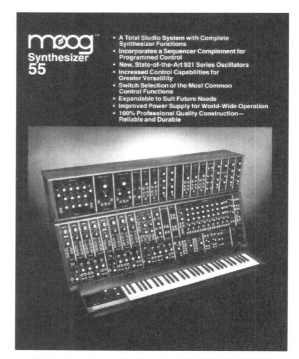

图6-1　Moog Synthesizer 55 模块化合成器

图6-2　Moog Matriarch 半模块化模拟合成器

拉脱维亚的 Erica 公司制造的 Syntrx 模拟合成器（如图6-3、6-4）以

1971 年 EMS（伦敦）生产的老式 Synthi A 为原型，又在其基础上进行了一些改进，如采样保持和数字矩阵。

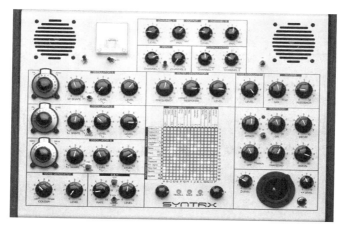

图 6-3　Erica 公司制造的 Syntrx 模拟合成器

图 6-4　雅马哈 DX7 数字合成器

6.1.4　中国的合成器

中国的合成器设计师和音乐家孟奇正在北京开发用于交互式电子音乐的合成器（如图 6-5）。他使用的是 EuroRack 的模块以及一些基于低通滤波器的小型独立模块。

他的合成器主要面向 20 世纪 90 年代末在中国兴起的 EMD（Electronic Dance Music，电子舞曲）和实验音乐①。

① 如需了解更多详情，可访问 https://www.mengqimusic.com。

图6-5　孟奇制作的设备

6.1.5　合成器中的信号

在合成器中，有以下两种类型的信号。一是音频信号：来自振荡器、噪声发生器和处理模块的输出（如滤波器、混响、包络等）。二是控制信号：在模拟合成器中，存在控制电压。控制电压是听不到的，它变化缓慢，在大多数情况下不会振荡。控制信号用于控制（即改变）数值，例如振荡器的频率。在软件合成器中，大多数控制信号是 MIDI 消息。脉冲用于触发事件，例如启动（触发）包络。

6.2　声学概念

在进一步介绍之前，我们先来回顾一些基本的声学概念。

6.2.1　频率

音高由频率来衡量，更准确地说，频率是指每秒内完成周期性变化的次数。每个音高都包含声音的一系列周期性变化（如图6-6）。频率的测量单位是 Hz（赫兹）。

低音　　　高音

图6-6　两种不同的频率

每秒内周期性变化（振动）的次数越多，音调就越高。音高 La 的频率为 440 Hz，即每秒钟振动 440 次。

据说人类可以听到 20 Hz 到 20000 Hz 之间的声音。实际上，我们只能识别 30 Hz 到 8000 Hz 之间的音高。

以钢琴的音域为例，从最低音的 25.5 Hz 到最高音的 4186 Hz 是钢琴的音域范围。然而，这只是理论上的可能性。在现实情况中，钢琴的音高在最低音的音区是很模糊的，从这个音区往上，音高才开始变得逐渐清晰。在钢琴音域中最高的八度音区演奏时，也会出现因噪音比音高更多而声音不清晰的现象。这也是为什么作曲家基本不为超过钢琴最高音区的音高进行创作的原因，因为人耳听不清楚音高，超过 4000 Hz 的声音空间一般留给乐器或音色泛音。

6.2.2　泛音列

声音的所有泛音称为"泛音列"。举个例子，图 6－7 为基于低音 do 的自然泛音，也就是说当在钢琴上演奏低音 do 时，这些泛音都包含在我们听到的声音中。大脑把所有的泛音融合成了一个声音，因此我们只听到 do。

图 6－7　低音 do 的泛音列对应音高

6.2.3　带宽

另一个有用的概念是音频带宽。每支麦克风都有自己的带宽，图 6－8 显示的是高质量麦克风的带宽。在 200 Hz 到 4000 Hz 之间时是平稳的，在 10000 Hz（10 kHz）左右有轻微的波动，这样的带宽对音乐和声音的录入来说，是非常适宜的。

每支麦克风都有自己独特的带宽。

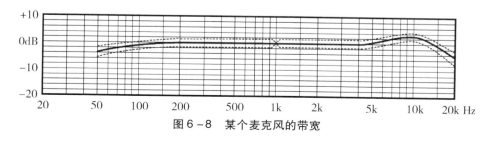

图 6－8　某个麦克风的带宽

6.2.4　音量大小

人耳可感知的或测量的声音音量以 dB（分贝）表示。然而，dB 并不是一个简单的单位，它有几种不同类别。

我们可以简单地将 dB 理解为测量声音强度的单位。人耳可以感知小到只有几十 dB（比如 30 dB）的声音（这时几乎是完全无声的）和大到刺耳的声音（大约 140 dB）。当声音低于 30 dB 左右时，我们就什么也听不到。这是因为人类的身体也会产生噪音——心脏的噪音、神经系统的噪音等等。如果进入消声室（吸收所有混响的房间）一段时间后，我们就能听到自己身体的声音。我们也用响度量表测量人类的听觉水平。"响度"一词表示人类能感知到的声音级别，表述声音的感性特征。强度用于衡量发出的声音，是可以精确地测量的；响度用于衡量感知到的声音，感知是难以测量的，它只能是一个比较结果（更响亮、更柔和等等）。10 dB 的差距意味着声音 A 的响度是声音 B 的两倍，但两者间的强度相差 10 倍，这是因为 dB 是用对数尺度来测量的。

信号通常用图表表示，图表会显示某个参数在维度中的变化情况。常用的图表有四种：三种类别的表示法——振幅/时间、振幅/频率、频率/时间，外加组合表示法。

6.2.5　振幅/时间

这种表示模式由两部分组成，取决于所选的时间尺度。如图 6 − 9 所示，时间以秒为单位，所以从开始到结束，声音都以振幅包络的形式来表示。

利用这种表示法，我们可以评估声音振幅随时间变化的整体轮廓。在通常情况下，我们可以将轮廓缩小成若干线段或曲线段：这就是在声音合成程序中转录自然声音的振幅包络的方式。一些分析程序会给出一定数量的点，这些点在时间上以固定的距离间隔开，首尾相连形成轮廓。我们基于这些结果进行数据简化，将此分析转换为有限数量的片段，这些片段便可清晰地表现包络。

声音振幅的演变可以用包络来表示。图 6 − 9 所示的是钟声的包络线。

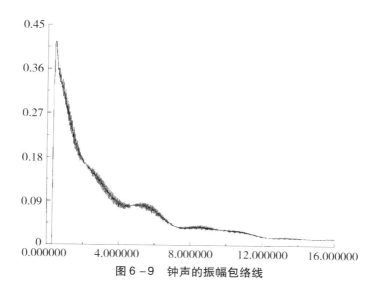

图 6 - 9　钟声的振幅包络线

振幅/时间图也能描述时域中的信号：信号在时域中表示为时间的函数，这种描述模式显示出检测信号的波形（如图 6 - 10）。振幅/时间图的时间尺度通常小至毫秒量级。这种模式有时也被称为"示波器模式"，因为它显示的是随时间变化的波形，很像示波器。尤其当我们以一个很小的时间尺度显示图像时，可以清晰地看到声波的形状。

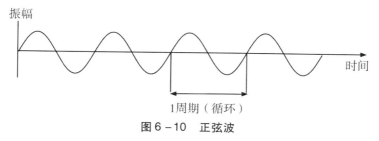

图 6 - 10　正弦波

在振幅/时间模式中，可以观察到相位和周期的概念。简单来说，相位指波形在时间轴上的相对位置。相位有多个计量单位，图 6 - 11 中的相位以度（°）为单位。

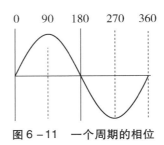

图 6 – 11　一个周期的相位

6.2.6　振幅/频率

当我们想知道声音的频谱内容时，可以将声音的组成部分显示为频率的函数，也就是我们所说的"频域"。图 6 – 12 显示的是谐波声音的频谱分量，以 h1、h2、h3、h4 等一系列分量的形式表示（h 为 harmonic，即"谐波"）。两条轴为振幅和频率。参考振幅轴，可得出每个分量的相对振幅。

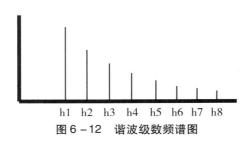

图 6 – 12　谐波级数频谱图

用快速傅里叶变换的方法进行信号分析的程序可以准确表示各个分量的频率位置和振幅。

6.2.7　频率/时间

最后一种表示法显示频率的演变、持续时间，并以不太精确的方式显示声音各分音振幅的变化。这种表示法主要用于测量分音的位置，特别是其持续时间。下图也称为"声波图"（如图 6 – 13），与分析模拟乐器相关。

图 6 - 13　钟声频谱分析（声波图）

6.2.8　组合表示法

上述的三类图表可以组合在一起，以三维形式表示（如图 6 - 14）。三个坐标轴分别为振幅（图中以"电平"值表示）、频率（单位为 kHz，图中以"音高"值表示）和时间（单位为秒）。皮埃尔·舍费尔便是利用此类三维图来表示声音的：

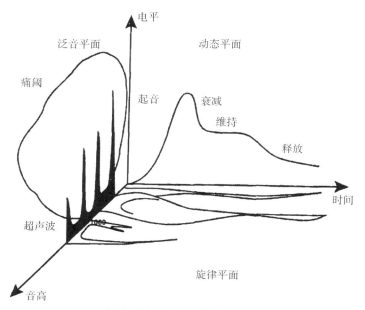

图 6 - 14　声音三维图

他将这三个平面分别称之为：

（1）泛音平面，表示振幅/频率；

（2）动态平面，表示振幅/时间；

（3）旋律平面，表示频率/时间。

图 6 – 15 为钟声的频谱分析，以三维图的形式呈现。

图 6 – 15　钟声频谱分析（组合表示法）

6.2.9　傅里叶合成

傅里叶（Fourier）展示了在数学上频谱如何分解成一系列简单的振动：每一次振动都是一个正弦信号。振动的频率是最大振动频率的整数倍，这样的振动即"谐波"，频率为 f、2f、3f、4f、5f 等（f 为 frequency，即"频率"）。注意，其周期持续时间逐渐减少：从 T、1/2T、1/3T、1/4T 等（T 为 Time，即"时间"）。为了消除经常出现的混淆，需特别说明一下术语，分音 f 也被称为"基频"或"谐波1"（即的 6.2.6 节的 h1）。

因为傅里叶的发现，我们知道了如何分析和合成复杂频谱。以一个只包含前三次谐波的方波为例（即谐波 1、3、5，方波信号只包含奇数阶的谐波），如图 6 – 16，我们会依次看到谐波 1、3 和 5，将它们叠加合在一起，就能得到最终的波形。

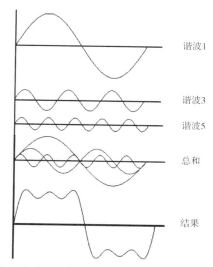

图 6 – 16 通过不同频率的基础波的叠加来合成新的波形

6.3 基本波形

在声音合成中，了解基本波形是很有必要的，基本波形会经常出现在模拟合成器和虚拟合成器中，并且也常用于声音合成软件，比如本书会作进一步讨论的 Csound。基本波形有以下四种（如图 6 – 17）：

（1）正弦波：只有一个谐波，通常称为"纯音"；

（2）三角波：仅由奇次谐波组成，振幅衰减非常快；

（3）方波：仅由奇次谐波组成，声音比三角波丰富；

（4）锯齿波：包含所有谐波，听起来是嗡嗡的声音效果。

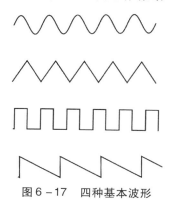

图 6 – 17 四种基本波形

245

6.3.1　正弦波

正弦波只有一个谐波，因此它有时也被称为"纯音"。当分析复杂的声音时，可看出它主要是由一系列谐波组成的，每一个谐波都是一个正弦波。（如图 6 – 18）

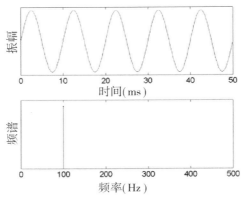

图 6 –18　正弦波频谱

6.3.2　三角波

三角波的频谱只包含奇次谐波，如图 6 – 19。每个谐波的振幅是其频率的平方，即是 1/奇次谐波次数的平方。那么，如果谐波 1 的振幅为 1，则谐波 3 的振幅为 $(1/3)^2$ 或 1/9，谐波 5 的振幅为 $(1/5)^2$ 或 1/25，以此类推。因此三角波的声音相对平滑，但与正弦波相差甚远。

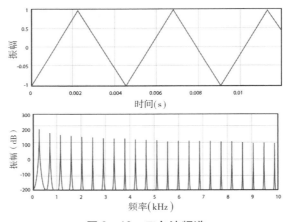

图 6 –19　三角波频谱

6.3.3 方波

方波的频谱也只包含奇次谐波，如图 6 - 20。每个谐波的振幅是其级数的倒数，即 1/奇次谐波次数。那么，如果谐波 1 的振幅为 1，则谐波 3 的振幅为 1/3，谐波 5 的振幅为 1/5，以此类推。

因此，从频谱上可以看出方波的波形频率范围宽广，但听起来也会感到刺耳。

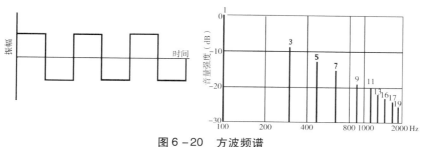

图 6 -20　方波频谱

6.3.4 锯齿波

锯齿波的频谱包含所有的谐波，如图 6 - 21。每个谐波的振幅是其级数的倒数，即 1/谐波次数。那么，如果谐波 1 的振幅为 1，谐波 2 的振幅为 1/2，谐波 3 的振幅为 1/3，以此类推。锯齿波是声音非常丰富的频谱，有时也称为"蜂鸣声"（buzz）。

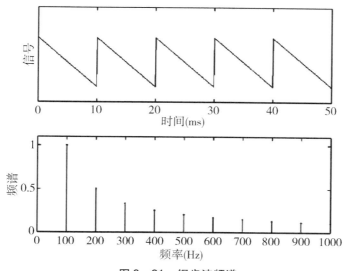

图 6 -21　锯齿波频谱

6.3.5　噪音

不同类型的噪音具有不同的频谱分布特征，这种分布一般用振幅/频率图表示。

白噪音是在高音区较为集中的类似呼吸的声音，各频段的能量分布均匀，无论在任何音区，带宽相同的各个频段具有相同的能量。例如，100 Hz 至 200 Hz（八度音程）之间的能量与 1000 Hz 至 1100 Hz（约一个半音的音程）之间的能量相同。从感知上讲，白噪音能给听者带来一种因高音而产生的光辉感。同时这也是模拟磁带的声音，以较为平坦的频谱呈现。

另一种类型的噪音是粉红噪音，它具有能量分布不均等的特征。这种噪音的每倍频程能量相等：例如，100 Hz 至 200 Hz 和 1000 Hz 至 2000 Hz 之间的能量是同样的。粉红噪音的能量衰减斜率是每倍频程 3 dB。人耳会感觉粉红噪音像深呼吸，声音不是很亮，有时也被称为 1/f 的噪音。相反，白噪音的能量每倍频程增加 3 dB，这也是它让人感受到明亮辉煌的原因。

噪音是一种广泛应用于声音合成中的声源。它最突出的特点是无固定音高，要么根本没有音高，要么音高模糊、不清晰。从这个意义上说，噪音与音高清晰的乐音是对立的。这种对立于如今的音乐领域而言没有意义，但在声学或科学的立场上来看，这确实事实。

原始噪音（没有经过音乐处理）有白噪音、粉红噪音、褐色噪音。

6.3.6　模拟合成器的例子

Arturia 公司的 Synthi V 虚拟合成器（如图 6 – 22）的机型仿照 EMS（伦敦）的 Synthi A 模拟合成器，包含三个振荡器：1 号振荡器（正弦波和三角波）、2 号振荡器（方波和三角波）、3 号振荡器（方波和三角波）。

图 6 – 22　Arturia Synthi V（左）和 Erica Syntrx（右）的三个振荡器

还有两个附加信号：噪音（白噪音＝高，粉色噪音＝低），滤波器（当响应为 10 时）。

6.4 数字合成器

在计算机中，声音合成通常从一个单循环波形开始。声音以一系列数字的形式存储在波表中，每个数字就是波表中的一个样本。用于描述所选周期的一系列样本排列形成波表，波表以采样的形式保存声音的周期或基本信号（如正弦波）。波表可视为计算机内存中的一系列字节，每个样本都放在一个内存字中，因此储存全部采样所需的内存字序列称为"波表"（如图 6 – 23）。声音合成语言即所谓的"函数"。本书中经常用其来指代波表。

在采样过程中，波表被加载到主存储器中。由于通常要计算波表的大小，所以必须仔细保存。直到近年，合成程序开始使用小波表，并用尽可能少的点来定义一个周期。当 MUSIC Ⅳ（1962）诞生时，由于当时使用的计算机中央存储器非常小（只有几千个字），所以波表限定为 512 个点。下面我们将看到使用小波表的缺点以及为解决该问题而产生的补偿机制。现如今，计算机主存储器的容量正大幅增加，一个波表通常至少有 4K 字（4096 个字）。

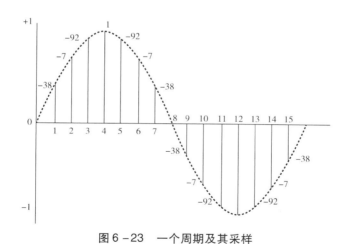

图 6 – 23 一个周期及其采样

图 6 – 24 是来自 MUSIC V 的例子，图片显示了一个完整的周期和波表中的样本数字。

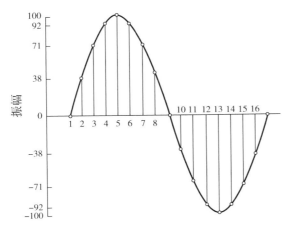

样本数	振幅
1	0
2	38
3	71
4	92
5	100
6	92
7	71
8	8
9	0
10	−38
11	−71
12	−92
13	−100
14	−92
15	−71
16	−38
ETC.	

图 6-24　波表和一个周期的采样

6.5　滤波器

合成器的滤波器部分有几种类型，如前所述，低通滤波器是较为常见的类型，下文将介绍其工作原理。

为便于描述滤波器的作用，我们先来了解声音的视觉效果。这种视觉效果用于表示"频域"：它显示某时刻的声音，就好比可以停止某个声音并观察它的组成。图 6-25 显示的是 100 Hz 的声音及其谐波，这是一个低音（在 sol2 和 sol#2 之间）。图中是低通滤波器对频谱的影响，高频谐波已被滤除。

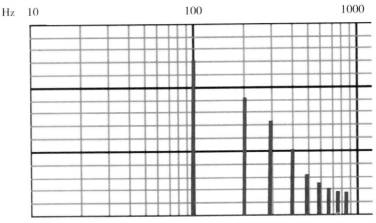

图 6-25　频谱

6.5.1 低通滤波器

图 6 – 26、6 – 27 为低通滤波器对频谱的影响，注意，已滤除较高的谐波。

低通滤波器有多种设置，最重要的是它的截止频率。超过该频率的频谱会被逐渐减弱和滤除。截频点可以移动，就像在电子音乐中经常听到的那样。

另一个重要设置是共振，这个设置有单独的控件。向上推动控件时，共振使滤波器处于振荡模式或接近振荡模式，形成具有高辨识度的效果。

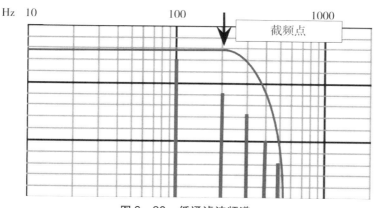

图 6 – 26 低通滤波频谱

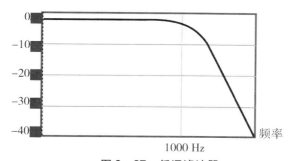

图 6 – 27 低通滤波器

6.5.2 高通滤波器

高通滤波器与低通滤波器恰恰相反，高通滤波器滤除的是低于截止频率的信号。（如图 6 – 28）

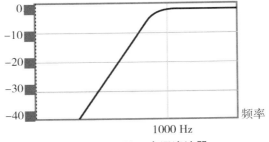

图 6 - 28　高通滤波器

6.5.3　带通滤波器

带通滤波器，有两个截止频率，能滤除频谱中高于上限截止频率和低于下限截止频率的部分。（如图 6 - 29）

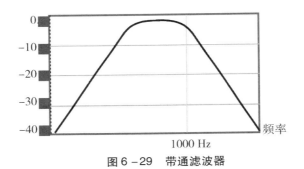

图 6 - 29　带通滤波器

6.5.4　陷波滤波器

陷波滤波器较为少见。它就像在频谱中制造一个"洞"，保留特定范围内的低频和高频信号。（如图 6 - 30）

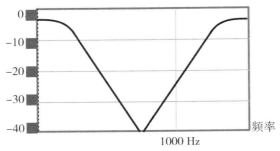

图 6 - 30　陷波（带阻）滤波器

6.5.5　均衡器

均衡器由多个滤波器组成，可通过调节推拉键来减弱或增强部分频谱。（如图 6 – 31、6 – 32）

图 6 – 31　Logic 推出的 Vintage Graphic EQ 插件

图 6 – 32　Steinberg 推出的 Frequency 均衡效果器

6.6　包络和 VCA

6.6.1　基础包络图形

基本合成器（如图 6 – 33）中的包络只有三个组成部分：起音（Attack，或译为"压缩"）、延音（Sustain，或译为"维持"）和释音（Release，或译

为"释放")。故此名为 ASR 包络（如图 6 − 34）。

图 6 − 33　Erica Syntrx 包络（左）和仿照 EMS VCS3 的 Arturia Synthi V 包络（右）

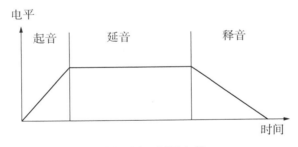

图 6 − 34　ASR 包络

合成器装置中另一种常见包络为四段包络。在起音之后，包络线下降，这一过程称为衰减段，随后是延音段，最后是释音段。这种类型的包络称为"ADSR 包络"，即起音（Attack）、衰减（Decay）、延音（Sustain）、释音（Release）（如图 6 − 35）。

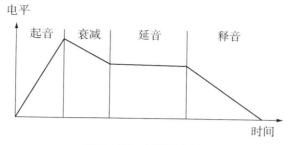

图 6 – 35　ADSR 包络

每段包络的持续时间皆可精确设定，这样 ADSR 包络就能连续发出类似于打击乐器的声音。或反其道而行之，当缓慢地压缩和释放时，就会发出类似于弓弦乐器的声音。

需要注意的是，当 MIDI 触发 ADSR（或 ASR）包络时，会出现一个特殊现象：释音部分只在音符结束时播放。类似于音乐家弹奏钢琴时，一直踩住共振踏板，停止弹奏键盘时，会出现共振或衰减，由于释音过程的存在，声音并不会突然切断。

复杂合成器提供多种可控包络线段（如图 6 – 35）或指数包络线段（如图 6 – 36）。指数包络线段在听感上会更自然。

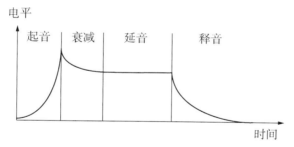

图 6 – 36　ADSR 包络（指数线段）

6.6.2　VCA：电压控制放大器

VCA（Voltage-Controlled Amplifier，即 "电压控制放大器"）这个名称源自于模拟合成器时代。如今，数字合成不使用控制电压，而代之以数字指令。然而，VCA 一词保留了下来，它指的是 DAW 中由自动化控制的放大器。

6.6.3　合成器工程文件

所有的合成器（如图 6 – 37），无论是硬件还是软件，都由多个模块组成。

255

模块分为两类，分别是：

（1）能产生声音的电路，称为"振荡器"或"发生器"；

（2）处理或转换声音的电路。

图 6 – 37 Arturia Synthi V 软件合成器

在合成器中，声音被称为"信号"，因为信号进入扬声器或耳机就会变成声音。合成器有各种各样的模块。通常情况下，用户建立连接，将信号从一个模块的输出发送到另一个模块的输入，直到信号发送到输出端。（如图 6 – 38）

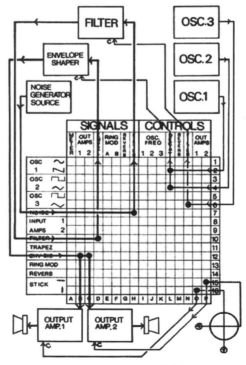

图 6 – 38 EMS VCS3 工程文件示意图

在 Arturia Synthi V（模拟或软件）中，信号的连接是通过矩阵进行的。如图 6 – 39，左侧列表显示的是信号源（模块的输出）。最上方一行显示的是"列"，即信号输出的目的地。在 Synthi V 中，信号源被"打包"后发送到某一列。

在 Synthi V 的矩阵中（图 6 – 39），左列接收音频信号，而右列接收控制信号。

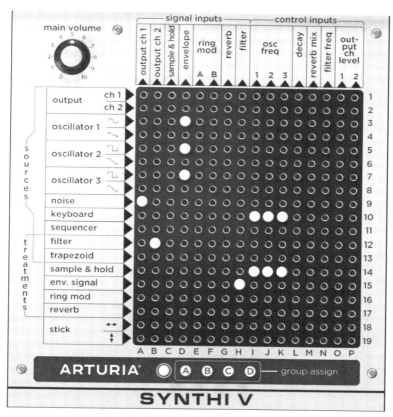

图 6 – 39　Arturia Synthi V 矩阵

6.6.4　采样保持模块

当一个信号产生时，可以用形状或曲线表示（如图 6 – 40）。在数字世界中，这条曲线是"已采样的"，也就是说它是一个连续的数字序列。每个数字称为一个"采样"。采样保持模块接收信号，观察曲线，并在特定时刻冻结曲线的值。

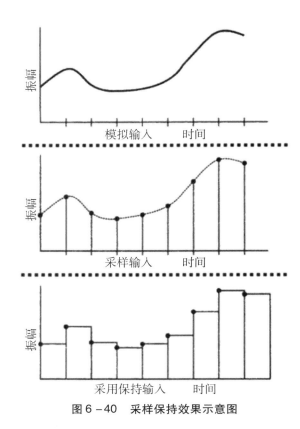

图 6 −40　采样保持效果示意图

　　常用方法是给采样保持模块发送噪音信号，也就是一段随机曲线。采样保持模块的输出，即被采样的噪音信号，通常用于振荡器，有时也用于滤波器的截频点。

7

21 世纪的计算机音乐实践

7.1 DAW

DAW（Digital Audio Workstation，即"数字音频工作站"，又被称为"宿主软件"），是音频和 MIDI 音序器的统称，常见的 DAW 软件有 Cubase、Logic、Pro Tools、Reaper、Harrison Mixbus、Ableton Live 等。

新型 DAW 能够处理多种不同类型的信号。这类软件可以读取外部声音文件，这些声音文件在导入 DAW 后就会出现在软件的时间轴上。导入后的声音文件将成为序列或工程文件的一部分。其中一部分声音文件会存储在特定的位置，而其他声音文件则被放在音序器的时间轴上。

有些 DAW 混音功能强大。这类软件所提供的工具，可帮助使用者进行适当的混音、母带处理和音频可视化。音乐工作者借助它们可以实现专业级混音，像专业工作室一样投身音乐制作。有些 DAW 软件允许多轨混音，例如支持 5.1、7.1 甚至 22.2 的各种多声道模式的混音。而 Pro Tools 等软件，只支持特定格式的插件，如 AAX。其他一些 DAW 软件支持 AU 或 VST 插件。这些平台都可以打造出高品质立体声混音。其中常见的混音工具有 Avid Pro Tools、Harrison Mixbus、Mixbus 32C 以及 Reaper。

另一类 DAW 更为多样，主要用于帮助制作人使用软件谱曲、制作和完成音乐作品。为此，这类 DAW 通常配备了采样播放器、采样库和软件合成器，也支持其他厂商的插件以及后期制作过程中所包含必要的混音工具。从某种程度上来说，这些 DAW 能够完成各种各样的作曲和混音任务。

DAW 价格差距非常大。一些 DAW 是完全免费的，比如 Pro Tools 1，虽然该软件的免费版本只能使用 16 个轨道，但附带多种实用插件。当我们提到 DAW 时，会想到 Cubase、Logic、Pro Tools、Digital Performer、Reaper、Mixbus 等软件。这些确实都是 DAW。那么，到底什么是 DAW？为什么这些软件都属于同一个类别？这是因为它们的出现都始于一个共同目的：能够混音并制作音乐。

DAW 由音序器组成，可以理解它将多个声音组合在一起形成一个序列，

即一段音乐。从本质上说，DAW 是一个音序器，音乐家可以利用它对声音进行排列组合，就像管弦乐作曲家根据乐谱编排乐器一样，音乐创作者可以使用 DAW 从各种音源中进行配器。

这个过程可以理解为：当管弦乐作曲家完成作曲和编排，管弦乐队登台表演，指挥走上指挥台，他们共同完成作品的完整呈现。在这个过程中，管弦乐作曲家的工作媒介是纸张，成果是乐谱，而真正的声音，则是在指挥家的指挥棒下由乐队演奏所产生的。有了 DAW 后，音乐创作者既是管弦乐作曲家又是指挥家，所有这些音乐创作和制作的任务都集成在软件中。接着，我们来分析一下 DAW 所提供的音乐操作功能。DAW 的核心是音序器——用于显示所有音轨组合而成的序列，是 DAW 的主窗口。

我们需要了解如何有效地使用 DAW。DAW 是一个复杂的软件，它汇集了音响工程师、混音师、音乐制作人的音乐制作经验和录音室技术，同时也充分利用了数字技术的优势。

一个 DAW 有多种类型的通道，因为要处理不同类型的信号。

– 音频信号（声音），例如合成器、外部声音文件或者采样等。有几种不同类型的音频信号。

– 辅助信号/插件信号，如效果器的输出（混响均衡器、压缩器等）。

– MIDI 信号，例如西贝柳斯（Sibelius）或 Finale 可以通过 MIDI 向采样库发送信息，从而播放乐谱。西贝柳斯或 Finale 中的音乐是以 MIDI 数据的形式呈现，但这些程序可以调用真实的声音，如采样。在这种情况下，乐谱中的 MIDI 音符会发送到播放器插件，该播放器插件会使用真实的声音采样来播放 MIDI 音符。

MIDI 音符也可以发送到外部设备，如合成器或者采样器，但是目前较少使用这种方法。可以从外部 MIDI 控制键盘（例如键盘）来接收 MIDI 音符。

为处理各类信号，DAW 提供了不同类型的通道。

– 音频：从磁盘读取的声音音频文件，播放或者与其他音频信号混合。

– 虚拟软件乐器：DAW 通常有自带的软件乐器（如 Cubase 的 HALion Sonic SE）。

– MIDI：MIDI 信号传送命令，不传送音频。

– 主通道（Master）：接收所有音频通道并将其混合成立体声。

– 辅助、插入、组、总线（Bus）：这些是接下来我们要讲的特殊类型通道，其名称在各个软件中或许会有所不同，但都具备相应的功能。

7.2　轨道和通道

在本节中，我们将讨论轨道与通道之间的区别。

在 DAW 中，可以将调音台设置为若干个通道。大多数新型 DAW 都有大量可用通道，具体情况因所用版本而异。在撰写本书时，Pro Tools 1 等一批免费 DAW 中有 16 个通道，而付费 DAW 通常会提供数百个可用通道。

那么轨道呢？"轨道"一词起源于磁带录音机时代。当时有立体声磁带录音机（2 轨道）、4 轨道、8 轨道、32 轨道乃至 64 轨道。现在人们普遍混用"通道"和"轨道"这两个词，哪怕两者之间存在区别，但在使用 DAW 时，它们是同义词。

然而，在使用硬件调音台时，"通道"和"轨道"还有是区别的。硬件调音台可能有 16 个通道，这个数字是固定的。每个通道可以接收一个轨道，即单声道或立体声。在这种情况下，通道是接收方，轨道是传输的内容。图 7 - 1 显示的是一款 16 通道的新型模拟调音台，Audient 4816。

图 7 - 1　安装在深圳大学计算机音乐实验室的模拟 Audient 调音台

也就是说，这两个词可以混用而且不会产生歧义。本书中会尽可能多使用"通道"一词，但也会出现"轨道"这个说法，不过两者具有相同的含义，可以互换使用。

7. 2. 1 了解 Bus

每个通道（channel）都可以将信号发送到 Bus①，因此 Bus 并不是一个通道，Bus 用于汇集多个通道的音频。譬如，可以将所有的鼓通道分为一组，再将包含所有鼓通道的 Bus 发送到一个立体声辅助通道，而辅助通道从 Bus 接收音频。

这样就可以控制所有的鼓声，可能是将 4、5 或 6 个通道发送到一个立体声通道，并通过推子调整其音量或添加一些声音效果器，如压缩器，均衡器或混响效果器。

因此，Bus 将各通道的信号汇集在一起，每个通道能够将其信号发送到一条或多条 Bus。此外，还可以控制发送到 Bus 的信号电平。把 Bus 想象成一辆公共汽车（其英文单词的本意），它在行驶路线上接载乘客。通常，Bus 将信号发送到辅助通道后，辅助通道从 Bus 接收音频。

音频通道（或"主"通道，master）能够将其信号发送到 Bus，这就是发送操作。Bus 汇集来自多个通道的信号，并将这一组信号发送到辅助通道（aux）。辅助通道可以将从 Bus 接收到的信号发送到一些效果器插件，比如混响效果器，然后接收效果器插件处理过的声音。这也是一种发送/接收操作。正如我们所看到的，发送、接收、辅助、组和总线（Bus）的原理是相互关联的（如图 7 - 2），只是在功能上有些许不同。

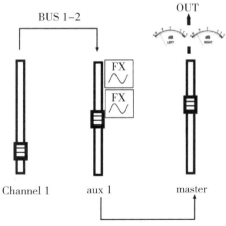

图 7 - 2 总线和带效果器（FX）的辅助通道及输出（OUT）

① 见 7.1 节末，Bus 常译为"总线"，意为混音总线和虚拟线路，但因主通道（Master）也常在实际使用中被称为"总线"，此节为避免混淆，在说明具体操作时，统一使用软件面板上的名称 Bus。——编者注

　　创建辅助通道的步骤是进入调音台，点击 Send（发送）按键，可以打开菜单窗口。单击 Bus 按键，可以打开一个展示所有可用 Bus 的可左右滚动的列表。Bus 上的信号可以由辅助通道接收。

　　如图 7-3 所示，以 Pro Tools 为例，4 个音频通道都被发送到立体声总线（Bus 1-2）。接着，该总线被辅助通道（Aux 2）接收。然后，可以在辅助通道（Aux 2）上添加效果器插件，这些插件就会作用于从通道 1 至 4 接收到的所有信号。例如，在这个辅助通道上插入混响插件，混响效果就可以同时应用到 4 个音频通道中。通过这种方式，我们可以只使用一个混响插件，而不需要分别在通道 1 至 4 中同时使用 4 个相同的插件。这样的话，计算机 CPU 的压力小于同时使用 4 个混响插件。

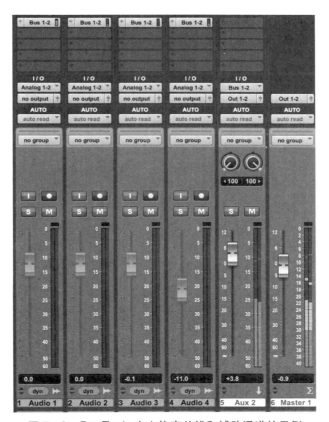

图 7-3　Pro Tools 中立体声总线和辅助通道的示例

　　即是把通道 1 至 4 发送到 Bus 上，辅助通道接收这些 Bus 的信号。这种发送和接收的操作概念在调音台和 DAW 中十分常见。具体说明的话，音频通道

（或"主"通道）将信号发送到 Bus，这就是发送。Bus 汇集来自多个通道的信号，并将这一组信号发送到辅助通道。辅助通道将从 Bus 接收到的信号发送到一些效果器插件中，如混响，然后接收效果器插件处理过的声音，这也是一种发送和接收的操作。

正如我们所见，发送、接收、辅助、组和总线（Bus）的使用是相通的，只是功能上有些许不同。

请注意，音频通道 1 至 4 没有输出，所以它们的信号是直接发送到立体声总线，然后辅助通道接收立体声总线的信号。

最后，主通道（master channel，即立体声）接收没有任何特定设置的辅助通道，信号全部经内部途径传输。（如图 7-4）

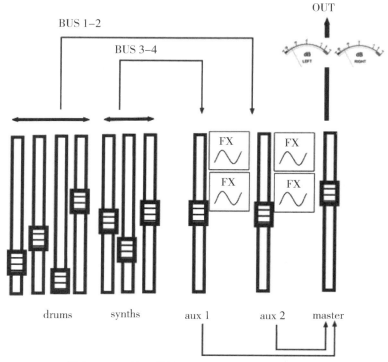

图 7-4　总线和带插件效果（FX）的辅助通道，
带有鼓声（drums）和合成器（synths）

如需在 4 个音频通道中的任何一个通道使用 Solo（独奏）按钮，必须把辅助通道也设置为 Solo 状态。（如图 7-5）

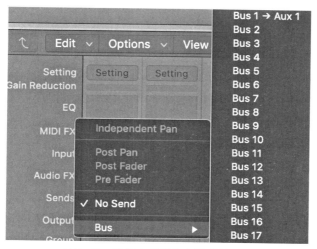

图 7 −5　选择在 DAW 中发送的 Bus

7.2.2　音序器窗口

图 7 −6 为 Pro Tools 的主窗口。

图 7 −6　Pro Tools 音序器窗口或主窗口

265

7.3 电平和 VU 表

在 DAW 中，电平显示在有调音台推子的仪表上。在每个轨道左侧附近的编辑窗口中也有小推子。理解这些仪表的指示内容对于控制音乐的声音来说是非常重要的。

在检查母带之前，要先测量录音材料的电平。这对于录音、混音以及母带处理都非常重要。数字系统如 DAW，用峰值表（或峰值监视表）测量声级。峰值表显示音量的瞬时变化。在 Pro Tools 或 Cubase 这类 DAW 中，以 0 刻度为基准的最大值。这个刻度的单位为全分贝刻度（dBFS）。在 DAW 中，电平通常用 dBFS 来测量。电平为 0 dBFS 意味着音频削波，即没有动态余量，无法超出此电平。我们必须避免这种情况，注意电平不要达到 0 dBFS。

另一种电平测量方法代表人耳对音量的感知，称为"音量单位"，或 VU，是电平变化的平均值，通常在老式 VU 表上显示。（如图 7 – 7）

图 7 – 7　VU 表插件

这个刻度与使用 dBVU 的模拟设备的刻度截然不同。VU 表是以 dBVU 单位为刻度，而非 dBFS。

通常在大多数 DAW 中，0 dBVU = – 18 dBFS，意即电平的 0 dBVU 对应 DAW 上的 – 18 dBFS。0 dBFS 是削波的阈值，不建议使用这个数值。将轨道平均电平设置为 – 18 dBFS 可为最高峰值留下足够的动态余量，可以允许出现高于 – 18 dBFS 的短时峰值。

在 DAW 中进行混音和母带处理时，要注意将平均电平设定在 – 18 dBFS 左右，此电平值会显示在推子右侧的仪表上，它符合人耳感知声音和音乐的方式，这就是音响师和混音师更青睐 VU 表的原因。

在混音阶段，较稳妥的做法是创建主推子，将其用于在混音前控制最终电平。但是，必须设置接收其他轨道的单个通道，确保电平不会达到 0 dBFS，使用主推子来设置仪表上显示的平均电平。

图7－8显示了应用于Pro Tools测试信号的三种不同的VU表。测试发生器发出频率为1000 Hz的正弦波。主通道（master channel）的VU表设置为－18 dBFS（全分贝刻度），主推子设置为0，VU表显示电平为0 dBVU。这证实了Pro Tools的电平控制设置为0 dBVU ＝ －18 dBFS。

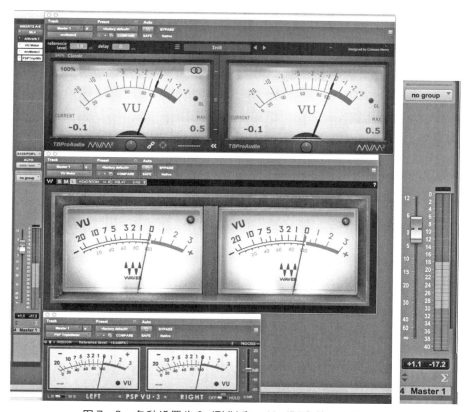

图7－8 各种设置为0 dBVU和－18 dBFS的VU表插件

除了DAW自带的VU表之外，还可以使用外部插件（可下载免费VU表插件），如MVMeter2（如图7－9）[①]。

7.3.1 时间轴

DAW也可以播放MIDI序列。正如我们所见，组成MIDI序列的并不是声音，而是命令：它相当于一份乐谱，乐谱上显示的是音符、休止符、节拍或节

① MVMeter2为免费插件，可至 https://www.tbproaudio.de/products 下载。

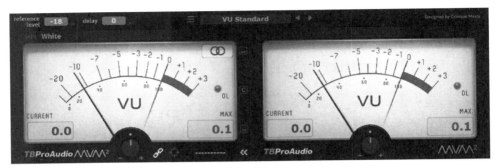

图 7 - 9　免费插件 MVMeter2

奏符号以及其他形式的记谱法。事实上，许多 DAW 都能够以乐谱的形式呈现 MIDI 序列，例如 Cubase 和 Logic。MIDI 可以通过 MIDI 键盘或 MIDI 乐器直接输入到 DAW 中，MIDI 序列会记录在该序列的 MIDI 轨道中。

7.3.2　MIDI 轨

输入 MIDI 序列的另一种方法是导入 MIDI 文件（例如由另一个软件生成的 MIDI 序列），如果此序列可以导入到 DAW 中，说明序列可以用乐谱编辑器播放，以常用的记谱方式显示。

7.3.3　MIDI 乐谱记谱

MIDI 记谱也可显示为一系列 MIDI 事件，在 MIDI 的语境下的记谱即是打开音符、关闭音符、修改程序设定、连续控制等等。

播放 MIDI 序列需要音源。音源有若干种，其中之一是软件乐器，常见的是 DAW 的合成器或插件合成器（有些插件是免费的，有些需要付费使用）。其中一些软件合成器实际上是 VST 插件（Cubase 和 Mixbus 常用），另一些是 AU。

7.4　插件

所有新型 DAW，如 Cubase、Logic、Pro Tools 或 MixBus 都配备大量插件。插件是独立于 DAW 的软件，而 DAW 能够使用插件进行许多操作。有的插件可用于创造声音，如声音合成器和采样播放器。还有的插件能处理声音的某些特性，这些插件主要分为三类：

（1）混响效果器：为声音增加共鸣；

（2）均衡器：带有滤波器，用于改变声音音色；

（3）压缩器：改变声音的动态范围，使声音不超过音量临界值。

所有常用 DAW 都拥有内置插件，如 Cubase、Logic、Pro Tools、MixBus 都自带一系列插件。有的音乐人在家庭工作室中从事创作，最受他们欢迎的 Logic 和 Cubase 就拥有种类最多的插件。例如，混响效果器、均衡器和压缩器等均是用于处理声音的插件，另一类则是音源插件，也称为"合成器"或"采样器"，这类插件提供不同的音色、音源和采样声音。

Logic 和 Cubase 已经自带了合成器和采样播放器等乐器插件，兼有用于混音的声音处理类插件，如混响效果器、均衡器和压缩器等。Pro Tools 和 MixBus 拥有的插件主要用于混音（混响效果器、均衡器和压缩器）。除了 DAW 自带的插件外，还可以购买商业公司出售的插件，亦可在网上寻找免费插件。

插件格式多样，有些格式可以兼容 DAW，有些则不能。例如，Pro Tools 只支持特定格式的插件，而这些插件与其他 DAW 不兼容。表 7-1 列出了各种插件格式及其对应的 DAW（截至撰写本书时），以 Apple Logic、Avid Pro Tools、Harrison Mixbus 和 Steinberg Cubase 这四个 DAW 为主。其他 DAW 也很受欢迎，如 Ableton Live、Digital Performer、Cakewalk、FL Studio、Reaper、Sonar 等。

插件是一种软件，能够与规模更大的程序共同运行。例如，DAW 使用插件进行各种声音处理：混响、均衡、压缩等等。插件分为几种类型，使用者必须要清楚哪种插件与自己使用的 DAW 兼容。

VST 插件是外部软件，通过 VST 协议加载到 DAW 中，1996 年在 Cubase 3.02 推出时，斯坦伯格公司（Steinberg）首次发布了这一协议。VST 是最广为人知的界面型效果器和乐器插件。时至今日，VST 的版本已经更新到第三代，通常被称为 VST3。VST 是业界使用最广泛的插件格式，Ableton、Cubase、Sonar 等 DAW 均支持 VST。

VST 插件更新了好几代，历代版本用数字来标识：VST1、VST2、VST3。但也并非所有 DAW 都支持 VST 插件，典型的例子如 Cubase。另一个较为常见的插件格式为 AU，是为苹果电脑开发的插件格式。AU 插件是苹果公司专有的音频技术，是 Mac X OS 提供的 Core Audio 音频处理基础设施的一部分。作为操作系统的组成部分，AU 插件为界面提供低延迟和系统级别的支持。苹果公司的 Logic 只支持 AU 格式的插件，Mixbus 或 Ableton Live 等其他 DAW 也支持 AU 格式的插件。

AAX 是一种标准插件格式，分为两种不同的类型：AAX DSP 和 AAX Native。之所以引入 AAX，是因为爱维德公司（Avid）发布 64 位版本的 Pro

Tools，这意味着需要具有 64 位处理能力的插件格式。使用 AAX，可以在 DSP 加速的 Pro Tools 系统和 Native 版的 Pro Tools 系统之间共享会话，并继续使用相同的插件。从版本 11 开始，Avid Pro Tools（包括 Pro Tools 1）只支持 AAX 插件；从 Pro Tools 11 开始，AAX 插件都是 64 位的。Pro Tools 10 支持 32 位的 AAX 插件。

　　RTAS 是 Digidesign 为 Pro Tools 系列而推出的插件格式，Pro Tools 10 及此前的版本与之兼容。为了与 Pro Tools 系列 DAW 软件兼容，许多插件制造商开发了 RTAS 版本的插件。RTAS 插件只能在 Pro Tools 中使用（仅限版本 10 及之前的版本），Pro Tools 从版本 11 起不再支持 RTAS 插件。

　　TDM（Time-division Multiplexing）是安装在外部硬件（如专用 DSP 处理器）上的 Pro Tools 插件。TDM 插件通常安装在配备了爱维德公司专用硬件的工作室中，这样计算机就不必处理这些任务了。

　　下表是各种插件格式的列表以及与之兼容的 DAW（截至撰写本书时）。

表 7 - 1　插件格式及 DAW 列表

格式	名称	兼容的 DAW
AAX	Avid Audio eXtension	Avid Pro Tools（包括 Pro Tools First）仅仅接受 AAX 插件；Pro Tools 11 的 AAX 插件是 64 位的 Pro Tools 10 接受 32 位 AAX 插件
AU	Apple Unit	与 Logic 和 Mixbus 兼容
RTAS	实时音频套件	前 Pro Tools 格式，自 Pro Tools 11 起不再适用
VST	虚拟工作室技术	由 Steinberg 开发，兼容于 Cubase、Nuendo、Mixbus，有几种 VST 的类型
VSTi	虚拟工作室技术乐器	VST 乐器插件
VSTfx	虚拟工作室技术音效	VST 插件，效果器，信号处理

　　如何在 Logic 中插入插件。你可以打开调音台，选择一个音频轨道。点击面板上标签为 Audio FX 的插槽时，就会显示插件，标签显示在调音台左侧。当选择插件时，可以从网站上下载应用程序，运行该应用程序，选择你想要的插件，然后就会下载安装程序。运行安装程序，DAW 就可以使用该插件了。

　　网络上有很多免费的插件，这些免费插件，虽然依然无法与高级付费插件相提并论，但已经足够好用。以下列出一些非常值得一试的免费插件，它们由 Melda Production 提供，是混音、母带处理以及声音设计和音乐创作的实用工具。①

　　混音及母带处理插件有：

　　（1）MCharmVerb：非常不错的混响插件。

　　（2）MCompressor：简单但有效的电平压缩器插件。

　　（3）MonvolutionEZ：卷积混响插件。

　　（4）MEqualizer：6 段式均衡器。

　　（5）MLoudnessAnalyzer：基于 EBU R128，用于控制广播情况下的电平。

　　（6）MOscillator：振荡器，测试生成器，可用于检查电平。

　　（7）MSpectralPan：非常有趣的声像光谱效果器。界面类似于均衡器，但输出为立体声。应用于不同的轨道，更加有助于分离乐器。

　　（8）MStereoExpander：用于控制立体声场深度范围。

　　（9）MStereoScope：从俯视角度图显示立体声场。

　　用于声音设计与电子声音生成的效果器有：

　　（1）MComb：共振多组合滤波器。

　　（2）MFlanger：镶边效果器。

　　（3）MFreqShifter：自带调制频率振荡器的移频器。

　　（4）MPhaser：相位效果器。

　　（5）MRingModulator：功能强大的环形调制器。是较为少见的效果器。

7.4.1　修改电平：音频标准化

　　如果录制文件的整体电平看起来较低，可使用 Pro Tools 中的 Normalization（标准化）插件，或任一具有此功能的 DAW 来进行调整。（如图 7-10）

　　①　Melda Productiond 的网址为 https://www.meldaproduction.com/effects/free。

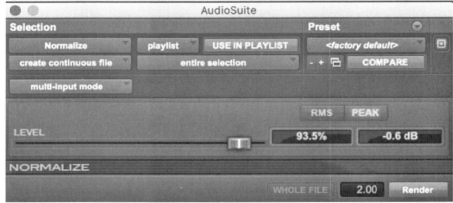

图 7 -10　音频标准化示例：90%（-0.6 dB）

7.4.2　插入虚拟乐器

在 Logic 中插入音源（虚拟乐器库）插件，需要打开调音台，选择 MIDI 轨道。单击面板上标签为 Input（输入）的插槽时，就会显示插件。这些标签出现在调音台左侧。图 7 -11 是音源插件列表，同时也包含乐器和采样播放器插件。

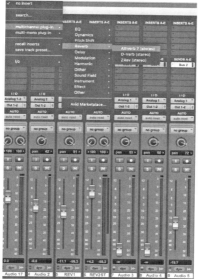

图 7 -11　可用插件滚动菜单（Logic、Cubase、Pro Tools）

7.4.3　Cubase

操作系统	Macintosh 和 Windows
下载地址	https://www.steinberg.net/cubase
可得性	付费

7. 4. 4　Logic

操作系统	Macintosh
下载地址	苹果应用程序商店（App Store）
可得性	付费

7. 4. 5　Pro Tools

操作系统	Macintosh 和 Windows
下载地址	https：//www. avid. com/pro-tools
可得性	免费和付费

7. 4. 6　Harrison MixBus 和 Mixbus32C

操作系统	Macintosh 和 Windows
下载地址	https：//harrisonconsoles. com/product/mixbus
可得性	付费

7. 4. 7　Reaper

操作系统	Macintosh 和 Windows
下载地址	https：//www. reaper. fm
可得性	免费和付费

7. 4. 8　Ableton Live

操作系统	Macintosh 和 Windows
下载地址	https：//www. ableton. com/en
可得性	付费

7. 4. 9　MOTU Digital Performer

操作系统	Macintosh 和 Windows
下载地址	https：//motu. com/en-us/products/software/dp
可得性	付费

7.5　MIDI

7.5.1　MIDI 的诞生

MIDI 标准于 1983 年制定，制定目的是为了能用一个键盘控制多个合成器。信息根据 MIDI 标准协议，以数字格式传输。MIDI 的工作原理源于乐器手势控制模式。选择 MIDI 这一名称（musical instruments digital interface，意为"乐器数字接口"）是因为需要将数字信息（如键盘所演奏的音乐）传输到模拟合成器上。MIDI 系统的设计目的就在于传输和转换演奏信息，包括演奏的音符，所选的一组声音或电子乐器，重音、弱音或渐强等微妙变化，等等。

MIDI 标准迅速获得了意想不到的成功。时至今日，人们依然使用 MIDI 标准连接电子音乐工作室的各种设备，甚至用它控制舞台上的灯光。

当时美国加州有一家以生产 Prophet 等模拟合成器而知名的公司 Sequential Circuits，其经理戴夫·史密斯（Dave Smith）提出建立一个系统，使合成器和键盘之间能够交换和传递音乐信息。1982 年，他制定了乐器之间交换数据的规则——以数字信号代表音乐信息。他在全美音乐商业协会（International Music Merchants Association，NAMM）展览会上首次展示了这一项目。该展览是每年 1 月在洛杉矶举办的国际乐器博览会，夏季还有一场规模较小的展览。

尽管好几家制造商都不看好这个项目，但 Sequential Circuits 公司的系统还是引起了一些日本公司的兴趣。1983 年 1 月，Sequential Circuits 键盘通过该系统成功控制了某日本品牌的合成器。MIDI 标准就此诞生，第一个用于数字音乐设备之间信息交换的规范就此正式公布。

如前所述，MIDI 一词为"乐器数字接口"（musical instruments digital interface）的首字母缩写。interface（接口）指的是确保两个系统之间通信的设备，构成 interface 一词的 inter 的意思是"在……之间"，而 face 则表示系统的某一方面或表面。"接口"可以实现一台计算机或一个数字系统的两个部分之间的数据传输。

值得一提的是，即使微型计算机诞生后经历了巨大的变革，但 MIDI 的工作原理自 1983 年以来一直并没有改变。事实上，MIDI 的出现得益于第一代微软和苹果个人电脑的问世。从那时起，个人电脑发生了很多变化，但 MIDI 的核心工作原理却始终未变，人们只是为它增加了几项新功能，使其操作更加灵活和强大，更好地适应现代数字工具的演变。

7.5.2　MIDI 信息的结构

如今，处理 MIDI 信息既简单又透明。MIDI 信息已经与虚拟乐器、数字键盘、乐谱软件、DAW 整合为一体。不过，理解 MIDI 的工作原理有助于克服它的局限性以及探索它的可能性。

MIDI 能够在数字设备之间传递不同类型的信息。例如，键盘可以通过 USB 接口连接到计算机上。无论在键盘上演奏什么音乐，DAW 或记谱软件都会接收到音高和音色等信息，键盘上的演奏就会被记录下来，并显示为乐谱。

MIDI 中的音乐信息有特定的形式。例如，音色作为声音的属性之一，不是用传统方法显示的。MIDI 无法识别乐谱中的强度记号，比如中强（mf）或强（f），而是按照 128 个数值来划分音量区间。同理，音高也不是用 do、re、mi 或 C、D、E 等字母来表示的，甚至不是用 Hz 来表示，而是由细分为 128 个的数值表示音高。你可能已经注意到了，MIDI 环境中可选的不同乐器或采样，即所谓的程序变更，有 128 个数值。

选择数字 128 是因为它对应数字数据的存储方式。更准确地说，每个内存字可包含 7 位可用数据，因此 MIDI 信息的储存容量为 128：从数字 0 至 127。我们来具体说一下其原理。

首先，了解数据在计算机或任何数字系统中的存储方式是很有必要的。在这些系统中，文本或声音等所有信息都是由数字表示的。正如我们在第 6 章中已经提到的，这些数字被收集在名为"字"（word）的单位中，字由一系列二进制位组成。计算机中所有信息都是数字，它不能理解除了数字之外的信息。计算机中的声音也是一长串数字。

要理解计算机的工作原理，我们需要知道它是如何表示数字的。

图 7–12 显示了十进制数和二进制数之间的对应关系，1 字节等于 8 位二进制数。了解这种特殊的储存原理有助于我们理解 MIDI，因为 MIDI 也遵循这一原理：所有 MIDI 信息皆由字节携带。

0	0	1
1	1	
2	10	2
3	11	
4	100	3
5	101	
6	110	
7	111	
8	1000	4
9	1001	
10	1010	
11	1011	
12	1100	
13	1101	
14	1110	
15	1111	
16	10000	5
…	…	…
127	01111111	7
128	10000000	8
…	…	…
255	11111111	8

图 7 - 12　二进制数字表

如上所述，MIDI 在数字设备之间传输消息。MIDI 数据或 MIDI 信息由一连串的字组成，每 1 个“字”有 10 个“位”（bit），其中 2 位用于保证传输质量，其余 8 位（即 1 个字节，byte）用于传输指令。“字节”最左边 1 位为 MSB（most significant bit，意为“最高有效位”），用于指示 MIDI 发送的消息类型。其他 7 位为“数据字节”。

7.5.3　MIDI 消息

MIDI 消息通常由数个连续字节组成，每 1 个字节有 8 个位。

7.5.4　Note ON 消息指令

当音符由 MIDI 发送，例如从 MIDI 键盘发送时，由 3 个连续字节共同构成了 MIDI 的 Note ON（音符开）消息。

如图 7 - 13 所示，这 3 个字节分别是：

（1）字节 1：通道号，该信息有 4 位编码。第 1 个字节（最高有效位）设置为 1，即值“1”，表示这是消息的第 1 个字节。接下来的 3 位表示这条消息是 Note ON。

（2）字节2：包含音高，有7位，涵盖128个不同的数值。第1位设为0，表示是连续字节。

（3）字节3：为"力度"，即演奏音符的力度，也有7位，因此可以有128个力度值。

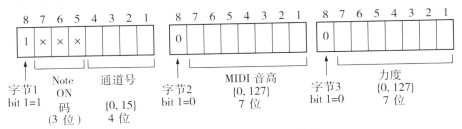

图 7－13　MIDI 的 Note ON 消息

为了停止音符播放，例如当松开 MIDI 键盘的按键或 DAW 发送停止信息时，就会生成 Note OFF（音符关）消息。

传输一条 Note ON 的 MIDI 消息大约需要 1 毫秒，信息是连续的，也就是串行的，意味着传输一个由 10 个音符组成的和弦大约需要 10 毫秒。虽然 10 毫秒看起来很短，但消息传输会因其他因素影响而延迟，如消息发出设备准备消息的时间，以及接收设备接收消息的时间。此外，若要削弱或停止正在发送的音符，就必须发送另一个 3 字节的消息，即 Note OFF 消息，它携带的信息与 Note ON 相同（通道号、音高和力度，在这种情况下，力度设置为0）。

传统音序器的传输方式是：计算机将 MIDI 消息发送到合成器或采样器。

如今，大多数操作都在计算机中进行，但人们仍在使用 MIDI。

每条信息（包括音高、音色、乐器等信息）都被编码记录。

共有 128 个音高（半音），编号是 1 到 128。

共有 128 个音色，编号是 1 到 128。

共有 128 种乐器，编号从 1 到 128。不过还是有很多乐器信息可以传送的，可以传送乐器库（例如管弦乐器库、打击乐器库、民族乐器库等）。

由于数据编码的原则，MIDI 不能表示超过 128 种乐器。在早期阶段，人们可能认为 128 种乐器已经绰绰有余，但很快，乐器的概念也开始适用于采样，因此乐器不再局限于管弦乐类，还包括了非欧洲乐器以及声音效果。基于同样的想法，MIDI 协议还规定最不同乐器的声部数量不得超过 16 个。即使每个乐器声部的音源都可以是多音色音源，也不能超过这个数字。由于受到 MIDI 最初定义的数字原则所限，有时我们需要运用编程技巧来规避这些限制。

278

虽然如此，但由于 MIDI 的出现，再加上 20 世纪 80 年代微型计算机的迅速发展，催生出了个人工作室（personal studio），又称为"家庭工作室"（home studio）。在计算机电子音乐这一新实践的背景下，软件行业也取得了引人注目的增长，软件行业取代音乐研究中心（如斯坦福大学的 CCRMA、麻省理工学院、GRM 或 IRCAM 等）成为了引领音乐发展的新力量。

音序器于 1985 年问世，最早的音序器用于演奏乐谱。而在 90 年代早期，其功能已经迅速扩展到声音文件的范畴。由此，音序器将 MIDI 数据和预先准备的声音相匹配。音乐创作者迅速对使用音序器创作音乐产生了浓厚兴趣。后来通用 MIDI 标准发布。

20 世纪 80 年代末，人们定下了一份乐器名单。该名单列出了 128 种不同的"程序"，涵盖了各类声音的名称。这就是名为"通用 MIDI 标准"（General MIDI）的预定义乐器分类表。例如，1 号乐器是大钢琴，2 号乐器是亮音钢琴，等等。注意，每家制造商都可以为每种乐器自行选择采样。因此，通用 MIDI 标准的实现可能因乐器的发声方式而异，但这些差异一般都很微小。

虽然通用 MIDI 标准相当普及，并广泛应用于多款软件中，但音源采样库其实是一个更好的选择，因为音源采样库能提供音质更好的声音。

在通用 MIDI 标准的 128 种乐器中，大部分是西方管弦乐器，也有一些日本传统乐器（但没有中国乐器，因为通用 MIDI 标准是基于日本提出的 MIDI 标准而制定的），还包括一些音效。

第二类由 47 种打击乐器组成。预留的 MIDI 通道 10 专属于鼓和打击乐器。

可参阅本书附录中的通用 MIDI 标准乐器列表。

8

混音、母带处理、音频可视化

8.1 信号的类型

调音台和 DAW 处理的信号包括以下几类：

（1）音频信号（声音文件），例如采样音频；

（2）MIDI 信号，例如西贝柳斯通过对 MIDI 文件的处理和读取来演奏乐谱；

（3）虚拟乐器，指创作或播放声音的软件插件。

例如，西贝柳斯中的音乐确实是用 MIDI 数据来表示的，但西贝柳斯也可以使用真实的采样声音。若使用真实的采样声音，乐谱的 MIDI 音符会发送到播放器插件，插件使用真实的乐器采样声音来演奏 MIDI 音符。

如 7.1 节所述，MIDI 音符也可以发送到外部设备，如合成器或者采样器，但是目前较少使用这种方法。可以从外部 MIDI 控制键盘（例如键盘）来接收 MIDI 音符。

我们可以在 DAW 中找到这些类型的通道。

－音频：从磁盘读取的声音音频文件，播放或者与其他音频信号混合。

－虚拟软件乐器：DAW 通常有自带的软件乐器（如 Cubase 的 HALion Sonic SE）。

－MIDI：MIDI 信号传送命令，不传送音频。

－主通道（Master）：接收所有音频通道并将其混合成立体声。

－辅助、插入、组、总线（Bus）：这些是接下来我们要讲的特殊类型通道，其名称在各个软件中或许会有所不同，但都具备相应的功能。

8.2 调音台

混音要在调音控制台（又称"调音台"）中进行。在 Cubase 中，打开调音台的路径是 Studio → MixConsole，点击后进入 Cubase 调音台界面。（如图 8－1）

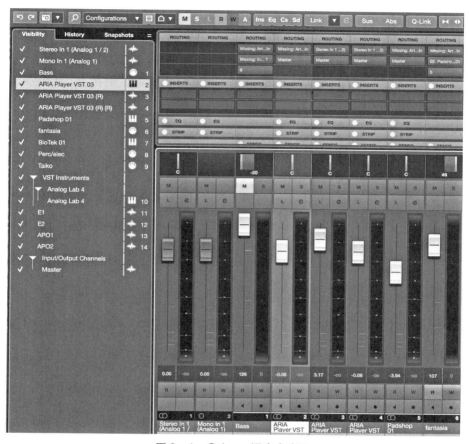

图 8 – 1　Cubase 调音台窗口

　　在 Logic 中，有两种打开调音台的方法。第一种是 Window → Open Mixer，调音台会显示在单独的面板上，可以自由移动。

　　第二种方法是 View → Show Mixer。调音台会显示在主窗口（音序器窗口）下方。无论哪种方式，都能打开 Logic 调音台窗口。（如图 8 – 2）

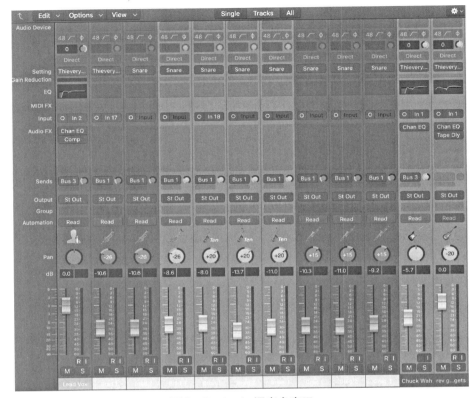

图 8 – 2　Logic 调音台窗口

在 Pro Tools 中，可以通过 Window → Mix 进入调音台。

8.2.1　DAW 的其他窗口

除了我们在上文认识的主窗口（音序器）以及调音台外，新型 DAW 还提供了以下三种类型的窗口模式，以便使用者运用各种工具创作和编辑音乐。

乐谱：用五线谱记谱的方式来显示 MIDI 轨道内对应的音符，音频轨道不能在乐谱中显示。

钢琴卷帘：用图形符号的形式来展示 MIDI 轨道和片段。注意，音频轨道也可以用钢琴卷帘展示，但这种模式容易令人混淆。

事件列表：以列表形式显示所有的 MIDI 音符和命令，列表可以编辑和修改。

8.2.2　钢琴卷帘

钢琴卷帘窗口显示 MIDI 事件：音符、连续控制和各种 MIDI 设置。使用者

可以编辑和修改列表，准确调整 MIDI 音符和命令。

MIDI 音符显示为音符的音名和八度数字，例如：C4、C#3、D3。

时间用小节和节拍来表示。音符的开头和结尾分为两栏。注意，由于 MIDI 是一个现场实时的系统，所以不会以秒为单位显示音符的确切持续时间。

使用 Logic 时，通过 Window → Open Piano Roll 打开钢琴卷帘。

Cubase 钢琴卷帘窗口的布局和功能与 Logic 非常相似。（如图 8－3）

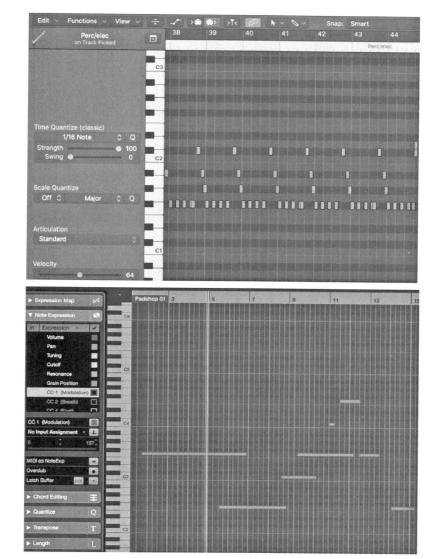

图 8－3 Logic 和 Cubase 的钢琴卷帘窗口

Pro Tools 使用了与 Cubase 不一样的名词，它把钢琴卷帘窗口称为"MIDI 编辑器"。打开 Pro Tools，选择 Window → MIDI Editor，就会弹出 Pro Tools 钢琴卷帘窗口。

8.2.3 事件列表

事件列表窗口显示 MIDI 事件：音符、连续控件和各种 MIDI 设置（如图 8－4）。使用者可以编辑和修改列表，准确调整 MIDI 音符和命令。

MIDI 音符显示为音符的音名和八度数字：C3、C#3、D3。

时间用小节和节拍来表示。音符的开头和结尾分为两栏。注意，因为 MIDI 是一个现场实时的系统，所以不会以秒为单位显示音符的确切持续时间。事件（如音符）的持续时间取决于事件激活（音符开）和事件结束（音符关）的时间差，不是用秒来表示，而是用节拍细分来表示。由于节拍本身取决于乐谱或段落的节奏和时间特征，这就是为何有时候需要谨慎编辑事件列表的原因。

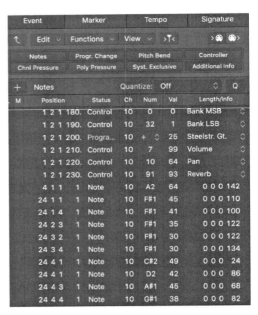

图 8－4　Logic 事件列表

Cubase 事件列表如图 8－5 所示。它显示了事件的类型，包括音符、乐器（程序改变）、控制器、触后等等。还会以小节和节拍显示音符的开始、结束

和长度，以及以钢琴卷帘显示音符，音量控制显示在右侧。数据大多可以修改编辑。

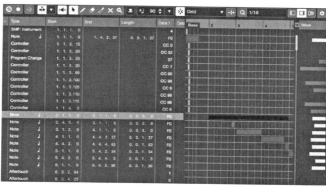

图 8-5　Cubase 事件列表

8.2.4　音频可视化

音频可视化就是创造声音的"图像"，如同画家在画布上构图。

由于可视化的声音音景由前景、中景和背景组成。所以电子音乐工作者会有意识地将某一些层次的声音放在最前面，而另一些层次的声音往后放置。然而，画面是平面的，是在一个二维空间内以现实的视角将各种元素结合起来，创造出具有不同声音音景深度的三维景观。

在音乐方面，有助于实现这种效果的是音频可视化。音频可视化指混音时将声音分布在左、中、右的任何地方。为实现这一点，可以使用 PAN 控制声向，并且可以实现自动化。

音频可视化的另一个维度是深度，轨道可以放置在前面或后面，我们可以使用混响和低通滤波器来创造深度。底色，也就是背景中的声音，在某种程度上使混响更加丰富，可以带给人一种离听者较远的印象。此外，声音频谱中高频较少，使用低通滤波器可达到此效果。最后，音量可以调弱，也可以不做调整。

9
Csound 和声音合成

9.1　声音合成程序的结构

声音合成程序可以分为两个截然不同的部分。一部分负责根据所选的振荡器和处理模块计算采样。由于程序的不同，这些模块也被称为"乐器""管弦乐队"或"工程文件"。

另一部分相当于"乐谱"，用于储存定义声音事件的数值并将其传输给"乐器"。基于这类程序所进行计算机处理操作的类型，及其生成的一系列用以交换音乐家所提供数据的基本指令，它们被称为"声学编译器"。

一件"乐器"具有各种功能，即所谓的"模块"（module）。例如20世纪60年代问世的模拟合成器，它为音乐家提供了用于合成和处理的基本设备，如振荡器、发生器、噪声、不同类型的固定或可变截止频率滤波器、环形调制器、移频器、包络发生器、可变增益放大器等等。在模拟合成器中，这些模块通过音频连接或控制电压连接组装起来，构成一件复杂的"乐器"。当由数字系统产生信号时，遵循的方法通常也是相同的："乐器"是由合成器的功能和对采样的处理"组装"起来的。马克斯·马修斯于1960年设计的程序MUSIC Ⅲ引入了这一原理，其功能后来被称为"单元发生器"。其中有些是定义模块配置的程序；有些程序的结构像真实语言一样，可在跨乐器的采样基础上加入计算算法，例如MUSIC Ⅳ程序的几个版本。

最简单的"乐器"可以只有振荡器和输出两个模块。振荡器可读取正弦波，而输出模块连接到象征性的扬声器上，实际上是负责将产生的样本传输到声音文件或转换器。

这些模块分为几种类别，主要有声音合成和声音处理（效果器）。还有一些其他的类别，如随机数生成模块等。

需要注意的是，"模块"在不同环境有不同的名称。例如，早期人们称之为"单元发生器"。Csound使用"操作码"（opcode）一词来特指具体模块的名称。在Max/MSP等其他程序中，模块被称为"物件"（object）。

不要被各式各样的称呼所迷惑。其实在每一种情况下，我们谈论的都是计算机科学所说的"函数"：即一个软件，它接收数据，在交换后产生数据结

果。例如，振荡器接收频率（音高）、振幅（电平，在大多数情况下）和波形，还可以接收相位。输出的是信号，信号继而被发送到另一个模块。

Csound 的前身是 MUSIC 系列程序，而该系列程序家族的第一个成员诞生于 1957 年。当时马克斯·马修斯是纽约附近贝尔实验室的一名研究人员，他发明了一种方法，用计算机计算波形，然后将波形转换成声音。这种方法至今仍被广泛使用。

马修斯的程序与其说是专为音乐而写的软件，不如说是一项科学实验，但他在程序问世后便发现音乐家们对使用计算创造音乐声音非常感兴趣。即使在那个年代，计算机难得一见，而且往往没有计算机可供音乐家使用，但马修斯仍添加了新功能，很快他开发的程序就能够创造出悦耳的、新奇的声音。1960年推出的 MUSIC Ⅲ 程序就具备了这些功能。

Csound 编写于 1985 年。1968 年，该软件的开发者巴里·菲尔柯曾于普林斯顿大学为 IBM 360 电脑改编了马克斯·马修斯的 MUSIC Ⅳ 程序。1973 年，当菲尔柯在麻省理工学院担任助理教授时，他为迪吉多公司的 PDP-11 计算机编写了一个相当成熟的程序，他称之为 MUSIC 11。在这一版本中，他引入了控制率的概念，用字母 k 命名变量。1985 年，他在巴黎 IRCAM 工作的期间，用 C 语言重写了这个版本。他把这个程序命名为 Csound，从此以后这个程序一直被广泛使用。

9.2 Csound 概述

Csound 是一款用于创造复杂且动听的声音的软件，它虽然不能取代常用的 DAW，如 Cubase、Logic 等，但它所生成的声音拥有准确度和高质量，其他程序难以与之比肩。就这一点而言，Csound 是一种工具，可作为现代作曲家在计算机音乐工作室中使用的创作工具的补充。可以使用 Csound 来创造声音，然后将创造的声音导入 DAW（Pro Tools、Logic 或 Cubase）进行混合，从而创作出一个完整的作品。

使用 Csound 的一种方法是为电子声音和乐器创作一首曲子，当乐器演奏时，电子声音同时播放出来，这类音乐叫作"混合类电子音乐"。另一种方法是纯粹为电子声音创作作品，然后直接通过扬声器播放出来，这类音乐叫作"幻听类电子音乐"。

9.2.1 安装 Csound

可以访问链接 https://csound.com/download.html，下载安装 Csound，安装

后 Csound 在后台进程中显示，不会放入应用程序文件夹中。通过网站 csound. com 可访问现有的 Csound 软件和文档。

要使用 Csound，还需要再安装前端界面程序 CsoundQT，安装后才能运行 Csound 的前端界面。CsoundQT 可访问链接 https://github. com/CsoundQt/ CsoundQt/releases 或 http://csoundqt. github. io/pages/install. html 下载。

如需获得更多关于 Csound 的资料，如参考手册等，可访问 https:// csound. com/download. html。

9.2.2　Csound 相关链接

操作码链接：https://csound. com/docs/manual/index. html。

GEN 函数链接：http://www. csounds. com/manual/html/ScoreGenRef. html。

9.2.3　CSD 文件

在新版 Csound 中，乐器、函数和乐谱已合并到一个文件中。

文件扩展名为 csd。

CSD 文件类似于 XML 文件（包含内容和标记的文件）。在撰写本书时，如上所述，最常见的前端界面程序是 CsoundQT。

以下是 CSD 文件的结构。

```
< CsoundSynthesizer >
< CsOptions >
- odac
< /CsOptions >
< CsInstruments >
sr = 44100
ksmps = 64
nchnls = 2
0 dbfs = 1

        ***  INSTRUMENT GOES HERE
< /CsInstruments >
< CsScore >
        ***  SCORE GOES HERE
< /CsScore
< /CsoundSynthesizer >
```

9.2.4 Csound 语法

Csound 会话由几个部分组成，后文将展示 Csound 文件的不同部分。

9.2.5 顶部

顶部（Header）为基本设置栏，基本设置包括采样率、控制率、通道等必要信息，这些信息也可从乐谱中直接复制。还可以在顶部决定输出为单声道还是立体声。

9.2.6 乐器

一件乐器（Instrument）由多个操作码（或"模块"）组成。处理音频信号的操作码输出以字母 a 开头（如 audio）。处理控件（类似于模拟合成器中的控制电压）的操作码输出以字母 k 开头。字母 i 表示在音符的整个持续时间内设置的变量，字母 i 也用在 Csound 乐谱中，放在音符的开头，后面跟着乐器编号。输出（即音频文件）被发送到操作码 out。

9.2.7 操作码

如前所述，操作码指"模块"（声音合成或声音处理），过去也被称为"单元发生器"。如今，Csound 已有数百种操作码，但真正常用的只有几种。

9.2.8 GEN 函数定义

包络由断点函数定义，波形由谐波的相对振幅（在 0 到 1 之间）定义。在大多数情况下，函数是一个表（计算机内存中包含一个列表和值的区域）。函数储存波形，如正弦波、三角波或包络波。在 Csound 中，每种类型的函数都由一个特定的数字表示。[①]

GEN 函数包含频谱或包络形状的定义及其他内容。一些操作码（如振荡器和包络的操作码）会读取并使用 GEN 函数。GEN 函数有许多不同类型。每种类型都有一个特定的数字编号。在以下的例子中，使用的是 GEN 10 函数。运用 GEN 10，可以定义谐波分音的频谱，从谐波 1 开始。每个谐波的振幅值在 0 到 1 之间，即 {0, 1}。

这个例子中的函数如下所示。

① 如需了解更多详情，可访问 https://csound.com/docs/manual/index.html。

```
f1 0 4096 10 0 0 0 0 .1 .2 .3 .4 .5 .7 .65 .6 .55 …
```

函数 1：是这个特定函数的名称，所以它是 f1（名称可自由选择）。一般情况下，起始时间都为 0，但之后也可以用不同的起始时间重新定义 f1。

4096 是包含频谱的表（计算机的储存区域）的长度。表的长度通常是 2 的 N 次方。

10 是函数类型，允许频谱由连续谐波定义。函数可以包含任何数量的谐波，一般会从谐波 1 开始。

9.2.9 标签

标签（Tag）定义了 Csound 文件的某些区域，如顶部、乐器、乐谱（Score）等等。每个区域都嵌入一个开始标签和一个结束标签之中。开始标签记为 < tag >，结束标签记为 < /tag >。例如，所有的 Csound 文件都以标签 < CsoundSynthesizer > 开始，文件的最后一个标签是 < /CsoundSynthesizer >。

< CsOptions > 和 < /CsOptions > 表示嵌入选项。

< Csinstruments > 和 < /Csinstruments > 表示嵌入乐器，在这个标签中可以有多个乐器：

```
instr 1        … endin
```

< CsScore > 和 < /CsScore > 表示嵌入乐谱。

9.2.10 指令

在 Csound 中，"指令"指用来表示进行某个操作的代码行，如振荡器、滤波器、包络等等，每个操作都有对应的指令。以下为 Csound 指令的两个例子：

```
ifreq = p6
asig oscil 1, 440, 0
```

9.2.11 变量

如前所述，Csound 的乐器可以区分音频信号（以字母 a 开头）、控制信号（以字母 k 开头），以及在整个音符输出中不发生变化的量（以字母 i 开头）。

音频信号是根据采样率来评估的（声音的采样率为每秒 44100 次），而控制信号只根据选择的控制率（kr）来评估（此例中为每秒 500 次）。这种双重计算率的原则，一定程度上解释了为何 Csound 比其他声音合成程序在计算速度上更具优势。

变量接受赋值，值可以是一个数字或一个名称。Csound 中的变量可看作合成器中的电线，电线传输音频信号，变量传输数据。变量接收一个操作码的输出数据后，再将数据交给另一个操作码，它在 Csound 的不同操作步骤之间起着衔接作用，就像一个盒子，数据在其中出入。

注意，在一个音符的整个持续时间内，变量内容可以是固定的，也可以是变化的，例如当变量接收振荡器的输出数据时，就会出现变化。

Csound 变量总是以字母 {a，i，k…} 开头，具体可以查看 Csound 文件的顶部。

```
<CsInstruments>
sr = 44100          ; sampling rate
kr = 4410           ; control rate
ksmps = 10          ; should be sr/kr
```

字母 a 开头的变量，表示内容随音频速率变化的值。例如，变量 asig 接收振荡器的输出数据，意即 asig 将接收以音频速率变化的数据（如每秒 44100 次）。这就是采样率（sampling rate，sr），它的值在顶部中指定为 sr = 44100。

字母 k 开头的变量，表示内容变化较慢的变量，它们以 k 速率（即控制速率）变化。这个值也可以在顶部中指定。在上例中 kr = 4410，控制率的值比采样速率慢 10 倍。

字母 i 开头的变量，表示该变量的设置适用于一个音符的整个持续时间。字母 i 也用在 Csound 乐谱中，i 出现在音符的开头，后面跟着乐器编号。

9.2.12 实时输出

```
<CsoundSynthesizer>
<CsOptions>
-odac
</CsOptions>
<CsInstruments>
```

< CsoundSynthesizer > 是整个起始标签。

< CsOptions > 用于放置命令参数。

-odac 是指输出到 DAC（实时）：生成的声音将被发送到计算机的选定输出端。

如果省略 -odac，Csound 将创建一个名为 test. aif 的音频文件。

9.2.13 渲染和输出声音

使用 Fout 操作码可生成一个声音文件。

```
Fout        " outputfilename.wav" 8  asig
```

9.2.14 乐谱结构

声音合成语言的传统分区以一组数值列表的形式表示。每组包含不同乐器模块所需的数值。

这里的乐谱可以看作是一组"事件"（event）的列表。每个事件都有一些由乐器读取和执行的数值。因而也可以说它是一个数值的列表，由多个参数字段（Parameter field，简称 P-field）组成。参数字段 1 即 p1，为乐器编号；p2 是起音时间（attack time，或译为"压缩时间"，是启动或激活的时间）；p3 是音符的持续时间。

乐谱由连续的代码行构成，每一行代表一个事件。

每个音符由连续的"参数字段"组成，参数字段是由乐器读取的数值。

乐器查看每一行乐谱，在连续字段中找到对应的参数字段，理解乐谱的构成：

p1，乐器编号。

p2，起音时间，即事件的开始时间，单位为秒。

p3，延音时间，即音符的持续时间，单位为秒。

p4 到 pn 可自由选择，但须对应操作码所期望的参数。

一个事件行通常包含各种乐器操作码所期望的所有参数字段。"参数字段"（Parameter field，简称 P-field）这个名字就源自借助打孔卡向计算机提供数据的老办法。早在 20 世纪 60 年代人们刚刚开始编写程序时，程序员还需要通过打孔卡对数据一行行地编码，因此有"字段"（field）一词。图 9 - 1 就是一张老式的打孔卡。

图 9 - 1 带参数字段的老式打孔卡

例如：

```
<CsScore >       ; tag indicating the start of the score
i10 0 60         ; event played on instrument 10 starts at 0" and
lasts 60"
s                ; end of section (if any)
e                ; end of score
</CsScore >      ; tag closing the score
```

图 9 - 2 为 Csound 中音符事件行的例子。

图 9 - 2　Csound 音符示例（事件列表）

9.2.15　设置 CsoundQT

如果在运行 Csound 时使用 CsoundQT 作为前端界面，可以在 CsoundQT 顶部菜单（如图 9 - 3）上，单击 Configuration（左起第七个标签）更改设置，以更好地满足自身需求。

图 9 - 3　CsoundQT 的顶部菜单

9.2.16　创建简易乐器

我们可以用一个振荡器和一个振幅包络来创建一个简易乐器。

振荡器采用的是 poscil 操作码，即是一个精密振荡器。包络使用的是 linen 操作码。

linen 操作码提供包络，即振幅的变化。当声音开始时，振幅为零，声音从无到有，随着包络的增长，音量逐渐增大至可听见的范围——这是包络逐渐增至最大的结果。最大的电平称为"振幅"，因此振幅就是要达到的电平。如果要用音乐术语表达，不妨将其想象成中弱或极强等力度。

如图 9 - 4 所示，左边是提供包络的 linen 操作码。右边的振荡器产生波形，振幅是 1，需要将振幅调整到适当的水平，这就是 linen 操作码提供包络的功能。

图 9 - 4 中可见，linen 操作码的包络输出和振荡器的音频信号是成倍增加的。

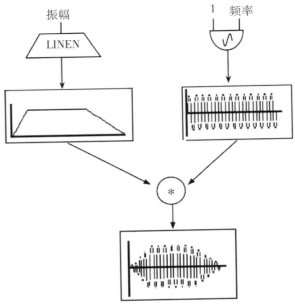

图 9 – 4 生成带有振幅包络的声音

有了 Csound，包络（ENV）与音频信号就不需要增倍了：linen 可以直接连接到振荡器（OSC）的左入口（如图 9 – 5）。

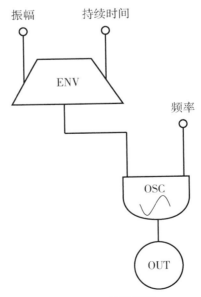

图 9 – 5 简易乐器

9.2.17 绘制乐器工程文件

为创建中的乐器绘制示意图，是最有助于设计乐器和控制产生音乐声音的所有相关操作的方法。在本书中，笔者使用了乐器工程文件的原理图，这些图示可以实现可视化，清楚展示工程文件中的模块，例如各种振荡器、包络、信号的加法或乘法等运算符。

请参考图 9 – 6、9 – 7，学习如何绘制乐器程序，图中展示了绘制程序的步骤。这个例子基于前文提及的程序，即带有一个振荡器和一个振幅包络的简易乐器。

（1）画一个半圆表示振荡器。半圆上方右边是频率输入口，左边输入口会接收到一个数值，该数值将乘以振荡器所产生波形的振幅，因此左边输入口称为"振幅输入口"。

（2）放置包络，此处使用的是 linen 操作码。linen 操作码接收四个参数：第一个为包络的最大振幅，以及另外三个以秒为单位的参数。这三个参数分别为起音时间（即上升段，从 0 开始然后达到振幅电平）、延音时间（此数值通常来自乐谱的第三个参数，即 p）以及释音时间（或衰减时间、末段，在此过程中包络归零）。在图 9 – 6 中，因为持续时间经常由 p3 给出，所以将其省略。

（3）绘制线条，创建模块之间的连接。

（4）画出振荡器的频率输入口。

（5）不要忘记绘制输出。

（6）添加进入输入口的变量的名称。

（7）最后添加参数字段，即乐谱中包含变量赋值的位置。

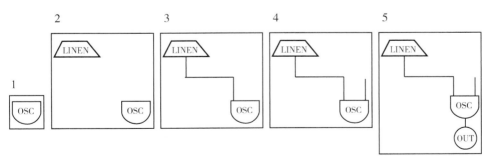

图 9 – 6　绘制乐器的初始步骤

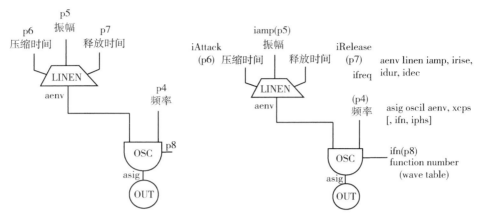

图 9 – 7　绘制乐器工程文件的最后步骤

以下是该乐器的完整代码。

```
<CsoundSynthesizer>
<CsOptions>
-odac                    ; realtime output
</CsOptions>
<CsInstruments>
sr = 44100       ; sampling rate
ksmps = 64       ; control rate
nchnls = 1       ; mono (1 channel)
0dbfs = 1        ; amplitude between 0 and 1
instr 1
idur      = p3
ifreq     = p4
iamp      = p5
iAttack   = p6
iRelease  = p7
ifn       = p8
aenv      linen          iamp, iAttack, idur, iRelease
asig      poscil         aenv, ifreq, ifn
out       asig
endin

</CsInstruments>
<CsScore>
; 1: a sine wave
; 2: spectrum with harmonics
; 3: playback of an external soundfile

f 1 0 4096 10 1
f 2 0 4096 10 .5 .5 .5 .4 .3 .2 .1
f 3 0 131072 1 "isthatyou.aiff" 0 0 0
; caution: the audio file must be in the same folder
; the size of the table must be a power of 2
;p1    p2      p3      p4      p5      p6      p7      p8
i 1    0       2       110     1       .1      1       1       ; uses function 1
i 1    1.6     2       98      .5      .001    1       2       ; uses function 2
i 1    3.1     1       .7      1       .001    .01     3       ; uses function 3
</CsScore>
</CsoundSynthesizer>
```

9.3 加法合成

这种名为"加法合成"的声音合成方法需要使用多个振荡器，每个振荡器都会产生一个波或谐波（也称为"分音"）。

图 9-8 为一组振荡器。每个振荡器接收一个频率（标记为 f_n）和一个振幅（标记为 a_n）。虽然该乐器不会产生动听的音乐效果，但它显示了加法合成（标记为 S）的基本原理。

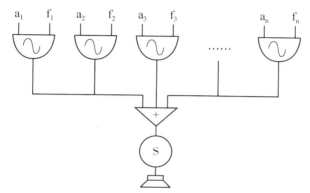

图9-8 基本加法合成工程文件

图 9-8 的简易乐器缺少一个逐渐改变振幅的装置，而图 9-9 的工程文件则添加了这么一个装置。每个振荡器都有自己的振幅包络，因此，每个分音的振幅和持续时间都是独立控制的，甚至可以通过调整振幅包络的形状，实现其压缩瞬间和释放持续时间的独立控制。也可在该乐器中添加其他控件，例如颤音。

如果使各分音完全独立的加法合成是一种应用非常广泛的方法，那么它显然需要大量的控制模块才能使其产生的声音具有生命力，这就出现了确定所有必要数值所需时间的问题。

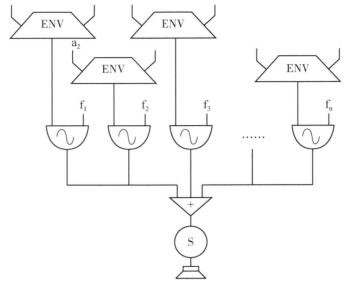

图 9–9　带振幅包络工程文件的加法合成

9.3.1　使用 Csound 创作音乐

　　在本节的例子中，将使用法国作曲家兼研究员让·克劳德·里赛特（Jean-Claude Risset）创造的加法合成乐器，该乐器被德国作曲家卡尔海因茨·斯托克豪森用于他 1984 年创作的《卡辛卡之歌》（*Kathinka's Gesang*）中。这个乐器的声音以某个频率（音高）为基础，再加上几个频率设置得非常接近的叠加振荡器。振荡器频率之间的差值设置成名为 delta（或 Csound 中的 idelta）的变量，即 delta 代表以 Hz 为单位的差值，然后再把所有的振荡器叠加在一起（如图 9–10）。

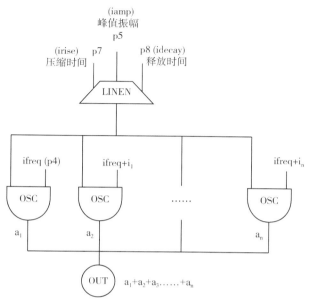

图 9 - 10　加法合成乐器生成（音高和节拍）

在 Csound 中，该乐器的频谱由振幅值组成。每个谐波的振幅为 0 到 1 之间的数字，从谐波 1（基波 1）开始，例如：

```
</CsInstruments>
<CsScore>
f1 0 4096 10 1 0 0 0 .1 .2 .3 .4 .5 .7 .65 .6 .55 .5 .45 .4 .35 .2 .1.5 .1 .07 .05
```

图 9 - 11 是这个频谱的图示。

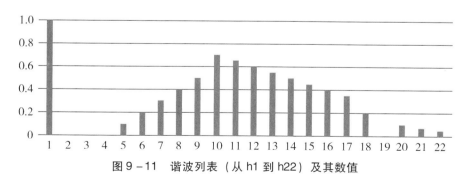

图 9 - 11　谐波列表（从 h1 到 h22）及其数值

声音的所有谐波称为"频谱"。举个例子，当我们在钢琴上演奏低音 do

299

时，我们听到的声音中包含了所有这些谐波。不过，我们认为只听到了低音 do 一个音符，是因为大脑把所有的谐波融合成一个单一的声音。

以下是在 Csound 中使用加法合成创建的乐器。

```
instr 10
iduration =  p3          ; duration of the note
ifreq     =  p4          ; frequency in Hertz
iamp      =  p5          ; max = 32767
idelta    =  p6          ; frequency interval
iAttack   =  p7          ; duration of the attack portion in seconds
iRelease  =  p8          ; duration of the release portion in seconds
iwf       =  p9          ; function number (wavetable)

i1 = idelta
i2 = 2*idelta
i3 = 3*idelta
i4 = 4*idelta
i5 = 5*idelta
i6 = 6*idelta
i7 = 7*idelta
i8 = 8*idelta
aenv     linen iamp, iAttack, iduration, iRelease
a1       oscili aenv, ifreq, iwf
a2       oscili aenv, ifreq+i1, iwf
a3       oscili aenv, ifreq-i1, iwf
a4       oscili aenv, ifreq+i1, iwf
a5       oscili aenv, ifreq-i2, iwf
a6       oscili aenv, ifreq+i3, iwf
a7       oscili aenv, ifreq-i3, iwf
a8       oscili aenv, ifreq+i4, iwf
a9       oscili aenv, ifreq-i4, iwf
a10      oscili aenv, ifreq+i5, iwf
a11      oscili aenv, ifreq-i5, iwf
a12      oscili aenv, ifreq+i6, iwf
a13      oscili aenv, ifreq-i6, iwf
a14      oscili aenv, ifreq+i7, iwf
a15      oscili aenv, ifreq-i7, iwf
a16      oscili aenv, ifreq+i8, iwf
a17      oscili aenv, ifreq-i8, iwf
out      a1+a2+a3+a4+a5+a6+a7+a8+a9+a10+a11+a12+a13+a14+a15+a16+a17
endin
</CsInstruments>
<CsScore>

f 1 0 4096 10 1 0 0 0 .1 .2 .3 .4 .5 .7 .65 .6 .55 .5 .45 .4 .35 .2 .1.5 .1 .07 .05
;1   2  3        4       5       6       7       8 9
i 10 0 60        55      800     .03     .5      1 1
e
```

此 Csound 乐谱的合成效果是产生带有循环节拍的声音，其频率分析如图 9 - 12。

我们来探讨一下上文提及的加法合成乐器。在该乐器中，许多振荡器一起演奏，每个振荡器的频率会略高于或略低于主频率，频率之间的差值以 Hz 为单位，差值是一个极小数值的倍数（或分数）关系。在上述例子中，此差值称作 delta，为 0.03 Hz，是一个非常小的数值。接下来我们将解释这个数值是如何计算出来的。如图 9 - 13 所示，在音符开始时，所有振荡器一起运行：波形的相位是一致的。由于它们的频率存在细微差异，当它们开始移动时：就会出现一个相移，这就是节拍。一段时间后，所有周期再次变得一致。

图 9-12 频率为 49 Hz 的加法合成乐器的频谱图

两个时刻之间的时间是可以计算的，在这个例子中，相位移动持续了 33 秒，因此不难可以计算 delta 的值是 1/33，也就是 0.03，delta 是 0.03 Hz。

在这个加法合成的例子中，delta 是一个固定值；加法合成乐器可以运用内部的循环变化创造出悦耳的声音。当 delta 等于 0.03 时，所有振荡器将在 33 秒后重新处于"同相"状态。因此，我们听到的节拍是循环的，选择整个相移周期的持续时间相当简单。

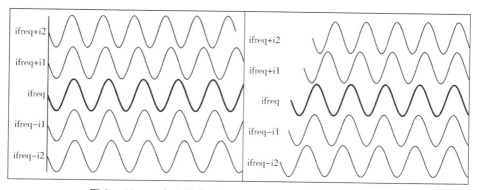

图 9-13 一个完整节拍周期的开始（左）和结束（右）

9.3.2 练习

本节的练习题目是创建一个变量 delta，使其初始值为 0，达到最大值

delta，然后在音符的持续期间内减少回 0。

为此，delta 必须由包络来控制，例如 linen 操作码。这种情况下，赋予操作码的振幅将是 delta 的数值。这样，linen 操作码就会产生一个包络，在起音时间结束时达到峰值 delta，然后在释音时间内衰减。（如图 9 - 14）

复制 Additive synthesis Csound 文件，并修改该文件以包含变量 delta。

图 9 - 14　变量 delta 的包络

图 9 - 15、9 - 16 是此声音效果的 FFT 图像。图像呈现出缓慢的"跳动"（两个音高非常接近的音符间的干扰现象），跳动不断增强，而当它达到 delta 的值时，就会减弱。我们将在下一段给出解决方案。你可以尝试用不同的 delta 值，有时采用较大的 delta 值会得到更好的效果。

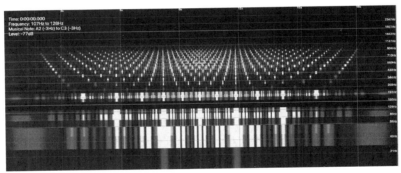

图 9 - 15　delta 递增和递减示意图（使用 Wavepad 进行分析）

图 9 - 16　delta 递增和递减示意图（使用 Audacity 进行分析）

　　解决这个问题的方法之一是包含 delta 的变量不能始终为 i 变量（以字母 i 开头的变量），因为 i 变量表示音符持续期间内的一个固定值，这意味着它不会接收 linen 包络的输出。所以需要将包含 delta 的变量设为 a 变量，a 变量的内容会不断变化。

　　linen 操作码将产生一个包络，该包络初始值为 0，上升到最大值，即 delta 的值，然后下降回 0。换言之，delta 将从 0 开始增大，继而达到最大值，然后归零。

　　确定此解决方法后，振荡器 2 到 n 就会把频率（p4）加到变量 delta 上（如图 9 − 17）。当音符开始时，没有跳动，然后跳动加强，最后减弱直至音符结束。

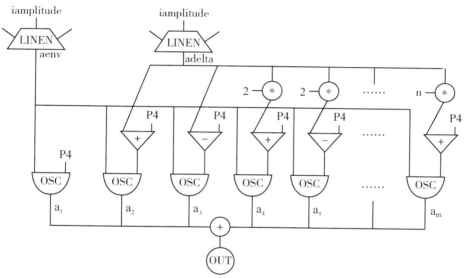

图 9 − 17　具有可变节拍间隔（delta）的乐器

```
instr 10
idur        =          p3
; p4 = freq
iamp        =          p5          ; max = 32767
ideltaf     =          p6          ; interval
irise       =          p7          ; attack duration of the amplitude envelope
idecay      =          p8          ; release duration of the amplitude envelope
iwf         =          p9          ; function number
iriseDLT    =          p10         ; attack duration of the delta envelope
idecayDLT   =          p11         ; release duration of the delta envelope

aenv    linen iamp, irise, idur, idecay
adeltalinen   ideltaf, iriseDLT, idur, idecayDLT

a1          oscili aenv, p4, iwf
a2          oscili aenv, p4+adelta, iwf
a3          oscili aenv, p4-adelta, iwf
a4          oscili aenv, p4+(adelta*2), iwf
a5          oscili aenv, p4-(adelta*2), iwf
a6          oscili aenv, p4+(adelta*3), iwf
a7          oscili aenv, p4-(adelta*3), iwf
a8          oscili aenv, p4+(adelta*4), iwf
a9          oscili aenv, p4-(adelta*4), iwf
a10         oscili aenv, p4+(adelta*5), iwf
a11         oscili aenv, p4-(adelta*5), iwf
a12         oscili aenv, p4+(adelta*6), iwf
a13         oscili aenv, p4+(adelta*6), iwf
a14         oscili aenv, p4+(adelta*7), iwf
a15         oscili aenv, p4+(adelta*7), iwf
a16         oscili aenv, p4+(adelta*8), iwf
a17         oscili aenv, p4-(adelta*8), iwf
out     a1+a2+a3+a4+a5+a6+a7+a8+a9+a10+a11+a12+a13+a14+a15+a16+a17
endin
f 1    0    4096   10   1   1   0   0   0   0   0   0   0   0   0   0   0   0   0   0   .55  .5   .45  .4   .35  .2   .1  .5
01   .01  .01  .01  .01  .01  .01  .01  .01  .01  .01  .01  .01  .01

;p1   p2        p3        p4        p5        p6        p7        p8        p9        p10       p11
i10   0         75        27.5      1500      .1        .001      1         1         35        35
e
```

9.4　声音建模：减法合成

　　模拟合成器时代曾经见证了减法合成的全盛时期。减法合成是一种可以从少量复杂声源中提取多种声音的简易方法。在减法合成过程中，使用频谱非常丰富的声音，并对其进行滤波处理：滤波器会减弱频谱的某些区域，或增强频谱以彰显其他区域。减法合成常用的信号是脉冲，因为脉冲的频谱非常丰富。斯托克豪森在他著名的电子声学作品《青年之歌》中正是运用这种方法，对一组脉冲信号进行了滤波处理。

　　自 20 世纪 20 年代起，减法合成就一直应用于电子乐器领域。例如，在德国的特劳特琴（Trautonium）使用振荡器产生丰富的波形，再通过放置在振荡器后面的滤波器来改变音色。现代合成器常将振荡器、滤波器和包络三者依次放置，组合起来创造"声音"。

　　如在图 9 – 18 中，振荡器的输出发送到滤波器，此示例中使用的是带通滤波器，带通滤波器有两个截止频率。其中上限截止频率不容许高于截止频率的信号通过，下限截止频率则去除低于截止频率的信号。

　　振荡器可以由读取外部声音文件的模块代替。

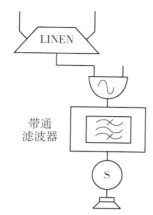

图9-18 带通滤波器的简易减法合成乐器

9.5 调频合成

9.5.1 调频合成概述

调频合成（frequency modulation synthesis，FM synthesis）只使用两个正弦波振荡器就能产生丰富的频谱（即包含许多分音的频谱），因此有"非线性合成法"一说。调频器（modulator）实为正弦波振荡器，载波器（carrier）同样也是正弦波振荡器（如图9-19）。

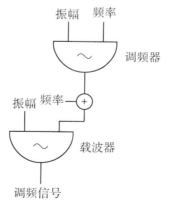

图9-19 基本的调频合成模型

以音乐声音中的颤音为例。如果我们将调频器（而非人声或单簧管的乐声）视为发出颤音的来源，那么在这个例子中，调频振荡器的频率就是颤音的速度。一般来说，人声产生的颤音，其速度比较慢，频率低于 10 Hz。

调频振荡器的振幅决定振动的深度：振幅越小，产生的深度越小。振幅越大，与声音的中心音调（或中心频率）的偏差就越大。这种由经调制的振荡器发出的声音，在合成乐器中称为"载波振荡器"（carrier oscillator）。在合成器中，这一环节由 LFO（low frequency oscillator，即"低频振荡器"）完成。

调频的深度也被称为"偏差"，即与原始音高之间的偏差。调频的幅度用 Hz 或音高来测量，如大至半音，小至四分之一音。也可以用音分来衡量，半音是 100 音分，四分之一音是 50 音分。

根据上述原理，人们总结出通过调频合成复合声音的方法。在调频合成中，调频器的频率在音频范围内，所以我们无法感知颤音，我们反而会听到一种丰富的声音。籍此美国作曲家约翰·卓宁（John Chowning）发现了调频合成声音的方法。

调频所产生的声音质量不仅取决于调频器的频率，而且很大程度上也取决于其振幅：这就是为什么使用这种方法创造音乐声音能够激起人们浓厚的兴趣。

卓宁在 1973 年提出了贝塞尔函数（Bessel function），以解析调频合成。该函数描述的是根据调制频率的振幅来创造和改变分音（他称之为"边频带"）。调频合成可以通过贝塞尔函数的数学模型来解释。

在进一步学习贝塞尔函数之前，我们先来了解一些重要的词汇。

c ＝载波频率（carrier frequency，单位为 Hz）

m ＝调制频率（modulator frequency，单位为 Hz）

d ＝偏差（deviation，单位为 Hz）

i ＝调频指数（modulation index）＝ d/m（偏差与调制频率的比率）

调频乐器中使用的另一个参数是载波频率与调频频率的比率，即 c∶m。

通过贝塞尔函数，我们可以直观地表达调频指数变化时的情况。函数代表每个频带的振幅及其变化。图 9 - 19 为一个基本的调频模型。

利用贝塞尔函数，我们可了解调频指数的数值对振幅和边频带振幅和时间位置的影响。图 9 - 20 显示了当指数从 0 增加到 20 时，边频带是如何变化的。

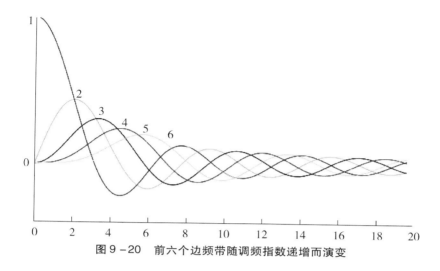

图 9 - 20 前六个边频带随调频指数递增而演变

9.5.2 调频乐器

图 9 - 21 展示的是一个简易调频乐器，注意该简易调频乐器带有振幅包络。

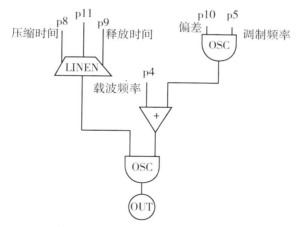

图 9 - 21 Csound 中的简易调频乐器

该乐器调制频率为 p4，载波频率为 p6。其中一种确定 p4 值的方法是考虑比率 c∶m。例如，如图 9 - 22 所示，比值 2.1 或 1.4 会产生有趣的声音，然后可以用载波频率乘以或除以该比率。

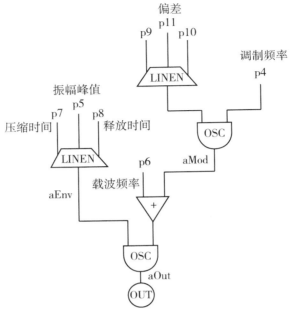

图 9 – 22 Csound 中的调频乐器

在这个乐器中，没有规定调制频率，而是由调制振荡器接收其频率输入值载波 + 比率。比率的数值决定了频谱是否为非谐波。例如，比值 2.1 或 1.4 会产生非谐波比率。然后，加入载波频率。以下是这个乐器的 Csound 代码，可供复制并在乐谱中更改其数值。

```
sr = 44100
ksmps = 44
nchnls = 1
0dbfs = 1 ; max amp = 1.
instr 1
aEnvMod        linen p11, p9, p3, p10
aMod           poscil aEnvMod, p4
aEnv           linen p5, p7, p3, p8
aOut           poscil aEnv, aMod
out            aOut
endin
</CsInstruments>
<CsScore>
;1      2       3       4       5       6       7       8       9       10      11
i1      0       10      55      .80     77      2       2       5       5       1500
i1      8       8       110     .80     154     2       2       2       6       2000
```

在图 9 – 23 中，偏差在上下限之间变化：最小偏差（MIN）可以是 0 或任何其他值，最大偏差（MAX）是 linen 包络达到的最大值。

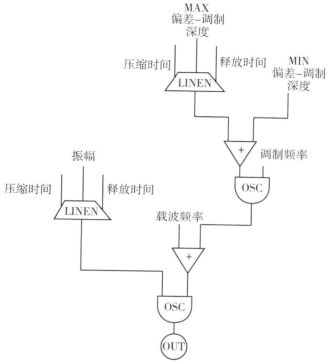

图 9 - 23　变偏差调频合成

9.5.3　约翰·卓宁的作品《声》

　　1981 年，约翰·卓宁在斯坦福大学的 CCRMA（音乐与声学计算机研究中心）创作了作品《声》（*Phone*），作品的主要声音来源是由调频技术合成的，有类似敲击的短促声，以及悠长而不断延展的线性声音。线性长音的不断演变是通过内插实现的：从一个状态逐渐过渡到另一个状态，这就是音色内插。

　　当颤音用在线性长音上，人声就出现了。注意颤音的音质至关重要：它必须围绕一个中心值具有一定的随机性，并可以随着时间的推移而产生变化（例如在开始时增加颤音，在结束时减少颤音）。同样，音高也不能完全稳定，必须包括一些变化，这些变化都会出现在自然的声音中。另外，频谱的丰富程度取决于它的振幅。

9.6 粒子合成

粒子合成的原理是利用声音的微小片段，这种微小片段叫作"粒子"。在创作者的控制下，软件会将粒子分组，形成声音的"粒子云"，粒子数量由密度参数控制。

粒子接收到的振幅包络，如图 9 - 24 所示。

通常有不同的包络可供选择，有些是猛烈的，有些则是温和的。在演奏的过程中，粒子可以移调，因而我们可以控制移调值的范围。

图 9 - 24 声音粒子图像

如果要使用粒子合成，可以选择不同的软件。虽然软件界面各异，但控制功能大同小异。在 Csound 中，粒子合成通过使用 grain 操作码实现。加州大学圣巴巴拉分校的美国作曲家、粒子合成技术的先驱柯蒂斯·罗兹（Curtis Roads）及其团队制作并发布了软件 EmissionControl2。Arturia 公司也发行了 Pigments，专门用于粒子合成。Pigments 可以作为一个独立程序运行，也可以作为插件使用，具有多种格式，包括 VST、VST3、AU 和 AAX。

如前所述，在 Csound 中粒子合成的操作码是 grain。此外，还有一些其他的操作码也可实现粒子合成。比如，grain2 操作码的控制功能较少，更易操作；grain3 提供了大量用于粒子合成的控制功能，处理起来会更精细一些；granule 也可以用于粒子合成，但是采用的是不同的控制功能。

作为初学者，可以从最常用的 grain 操作码开始进行创作。

以下是 Csound 使用指南提供的 grain 语法：

```
ares grain xamp, xpitch, xdens, kampoff, kpitchoff, kgdur, igfn,
iwfn, imgdur [, igrnd]
```

该操作码至少有九个参数，每个参数都对应一类声音合成（由粒子模型提供）的控制功能。

9.7 弦乐合成：卡普拉斯 - 斯特朗算法

根据凯文·卡普拉斯（Kevin Karplus）和亚历克斯·斯特朗（Alex Strong）的算法，合成过程适用于模拟各种拨弦乐器以及某些敲击乐器的声音。卡普拉

斯－斯特朗算法（Karplus-Strong Algorithm）于20世纪80年代在斯坦福大学开发，并因大卫·贾菲（David Jaffe）的两部作品《愿你的孩子都成为杂技演员》（*May All Your Children Be Acrobats*，1981）和《硅谷崩溃》（*Silicon Valley Breakdown*，1982）而广为人知。

波表由一系列随机样本或任意类型的波形构成。读取和处理从表中读取的样本的算法将初始声音转换为激发共振（excitation-resonance）声。从声音产生的开始，我们可以通过一系列操作逐渐改变初始声音的频谱和振幅。并且就像真正的拨弦乐器一样，卡普拉斯－斯特朗算法产生的高音部分比低音部分衰减得更快。

卡普拉斯－斯特朗算法的优点之一是它既能合成拨弦类或某些打击乐器的声音，又能处理声音。事实上，我们可以将声音导入到设备的波表中，然后转换出来。

在 Csound 中，pluck 操作码能产生一种如拨弦乐器般衰减的声音。这种弦乐合成基于卡普拉斯－斯特朗算法，属于物理建模的范畴。

如图 9－25、9－26 所示，在以下乐器中，expseg 操作码生成一个持续时间为 p3（即音符持续时间）的包络，然后滤波器协助调整音色。

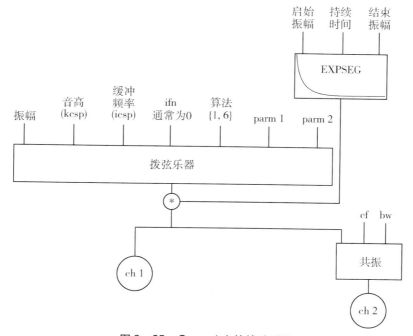

图 9－25　Csound 中的拨弦乐器

```
1   ; KS-2.csd
2   ; KARPLUS STRONG WITH ENVELOPE AND RESON<CsoundSynthesizer>
3   <CsOptions>
4   -odac
5   </CsOptions>
6   <CsInstruments>
7
8   sr = 44100
9   ksmps = 32
10  nchnls = 2
11  0dbfs  = 1
12
13  instr 1
14  ;p4    method of decay {1, 6}
15  ;p5    pitch of the plucked string (kcps)
16  ;p6    usually same as kcps, but can be set at other values (icps)
17  ;p7    value needed by some methods
18  ;p8    value needed by some methods
19  ;p9    reson: bandwidth
20  ;p10   reson: center frequency of the filter
21
22  kcps = 220
23  icps = p5
24  ifn  = 0
25  imeth = p4
26
27  kenv    expseg 1., p3, .01    ; exponential amplitude envelope
28
29  ;asig pluck kamp, kcps, icps, ifn, imeth [, iparm1] [, iparm2]
30  asig pluck .9,     p5,     p6,    ifn, imeth, p7, p8
31
32  a2 reson asig, p10, p9, 2   ;filter for channel 2
33  outs asig * kenv, a2 * kenv
34  endin
35  </CsInstruments>
36
37  <CsScore>
38  p1    p2    p3    p4    p5    p6    p7    p8    p9    p10
39  i1    0     4     2     110   92    2     2     2200  2
40  i1    4     4     2     92    92    2     4     100   2
41  i1    8     4     2     92    92    2     2     200   200
42  i1    12    4     2     92    92    2     10    1200  1200
43  i1    16    4     5     92    92    .5    .5    100   2
44  i1    20    4     5     92    92    .5    .5    300   100
45  i1    24    15    1     92    92    2     10    .     .
46  e
47  </CsScore>
48  </CsoundSynthesizer>
```

图 9 - 26　拔弦乐器 Csound 代码

312

<p style="text-align:center">10</p>

工作室与舞台的音乐软件

10.1 音乐编辑软件

10.1.1 Audacity

Audacity 是一款实用软件,可用于多种音频编辑任务。

它可以在声音文件的某些点添加标记,标记是一种语言指示,称为"标签"(label)。使用者可以键入任何标签,如"第一小节""副歌""间歇"等等。

如需输入标签,可以将光标(鼠标指针)指向要添加标签之处。

依次选择菜单中的编辑(Edit)、标签(Labels)、添加标签(Add Label at Selection)。(如图 10 – 1)

图 10 – 1 Audacity 的标签菜单

记号会出现在波形图像下方。可以输入标签内容。如图 10 – 2 所示。

图 10 -2　Audacity 的标签记号

10.1.2　使用 Audacity 保存和导出

编辑完成后，可通过以下步骤保存作品。

依次选择菜单中的文件（File）、保存项目（Save Project），创建一个扩展名为 ".aup" 的文件。注意： ".aup" 文件不是声音文件。它包含声音文件，但为 Audacity 添加了特定的数据。要在 Audacity 中保存（或导出）一个声音文件需要使用 File ／ Export 命令。

操作系统	Macintosh、Windows、Linux
下载地址	https://www. audacityteam. org/download
可得性	免费

10.1.3　Max

1987 年，米勒·帕克特开发了 Max 程序，菲利普·马努里在 1987 年创作的长笛和电子音乐作品《木星》等新作品使用了该程序。

1997 年，戴维·兹卡雷利（David Zicarelli）创办 Cycling 74 公司，该公司于 1998 年开始发布 Max/MSP（音频处理）软件。

Max 从发布之初就广受欢迎，这一现场表演工具有两大特点：实时运行以及响应外部设备的控制。

图 10 – 3　一个简单的 MIDI 工程

Max 的这两个特点，即使在加入扩展软件 MSP，增加了对音频信号的处理功能后，依然保留了下来。20 世纪 90 年代，凭借丰富的交互模式，Max 在世界范围内广泛用于现场表演。

今天，Max/MSP 简称为 Max，它整合了 MIDI 和音频信号处理功能。（如图 10 – 3、10 – 4）

图 10 – 4　用 Max 创建的应用程序 Groove Machine

操作系统	Macintosh、Windows
下载地址	https://cycling74.com
可得性	付费（有试用期）

315

10.2　Pure Data

与 Max 一样，Pure Data 也是实时图形编程软件。事实上，Pure Data 也是由 Max 的制作者米勒·帕克特开发的。因此，在这两个程序中发现许多名称相似的对象也就不奇怪了。两者的主要区别之一是 Max 由一家商业公司提供支持，这家公司改善了图形界面并增加了对象的数量，而 Pure Data 基本上仅由开发者米勒·帕克特个人负责维持，他是加利福尼亚大学圣迭戈分校的音乐教授。

Pure Data 用于处理实时、交互式音乐以及视频。由于 Pure Data 在 Macintosh、Windows 和 Linux 三种平台上都是免费的，因此形成了一个国际用户社区，社区成员会共享工程文件和拓展资源。我们可访问 Pure Data 的网站加深对该软件的了解，网站还会持续发布并更新关于社区的最新信息。

需要注意的是有些书提及的音乐示例是 Pure Data 编写的，例如帕克特的《电子音乐理论与技巧》（*The Theory and Technique of Electronic Music*）一书，这本书可以免费下载①。还有 2005 年由 Pure Data 用户社区出版的书籍《Bang：Pure Data》。（如图 10 – 5）

图 10 –5　《Bang：Pure Data》工程插图（引自第 118 页）

①　可至 http://msp. ucsd. edu/techniques. htm 下载。

操作系统	Macintosh、Windows、Linux
下载地址	https：//puredata. info
可得性	免费

10. 3　SuperCollider

　　软件 SuperCollider 现在由社区用户维护，它可用于多个系统。可在以下网站获得相关使用文档：doc. sccode. org/Overviews/Documents. html。SuperCollider 的社区非常活跃，经常有用户分享个人成果。

　　以下是一个梳状滤波器的应用例子：

```
// These examples compare the variants, so that you can hear the difference in interpolation
// allocate buffer
b = Buffer.alloc(s,44100,1);
// Comb used as a resonator. The resonant fundamental is equal to
// reciprocal of the delay time.
{ BufCombN.ar(b.bufnum, WhiteNoise.ar(0.01), XLine.kr(0.0001, 0.01, 20), 0.2) }.play;
{ BufCombL.ar(b.bufnum, WhiteNoise.ar(0.01), XLine.kr(0.0001, 0.01, 20), 0.2) }.play;
{ BufCombC.ar(b.bufnum, WhiteNoise.ar(0.01), XLine.kr(0.0001, 0.01, 20), 0.2) }.play;
// with negative feedback:
{ BufCombN.ar(b.bufnum, WhiteNoise.ar(0.01), XLine.kr(0.0001, 0.01, 20), -0.2) }.play;
{ BufCombL.ar(b.bufnum, WhiteNoise.ar(0.01), XLine.kr(0.0001, 0.01, 20), -0.2) }.play;
{ BufCombC.ar(b.bufnum, WhiteNoise.ar(0.01), XLine.kr(0.0001, 0.01, 20), -0.2) }.play;
// used as an echo.
{ BufCombC.ar(b.bufnum, Decay.ar(Dust.ar(1,0.5), 0.2, WhiteNoise.ar), 0.2, 3) }.play;
```

操作系统	Macintosh、Windows、Linux
下载地址	https：//supercollider. github. io/download
可得性	免费

10. 4　处理分析软件

10. 4. 1　GRM Tools

　　GRM Tools 是一套声音处理软件。它以各种插件的格式出现，可以在所有流行的 DAW 和编辑软件中使用；同时也是独立的程序，可以单独使用。

　　GRM Tools 是长期创新声音处理研究的成果。1948 年，皮埃尔·舍费尔在巴黎开创了具体音乐（Musique concrete）这一音乐类型，然后在 1958 年成立

了 GRM。在 20 世纪 70 年代后期，GRM 开始使用计算机，并自然而然地将声音处理理念应用到数字世界中。为此，他们开发了一个特殊的硬件 SYTER（又称"实时系统"）。SYTER 设备可以运行多种算法来处理声音，主要用于处理录制的声音。SYTER 与 GRM 同步发展，GRM 的大多数音乐家主要通过转换录制的声音来制作电子音乐。

在 20 世纪 90 年代，GRM 开发了声音处理软件 GRM Tools，从此可以无需购买 SYTER 数字处理器，直接使用 GRM Tools。

GRM Tools 有一组插件和独立程序。插件是为大多数 DAW 设计的，有 VST、RTAS、AAX、Stand Alone 和适用于 Mac 的 AU 等等。

操作系统	Macintosh、Windows
下载地址	https://inagrm.com/en/store
可得性	付费

10.4.2　IRCAM TS2

位于巴黎的 IRCAM 公司生产多款音乐应用软件。在很长一段时间里，AudioSculpt 都是专门用于分析声音的程序。但在撰写本书时，它已不再与最新版的 Macintosh 操作系统（OS 10.15，Catalina）相兼容，并被新程序 TS2 所取代。

操作系统	Macintosh、Windows、Linux
下载地址	https://www.ircamlab.com/products/software
可得性	付费

10.4.3　Praat

Praat 是一款专门用于研究声音的软件，包括研究动物的声音。软件内有许多用于分析声音的设置以及算法。该软件是免费的，而且声音分析的可能性非常多，因此在研究实验室中很受欢迎。

操作系统	Macintosh（至 10.14 版）、Windows、Linux
下载地址	https://www.fon.hum.uva.nl/praat
可得性	免费

10.4.4　Spear

　　这款分析软件在声音分析的显示方式上别具一格。分析完成时，声音频谱会以若干线条的形式展现，灰色的阴影表示振幅。用户可以抓取任何一条线并在频谱中移动，也可以选择频谱的某个部分，并将其移动到另一个位置（例如换位）。

　　另一个有趣的特点是该程序可以将用户所选的线条进行合成。在某种程度上，这是一种音频的加法合成。

操作系统	Macintosh、Windows
下载地址	https://www.klingbeil.com/spear/downloads
可得性	免费

10.4.5　GRM-Player

　　GRM-Player 是 GRM 最近推出的一个独立程序。（如图 10 – 6）它是免费发布的，可以在 Mac 和 Windows 系统上运行。

　　尽管 GRM-Player 外观简约，但它其实是一个功能强大的软件，可以用多种方式进行声音文件的转换。

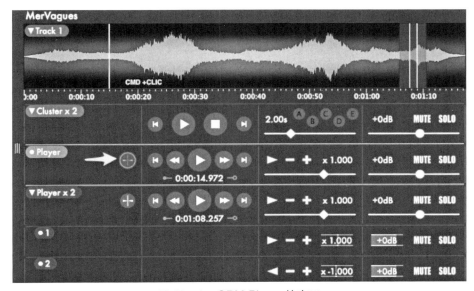

图 10 – 6　GRM-Player 的窗口

操作系统	Macintosh、Windows
下载地址	https://inagrm.com/fr/showcase/news/372/grm-player
可得性	免费

11

作曲与人工智能软件

11.1　视觉交互软件

计算机辅助作曲软件被归入这一类软件中，例如 IRCAM 的 OpenMusic 程序。而开发 OpenMusic 程序所用的 Lisp，是自 1958 年发明后仍广泛应用于人工智能研究的编程语言。

对于现在的 OpenMusic，IRCAM 的研究人员是这样描述的：

"OpenMusic（简称 OM）是一个可视化编程环境，由 IRCAM 设计和开发，主要用于音乐创作。使用者可以利用展示音乐结构和创作过程的图形界面来进行编程，从而创建和测试作曲模型。"[①]

11.2　分析计算机辅助作曲

11.2.1　卡伊娅·萨莉亚霍《远方的爱》中 OpenMusic 的运用

卡伊娅·萨莉亚霍（Kaija Saariaho），芬兰作曲家，出生于 1952 年。曾在芬兰赫尔辛基的西贝柳斯学院学习，后来在德国弗莱堡师从英国作曲家布莱恩·芬尼豪赫（Brian Ferneyhough）。20 世纪 80 年代初，她定居巴黎，与皮埃尔·布列兹（Pierre Boulez）在巴黎成立的 IRCAM 保持密切合作。

在让－巴蒂斯特·巴里埃（Jean-Baptiste Barriere）和研究人员的协助下，她在 IRCAM 创作了多首作品。这段经历使她的创作方向转为使用 OpenMusic 等计算机辅助程序进行作曲。她经常使用一个名为"共振模型"（Models of Resonance）的软件处理音频。她用这种方法分析声音并提取其频谱包络。

《远方的爱》（*Love from Afar*）是卡伊娅·萨莉亚霍创作的第一部歌剧，是

① 见 Carlos Agon 和 Moreno Andreatta《在开放音乐视觉编程语言中的平铺韵律规范的建模和实现》（Carlos Agon and Moreno Andreatta, "Modeling and Implementing Tiling Rhythmic Canons in the OpenMusic Visual Programming Language", *Perspectives of New Music* vol. 49, n. 2, 2011, pp. 66 – 91）。

萨尔茨堡音乐节（奥地利）、夏特莱剧院（法国）和圣达菲歌剧院（美国）的委约作品。

在这部歌剧中，每个角色都有自己独有的和弦进行，其中有些进行是用微分音程记谱的（如图 11−1、11−2、11−3）。

图 11−1　为角色若弗雷（Jaufré）设计的和弦

图 11−2　为角色朝圣者设计的和弦

图 11−3　为角色克莱曼斯（Clemence）设计的和弦

图 11−4、11−5 是《远方的爱》使用 OpenMusic 编程的两个例子。图 11−4 是对贝森朵夫钢琴的声音及作品中和弦的频谱分析。

Exemple d'analyse et de filtre avec un echantillon de piano
Boesendorfer (marcato Fa#0) et de l'accord J_chord_a de Jaufré

```
45.5    0.0025    0.0243
68.5    0.0207    0.0166
91.3    0.0092    0.0092
114.3   0.0108    0.0433
137.2   0.0298    0.0690
160.4   0.0066    0.1172
183.3   0.0016    0.1872
206.6   0.0044    0.1980
229.9   0.0092    0.1214
253.2   0.0094    0.1444
266.0   0.0182    6.7824
276.7   0.0223    0.2241
300.3   0.0042    0.0246
```

boe.mc_f#0.m5.max spectre d'amplitude

boe.mc_f#0.m5.max extrait de l'analyse
par modèle de resonance (frequence,
amplitude, largeur de bande)

boe.mc_f#0.m5.max spectre de largeur de bande

```
124.0    0.0188    0.0542
185.8    0.0019    0.1884
248.0    0.0093    0.1393
331.1    0.0207    0.1977
340.8    0.0239    0.2215
371.6    0.0117    0.4848
541.0    0.0103    1.2740
662.2    0.0231    0.4385
681.6    0.0202    0.3664
1082.0   0.0053    0.7624
1113.7   0.0050    0.4951
1575.1   0.0035    0.7131
1873.1   0.0018    1.2182
1984.5   0.0025    1.0978
2227.5   0.0011    1.5228
3150.2   0.0049    3.9091
3746.2   0.0017    2.9229
3969.0   0.0023    4.1092
```

J_chord_a

mapping de J_chord_a sur les spectres du piano

extrait des données du filtre
résultant calculé (frequence,
amplitude, largeur de bande)

图 11 -4　钢琴声音的频谱分析

　　图 11 -5 展示的是用 OpenMusic 语言编写的复杂工程文件。和弦是通过共振模型来处理的，而共振模型本质上是频谱的包络线，也称为"频谱包络"。因此，和弦的色彩完全由模型的频谱结构转换，于是和弦的音高、响度与钢琴的音色之间就有了交互。

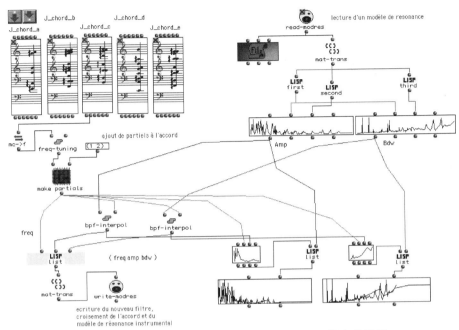

图 11 – 5　《远方的爱》所使用 OpenMusic 工程文件示例

11. 2. 2　AudioMulch

AudioMulch 是一款澳大利亚软件，它专为实现实时互动型表演而设计。这款软件已经形成了一个用户社区。

该软件的网站设有专门的介绍页面（如图 11 – 6）。AudioMulch 的操作界面由两个面板构成。其中一个面板具有可视化编程功能，且与 Max、PureData、Kyma 非常相似。在另一个面板中，用户可以组装混响、延迟和其他效果模块。

AudioMulch 的其中一个实用功能是可以加载实时使用的 VST 和音频单元插件。

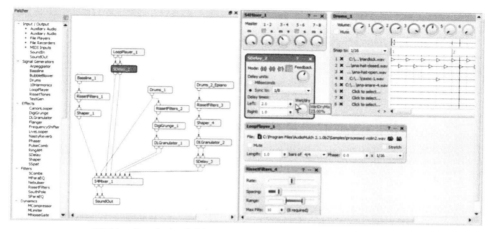

图 11-6　来 AudioMulch 页面示意图，显示各种交互面板

操作系统	Macintosh、Windows
下载地址	https://www.audiomulch.com
可得性	付费（2 个月试用期）

11.2.3　ChucK

　　ChucK 是中国音乐家王戈在普林斯顿大学就读期间开发的软件。王戈目前任教于斯坦福大学，仍在对 ChucK 软件进行更新维护。

　　ChucK 是一款实时软件，主要用于现场表演的声音合成。其程序持续识别表演者的输入信息，并对其做出响应，因此它非常适合于"实时编码"表演。所有的编程都是通过输入代码行来完成的。ChucK 语言指令是直译式的，不需要经过编译，因此程序会实时响应表演者的所有操作。这正是 ChucK 非常适合于"实时编码"的原因。

```
// a simple comb filter
// Ge Wang (gewang@cs.princeton.edu)
// feedforward
Impulse imp => Gain out => dac;
// feedback
out => Delay delay => out;
// our radius
.99999 => float R;
// our delay order
500 => float L;
// set delay
L::samp => delay.delay;
// set dissipation factor
Math.pow( R, L ) => delay.gain;
// fire impulse
1 => imp.next;
// advance time
(Math.log(.0001) / Math.log(R))::samp => now;
```

操作系统	Macintosh、Windows、Linux
下载地址	https://chuck. cs. princeton. edu
可得性	免费

12

21 世纪的录音棚实践

12.1 录制

12.1.1 录制人声

录音时，应采取以下预防措施：

（1）将麦克风放置在略高于嘴的位置，并略微移向一侧，这样，麦克风就不会拾取爆破音。

（2）稍微转动麦克风，使其收音的正面不是正对着嘴。

（3）如果情况允许，可以选择使用全指向麦克风。这种麦克风可以有效规避爆破音。

（4）使用防喷罩，将其放置在麦克风前，距离 5 或 6 厘米处。

（5）可以要求歌手在演唱时，如遇到以 p 或 b 开头的字词，就轻轻地侧过头去。

（6）检查麦克风输入通道上的电平信号范围：如果因录入声音太大而发生削波，会在电平表上显示出来。这种情况，在母带和后期处理过程中是无法挽救的。因此在录音前必须与歌手排练，找到合适的电平信号范围。需要注意的是，在一首歌中，总电平信号可能会在接近尾声时提高。

（7）在 DAW 软件中查看电平信号表（峰值表和 VU 表）。

12.1.2 唇齿音

唇齿音在高音区较为突出，经常出现在发 s 音时，有时发 t 音时也会出现。唇齿音在女歌手中较常见，但男歌手亦有此情况。唇齿音的出现因语言而异，说某些语言（例如英语）时唇齿音更为突出，但同时也要考虑个人因素。

可在录制后的母带处理阶段使用 DeEsser 插件。

DeEsser 插件的作用是减弱或消除唇齿音。当歌手发出唇齿音时，就需要在母带处理的阶段对其进行处理。

录音时的应对方法与爆破音一样：将麦克风放在略高于嘴的位置，并稍微

移向侧面。这样，就可以减少唇齿音的收录。

12.1.3 削波

音频电平信号过载时会发生削波。从麦克风拾音到录音录入 DAW，削波可能发生在任何环节。

电容式麦克风可以毫不费力地接收很大的音量，因而出现过载的几率很小。麦克风连接调音台或声卡，具体做法是将麦克风插入调音台或声卡的麦克风接口（Mic Input）处。至关重要的是，在连接成功后，要让演唱者/演奏者尝试其最大最小音量的范围，以此来观察麦克风输入的电平信号范围，从而确保没有出现削波。

12.1.4 邻近效应

全指向电容式麦克风（如 Neumann TLM103）可能会产生"邻近效应"（Proximity effect）。

邻近效应出现在当麦克风靠近嘴时。此时低音频率响应增加，出现"轰轰"的低声。这种效果可以给人带来一种近距离、亲密的印象，也可以用来烘托情绪氛围，比如在电影中烘托恐怖的氛围。邻近效应在录制女性声音时可能会产生有趣的效果，但正常唱歌时并不需要这种特殊的音效。录音时要注意邻近效应，但在适当的时候也要毫不犹豫地加以利用。

12.2 麦克风

首先，我们需要了解麦克风的种类。其中比较常见的是动圈麦克风、驻极体电容麦克风、幻象电源供电的专业级电容麦克风。

12.2.1 动圈麦克风

动圈式麦克风发明于 1925 年左右，是最古老的麦克风。在此之前，麦克风的雏形是"炭精话筒"，它自 1876 年起应用于电话中。

动圈麦克风通常用于舞台之上，供歌手手持。也有供乐器用麦克风，如放置在吉他放大器前（如图 12–1）或鼓的前方的麦克风。

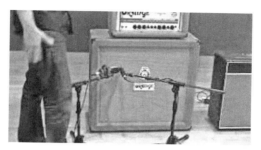

图 12 -1　放置在吉他放大器前的动圈话筒对吉他放大器录音

动圈麦克风舒尔（Shure）SM87A（如图 12 -2）深受歌手们的喜爱，因为它可以最大限度减少歌手的呼吸声和风噪声的干扰，且降低麦克风支架发出的噪音。

图 12 -2　舒尔 SM87A 动圈麦克风

12.2.2　驻极体电容麦克风

驻极体电容麦克风通常采用电池供电，比如一节 1.5 伏的电池。一些驻极体麦克风由设备供电，如智能手机或数字录音机。

电容麦克风发明于 1962 年，其质量良莠不齐，通常缺乏捕捉高频信号的能力。驻极体电容麦克风常用于价格实惠的数字录音机中。

12.2.3　电容麦克风

幻象电源供电的专业级电容麦克风录音质量最好，因此常用于录音棚。电容麦克风比驻极体需要更多的电源供电。一般来讲，专业级电容麦克风需 48 伏或 12 伏的幻象电源供电，其中最常见的是 48 伏。

之所以叫"幻象"电源，是因为用传输音频信号的同一根电缆为麦克风供电。相当于不存在一个"具象的"电源，由音频调音台、接口或数字录音机供电。

12.3　麦克风的特点

在本节中，我们将了解麦克风如何对捕捉到的声音做出反应。麦克风有多种捕捉声音的方式，在录音时了解不同麦克风的特性是极为重要的。

12.3.1　心形指向麦克风

心形指向麦克风主要用于捕捉位于前方的声音，之所以称作"心形"，是因为其指向性的形状看起来像心形。图12-3中的红圈就是麦克风的指向性，是麦克风最灵敏的区域。手持心形麦克风时，捕捉到的声音绝大部分来自前方。心形麦克风能有效屏蔽侧方及后方的声音，不过，心形麦克风的带宽很少是平的。

大部分麦克风是心形指向的，心形指向麦克风是最常见的麦克风类型。

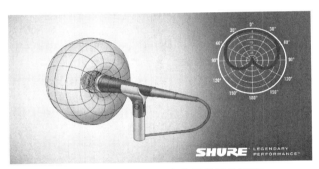

图12-3　舒尔心形麦克风的极性图案

12.3.2　全指向麦克风

全指向麦克风（如图12-4）可捕捉到周围（前方、侧方、后方）的大部分声音。

图12-4　全指向麦克风

12.3.3 8 字形指向麦克风

8 字形指向麦克风可捕捉前方及后方的声音。8 字形指向麦克风的应用不及心形指向及全指向麦克风广泛。还有一种 8 字形指向麦克风，叫作带状麦克风，这类麦克风通常价格昂贵，容易损坏，并且不能在录音棚以外使用，但录音质量很好。

12.3.4 枪式麦克风

枪式麦克风，是一种置于长管中的超心形麦克风，它沿狭窄的极性图案从正面捕捉声音，具有高度指向性。枪式麦克风的常见用途为收录鸟叫声、影视拍摄收音等，可以较为有效地减少在录制过程中录入周围噪音（如录像机机器声）。

这种麦克风常用于集中捕捉某个声源，但是带宽范围窄。

12.3.5 麦克风极性图案

图 12 – 5 为各类麦克风的极性图案。

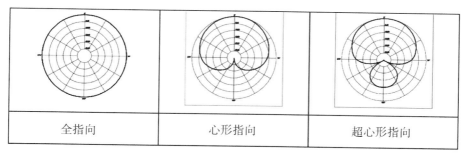

| 全指向 | 心形指向 | 超心形指向 |

图 12 – 5 麦克风极性图案

12.4 立体声录音

12.4.1 XY 制式

两支心形指向麦克风以 90°夹角，一上一下地紧靠放置，就是 XY 制式。市面上有很多商用 XY 立体声麦克风（如图 12 – 6）。这类麦克风拾音立体效果突出，但与其他制式相比，XY 制式的声像较窄。

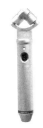

图 12－6　罗德（Røde）NT4 立体声麦克风

12.4.2　ORTF 制式

两支心形指向麦克风相距 17 厘米，以 110°夹角朝向音源放置（如图 12－7），就是 ORTF 制式。这种录音方式可以提供更为宽广的立体感，经常悬挂于管弦乐队的前方，被音响工程师用于音乐厅拾音。

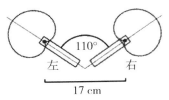

图 12－7　ORTF 制式

12.4.3　AB 制式

两支心形指向麦克风，相距 40 到 80 厘米放置（如图 12－8），就是 AB 制式（也称为"间隔制式"）。这种录音方式立体感虽好，但声音效果不太自然。推荐使用 XY 制式或 ORTF 制式。

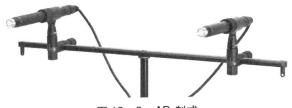

图 12－8　AB 制式

Appendices & Bibliography
附录及参考文献

Appendices　附录

1　MIDI Pitch Table　MIDI 音高对照表

| Octave #
八度 #
C | Note Numbers　音符编号 | | | | | | | | | | | |
|---|---|---|---|---|---|---|---|---|---|---|---|
| | C# | D | D# | E | F | F# | G | G# | A | A# | B |
| − 1 | 0 | 1 | 2 | 3 | 4 | 5 | 6 | 7 | 8 | 9 | 10 | 11 |
| 0 | 12 | 13 | 14 | 15 | 16 | 17 | 18 | 19 | 20 | 21 | 22 | 23 |
| 1 | 24 | 25 | 26 | 27 | 28 | 29 | 30 | 31 | 32 | 33 | 34 | 35 |
| 2 | 36 | 37 | 38 | 39 | 40 | 41 | 42 | 43 | 44 | 45 | 46 | 47 |
| 3 | 48 | 49 | 50 | 51 | 52 | 53 | 54 | 55 | 56 | 57 | 58 | 59 |
| 4 | 60 | 61 | 62 | 63 | 64 | 65 | 66 | 67 | 68 | 69 | 70 | 71 |
| 5 | 72 | 73 | 74 | 75 | 76 | 77 | 78 | 79 | 80 | 81 | 82 | 83 |
| 6 | 84 | 85 | 86 | 87 | 88 | 89 | 90 | 91 | 92 | 93 | 94 | 95 |
| 7 | 96 | 97 | 98 | 99 | 100 | 101 | 102 | 103 | 104 | 105 | 106 | 107 |
| 8 | 108 | 109 | 110 | 111 | 112 | 113 | 114 | 115 | 116 | 117 | 118 | 119 |
| 9 | 120 | 121 | 122 | 123 | 124 | 125 | 126 | 127 | | | | |

2 Frequency – MIDI Pitch　音频与 MIDI 音高对照表

Middle C = C3 [①]

Midi	Pitch		Midi	Pitch	Frequency	Midi	Pitch	Frequency	Midi	Pitch	Frequency
0:	C -2	-	12:	C -1	-	24:	C0	32.70	36:	C1	65.40
1:	C# -2	-	13:	C# -1	-	25:	C#0	34.64	37:	C#1	69.29
2:	D -2	-	14:	D -1	-	26:	D0	36.70	38:	D1	73.41
3:	Eb -2	-	15:	Eb -1	-	27:	Eb0	38.89	39:	Eb1	77.78
4:	E -2	-	16:	E -1	-	28:	E0	41.20	40:	E1	82.40
5:	F -2	-	17:	F -1	-	29:	F0	43.65	41:	F1	87.30
6:	F# -2	-	18:	F# -1	-	30:	F#0	46.24	42:	F#1	92.49
7:	G -2	-	19:	G -1	-	31:	G0	48.99	43:	G1	97.99
8:	G# -2	-	20:	G# -1	-	32:	G#0	51.91	44:	G#1	103.82
9:	A -2	-	21:	A -1	27.50	33:	A0	55.00	45:	A1	110.00
10:	Bb -2	-	22:	Bb -1	29.13	34:	Bb0	58.27	46:	Bb1	116.54
11:	B -2	-	23:	B -1	30.86	35:	B0	61.73	47:	B1	123.47

Midi	Pitch	Frequency	Midi	Pitch	Frequency	Midi	Pitch	Frequency	Midi	Pitch	Frequency
48:	C2	130.81	60:	C3	261.62	72:	C4	523.25	84:	C5	1046.50
49:	C#2	138.59	61:	C#3	277.18	73:	C#4	554.36	85:	C#5	1108.73
50:	D2	146.83	62:	D3	293.66	74:	D4	587.32	86:	D5	1174.65
51:	Eb2	155.56	63:	Eb3	311.12	75:	Eb4	622.25	87:	Eb5	1244.50
52:	E2	164.81	64:	E3	329.62	76:	E4	659.25	88:	E5	1318.51
53:	F2	174.61	65:	F3	349.22	77:	F4	698.45	89:	F5	1396.91
54:	F#2	184.99	66:	F#3	369.99	78:	F#4	739.98	90:	F#5	1479.97
55:	G2	195.99	67:	G3	391.99	79:	G4	783.99	91:	G5	1567.98
56:	G#2	207.65	68:	G#3	415.30	80:	G#4	830.60	92:	G#5	1661.21
57:	A2	220.00	69:	A3	440.00	81:	A4	880.00	93:	A5	1760.00
58:	Bb2	233.08	70:	Bb3	466.16	82:	Bb4	932.32	94:	Bb5	1864.65
59:	B2	246.94	71:	B3	493.88	83:	B4	987.76	95:	B5	1975.53

Midi	Pitch	Frequency	Midi	Pitch	Frequency	Midi	Pitch	Frequency
96:	C6	2093.00	108:	C7	4186.01	120:	C8	8372.02
97:	C#6	2217.46	109:	C#7	4434.92	121:	C#8	8869.84
98:	D6	2349.31	110:	D7	4698.64	122:	D8	9397.27
99:	Eb6	2489.01	111:	Eb7	4978.03	123:	Eb8	9956.06
100:	E6	2637.02	112:	E7	5274.04	124:	E8	10548.08
101:	F6	2793.82	113:	F7	5587.65	125:	F8	11175.30
102:	F#6	2959.95	114:	F#7	5919.91	126:	F#8	11839.82
103:	G6	3135.96	115:	G7	6271.93	127:	G8	12543.85
104:	G#6	3322.43	116:	G#7	6644.87			
105:	A6	3520.00	117:	A7	7040.00			
106:	Bb6	3729.31	118:	Bb7	7458.62			
107:	B6	3951.06	119:	B7	7902.13			

① 需注意，此处的中央 C 确为 C3，而非常见的 C4。——译者注

3 Pitch Table – Micro Intervals 微分音音高表

This table shows micro-intervals, up to $1/8^{th}$ of tone.

Column 1 gives the frequency in Hertz, with two decimals.

Column 2 gives the pitch on a fine resolution of a $1/8^{th}$ of a tone, or a $1/4^{th}$ of a semitone.

Micro-intervals are based on a division of the whole tone (like *do – re*, or *la – si*). A tempered semitone is a division of the tone in two, hence a quarter tone is division by 4, and a $1/8^{th}$ is a division by 8.

For example：

C tempered pitch of the 12 tone scale.

Ch tempered pitch of the 48 tone scale. Ch means：one $1/8^{th}$ tone above C.

Cq tempered pitch of the 24 tone scale. Cq means：one $1/4^{th}$ tone above C.

Cqh tempered pitch of the 48 tone scale. Cqh means：one $1/8^{th}$ tone above Cq, or three $1/8^{th}$ of tone.

It is also one $1/8^{th}$ of tone below C#.

Column 3 shows the pitches on a tempered 12 tone scale (no microtones).

Column 4 shows the pitch expressed as MIDI pitch. [1]

下表所示为微分音，最高为八分之一音。

第 1 列为频率，单位是赫兹（Hz），保留 2 位小数。

第 2 列为八分之一音或四分之一半音的精细分辨率。

微分音是基于对整个全音的划分（如 do-re 或 la-si）。等程半音是全音的二分之一，因此四分之一音是全音的四分之一，八分之一音是全音的八分之一。

例如：

C 音阶的调和音高。

[1] If you used the scale of midicents, for example with OpenMusic, where C3 = 6000, the quarter tone above C3 is written 6050, one $1/8^{th}$ of tone above C3 is 6025, and three $1/8^{th}$ of tone above is 6075.

Ch 48 音阶的调高。Ch 是指比 C 高八分之一音。

Cq 24 音阶的调高。Cq 是指比 C 高四分之一音。

Cqh 48 音阶的调高。Cqh 是指比 Cq 高八分之一音，或三个八分之一音。它也比 C#音低八分之一音。

第 3 列所示为 12 音阶的音高（没有微音）。

第 4 列所示为以 MIDI 音调形式呈现的音调。[①]

① 如使用这个音阶，以在 OpenMusic 中的应用为例，C3 = 6000，比 C3 高四分之一音写作 6050，比 C3 高八分之一音写作 6025，比 C3 高三个八分之一音写作 6075。

Freq	Note		
16.35	do – 1		
16.59	doh – 1		
16.83	doq – 1		
17.08	doqh – 1		
17.32	do# – 1		
17.58	do#h – 1		
17.83	do#q – 1		
18.09	do#qh – 1		
18.35	re – 1		
18.62	reh – 1		
18.89	req – 1		
19.17	reqh – 1		
19.45	re# – 1		
19.73	re#h – 1		
20.02	re#q – 1		
20.31	re#qh – 1		
20.60	mi – 1		
20.90	mih – 1		
21.21	miq – 1		
21.51	miqh – 1		
21.83	fa – 1		
22.14	fah – 1		
22.47	faq – 1		
22.79	faqh – 1		
23.12	fa# – 1		
23.46	fa#h – 1		
23.80	fa#q – 1		
24.15	fa#qh – 1		
24.50	sol – 1		
24.86	solh – 1		
25.22	solq – 1		
25.58	solqh – 1		
25.96	sol# – 1		
26.33	sol#h – 1		
26.72	sol#q – 1		
27.11	sd#qh – 1	la – 1	21
27.50	la – 1	la – 1	21
27.90	lah – 1	la – 1	21
28.31	laq – 1	la – 1	21
28.72	laq – 1	la# – 1	22
29.14	la# – 1	la# – 1	22
29.56	la#h – 1	la# – 1	22
29.99	la#q – 1	la# – 1	22
30.43	la#qh – 1	si – 1	23
30.87	si – 1	si – 1	23
31.32	sih – 1	si – 1	23
31.77	siq0	si – 1	23
32.23	siqh – 1	do0	24
32.70	do0	do0	24
33.18	doho	do0	24
33.66	doqo	do0	24
34.15	doqho	do#0	25
34.65	do#0	do#0	25
35.15	do#h0	do#0	25
35.66	do#q0	do#0	25
36.18	do#qho	re0	26
36.71	re0	re0	26
37.24	reh0	re0	26
37.78	req0	re0	26
38.33	reqh0	re#0	27
38.89	re#0	re#0	27
39.46	re#h0	re#0	27
40.03	re#q0	re#0	27
40.61	re#qh0	mi0	28
41.20	mi0	mi0	28
41.80	mih0	mi0	28
42.41	miq0	mi0	28
43.03	miqh0	fa0	29
43.65	fa0	fa0	29
44.29	fah0	fa0	29
44.93	faq0	fa0	29
45.59	faqho	fa#0	30
46.25	fa#0	fa#0	30
46.92	fa#h0	fa#0	30
47.60	fa#q0	fa#0	30
48.30	fa#qh0	sol0	31
49.00	sol0	sol0	31
49.71	solh0	sol0	31
50.44	solq0	sol0	31
51.17	solqh0	sol#0	32
51.91	sol#0	sol#0	32
52.67	sol#h0	sol#0	32
53.43	sol#q0	sol#0	32
54.21	sol#qh0	la0	33
55.00	lao	lao	33
55.80	lah0	la0	33
56.61	laq0	la0	33
57.44	laqh0	la#0	34
58.27	la#0	la0	34
59.12	la#h0	la#0	34
59.98	la#q0	la#0	34
60.85	la#qh0	si0	35
61.74	si0	si0	35
62.63	sih0	si0	35
63.54	siq1	si0	35
64.47	siqh0	do1	36
65.41	do1	do1	36
66.36	doh1	do1	36
67.32	doq1	do1	36
68.30	doqh1	do#1	37
69.30	do#1	do#1	37
70.30	do#h1	do#1	37
71.33	do#q1	do#1	37
72.36	do#qh1	re1	38
73.42	re1	re1	38
74.48	reh1	re1	38
75.57	req1	re1	38
76.67	reqh1	re#1	39
77.78	re#1	re#1	39
78.91	re#h1	re#1	39
80.06	re#q1	re#1	39
81.23	re#qh1	mi1	40
82.41	mi1	mo1	40
83.61	mih1	mi1	40
84.82	miq1	mi1	40
86.06	miqh1	fa1	41
87.31	fa1	fa1	41
88.58	fah1	fa1	41
89.87	faq1	fa1	41
91.17	faqh1	fa#1	42
92.50	fa#1	fa#1	42
93.84	fa#h1	fa#1	42
95.21	fa#q1	fa#1	42
96.59	fa#qh1	sol1	43
98.00	sol1	sol1	43
99.42	solh1	sol1	43
100.87	solq1	sol1	43
102.34	solqh1	sol#1	44
103.83	sol#1	sol#1	44
105.34	sol#h1	sol1	44
106.87	sol#q1	sol#1	44
108.42	sol#qh1	la1	45
110.00	la1	all	45
111.60	lah1	la1	45
113.22	laq1	la1	45
114.87	laqh1	la#1	46
116.54	la#1	la#1	46
118.24	la#h1	la#1	46
119.96	la#q1	la#1	46
121.70	la#qh1	si1	47
123.47	si1	si1	47
125.27	sih1	si1	47
127.09	siq2	si1	47
128.94	siqh1	do2	48

续表

130.81	do2	do2	48	261.63	do3	do3	60	523.25	do4	do4	72
132.72	doh2	do2	48	265.43	doh3	do3	60	530.86	doh4	do4	72
134.65	doq2	do2	48	269.29	doq3	do3	60	538.58	doq4	do4	72
136.60	doqh2	do#2	49	273.21	doqh3	do#3	61	546.42	doqh4	do#4	73
138.59	do#2	do#2	49	277.18	do#3	do#3	61	554.37	do#4	do#4	73
140.61	do#h2	do#2	49	281.21	do#h3	do#3	61	562.43	do#h4	do#4	73
142.65	do#q2	do#2	49	285.30	do#q3	do#3	61	570.61	do#q4	do#4	73
144.73	do#qh2	re2	50	289.45	do#qh3	re3	62	578.91	do#qgre4	74	
146.83	re2	re2	50	293.66	re3	re3	62	587.33	re4	re4	74
148.97	reh2	re2	50	297.94	reh3	re3	62	595.87	reh4	re4	74
151.13	req2	re2	50	302.27	req3	re3	62	604.54	req4	74	
153.33	reqh2	re#2	51	306.67	reqh3	re#3	63	613.33	reqh4	75	
155.56	re#2	re#2	51	311.13	re#3	re#3	63	622.25	re#4	re#4	75
157.83	re#h2	re#2	51	315.65	re#h3	re#3	63	631.30	re#h4	re#4	75
160.12	re#q2	re#2	51	320.24	re#q3	re#3	63	640.49	re#q4	re#4	75
162.45	re#qh2	mi2	52	324.90	re#qh3	mi3	64	649.80	re#qh4	mi4	76
164.81	mi2	mi2	52	329.63	mi3	mi3	64	659.26	mi4	mi4	76
167.21	mih2	mi2	52	334.42	mih3	mi3	64	668.84	mih4	mi4	76
169.64	miq2	mi2	52	339.29	miq3	mi3	64	678.57	miq4	mi4	76
172.11	miqh2	fa2	53	344.22	miqh3	fa3	65	688.44	miqh4	fa4	77
174.61	fa2	fa2	53	349.23	fa3	fa3	65	698.46	fa4	fa4	77
177.15	fah2	fa2	53	354.31	fah3	fa3	65	708.62	fah4	fa4	77
179.73	faq2	fa2	53	359.46	faq3	fa3	65	718.92	faq4	fa4	77
182.34	faqh2	fa#2	54	364.69	faqh3	fa#3	66	729.38	faqh4	fa#4	78
185.00	fa#2	fa#2	54	369.99	fa#3	fa#3	66	739.99	fa#4	fa#4	78
187.69	fa#h2	fa#2	54	375.38	fa#h3	fa#3	66	750.75	fa#h4	fa#4	78
190.42	fa#q2	fa#2	54	380.84	fa#q3	fa#3	66	761.67	fa#q4	fa#4	78
193.19	fa#qh2	sol2	55	386.38	fa#qh3	sol3	67	772.75	fa#qh4	sol4	79
196.00	sol2	sol2	55	392.00	sol3	sol3	67	783.99	sol4	sol4	79
198.85	solh2	sol2	55	397.70	solh3	sol3	67	795.39	solh4	sol4	79
201.74	solq2	sol2	55	403.48	solq3	sol3	67	806.96	solq4	sol4	79
204.68	solqh2	sol#2	56	409.35	solqh3	sol#3	68	818.70	solqh4	sol#4	80
207.65	sol#2	sol#2	56	415.30	sol#3	sol#3	68	830.61	solq#4	sol#4	80
210.67	sol#h2	sol#2	56	421.35	sol#h3	sol#3	68	842.69	sol#h4	sol#4	80
213.74	sol#q2	sol#2	56	427.47	sol#q3	sol#3	68	854.95	sol#q4	sol#4	80
216.85	sol#qh2	la2	57	433.69	sol#qh3	la3	69	867.38	sol#qh4	la4	81
220.00	la2	la2	57	440.00	la3	la3	69	880.00	la4	la4	81
223.20	lah2	la2	57	446.40	lah3	la3	69	892.80	lah4	la4	81
226.45	laq2	la2	57	452.89	laq3	la3	69	905.79	laq4	la4	81
229.74	laqh2	la#2	58	459.48	laqh3	la#3	70	918.96	laqh4	la#4	82
236.47	la#h2	la#2	58	472.94	la#h3	la#3	70	945.89	la#h4	la#4	82
239.91	la#q2	la#2	58	479.82	la#q3	la#3	70	959.65	la#q4	la#4	82
243.40	la#qh2	si2	59	486.80	la#qh3	si3	71	973.61	la#qh4	si4	83
246.94	si2	si2	59	493.88	si3	si3	71	987.77	si4	si4	83
250.53	sih2	si2	59	501.07	sih3	si3	71	1002.13	sih4	si4	83
254.18	siq3	si2	59	508.36	siq3	si3	71	1016.71	siq5	si4	83
257.87	siqh2	do3	60	515.75	siqh3	do4	72	1031.50	siqh4	do5	84

续表

1046.50	do5	do5	84	2093.00	do6	do6	96	4186.01	do7		108
1061.72	doh5	do5	84	2123.45	doh6	do6	96	4246.90	doh7	do7	108
1077.17	doq5	doq5	84	2154.33	doq6	do6	96	4308.67	doq7	do7	108
1092.83	doqh5	do#5	85	2185.67	doqh6	do#6	97	4371.34	doqh7	do#7	109
1108.73	do#5	do#5	85	2217.46	do#6	do#6	97	4434.92	do#7		109
1124.86	do#h5	do#5	85	2249.71	do#h6	do#6	97	4499.43	do#7		109
1141.22	do#q5	do#5	85	2282.44	do#q6	do#6	97	4564.87	do#7		109
1157.82	do#qh5	re5	86	2315.64	do#qh6	re#6	98	4631.27	do#qh7	re7	110
1174.66	re5	re5	86	2349.32	re6	re6	98	4698.64	re7	re7	110
1191.74	reh5	re5	86	2383.49	reh6	re6	98	4766.98	reh7	re7	110
1209.08	req5	re5	86	2418.16	req6	re6	98	4836.32	req7	re7	110
1226.67	reqh5	re#5	87	2453.33	reqh6	re#6	99	4906.66	reqh7	re#7	111
1244.51	re#5	re#5	87	2489.02	re#6	re#6	99	4978.03	re#7	re#7	111
1262.61	re#h5	re#5	87	2525.22	re#h6	re#6	99	5050.44	re#h7	re#7	111
1280.97	re#q5	re#5	87	2561.95	re#q6	re#6	99	5123.90	re#q7	re#7	111
1299.61	re#qh5	mi5	88	2599.21	re#qh6	mi6	100	5198.43	re#qh7	mi7	112
1318.51	mi5	mi5	88	2637.02	mi6	mi6	100	5274.04	mi7	mi7	112
1337.69	mih5	mi5	88	2675.38	mih6	mi6	100	5350.75	mih7	mi7	112
1357.51	miq5	mi5	88	2714.29	miq6	mi6	100	5428.58	miq7	mi7	112
1376.89	miqh5	fa5	89	2753.77	miqh6	fa6	101	5507.54	miqh7	fa7	113
1396.91	fa5	fa5	89	2793.83	fa6	fa6	101	5587.65	fa7	fa7	113
1417.23	fah5	fa5	89	2834.46	fah6	fa6	101	5668.93	fah7	fa7	113
1437.85	faq5	fa5	89	2875.69	faq6	fa6	101	5751.38	faq7	fa7	113
1458.76	faqh5	fa#5	90	2917.52	faqh6	fa#6	102	5835.04	faqh7	fa#7	114
1479.98	fa#5	fa#5	90	2959.96	fa#6	fa#6	102	5919.91	fa#7	fa#7	114
1501.50	fa#h5	fa#5	90	3003.01	fa#h6	fa#6	102	6006.02	fa#h7	fa#7	114
1523.34	fa#q5	fa#5	90	3046.69	fa#q6	fa#6	102	6093.38	fa#q7	fa#7	114
1545.50	fa#qh5	sol5	91	3091.00	fa#qh6	sol6	103	6182.01	fa#qh7	sol7	115
1567.98	sol5	sol5	91	3135.96	sol6	sol6	103	6271.93	sol7	sol7	115
1590.79	solh5	sol5	91	3181.58	solh6	sol6	103	6363.15	solh7	sol7	115
1613.93	solq5	sol5	91	3227.85	solq6	sol6	103	6455.71	solq7	sol7	115
1637.40	solqh5	sol#5	92	3274.80	solqh6	sol#6	104	6549.61	solqh7	sol#7	116
1661.22	sol#5	sol#5	92	3322.44	sol#6	sol#6	104	6644.87	sol#7	sol#7	116
1685.38	sol#h5	sol#5	92	3370.76	sol#h6	sol#6	104	6741.53	sol#h7	sol#7	116
1709.90	sol#q5	sol#5	92	3419.79	sol#q6	sol#6	104	6839.58	sol#q7	sol#7	116
1734.77	sol#qh5	la5	93	3469.53	sol#qh6	la6	105	6939.07	sol#qh7	la7	117
1760.00	la5	la5	93	3520.00	la6	la6	105	7040.00	la7	la7	117
1785.60	lah5	la5	93	3571.20	lah6	la6	105	7142.40	lah7	la7	117
1811.57	laq5	la5	93	3623.14	laq6	la6	105	7246.29	laq7	la7	117
1837.92	laqh5	la#5	94	3675.84	laqh6	la#6	106	7351.69	laqh7	la#7	118
1864.66	la#5	la#5	94	3729.31	la#6	la#6	106	7458.62	la#7	la#7	118
1891.78	la#h5	la#5	94	3783.55	la#h6	la#6	106	7567.11	la#h7	la#7	118
1919.29	la#q5	la#5	94	3838.59	la#q6	la#6	106	7677.17	la#q7	la#7	118
1947.21	la#qh5	si5	95	3894.42	la#qh6	si6	107	7788.84	la#qh7	si7	119
1975.53	si5	si5	95	3951.07	si6	si6	107	7902.13	si7	si7	119
2004.27	sih5	si5	95	4008.54	sih6	si6	107	8017.07	sih7	si7	119
2033.42	siq6	si5	95	4066.84	siq7	si6	107	8133.68	siq8	si7	119
2063.00	siqh5	do6	96	4126.00	siqh6	do7	108	8251.99	siqh7	do8	120

续表

8372.02	do8	do8	120
8493.79	doh8	do8	120
8617.34	doq8	do8	120
8742.68	doqh8	do#8	121
8869.84	do#8	do#8	121
8998.86	do#h8	do#8	121
9129.75	do#q8	do#8	121
9262.55	do#qh8	re8	122
9397.27	re8	re8	122
9533.96	reh8	re8	122
9672.63	req8	re8	122
9813.33	reqh8	re#8	123
9956.06	re#8	re#8	123
10100.88	re#h8	re#8	123
10247.80	re#q8	re#8	123
10396.86	re#qh8	mi8	124
10548.08	mi8	mi8	124
10701.51	mih8	mi8	124
10857.16	miq8	mi8	124
11015.08	miqh8	fa8	125
11175.30	fa8	fa8	125
11337.85	fah8	fa8	125
11502.76	faq8	fa8	125
11670.08	faqh8	fa#8	126
11839.82	fa#8	fa#8	126
12012.04	fa#h8	fa#8	126
12186.75	fa#q8	fa#8	126
12364.01	fa#qh8	sol8	127
12543.85	sol8	sol8	127
12726.31	solh8	sol8	127
12911.42	solq8	sol8	127
13099.22	solqh8	sol#8	128
13289.75	slo#8	sol#8	128
13483.05	sol#h8	sol#8	128
13679.17	sol#q8	sol#8	128
13878.14	sol#qh8	la8	
14080.00	la8	la8	
142847.80	lah8	la8	
14492.58	laq8	la8	
14703.38	laqh8	la#8	
14917.24	la#8	la#8	
15134.22	la#h8	la#8	
15354.35	la#q8	la8	
15577.68	la#qh8	si8	
15804.27	si8	si8	
16034.14	sih8	si8	
16267.37	siq8	si8	
16503.98	siqh8	do9	

4 Frequency – Pitch – Csound Value 频率、音高与 Csound 值对照表

This table presents a conversion between several pitch representations. This is useful when using pitch notation in MIDI, in Csound and other software.

For the conventional pitch, the table used the common letter notations, where *do* = C, *re* = D and so on from A to G.

In the table, there are 5 columns.

Column 1: only the C pitch is indicated with the octave, where middle C = C3.

Column 2: in this column, the octave number is different. This comes from a Csound representation, so we kept it. Middle C = C5. Do not get confused, simply refer to the table for correspondence.

Column 3: here, the pitch is indicated by its frequency. Note that there are 3 decimals, which is probably too many in most cases. If you use frequency notation, you can reduce to 1 or 2 decimals depending on your needs.

Column 4: this is one of many Csound pitch representation. This is one called cpspch, where cps means "cycles per seconds", an old manner of naming the frequency. Today, we mostly used "Hertz", but it's the same thing. "pch" means pitch-class, a system in which the pitches of a scale are named by their rank in the octave, where C = 0, C# = 1, D = 2 and so on, up to B = 11.

Column 5: this is the standard MIDI notation, beware that the MIDI pitches start at 0, up to 127. In some other notations, they start at 1 up to 128.

下表列示几种音高表示之间的转换关系。在 MIDI、Csound 和其他软件中，使用与音高对应的数值和表示法时，可以参考下表。

对于传统音高，表中使用常见记谱方法，do = C、re = D，从 A 到 G 以此类推。

表格共有 5 列。

第 1 列：只有 C 音高用八度表示，中央 C = C3。

第 2 列：在这一列中，八度数值不同是因为使用的是 Csound 表示法，为便于使用，我们将其纳入表内。中央 C = C5。不要混淆，只需参考表格即可。

第 3 列：在这一列中，音高是用它的频率来表示的。注意，这里显示了 3 位小数，但在大多数情况下可能不需要保留到 3 位。如果使用频率表示法，可以根据需要减少到 1 或 2 位小数。

第 4 列：这是众多 Csound 音高表示法中的一种，称为 cpspch。其中 cps 的意思是"周期/秒"（cycles per seconds），这是频率单位的旧式名称，如今我们主要使用赫兹（Hz），但其实二者的概念是一样的。pch 的意思是"音高级别（pitch-class）"，一个音阶的音高根据它在八度中的等级命名，其中 C = 0、C# = 1、D = 2，以此类推，最高为 B = 11。

第 5 列：标准 MIDI 符号，注意 MIDI 音高从 0 开始，最高为 127。在其他一些音高编号方法中，编码从 1 至 128。

	NOTE	CPS	CPSPCH	MIDI
Do-2	C0	8. 176	3. 00	0
	C#0	8. 662	3. 01	1
	D0	9. 177	3. 02	2
	D#0	9. 723	3. 03	3
	E0	10. 301	3. 04	4
	F0	10. 913	3. 05	5
	F#0	11. 562	3. 06	6
	G0	50	3. 07	7
	G#0	12. 978	3. 08	8
	A0	13. 750	3. 09	9
	A#0	14. 568	3. 10	10
	B0	15. 434	3. 11	11
Do-1	C1	16. 352	4. 00	12
	C#1	17. 324	4. 01	13
	D1	18. 354	4. 02	14
	D#1	19. 445	4. 03	15
	E1	20. 602	4. 04	16
	F1	21. 827	4. 05	17
	F#1	23. 125	4. 06	18
	G1	24. 500	4. 07	19
	G#1	25. 957	4. 08	20
	A1	27. 500	4. 09	21
	A#1	29. 135	4. 10	22

续表

	NOTE	CPS	CPSPCH	MIDI
	B1	30. 868	4. 11	23
Do 0	C2	32. 703	5. 00	24
	C#2	34. 648	5. 01	25
	D2	36. 708	5. 02	26
	D#2	38. 891	5. 03	27
	E2	41. 203	5. 04	28
	F2	43. 654	5. 05	29
	F#2	46. 249	5. 06	30
	G2	48. 999	5. 07	31
	G#2	51. 913	5. 08	32
	A2	55. 000	5. 09	33
	A#2	58. 270	5. 10	34
	B2	61. 735	5. 11	35
Do 1	C3	65. 406	6. 00	36
	C#3	69. 296	6. 01	37
	D3	73. 416	6. 02	38
	D#3	77. 782	6. 03	39
	E3	82. 407	6. 04	40
	F3	87. 307	6. 05	41
	F#3	92. 499	6. 06	42
	G3	97. 999	6. 07	43
	G#3	103. 826	6. 08	44
	A3	110. 000	6. 09	45
	A#3	116. 541	6. 10	46
	B3	123. 471	6. 11	47
Do 2	C4	130. 813	7. 00	48
	C#4	138. 591	7. 01	49
	D4	146. 832	7. 02	50
	D#4	155. 563	7. 03	51
	E4	164. 814	7. 04	52

续表

	NOTE	CPS	CPSPCH	MIDI
	F4	174. 614	7. 05	53
	F#4	184. 997	7. 06	54
	G4	195. 998	7. 07	55
	G#4	207. 652	7. 08	56
	A4	220. 000	7. 09	57
	A#4	233. 082	7. 10	58
	B4	246. 942	7. 11	59
Do 3	C5	261. 626	8. 00	60
	C#5	277. 183	8. 01	61
	D5	293. 665	8. 02	62
	D#5	311. 127	8. 03	63
	E5	329. 628	8. 04	64
	F5	349. 228	8. 05	65
	F#5	369. 994	8. 06	66
	G5	391. 995	8. 07	67
	G#5	415. 305	8. 08	68
A3	A5	440. 000	8. 09	69
	A#5	466. 164	8. 10	70
	B5	493. 883	8. 11	71
Do 4	C6	523. 251	9. 00	72
	C#6	554. 365	9. 01	73
	D6	587. 330	9. 02	74
	D#6	622. 254	9. 03	75
	E6	659. 255	9. 04	76
	F6	698. 456	9. 05	77
	F#6	739. 989	9. 06	78
	G6	783. 991	9. 07	79
	G#6	830. 609	9. 08	80
	A6	880. 000	9. 09	81
	A#6	932. 328	9. 10	82

续表

	NOTE	CPS	CPSPCH	MIDI
	B6	987. 767	9. 11	83
Do 5	C7	1046. 502	10. 00	84
	C#7	1108. 731	10. 01	85
	D7	1174. 659	10. 02	86
	D#7	1244. 508	10. 03	87
	E7	1318. 510	10. 04	88
	F7	1396. 913	10. 05	89
	F#7	1479. 978	10. 06	90
	G7	1567. 982	10. 07	91
	G#7	1661. 219	10. 08	92
	A7	1760. 000	10. 09	93
	A#7	1864. 655	10. 10	94
	B7	1975. 533	10. 11	95
Do 6	C8	2093. 005	11. 00	96
	C#8	2217. 461	11. 01	97
	D8	2349. 318	11. 02	98
	D#8	2489. 016	11. 03	99
	E8	2637. 020	11. 04	100
	F8	2793. 826	11. 05	101
	F#8	2959. 955	11. 06	102
	G8	3135. 963	11. 07	103
	G#8	3322. 438	11. 08	104
	A8	3520. 000	11. 09	105
	A#8	3729. 310	11. 10	106
	B8	3951. 066	11. 11	107
Do 7	C9	4186. 009	12. 00	108
	C#9	4434. 922	12. 01	109
	D9	4698. 636	12. 02	110
	D#9	4978. 032	12. 03	111
	E9	5274. 041	12. 04	112

续表

	NOTE	CPS	CPSPCH	MIDI
	F9	5587. 652	12. 05	113
	F#9	5919. 911	12. 06	114
	G9	6271. 927	12. 07	115
	G#9	6644. 875	12. 08	116
	A9	7040. 000	12. 09	117
	A#9	7458. 620	12. 10	118
	B9	7902. 133	12. 11	119
Do 8	C10	8372. 018	13. 00	120
	C#10	8869. 844	13. 01	121
	D10	9397. 273	13. 02	122
	D#10	9956. 063	13. 03	123
	E10	10548. 08	13. 04	124
	F10	11175. 30	13. 05	125
	F#10	11839. 82	13. 06	126
	G10	12543. 85	13. 07	127

5　Amplitude Conversion Table　振幅换算表

This table shows the conversion between three scales: decibels (dB), relative amplitude between 0 and 1, where 1 is the maximum amplitude, and amplitude values for sounds computed in 16 bits.

下表显示三种不同单位之间的转换关系：分贝（dB）、0 到 1 之间的相对振幅（Relative amp.，其中 1 是最大振幅）以及以 16 位计算的声音振幅值（16 bits amp.）。

dB	Relative amp.	16 bits amp.	dB	Relative amp.	16 bits amp.
0	1.0000	32767.0	−30	0.0316	1036.2
−1	0.8913	29203.6	−31	0.0282	923.5
−2	0.7943	26027.8	−32	0.0251	823.1
−3	0.7079	23197.3	−33	0.0224	733.6
−3	0.6310	20674.6	−34	0.0200	653.8
−5	0.5623	18426.2	−35	0.0178	582.7
−6	0.5012	16422.4	−36	0.0158	519.3
−7	0.4467	14636.5	−37	0.0141	462.8
−8	0.3981	13044.8	−38	0.0126	412.5
−9	0.3548	11626.2	−39	0.0112	367.7
−10	0.3162	10361.8	−40	0.0100	327.7
−11	0.2818	9235.0	−41	0.0089	292.0
−12	0.2512	8230.7	−42	0.0079	260.3
−13	0.2239	7335.6	−43	0.0071	232.0
−14	0.1995	6537.9	−44	0.0063	206.7
−15	0.1778	5826.9	−45	0.0056	184.3
−16	0.1585	5193.2	−46	0.0050	164.2
−17	0.1413	4628.5	−47	0.0045	146.4
−18	0.1259	4125.1	−48	0.0040	130.4
−19	0.1122	3676.5	−49	0.0035	116.3
−20	0.1000	3276.7	−50	0.0032	103.6
−21	0.891	2920.4	−51	0.0028	92.3
−22	0.0794	2602.8	−52	0.0025	82.3
−23	0.0708	2319.7	−53	0.0022	73.4
−24	0.0631	2037.5	−54	0.0020	65.4
−25	0.0562	1842.6	−55	0.0018	58.3
−26	0.0501	1642.2	−56	0.0016	51.9
−27	0.0447	1463.6	−57	0.0014	46.3
−28	0.0398	1304.5	−58	0.0013	41.3
−29	0.0355	1162.6	−59	0.0011	36.8
			−60	0.0010	32.8

6　Time Division and Digital Storage　时间换算和数字存储

6.1　Digital Storage　数字存储

In this table, we take the byte (8 bits) as unit. In some cases, the unit may be the bit.

k：1 kilo ＝ 1000　　bytes ＝ 1 thousand bytes ＝ 10^3 bytes[①]

M：1 mega ＝ 1000 kilos ＝ 1 million bytes ＝ 10^6 bytes

G：1 giga ＝ 1000 megas ＝ 1 billion bytes ＝ 10^9 bytes

T：1 tera ＝ 1000 gigas ＝ 1000 billion bytes ＝ 10^{12} bytes

1 B（字节）　＝8 bit（位）

1 kB（Kilobyte，千字节）　＝1000 B＝10^3 B（千字节）[②]

1 MB（Megabyte，兆字节）　＝1000 kB＝10^6 B（百万字节）

1 GB（Gigabyte，吉字节）　＝1000 MB＝10^9 B（十亿字节）

1 TB（Terabyte，太字节）　＝1000 GB＝10^{12} B（万亿字节）

6.2　Time Division　时间换算

1 second　＝　　　　　1

100ms　＝　　　　　0.1 s　　1/10

10ms　＝　　　　　0.01 s　　1/100

1ms　＝　　　　　0.001 s　　1/1000

There are 1000 milliseconds in 1 second.

100 毫秒 ＝0.1 秒 ＝1/10 秒

10 毫秒 ＝0.01 秒 ＝1/100 秒

1 毫秒 ＝0.001 秒 ＝1/1000 秒

1000 毫秒 ＝1 秒

①　Caution, kilo may also mean 1024（2^{10}）.

②　据国际单位制标准（SI），1 kB＝1000 B，以此类推。如果照国际电工委员会（IEC）命名标准，用于二进制存储单位的标准命名是 KiB、MiB 等，1 KiB＝1024 B＝2^{10} B，以此类推。在日常使用中，kB 确有二者混用指代不明的情况，此处遵从的是国际单位制标准。——编者注

7　Table of Powers of Two　2 的 N 次方对照表

This table is useful when using Csound. The GEN function 1 stores an external soundfile（wav or aiff）into a table. The size of the table must be equal to a power of two. The maximum tablesize is 16777216（224）points.

For example：f 1 0 131072 1 "soundfile. wav" 0 0 0

下表在使用 Csound 时非常有用。GEN 函数 1 将外部声音文件（wav 或 aiff）储存到表格中。表格的大小必须等于 2 的 N 次方，最大值为 16777216（224）点。

例如：f 1 0 131072 1 "soundfile. wav" 0 0 0。

Binary Value 二进制数值	Decimal Equivalent 十进制数值
2^0	1
2^1	2
2^2	4
2^3	8
2^4	16
2^5	32
2^6	64
2^7	128
2^8	256
2^9	512
2^{10}	1048
2^{11}	2048
2^{12}	4096
2^{13}	8192
2^{14}	16384
2^{15}	32768

续表

Binary Value 二进制数值	Decimal Equivalent 十进制数值
2^{16}	65536
2^{17}	131072
2^{18}	262144
2^{19}	524288
2^{20}	1048576
2^{21}	2097304
2^{22}	4194304
2^{23}	8388608
2^{24}	16777216
2^{25}	33554432
2^{26}	67108864
2^{27}	134217728
2^{28}	268435456
2^{29}	536870912
2^{30}	1073741824
2^{31}	2147483684
2^{32}	4294967296

8 Correspondence Decimal – Binary 十进制与二进制对应关系表

0	0	1
1	1	
2	10	2
3	11	
4	100	3
5	101	
6	110	
7	111	
8	1000	4
9	1001	
10	1010	
11	1011	
12	1100	
13	1101	
14	1110	
15	1111	
16	10000	5
...
127	01111111	7
128	10000000	8
...
255	11111111	8

Decimal 十进制	Binary 二进制	Power of Two 2 的平方
0	0	
1	1	2^0
2	10	2^1
4	100	2^2
8	1000	2^3
16	10000	2^4
32	100000	2^5
64	1000000	2^6
128	10000000	2^7
256	100000000	2^8

9 General MIDI 通用 MIDI

1	Acoustic Grand Piano	平台钢琴		32	Guitar Harmonics	吉他泛音
2	Bright Acoustic Piano	亮音钢琴		33	Acoustic Bass	民谣贝斯
3	Electric Grand Piano	电钢琴		34	Electric Bass（finger）	电贝斯（指奏）
4	Honky-tonk Piano	酒吧钢琴		35	Electric Bass（pick）	电贝斯（拨奏）
5	Electric Piano 1	电钢琴 1		36	Fretless Bass	无格贝斯
6	Electric Piano 2	电钢琴 2		37	Slap Bass 1	捶钩贝斯 1
7	Harpsichord	大键琴		38	Slap Bass 2	捶钩贝斯 2
8	Clavinet	电翼琴		39	Synth Bass 1	合成贝斯 1
9	Celesta	钢片琴		40	Synth Bass 2	合成贝斯 2
10	Glockenspiel	钟琴		41	Violin	小提琴
11	Musical Box	音乐盒		42	Viola	中提琴
12	Vibraphone	颤音琴		43	Cello	大提琴
13	Marimba	马林巴琴		44	Contrabass	低音大提琴
14	Xylophone	木琴		45	Tremolo Strings	颤弓弦乐
15	Tubular Bell	管钟		46	Pizzicato Strings	弹拨弦乐
16	Dulcimer	洋琴		47	Orchestral Harp	竖琴
17	Drawbar Organ	音栓风琴		48	Timpani	定音鼓
18	Percussive Organ	敲击风琴		49	String Ensemble 1	弦乐合奏 1
19	Rock Organ	摇滚风琴		50	String Ensemble 2	弦乐合奏 2
20	Church Organ	教堂管风琴		51	Synth Strings 1	合成弦乐 1
21	Reed Organ	簧风琴		52	Synth Strings 2	合成弦乐 2
22	Accordion	手风琴		53	Voice Aahs	人声 "啊"
23	Harmonica	口琴		54	Voice Oohs	人声 "喔"
24	Tango Accordion	探戈手风琴		55	Synth Voice	合成人声
25	Acoustic Guitar（nylon）	木吉他（尼龙弦）		56	Orchestra Hit	交响打击乐
26	Acoustic Guitar（steel）	木吉他（钢弦）		57	Trumpet	小号
27	Electric Guitar（jazz）	电吉他（爵士）		58	Trombone	长号
28	Electric Guitar（clean）	电吉他（原音）		59	Tuba	大号（吐巴号、低音号）
29	Electric Guitar（muted）	电吉他（闷音）		60	Muted Trumpet	闷音小号
30	Overdriven Guitar	电吉他（破音）		61	French Horn	法国号（圆号）
31	Distortion Guitar	电吉他（失真）		62	Brass Section	铜管乐

续表

63	Synth Brass 1	合成铜管 1
64	Synth Brass 2	合成铜管 2
65	Soprano Sax	高音萨克斯风
66	Alto Sax	中音萨克斯风
67	Tenor Sax	次中音萨克斯风
68	Baritone Sax	上低音萨克斯风
69	Oboe	双簧管
70	English Horn	英国管
71	Bassoon	低音管（巴颂管）
72	Clarinet	单簧管（黑管、竖笛）
73	Piccolo	短笛
74	Flute	长笛
75	Recorder	直笛
76	Pan Flute	排箫
77	Blown Bottle	瓶笛
78	Shakuhachi	尺八
79	Whistle	哨子
80	Ocarina	陶笛
81	Lead 1（square）	方波
82	Lead 2（sawtooth）	锯齿波
83	Lead 3（calliope）	汽笛风琴
84	Lead 4（chiff）	合成吹管
85	Lead 5（charang）	合成电吉他
86	Lead 6（voice）	人声键盘
87	Lead 7（fifths）	五度音
88	Lead 8（bass + lead）	贝斯吉他合奏
89	Pad 1（new age）	新世纪
90	Pad 2（warm）	温暖
91	Pad 3（polysynth）	多重合音
92	Pad 4（choir）	人声合唱
93	Pad 5（bowed）	玻璃
94	Pad 6（metallic）	金属
95	Pad 7（halo）	光华

96	Pad 8（sweep）	扫掠
97	FX 1（rain）	雨
98	FX 2（soundtrack）	电影音效
99	FX 3（crystal）	水晶
100	FX 4（atmosphere）	气氛
101	FX 5（brightness）	明亮
102	FX 6（goblins）	魅影
103	FX 7（echoes）	回音
104	FX 8（sci-fi）	科幻
105	Sitar	西塔琴
106	Banjo	五弦琴（班卓琴）
107	Shamisen	三味线
108	Koto	十三弦琴（古筝）
109	Kalimba	卡林巴铁片琴
110	Bagpipe	苏格兰风笛
111	Fiddle	古提琴
112	Shanai	印度唢呐
113	Tinkle Bell	叮当铃
114	Agogo	阿哥哥鼓
115	Steel Drums	多则钢鼓
116	Woodblock	木鱼
117	Taiko Drum	太鼓
118	Melodic Tom	定音筒鼓
119	Synth Drum	合成鼓
120	Reverse Cymbal	逆转钹声
121	Guitar Fret Noise	吉他滑弦杂音
122	Breath Noise	呼吸杂音
123	Seashore	海岸
124	Bird Tweet	鸟鸣
125	Telephone Ring	电话铃声
126	Helicopter	直升机
127	Applause	拍手
128	Gunshot	枪声

Percussion Sounds 打击乐音

35	Bass Drum 2	大鼓 2
36	Bass Drum 1	大鼓 1
37	Side Stick	小鼓鼓边
38	Snare Drum 1	小鼓 1
39	Hand Clap	拍手
40	Snare Drum 2	小鼓 2
41	Low Tom 2	低音筒鼓 2
42	Closed Hi-hat	低音筒鼓 1
43	Low Tom 1	低音筒鼓 1
44	Pedal Hi-hat	脚踏开合钹
45	Mid Tom 2	中音筒鼓 2
46	Open Hi-hat	开放开合钹
47	Mid Tom 1	中音筒鼓 1
48	High Tom 2	高音筒鼓 2
49	Crash Cymbal 1	强音钹 1
50	High Tom 1	高音筒鼓 1
51	Ride Cymbal 1	打点钹
52	Chinese Cymbal	钹
53	Ride Bell	响铃
54	Tambourine	铃鼓
55	Splash Cymbal	小钹铜钹
56	Cowbell	牛铃
57	Crash Cymbal 2	强音钹 2
58	Vibra Slap	噪音器

59	Ride Cymbal 2	打点钹 2
60	High Bongo	高音邦加鼓
61	Low Bongo	低音邦加鼓
62	Mute High Conga	闷音高音康加鼓
63	Open High Conga	开放高音康加鼓
64	Low Conga	低音康加鼓
65	High Timbale	高音天巴雷鼓
66	Low Timbale	低音天巴雷鼓
67	High Agogo	高音阿哥哥鼓
68	Low Agogo	低音阿哥哥鼓
69	Cabasa	铁沙铃
70	Maracas	沙槌
71	Short Whistle	短口哨
72	Long Whistle	长口哨
73	Short Guiro	短刮瓜
74	Long Guiro	长刮瓜
75	Claves	击木
76	High Wood Block	高音木鱼
77	Low Wood Block	低音木鱼
78	Mute Cuica	闷音锯加鼓
79	Open Cuica	开放锯加鼓
80	Mute Triangle	闷音三角铁
81	Open Triangle	开放三角铁

Bibliography　参考文献

BATTIER M, LIAO L N. Electronic music in east Asia ［M］//EMMERSON S. The Routledge research companion to electronic music: reaching out with technology. London: Routledge, 2018: 49 – 76.

BOULANGER R. The Csound book ［M］. Cambridge (MA): The MIT Press, 2000.

CHADABE J. Electric sound: the past and promise of electronic music ［M］. Upper Saddle River (N. J.): Prentice Hall, 1997.

CHOWNING J M. The synthesis of complex audio spectra by means of frequency modulation ［J］. Computer music journal, 1977, 1: 46 – 54.

CIPRIANI A, GRIZI M. Electronic music and sound design ［M］. Roma: ConTempoNet, 2010 – 2019.

GOTO S. Emprise ［M］. Tokyo: Stylenote, 2016.

HAGAN K, PUCKETTE M. Behind the tracks: musicians on selected electronic music ［M］. Cambridge (MA): The MIT Press, 2020.

HILLER L A, ISAACSON L M. Experimental music: composition with an electronic computer ［M］. New York: McGraw-Hill Book Company, 1959.

HOLMES T. Electronic and experimental music: technology, music, and culture ［M］. New York: Routledge, 2020.

LANDY L. Understanding the art of sound organization ［M］. Cambridge (MA): The MIT Press, 2007.

MATHEWS M. The technology of computer music ［M］. Cambridge (MA): The MIT Press, 1969.

ROADS C. The computer music tutorial ［M］. Cambridge (MA): The MIT Press, 1996.

SCHAEFFER P. Treatise on musical objects: an essay across disciplines ［M］. Oakland: University of California Press, 2021.

TERUGGI D. Technology and musique concrète: the technical developments of the groupe de recherches musicales and their implication in musical composition ［J］. Organised sound, 2007, 2: 213 – 231.

WANG J. Half sound, half philosophy［M］. New York：Bloomsbury Academic，2021.

ZHANG X. The power of arterial language in constructing a musical vocabulary of one's own：inheriting the inspiration and gene of innovation in electroacoustic music from Chinese culture［M］// BATTIER M，FIELDS K. Electronic music in East Asia，London：Routledge，2020：125 – 133.

ZIMMER F. Bang：a pure data book［M］. Hofheim am Taunus：Wolke-Verlag，2006.

白小墨，韩彦敏，陆敏捷，等. 电子音乐理论基础［M］. 成都：西南师范大学出版社，2014.

黄忱宇. 电子音乐与计算机音乐基础理论［M］. 北京：华文出版社，2005.

黄忱宇. 西方电子与计算机音乐史：电子、数字科技影响下的西方音乐［M］. 北京：中央音乐学院出版社，2012.

韩宝强. 音的历程［M］. 北京：中国文联出版社，2003.

胡晓，陆敏捷，韩彦敏. 民族器乐与电子音乐《幻境》音乐剧场［M］. 成都：西南师范大学出版社，2020.

柯蒂斯·罗兹. 计算机音乐教程［M］. 北京：人民音乐出版社，2011.

杰弗瑞·斯托莱特. Kyma 系统实用技巧［M］. 成都：西南师范大学出版社，2014.

李嘉. 电子音乐创作思维在声学乐器中的实现特征：从具有电子音乐工作经验的作曲家谈起［J］. 中央音乐学院学报，2011，4：90 – 99.

李琨. VVVV 与新媒体艺术创作［M］. 成都：西南师范大学出版社，2018.

李颖. 国内外电子音乐的发展状况：吴粤北教授座谈会纪要［J］. 天津音乐学院学报，2014，1：124 – 128.

林达悃. 影视录音电声学［M］. 北京：中国广播电视出版社，2005.

林达悃. 影视录音声学基础［M］. 北京：中国广播电视出版社，2005.

刘健，钱仁平，冯坚. 电子音乐创作与研究文集［M］. 上海：上海音乐出版社：2007.

倪朝晖. 算法作曲理论与实践［M］. 成都：西南师范大学出版社，2015.

吴林励. 中国电子音乐创作研究［M］. 北京：文化艺术出版社，2011.

吴粤北. 先锋派实验音乐之涅槃［M］. 上海：上海音乐学院出版社，2011.

许鹏. 新媒体艺术论［M］. 北京：高等教育出版社，2006.

杨万钧. CSOUND 音乐编程入门［M］. 成都：西南师范大学出版社，2015.

杨万钧. PURE DATA 图形化音乐编程技术与应用［M］. 成都：西南师范大学出版社，2017.

于祥国. 十年磨一剑：中央音乐学院中国现代电子音乐中心成立十周年纪念［J］. 中央音乐学院学报，2004，3：105－108.

张伯瑜. 魂之乐事：音乐学术交流纪实录［M］. 北京：中央音乐学院出版社，2018.

张小夫. 电子音乐的概念界定［J］. 中央音乐学院学报，2002，4：30－32.

张小夫. 对中国电子音乐发展脉络的梳理与评估［J］，艺术评论，2012，4：27－40.

赵晓雨. 艺术理念与技术创新驱动下的中国电子音乐发展［J］. 中央音乐学院学报，2019，4：83－90.

钟子林. 西方现代音乐概述［M］. 北京：人民音乐出版社，1991.